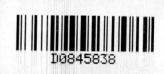

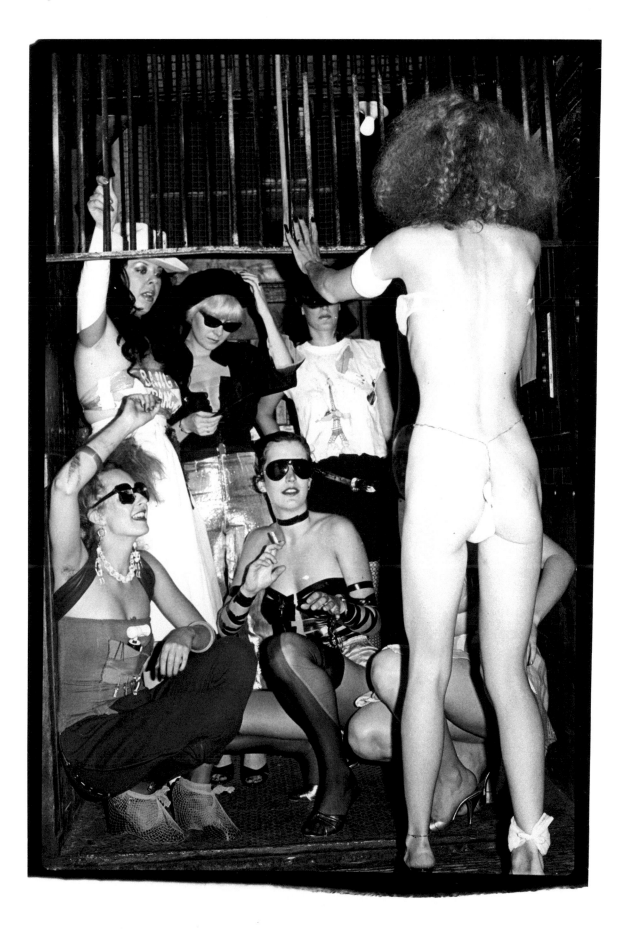

Is Toronto Burning?

Three Years in the Making (and Unmaking)
of the Toronto Art Scene

Philip Monk

agYU black dog
publishing
london uk

STRIKE

ART COMMUNICATION EDITION, VOL. 2, No. 2, MAY, 1978

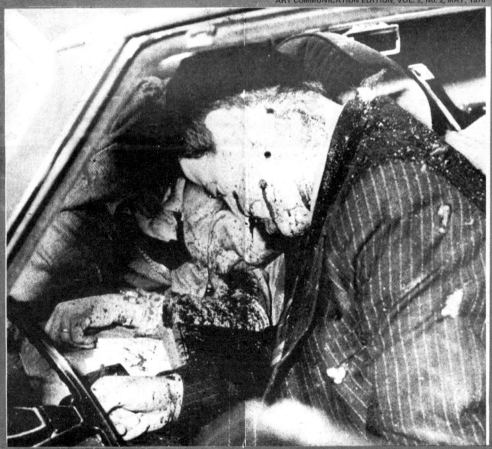

CANADA & U.S....$.50
FRANCEF3
GERMANYDM2
ITALYLIT500
UNITED KINGDOM 30p

**TORTURE
POST-MARXISM
RED BRIGADES**

Contents

WINNIPEG — For only $5.00 (members $4.50), the Winnipeg Art Gallery is offering a one-time only chance to experience General Idea's notorious rehearsal for the **1984 Miss General Idea Pageant.** The gallery will be turned into a giant T.V. studio and the ____ will be recorded ____ ____ the ____

On Saturday, October 22 at 8 p.m., includes a performance followed by a party scene with music by Toronto's hottest punk band **the Dishes,** and a bar provided by the gallery. A surprise ending promises to bring the house down in flames. General Idea has been working together since 1968. The first Miss General Idea ____ ____wn Mimi Paige, was chosen

will rehearse the audience, the contestants, an ____ musicians for the 1984 Miss General Idea Page ____ front of the studio cameras. The performance i ____ personal appearances by General Idea ____ ____p, Felix Partz, and Jorg ____

The Winnipeg Art Gallery

1977

Toronto in the late 1970s was one of the last avant-gardes. In the internet era and age of social media, the conditions for the underground seem no longer possible. Instant availability and constant communication of cultural products, uploaded and downloaded by the democratic mob, are not receptive to singular events that need be sustained in settings of quasi-secrecy in small rooms on side streets. Truly, it is no analogous coincidence how well Roland Barthes' *Camera Lucida*, published in 1980, marks the division between the "that has been" of the analogue print and our digital age. The turn of the decade, 1980, that's really the end of my story. From the perspective of here and now, this "that has been" is no lament for a lost art scene that formed in a few short years in Toronto in the 1970s, then dissolved. But in a sense, you had to be there to recognise how analogue our experience of it was. You had to walk the mean streets of Toronto's abandoned warehouse district on nights of its heat-blasted summers and dread winters on your way to a performance or video screening to feel how real it was, how material the feel of the buildings and streets. Looking back on archival photographs of downtown Toronto streetscapes then (in a bleak economic period, moreover), you realise how dour and grey it was. And so too was the art, shades of grey and black—all those video and photographs that render this scene, not to be contradictory, vivid for us today, definitely not dour. They were, place and product, a dialogue. The art scene was a precinct, a place you had to enter, but not be policed. But an underground would not be a scene unless it disseminated itself through these very images of itself. Disseminated itself and was received from afar. And drew people to it. This is also the story of the Toronto art community.

In a sense, what follows is a story, a story with a cast of characters. These characters are pictured in video, photography, and print—not necessarily as portraits but rather as performers. The cast repeats, almost as if in a soap opera, with name and identity changes. Artists reappear performing in

their own work and acting in others. This is a thing that makes Toronto distinctive, not just this co-operative production or staging (that also existed behind the scenes in artists shooting friends' works, for instance), but also the *fictional* image artists sustained of an art scene before it was recognised as one—and that helped usher it in. To be more exact, the reason it came into being, performatively. In this 'fiction' we discover a collective portrait of an art scene and also an image of its making.

Some would contend that it is not the performances of this fiction but the places of primary production that Toronto artists collectively constructed—the so-called artist-run system—that is the real story. Construction not construal. Certainly, artists would say this. "We, the producers, are the ones to write this history, not those, secondary to the scene, who call themselves writers." This ethos of primary production, unfortunately, has not issued in a history—and this is a problem that writers have to take up. As important as the artist-run system was, my aim is not to document it. If at times I err on the side of ironic ambiguity over political earnestness, by which you could sometimes identify these opposing sides—fictional performance and primary production, respectively—I would only be intervening historically in the conflicted real-time 'soap opera' of that past scene. For given Toronto's resistance to history, to the writing of its history, it is necessary to first mythologise a scene before you can write a history of it. We need to make a moment iconic as much as its individuals. So *Is Toronto Burning?* deals with this collective moment when the Toronto art scene imagined and created itself.

There would be no invention without contention. Here the title resonates. For in these three short years—1977, 1978, 1979—Toronto would make, then unmake, and remake itself again. A penchant for posing was countered by a fashion for politics, the posturing of which was at times volatile and factional. Performativity and politics, in their mutual conviviality and contestation, together the two would fashion an art scene.

STRIKE

SUBSCRIBE

STRIKE

**15 DUNCAN STREET
TORONTO, ONTARIO
M5H 3H1, CANADA**

for information call (416) 593 4111

NAME

ADDRESS

CITY

PROVINCE POSTAL CODE

COUNTRY

PLEASE FIND ENCLOSED CHEQUE OR
 MONEY ORDER FOR $7.00

Was Toronto Burning?

Late in 1977, an important part of Toronto real estate burned down. During rehearsal for General Idea's periodic Pageant, *The 1984 Miss General Idea Pavillion* housing it caught fire. It turns out, strangely, that the match was lit by General Idea, the artists themselves, who then strategically fanned the flames. In Toronto, 1977 was the summer of punk and perhaps General Idea caught its incendiary impulse from that provocative populist conflagration. General Idea always had its collective finger on the pulse of the zeitgeist, here perhaps on its fuse. For Toronto was to burn. Not literally—just as General Idea did not literally destroy their Pavillion, which, of course, was only a fictional construction. The Pavillion's destruction was a response, though. Its destruction was symptomatic of profound changes in the Toronto art scene when "the sentimentalism of late 60s early 70s essentially surrealistic aesthetic [had] been replaced by a certain pragmatic anarchy".[1] Whether or not aesthetics, pragmatically, had been replaced by anarchy, General Idea was on the mark: sentimentalism definitely had been supplanted by politics.

Sentimentalism, you could say, infected the early years of the artist-run system Canada became famous for, instituted as it was in the early 1970s, at least in Toronto, by a bunch of hippies and draft dodgers. They took advantage of federal youth employment programmes (established to defuse youth unrest in the wake of high unemployment and the threat of armed insurrection by the FLQ, the *Front libération du Québec*) to set up an ideal framework of artist-initiated and artist-controlled activity. A few years later, with the encouragement and funding of the Canada Council for the Arts, it was consolidated into a national system—the Association of National Non-Profit Artists' Centres (ANNPAC)—but which some artists still preferred to call, using Robert Filliou's elevating and inclusive nomenclature, the eternal network.

General Idea, *"Destruction":*
The Ruins of the 1984
Miss General Idea Pavillion, 1977

But already the recently instituted artist-run system was in turmoil, at least in Toronto.[2] A Space, the queen bee of the artist-run system, billing itself the first and foremost of the national organisation, had its funding suspended by the Canada Council in 1978. But before even the Council-funded advisory committee report for restructuring had been accepted at the annual meeting, a 'coup' occurred that radically changed the gallery's direction and, in reaction, set off a slew of artist-initiated initiatives elsewhere in the city. Meanwhile across town, A Space's rival, the Centre for Experimental Art and Communication (CEAC), a few months earlier also met government resistance—but from the police and secret service, too, not just funding agencies. Throughout 1977, CEAC had radicalised itself and promoted its revolutionary political programme through its near-monthly publication *Art Communication Edition*, later called *Strike*. *Strike*'s May 1978 editorial, in the wake of Aldo Moro's murder in Rome, called for Red Brigade-style knee-capping. Hardly had the printing ink dried, and before the newsprint bundles were even delivered, the foolhardy comment had been leaked and a Toronto tabloid's morning front page headline screamed "Ont.[ario] grant supports Red Brigades ideology" with a subtitle informing readers "Magazine supporting kneecap-shooting gets $2,500 'arts' award". The scandal spread like wildfire across the media. Ministers were called to account on the floor of the provincial legislature, and even Prime Minister Pierre Trudeau was questioned in the House of Commons. Councils quickly responded and all three arts funding levels—federal, provincial, and municipal—abolished CEAC's funding, with the consequence that CEAC lost its building, purchased, remarkably, with provincial lottery funds! Nonetheless, CEAC eked out one more edition of *Strike*, disingenuously arguing its stance, but, shunned in the frightened art community, three members of the collective fled to New York City while the others remained in Toronto, their careers crushed.

In competition with each other, A Space and CEAC were at the centre of the art politics of the period, but their politics represented different issues or expressed different values. At A Space it was a battle for the space itself and the direction of the institution. There was little of political art here. With the hardening of attitudes as punk and new wave replaced the hippie values of the early-to-mid 1970s, A Space was seen to stand for old values in the stepped-up competition of the international art world. The A Space old guard was sentimentalist. With the coup and 'take-over' of the institution in 1978, art politics were out of the way, and it was business as usual. A Space was just that: a neutral space that could be filled in different ways... or taken over—hijacked by a voting membership—for different purposes. CEAC was another matter. As an institution, CEAC itself was a platform for radical political action, and its institutional products—tabloid journal and performance tours—

were vehicles for the dissemination of its ideology. Both the institution and its contents were political and tightly controlled by a directorship that was self-appointed not elected.

Politics were doubly articulated in Toronto art in the late 1970s. Here then were the political parameters of the Toronto downtown art scene: on the one hand, there was the *art* politics of palace coups; on the other hand, there was the *politics* of art. The latter was a politics of revolutionary affirmation and affiliation. The outcome of politics in the real world came as a surprise to CEAC, however: losing its funding was not what it expected of an effective art, least of all an art that was contradictorily government funded! The middle term, then, equally contradictory, would be a *political art* that was not effective outside the art world, an art that was more rhetorical than reality driven, contrary to artists' presumed intentions or actual statements. The rhetoric meant that it would be a political art of content, not action. The question of what an effective art could be, though, remained a constant issue during this period, effective art being one that addressed a public by having an audience, however motivated it became. What could the criterion of success then be? In their 1977 faux *Press Conference*, General Idea—ironically(?), facetiously(?)—floated a controversial answer: "It's not effective unless it sells."

Selling in Toronto was an uptown affair, however. So, while downtown burned, uptown fiddled. Uptown played its tune to an altogether different score. Alternative art, interdisciplinary art, heavens, *video* art did not sell, so the fiduciary domain and accompanying prestige was assumed by the commercial galleries that congregated relatively close to one another in the Yorkville Village area—an old hippie haunt before the hippies, folksingers, and student radicals were turfed out for commercial galleries and upscale boutiques. This domain thought itself the Toronto art scene. Moreover, it thought Toronto the centre of the Canadian art world.

A special Toronto issue of the mainstream Montreal art magazine *Vie des arts* bears witness to this self-testimony. Published in spring 1977, it opens a window on what presumably was then happening in Toronto. Guest-edited by Roald Nasgaard, contemporary curator at the Art Gallery of Ontario, it began with the typical Toronto need for a disclaimer in asserting its history. "The apparent need to introduce the issue with a disclaimer points to the difficulty of coming to terms with just what *is* the art of the city which believes itself, and no doubt is, the most important artistic centre in Canada."[3] Establishment consensus was that the flag bearers were senior artists Jack Bush and Michael Snow.[4] Jack Bush had been heralded by none other than Clement Greenberg as the salvation of colour field painting for the 1970s, and he was mentor in Toronto to a rag-tag group of young 'lyrical expressionist' painters of Matissean inspiration that exhibited at the Sable-Castelli Gallery. Similarly, Michael

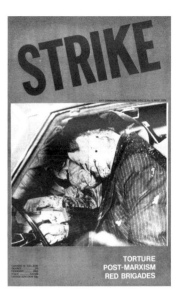

Strike 2, May 1978

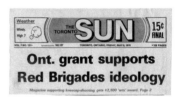

The Toronto Sun, 5 May 1978

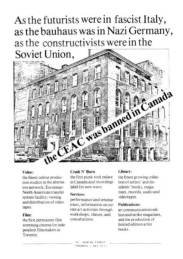

CEAC Advertisement, *Magazine* [Ontario Association of Art Galleries], winter 1978/1979

Snow had been championed by New Yorkers Annette Michelson and
P Adams Sitney for his structural films, but his multi-media work in
sculpture and photography was just as influential in Toronto. Sculpture,
actually, was the liberating form for a number of young Toronto artists as
it served as "an instrument for investigating and clarifying certain specific
aspects of their own existence and experience in the contemporary world",
wrote Walter Klepac.[5] Not that this meant their work was subjective;
it was rigorous in its own ways. Almost all the artists mentioned by
Klepac—in particular, David Rabinowitch, Royden Rabinowitch, Ian
Carr-Harris, Robin Collyer, Robin MacKenzie, Colette Whiten, and
Murray Favro—showed at the Carmen Lamanna Gallery. There was
no question that sculpture trumped painting in Toronto, just as the
Lamanna Gallery—which had been invited to the Third International
Pioneer Galleries exhibition in Lausanne, Switzerland in 1970—trumped
the Sable-Castelli Gallery.

Nasgaard was catholic, or prescient enough, to include writers
who addressed not only diversity of media beyond painting and
sculpture (though, significantly, not photography) but also the
established uptown scene *and* incipient downtown community where
the actual experimentation was happening. David Buchan (an artist
in General Idea's circle, who also worked at the collective's artist-run
centre Art Metropole) wrote on what is now a lost history of women's
performance art of the mid-1970s. These ironic, fashion-oriented
performances by second wave feminist artists were usually collective
in creation and took the "preformed cultural phenomena of fashion
shows, ice follies, wedding ceremonies, cabaret entertainments
or dime-store-novel plots" for their camp critiques of gender
construction.[6] Peggy Gale (Art Metropole's Video/Film Director)
wrote of the relatively new form of video art, merely a half-decade
old—an art form that would go on to garner prestige for Canadian
art as a cultural export. According to her, Toronto's contribution was
"best known in international video circles for the artists' use of the
medium" to explore artists' "interior realities".[7] Lisa Steele and Colin
Campbell were prime examples, but Rodney Werden was singled
out, too, for his frank fascination with sexuality. Video's rudimentary
editing capability dictated the form of these early works, which made
them seemingly naturalistic and intimately confessional; but General
Idea were acknowledged for their mimicry of broadcast television
formats that was both a disguised media analysis and a "structural
investigation of the phenomenon of culture". By the decade's end Toronto
video artists would be looking to place their work on broadcast
or cablecast television. It was only natural in Marshall McLuhan's
hometown that adventurous artists would embrace new technologies
and seek to address a mass audience.

Another contemporary report published in 1977 in the Milan art magazine *TRA* was more partisan in outlook and had no need for any disclaimer:

> The beginning of a new Canadian avant-garde and/or radical consciousness dates from about 1970. Although sporadic attempts were made by some groups and galleries in the sixties (such as the artists' circle around Michael Snow, who left Toronto in the mid-sixties for a decade in New York), the arrival of Carmen Lamanna in Toronto was essential for the realization and growth of innovation within the artistic milieu. Lamanna was the one art dealer to encourage the first experiments in the new forms of land art, post minimalism and later some attempts in narrative art.
>
> Throughout the sixties, neither a strong consciousness, nor a rethinking of the art structure were cultivated. Only at the turn of the decade did the new socializing movements begin to take shape through the cafes, new theatre groups, collectives of political, feminist and most importantly the gay liberation movement.
>
> Parallel, though seldom connected to these collective movements, artists groups worked around the new art functions of conceptual and post-Warhol extractions.[8]

Although supposedly reporting on all Canada in these opening paragraphs, Amerigo Marras really was describing Toronto, where he himself resided. Moreover, he was implicitly implicating himself in the 1970s "rethinking of the art structure" as he was the mastermind and instigator of CEAC's polemics, being the centre's founding director. Significantly, the "and/or" of his opening sentence elided what in reality would be divisive and contentious amongst the city's artists—but that would come later. Nonetheless, he was unapologetic, despite the important nod to Carmen Lamanna, that the new forces were collective: not determined by the commercial interests of uptown galleries but by Toronto's "new socializing movements".

If politics defined the period, downtown artists were also shaping themselves into a scene. Its contours would be shaped, and shattered at times, by the problematic parallelism of its "post-Warhol extractions" with the "new socializing movements", on the one hand, and of its marginal social scene with the civil society surrounding it, on the other. Yet, at that point, the downtown art scene operated not in a vacuum but, let's say, in a vacancy. Part of that vacancy was the open territory of the downtown Toronto landscape where it would situate itself—a sketchy neighbourhood right on the edge of the financial district, with its dive hotels, drinking taverns, greasy spoons, and empty turn-of-the-century warehouses surrounded by vast parking

Downtown Toronto, circa 1970

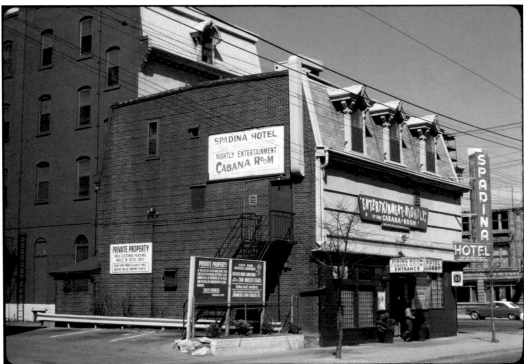

Boundaries of the downtown art scene

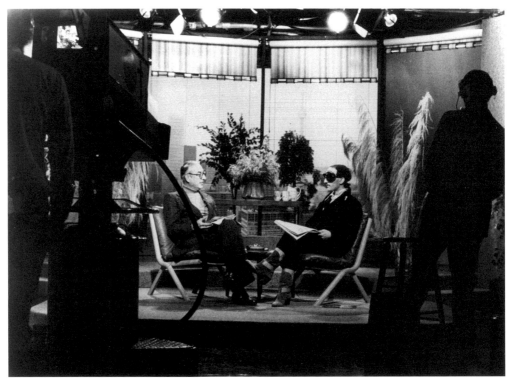

Amerigo Marras being interviewed by Warren Davis on *Time For You*, CBC Television, 1977

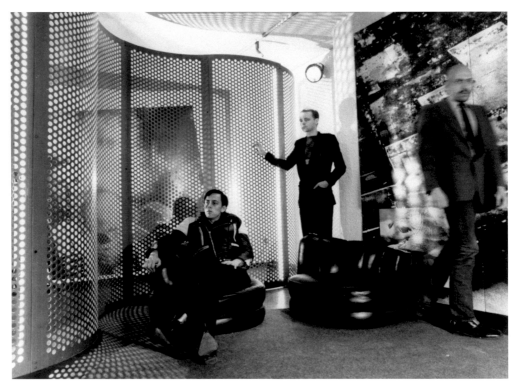

General Idea, *Reconstructing Futures*, 1977

lots, the residue of demolished buildings. It was pretty vacant. And nobody was watching.

Absent, too, was any guiding movement in contemporary art. Whether it was the 'pluralism' of the moment, or a case of 'post-movement' art, nothing of compelling interest was coming out of New York in the mid-1970s. With its colonial insecurities, Toronto tended to follow New York: we had Abstract Expressionists, Pop artists, Minimalists, and postminimalists, too![9] And they would duly be shown, if lucky, at the Art Gallery of Ontario. Meanwhile, the uptown galleries tried to obscure this absence with the illusionary haze of its yards and yards of colour-field canvases. It was pretty vacant! Or the other way around: there was lots of vacant prettiness. With no consensus in New York, nothing presented itself as the next step, and so in the artistic vacancy of the moment, the next step could be a step aside. Art scenes, momentarily, could develop according to their own terms outside the imperialist tyranny of New York's dominance, a tyranny always locally reinforced. And so London, Paris, Cologne, or Toronto could go each its own way—maybe even New York itself, as the Lower East Side phenomena later temporarily proved.[10]

Suddenly there were no givens. "Then, out of the confusion, a whole new milieu came into being, born of the daily contacts of painters and poets, a milieu with all the curious and exaggerated features of a sect, but without its ready-made pretexts for coming into existence."[11] Georges Bataille wrote this of the late nineteenth-century French avant-garde, but he might as well have been speaking about Toronto in the late 1970s. That is, if we substitute video artists and magazine publishers for painters and poets. Obviously, in Toronto, there was no salon and conservative state patronage to rebel against, but equally there was no set of values to adhere to.

What was needed were new values. What was needed, according to AA Bronson of General Idea, was:

> ... a dream community connected by and reflected by the media; that is authenticated by its own reflection in the media; as such a Canadian artist desiring to see not necessarily himself, but the picture of his art scene pictured on TV; and knowing the impossibility of an art scene without real museums (the Art Gallery of Ontario was not a real museum for us), without real art magazines (and *artscanada* was not a real art magazine for us), without real artists (no, Harold Town was not a real artist for us, and we forgot that we ourselves were real artists, because we had not seen ourselves in the media—real artists, like Frank Stella, appeared in *Artforum* magazine); as such as an artist desiring such a picture of such a scene, such a reality from sea-to-shining-sea, then, it was natural to call upon our national attributes—

the bureaucratic tendency and the protestant work ethic—and working together, and working sometimes not together we laboured to structure, or rather to untangle from the messy post-sixties spaghetti of our minds, artist-run galleries, artists' video, and artist-run magazines. And that allowed us to allow ourselves to see ourselves as an art scene. And we did.[12]

Bronson's reference points were Toronto, though the point was that there was no consensus as to what constituted a relevant art scene in the city. While "from sea-to-shining-sea" was a dream, Toronto was *realpolitik*. It was a matter of the day-to-day construction of an art scene where there were no "ready-made pretexts for coming into existence". So by means of artist-run galleries, artists' video, and artist-run magazines—that artists respectively created, made, and disseminated—a blank space was filled in. What was filled in was an *image*, an image that then realised itself in a scene—by the very means of portraying that scene. And so, in Toronto, the new reference point became: an art scene looking at itself. Within a developing downtown art scene of daily contacts, within this vacant space in which nobody was watching, the nobody-watching was transformed into a scenario of artists looking at themselves and talking together. And talking together and looking at themselves, they made videos and took photographs and made magazines, depicting themselves and others, moreover, producing and appearing in each other's work. Such producing each other's works and appearing in them visualised these new values, although they weren't necessarily then understood as such. Or articulated. Articulation was not about co-operation; it was not about consensus but, rather, contention. What was articulated then was the contestation within the community. Visualisation and articulation, co-operation and contestation, both went together to contribute to the making of a scene in Toronto.

Just as Bronson was looking back from the perspective of 1983 over the past decade of the heroic years of instituting a national artist-run system, so in 1987 he cast his gaze back on ten years of Toronto art. If in the first he surveyed the realisation of a dream, did this astute observer know in the second that the dream already was over for Toronto and that the city's art scene already was in ruins? Nonetheless, he writes:

Toronto's most salient characteristics, to my mind, are these two: an overwhelming pragmatism—(Toronto artists were constructing an art scene, not an alternative)—and an unruly diversity resulting from an ongoing migration of artists from other regions to Toronto.

The first of these is best revealed in Toronto's fascination with periodicals and video. In order to be an art scene you have to be able to see yourself as an art scene. In the early 70s magazines such as

FILE, Proof Only, Image Nation and *Impulse* set out to do just that, to reflect the art scene back to itself. Similarly, early Toronto video was usually narrative and usually aimed at an audience of other artists. Artists starred in each others tapes, and a premiere of a new Colin Campbell tape at the Cabana Room was a little like attending the Academy Awards. In this way both periodicals and video aided artists in seeing themselves as an art scene and in representing themselves as an art scene.

As for Toronto's diversity, it is clear that Toronto has no specific regional characteristics. It is rather a mosaic of regional characteristics from other parts of the country, here thrust into continuous disarray. Toronto is the only Canadian city in which the art scene is continually fracturing, and thrives by that fracturing.[13]

Well, in a way, here is my story in nucleus: the idea of Toronto making itself—and making itself visible—while fracturing at the same time. "In seeing themselves as an art scene and in representing themselves as an art scene", the idea was not necessarily intentional or conscious, that is, to represent itself as a scene. Artworks were made that, in retrospect, can be read as allegories of (the construction) of an art scene, as reflections of the quotidian ways people worked, played... and argued. Creation of a scene was the consequence of what could only be called a fictional act. The fictive was constitutive.

That this representation in its time was photographic, or necessarily photographic (that is, the photographic medium extended into video and magazine publication) is important. In spite of the fact, obviously, that there were sculptors and painters—both avant-garde and retrograde—operating in Toronto, here is the means by which the scene was represented—but also how it came *to be*. Picturing itself to itself, it eventually pictured itself to others. So the image we have today of this scene extends beyond its artworks and might also involve various archival documents—photographs and magazines—and those incidental to artistic intent but not to its promotion: posters, advertisements, flyers, etc.[14]

That *Vie des arts* had no category for photographic work in its collection of Toronto articles makes us pause, however.[15] How in these few years could the Toronto art scene define itself by photography and yet the medium itself not be recognised in genesis in a 1977 survey? Maybe Nasgaard failed to come to terms with the uses of photography as practiced in Toronto—or maybe he was just not interested. Maybe the problem was that what looked like conceptual art was naive and only derivative of it. Or was it that Toronto was unwilling to embrace a photographic art that was language-based because of its critics' and curators' phenomenological bias, itself derived from the obdurate and taciturn authority of American Minimalism?

Photography was more than a medium. It was generative. It pictured a scene that was about to be. But the unruly fracturing Bronson writes about potentially was destructive, too. The "fracturing": here is the other side of the story—not just a productive splintering but a factional clash.[16] If the allegories are fictional, while still depicting actual situations, the fracturing was real. If fracturing factionalism was a fact, at times it was also a fiction. Witness the destruction of *The 1984 Miss General Idea Pavillion*; but wasn't this just as much allegorical of the real fracturing within the Toronto art world? The destructive and the fictional, or the factional and the fictional, perhaps these are the two poles around which the art community constituted itself and around which we can construct our story. The factional and fictional: perhaps these are only other ways of saying the political and the performative.

1 General Idea, "Editorial", *FILE*, vol 3, no 4, autumn 1977, p 11.

2 This was evident as early as 1975 as AA Bronson reports then on troubles at A Space: "If anyone were interested in boredom as art and at one time people were, I suppose Toronto would interest people. Toronto is boring. Perhaps it is all too easy to say that Toronto is boring. Nevertheless it is and that is why it is all too easy to say. I, for one, am bored with Toronto. In particular I am bored with the Toronto art scene. I am bored by the petty politicizing and the strict division into minor camps which makes of the Toronto I know the uniquely boring object it is today. The most popular topic of conversation these days is who is trying to grab power and why they shouldn't. In fact power itself is an object of much derision, despite the fact that everyone wants it. Power first became the local chic scapegoat late last October when Marien Lewis resigned from A Space, throwing an entire scene into a series of hysterical convulsions which resulted in the less than satisfactory condition which exists at A Space today: an abortive and nostalgia-ridden bureaucracy." Bronson, AA, "Hurricane Hazel, Marien Lewis, & Other Natural Catastrophes", *Only Paper Today*, vol 2, no 4, January 1975, p 1. For the ongoing A Space saga, see Mays, John Bentley, "Should Karen Ann Quinlan be Allowed to Die", *Only Paper Today*, vol 5, no 1, February 1978, pp 18–19; Bronson, AA, "Imagine A Space as Karen Ann Quinlan....", *Centerfold*, vol 2, no 6, September 1978, pp 104–109; and various articles and editorials by Victor Coleman in *Only Paper Today* and letters to the editor in *Centerfold*.

3 Nasgaard, Roald, "A Glance at Toronto", *Vie des Arts*, vol 21, no 86, 1977, p 83.

4 "Jack Bush and Michael Snow emerge not only as the major artists presently working in Toronto, but also as the major figures in contemporary Canadian art." Cameron, Eric, "Michael Snow's Cover to Cover", *Vie des Arts*, vol 21, no 86, 1977, p 88.

5 Klepac, Walter, "Recent Sculpture in Toronto", *Vie des Arts*, vol 21, no 86, 1977, p 84.

6 Buchan, David, "Artists in Residence: Women's Performance Art in Canada", *Vie des Arts*, vol 21, no 86, 1977, p 86.

7 Gale, Peggy, "Toronto Video: Looking Inward", *Vie des Arts*, vol 21, no 86, 1977, pp 85–86.

8 Marras, Amerigo, "Canadian Vanguard 1970–1976", *TRA* (Milan), no 4/5, 1977. I quote here from the original manuscript in the CEAC Fonds, Clara Thomas Archives and Special Collections, York University, Toronto, 1981-010/007(03). When published, the opening paragraph reference to Carmen Lamanna here appears later in the text.

9 "Toronto has remained persistently provincial. It has been continually difficult for any 'style' to strike strong, self-sustaining local roots because it has usually been adopted from outside at a relatively fully developed stage. Toronto artists, without having the understanding derived from participating in the formative steps of the imported style, have been without the preconditions to develop it meaningfully in new directions, except to fuss it up. Whether we like it or not, and though we may acknowledge it as a false premise to depend too much in one's art on external models, it is nevertheless what Toronto artists have done and perhaps inevitably had to do. Is there any other way of explaining the range of eclecticism in Toronto art of the 50s and 60s and the curious

emptiness at the core of their work despite amazing technical virtuosity?" Nasgaard, "A Glance at Toronto", p 83.

10 Not everyone saw this crisis in a positive light. "With the present complete erosion of confidence in the earlier New York hegemony over 'world' art, and the resulting increasing penetration of critical mystification, the notion of an authentic *internationale* of modernist visual culture collapses. In respect of our own immediate reaction here in Canada to this development, the response appears to be one either of complete disorientation or of a headlong flight into regionalism, into the contradictory and paradoxical search for a local iconographic justification of the 'international' concept." Coutts-Smith, Kenneth, "Political Content in Art: The erosion of 'internationalism'", *Centerfold*, vol 3, no 4, April/May 1979, p 187.

11 Bataille, George, *Manet*, Austryn Wainhouse and James Emmons trans, New York: Skira Inc, 1955, p 59.

12 Bronson, AA, "The Humiliation of the Bureaucrat: Artist-run Spaces as Museums by Artists", *Museums by Artists*, AA Bronson and Peggy Gale eds, Toronto: Art Metropole, 1983, pp 29–30. Reprinted in *From Sea to Shining Sea*, AA Bronson ed, Toronto: The Power Plant, 1987, p 164.

13 Bronson, AA, "Artist-initiated Activity in Canada", *From Sea to Shining Sea*, p 12.

14 See Monk, Philip, *Picturing the Toronto Art Community: The Queen Street Years*, insert in *C international contemporary art*, no 59, September–November 1998.

15 Unless Eric Cameron's article "Michael Snow's Cover to Cover", devoted to the purely photographic artist's book of that name, was to play this role. The article was somewhat dismissive of Snow's book and makes this telling comment about Toronto art: "In an issue on Toronto art one seeks to discern Torontonian elements and Michael Snow's films may reveal them negatively in passages of emotional overstatement. This is a failing of a lot of Canadian art, but particularly that coming out of Toronto and I suspect it marks the bluntness of a provincial sensibility." Cameron, "Michael Snow's Cover to Cover", p 89.

16 "Heterogeneity does not, of course, imply universal acceptance by all parties. Quite the contrary, battle lines can be sharply drawn." Nasgaard, "A Glance at Toronto", p 83.

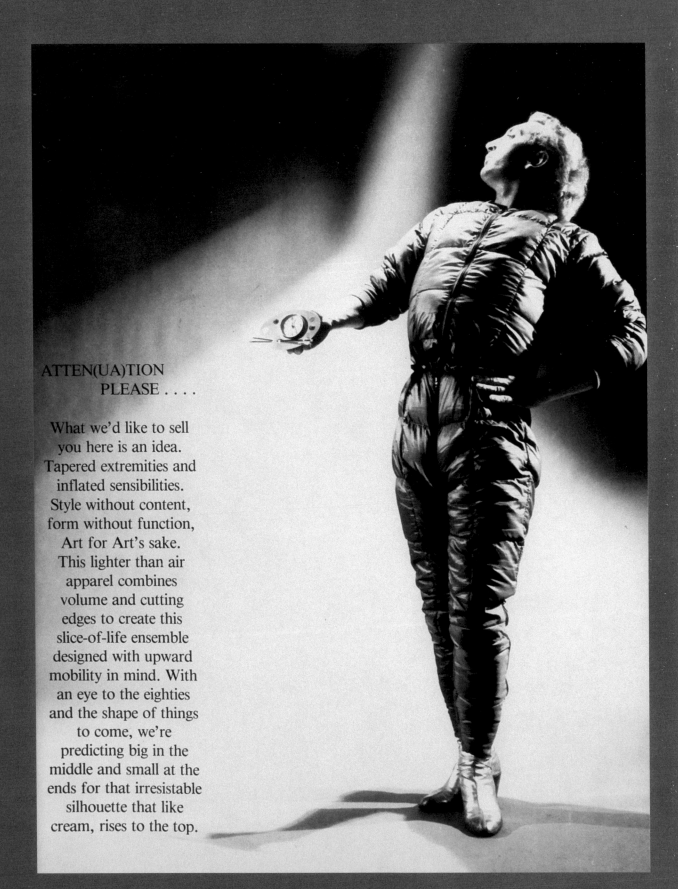

ATTEN(UA)TION
 PLEASE

What we'd like to sell
 you here is an idea.
Tapered extremities and
 inflated sensibilities.
Style without content,
form without function,
 Art for Art's sake.
This lighter than air
 apparel combines
 volume and cutting
 edges to create this
slice-of-life ensemble
designed with upward
mobility in mind. With
 an eye to the eighties
and the shape of things
 to come, we're
 predicting big in the
middle and small at the
ends for that irresistable
 silhouette that like
cream, rises to the top.

Posturing

Some say the art scene is all pose. But would posturing also infect what was most earnest in the late 1970s: politics, for instance? Art politics and political art? Can one recognise politics in a pose, or vice versa—as when Western artists adopted Red Guard postures to advance their own politics, even as the Chinese Cultural Revolution was in demise? 'Strike a pose' was the unspoken attitude of the day.

If we look deep enough into the word we find that a 'position' is also a posture. Whether as frivolous entertainment or earnest action, performance or political art, posturing was always the display of a position; it was a posited stance. And a pose demanded an audience. But there was always the question of *who* your audience was. According to political artists in-crowd art was a failure of social responsibility. Its entertainments were unedifying. What was required of art instead was action on a public—*the* public. A pose had to be acted upon; everyone could agree on that. But did a pose, as well, have to be *sold* to be effective? Effectivity was the issue. A pose had to be convincing. And convincing sometimes took talk.

History shows that there were more commonalities than contradictions in what once were thought to be oppositions in Toronto art. For instance, we can now say that there was a fashion for politics in politics' penchant for posing. So if posturing (whether frivolous or earnest) was the essence of the images produced in Toronto, only their texts directed them to different audiences. To arrive at a pose was the purpose of self-fashioning and a pose was always and already articulation. Texts, too, even those published separate from images, were verbal poses that expressed the elaboration of provocative conclusions. Strike an ideological pose was the urgency of the day.

Images not only posed, they talked. This was part of their conviviality, indeed, of their theatricality. Talk was the theatricality of Toronto art.

David Buchan, *Modern Fashions Suite: Atten(ua)tion Please*, 1977, silver gelatin print, 152.4 x 116.8 cm

Talk encompassed various media and bound them to each other, but so did the common adoption of a performative mode. Even straight photography performed. What united queer and straight art in Toronto was a camp conceptualism that was embodied, gendered, and transgressive. But this did not go uncontested. Dominant phenomenological and political biases inherently dismissed this work. So not only battling texts that expressed differing ideological positions, Toronto art could be reconfigured as a series of poses that implicitly countered one another.

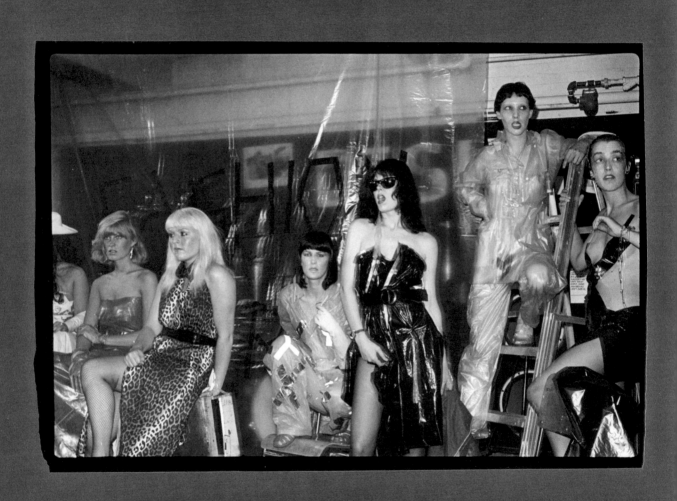

A Penchant for Posing

OPPOSITE
Isobel Harry, *Fashion Burn*, June 1977

Fashion on Parade

By the end of the 1970s, most of Roland Barthes' books had been translated into English, although his influence in defining postmodernist art discourse in North America (as a *doxa*, he might add) only began later in 1983–1984. But the theory was all there, especially for those in 1977 who read his anthology *Image–Music–Text*, published in English that year.[1] Even earlier in the decade, General Idea had relied on Barthes' text "Myth Today", his concluding essay to *Mythologies*, to elevate the group, indeed its corporate brand, from the anonymous crowd of correspondence or mail artists active in the early 1970s, whose work *FILE* magazine had been founded to disseminate. Now *FILE* promoted General Idea themselves with the publication of the 1975 "Glamour" manifesto where semiology supplanted structuralism as a descriptive model. If Claude Lévi-Strauss' structural anthropology had supplied the theoretical underpinnings to the mythic universe correspondence art represented, Barthes' semiological analyses of mass culture provided an analogy, if transposed to the rich image-repertoire of American culture, to critique its ideology—but now not from the outside but rather by performatively inhabiting Hollywood's, Tin Pan Alley's, and Madison Avenue's manufactured creations.[2] The novel idea was not necessarily to critique an image already there, but to perform another in its place. In this way, semiology and performativity allied themselves during this period of Toronto art.

But it didn't take Barthes for a group of feminist artists, writers, singers, and fashionistas to perform their own critiques of the suffocating traditional roles of women as played out in and reinforced by the mass media. They had first-hand experience of the liberating yet debilitating effects of popular culture: all that girl group sorrow of boyfriends' beckoning and mothers' no. It was not only Bryan Ferry who could

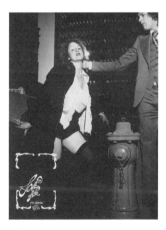

A.S.A. Harrison, *Love Letter*, 1976 (poster)

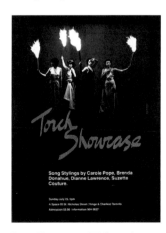

Torch Showcase, 1976 (poster)

General Idea, documentation of *The
1971 Miss General Idea Pageant*, 1971
(Portrait of Granada Gazelle, Miss
General Idea 1969)

recuperate these songs of teenage girls' angst as camp. Second wave
feminists could, too. So for a couple of years in the mid-1970s,
these women lip-synched and paraded themselves down runways in
period costume sewn up and fashioned from thrift shops or vintage
stores, notably in *Glamazon*, 1975, organised by Dawn Eagle and
Granada Gazelle.[3]

Here is Toronto writer Jennifer Oille's period description of what little
we know of *Glamazon*:

> Glamazon started where WW II left fashion. Since Diana Vreeland
> of New York's Met has already canonized the look of the 20's and
> 30's, Granada Gazelle and Dawn Eagle decided to re-stage *la ligne* of
> the subsequent decades in a two night stand. With aid in the field of
> finance, fashion and fabric from the Ontario Arts Council, Butterick
> and McCall's Patterns, Eatons' Archives, the ROM and Jean Pierce
> Ltd, she stitched together forty runway numbers cutting a swath
> through Fath into Dior elegance, Chanel banal, and Courrèges
> relevance with time out for the housewife (in turquoise to match
> her melmac dishes), the suburbanite (in beige leather to look like
> leatherette to the tune of Town Without Pity) and the hippy (not
> conscientious enough to reject animal skins).[4]

General Idea, *Untitled*, 1973–1974
(Sandy Stagg models the *Hand of the
Spirit Make-up*)

Women's performances established a trope in Toronto. But you
wouldn't know it. There is little documentary evidence of these ironic
runway productions, perhaps because they were not taken seriously
in their time—perhaps seen to be only entertainment or mere women's
work—but they fail even to make an appearance in the two main
histories of performance art in Canada.[5] Submerged, this practice would
reappear a decade later in 1980s feminist performance. Yet in-between,
the practice would persist, but only by the practitioners changing
gender—and the practice then changing medium: from performance to
photography. Here would be a new alliance, not only between feminists
and gay artists, but between media as well, that together would shape the
art scene—or contaminate it, if you prefer. This alliance would have a
long-term effect on establishing the character of Toronto art.

"Glamazon was so inspiring. After the Sunday performance, I
overheard some of the guys whispering about organizing their own
version of Glamazon. Pleated slacks, scout uniforms, clamdiggers,
Ivy League, bowling shoes. They were referring to it as the 'Butch-
O-Rama'."[6] One of these whispering guys no doubt was sometime
collaborator David Buchan, who would be inspired to continue
these women's work, allying his sympathetic creations as well to the
strategies of General Idea, with whom he was associated as a friend and
employee at Art Metropole. He recognised what these women were

doing, firsthand as *Glamazon*'s stage manager, and later wrote about it, sketching the platform on which they performed and outlining the cultural parameters within which they ironically operated (but also continuing their tongue-in-cheek insouciance with his femino-punk homage in his 1977 runway show *Fashion Burn*):

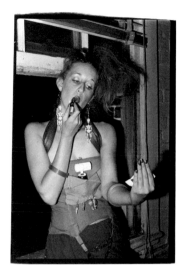

Isobel Harry, *Dawn Eagle at Fashion Burn*, June 1977

The preformed cultural phenomena of fashion shows, ice follies, wedding ceremonies, cabaret entertainments or dime-store-novel plots determines the shape the events take, the raw material out of which the fabric of the work is made. The artists, writing words for their characters to speak, creating clothing for them to wear, choreographing their movement, virtually take over their bodies to mobilize their own ideas, with the intention of creating finished works that bear witness to their personal visions. Drawing heavily upon theatrical convention, the overall quality of the work tends to be conceptual in nature, using established styles of information presentation to house newly designed and reshaped content. The actual performing of the pieces is laden with reference to the intention of the work, but usually cloaked behind an ironic translation of the original intention of the genre. Contemporary mythologies are the prime source of inspiration. Platforms, pedestals, and runways are used to separate the audience from the meaning and ensure that they get it at the same time.[7]

Taking up one reviewer's suggestion that *Glamazon* should have played at the Imperial Room of Toronto's top hotel The Royal York, two years later Buchan would perform *Geek/Chic* at its faded rival, the Crystal Ballroom of the King Edward Hotel. (Toronto was nothing if not colonial, judging by the names of its hotels alone.) "The original inspiration came from my involvement with *Glamazon*. I was excited by it and thought it was more interesting than painting or performance art as I was aware of it. My excitement was based on the fact that nothing interested me more than clothing and I began to wonder what an appropriate male version of *Glamazon* might be like. Could you in fact do a fashion show that was an historical analysis of men's clothing from 1940 to say 1970, which is the time period *Glamazon* worked with?"[8] Apparently not. Buchan realised that men's dress was almost identical year to year, so he understood "that if I wanted to do a fashion show I could do one based on my own wardrobe". The outcome, the performance *Geek/Chic*, was much more than a tour through Buchan's wardrobe, his closet, that is. Buchan did not sew; what he produced were fashion plates. A fashion plate himself, his outfits were types as if already composed by pose, prose, and photography. In other words, they were already staged as advertising or fashion magazine spreads. They were not just retro, but *outré*: geek

Isobel Harry, *David Buchan at Fashion Burn*, June 1977

not chic. Presented live in the 26 May 1977 event, they were decomposed there into a slide show with voiceover.[9] To get an idea of how this worked we can look to Buchan's artist's project for *FILE* magazine where these elements were recomposed once again, not so much as a documentary trace but as a contextual transformation in a magazine layout.[10]

In probing the dimensions of the title, of what was 'in' and what was 'out', Buchan decided "what could be more 'out' or 'outré' than something that would appear to the clothing industry to have no marketable value".[11] The sales job then was how to sell the geek as chic, which the image alone (the 'geek' element) could not do. To be "very Geek, very chic", to turn one into the other, takes convincing, which is the role of language here: mimicking fashion commentary and ad copy in order to sell an *abject* image—even though posed, lit, and shot professionally. Yet through this ironic *détournement*, it is not Buchan's aim simply to denounce the fashion or advertising industries, following on as well from the ideological critique Barthes' "Myth Today" permits in exposing the bourgeois motivation of all contemporary myth. And is fashion not the epitome of bourgeois ideology? Buchan is hardly interested in naturalising something that is constructed intentionally to be artificial. As a 'wardrobe artist' the artificial was the standard item of his repertoire. But in surreptitiously mimicking fashion and advertising's contents and forms to achieve other ends, Buchan follows Barthes when the author advocates:

> It thus appears that it is extremely difficult to vanquish myth from the inside.... Truth to tell, the best weapon against myth is perhaps to mythify it in its turn, and to produce an *artificial myth*: and this reconstituted myth will in fact be a mythology. Since myth robs language of something, why not rob myth? All that is needed is to use it as the departure point for a third semiological chain, to take its signification as the first term of a second myth.[12]

While semiology may have helped Buchan construct his work, and helps us analyse it, it was not necessarily employed there just to make a critique. That is, what Buchan performs is not just camp parody, ridicule, or ironic put-down of either the mainstream or the margin (the *outré*). Yes, to a degree he creates a third semiological chain of the geek-chic on the basis of the second order of fashion. Yes, he appropriates advertising and inhabits it codes, to use a language more in vogue in the early-to-mid 1980s. But he does not stop there. Rather, he inserts a zero value into the structural system of fashion: "The no-man's land between good taste and bad taste. No taste. The domain of GEEK/CHIC."[13] The effect is not to render this value system void but to insinuate new values into it—through its very means and within its very framework of exposition and spotlit exposure.

PP 33–36
David Buchan, "Geek/Chic", *FILE*, spring 1977

GEEK/CHIC
DAVID BUCHAN

Photographed by Michael Robertson

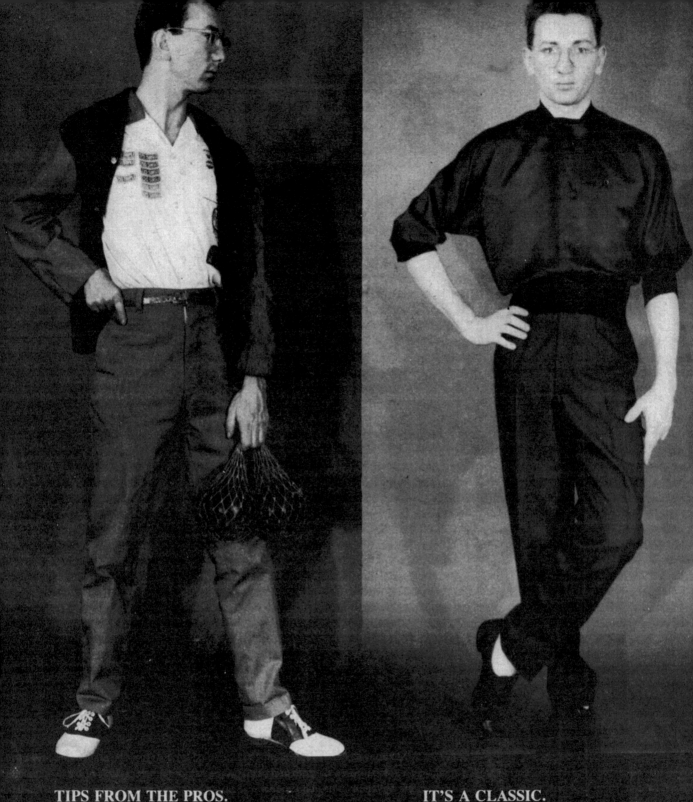

TIPS FROM THE PROS.

Spare time. How to fill it? What does the fashion industry
have to learn from him? Even as a child he had good co-
ordination. He sets them up, and knocks them down.
Everything goes together. The shoes go with the pants,
which go with the sweater/jacket, which goes with the
shirt, which goes with the balls. Which goes without
saying. A striking ensemble.

IT'S A CLASSIC.

Blue boy redefined. The best of both worlds. The ele-
gance of evening wear and the convenience of casual
attire. Midnight blues harmonize in this symphony of
synthetics. A new vision. A structural solution to the
problems of contemporary aesthetics. A model man.
Perfectly posed, immaculately conceived. Very Geek,
very chic.

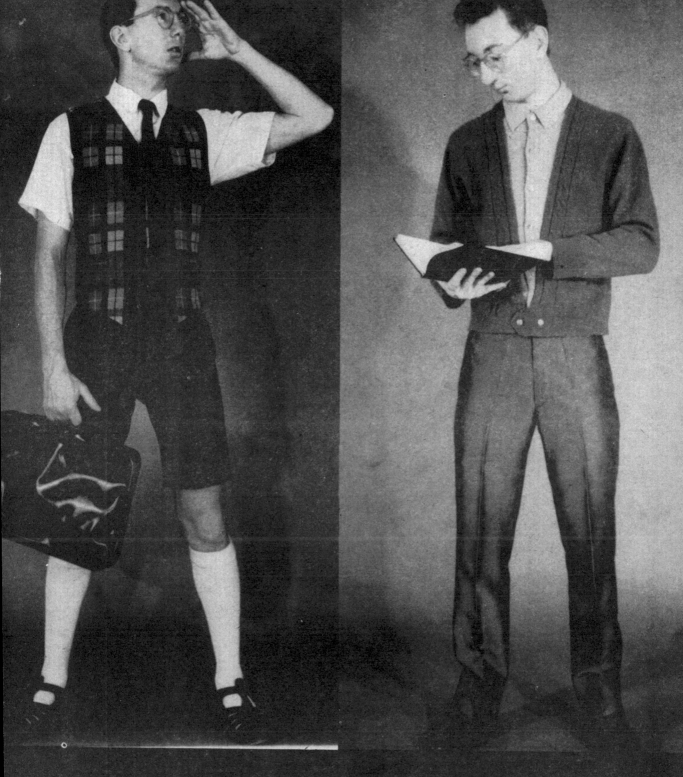

VESTED INTERESTS

Mr. Modern Shopper is the ideal consumer. More cash than dash, for sure. Everything has a price and he's always taking stock. Buying and selling. Bargain hunting. Generally shopping around. Inspirational shots are a dime a dozen. The only Midnight Madness he ever experienced was at Plumbing World. A Bargain at twice the price. Let's make a deal.

DRESSING FOR TURKEYS.

Honk if you love Jesus. Some Geeks go to church. Then they go to heaven. If they're good. He's real good. Holier than thou too. Ex-president of Youth for Christ. Plays the accordian. Collects stamps. Subscribes to National Geographic. A large slice of Mom and Apple Piety. Please. Hold the ice cream. Thank-you. 100% GEEK.

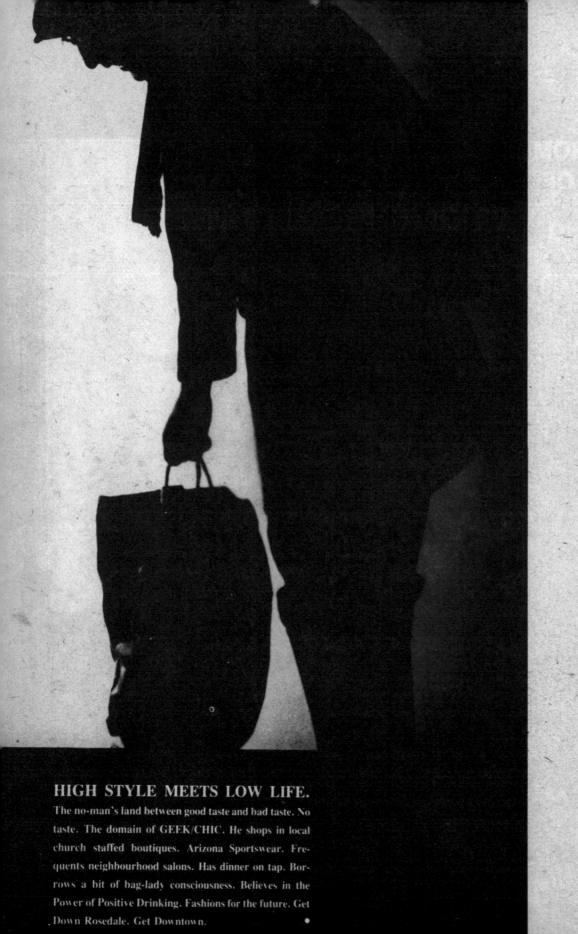

HIGH STYLE MEETS LOW LIFE.

The no-man's land between good taste and bad taste. No taste. The domain of GEEK/CHIC. He shops in local church staffed boutiques. Arizona Sportswear. Frequents neighbourhood salons. Has dinner on tap. Borrows a bit of bag-lady consciousness. Believes in the Power of Positive Drinking. Fashions for the future. Get Down Rosedale. Get Downtown.

So while we might at first think that Buchan only turns fashion and advertising's devices on themselves in order to deflate their meaning, he actually uses their clichéd forms to convey other messages—and other values. His mimicry opens a gap where other codes supervene on those commonly expected—and we get the *geek* instead of the chic, or whatever else was *outré* rather than normative. Buchan was not alone; he would share these strategies with a number of Toronto artists. The resulting works would be neither seeming critique, as Roland Barthes would have it, nor seeming entertainment, as Susan Sontag would make camp out to be when she wrote, "To emphasize style is to slight content, or to introduce an attitude which is neutral with respect to content. It goes without saying that Camp sensibility is disengaged, depoliticized— or at least apolitical."[14] Whether content was political or not, with such artists the 'message' hardly ever was neutral.

But would *we* get the message? Or would it take time for the 'message' to be read? As a man, Buchan was no less successful in being taken seriously than the Glamazons were. His work was equally dismissed as entertainment. But then neither was General Idea wholly taken seriously; their *FILE* magazine, for instance, was likewise dismissed by one critic simply as a "pageantry of camp parody".[15] How then would this type of work escape being received merely as a frivolous sideshow to become the city's main act, historically speaking? Well, for a start, by transforming performance strategies into photography and print and circulating them, for instance, within a magazine, *FILE*, let's say.

Camp Conceptualism?

Whether or not it was consciously applied, semiology would define the photography of the period. Semiology would not lay down the rules, but in retrospect it would offer explanation for much of the photographic work produced in Toronto at a time when photography was first going big—in both influence and size. It is not as if Toronto artists were studying semiology and thinking about their work in terms of signs, signifiers, and signifieds rather than as an orthodox relation of image and text as laid down by conceptual art. In the latter, components were separated as if still medium specific into non-descript photographs and informational texts. Slowly the separated elements came back together in the mid-1970s—but according to different strategies that were not so much documentary as fictional at times. At first some of this work was called Story Art or Narrative Art and included, when it was photographic, artists James Collins, Bill Beckley, and Mac Adams, and to which we might add Vancouver artist Ian Wallace. These constructed photographs had implied story lines but no texts. If to this list of artists we were to add the constructed photographs of Les Krims, Duane Michals, and Lucas Samaras, we might think of Gramsci's comment that "the crisis

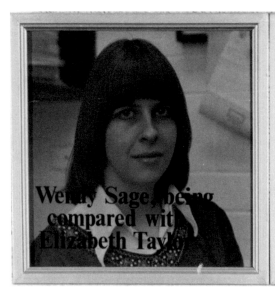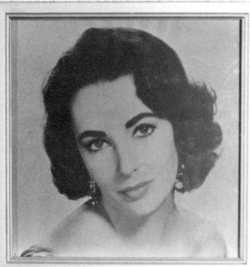

Ian Carr-Harris, *Wendy Sage Being Compared*,
1973, letraset on photograph, 31.1 x 61.6 cm

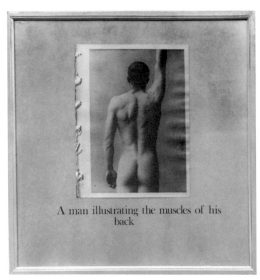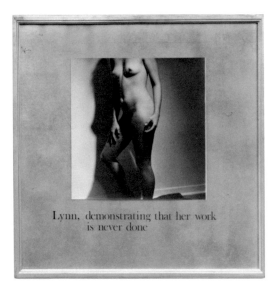

Ian Carr-Harris, *A Man Illustrating*, 1973,
letraset on photograph, each 61 x 61 cm

consists precisely in the fact that the old is dying and the new cannot be born; in this interregnum a great variety of morbid symptoms appear", for this was precisely the problem of this period of 'post-movement' art (which included the banalities of what was called pattern painting and the precursors of new image painting). Aptly, this work lent itself to magazine spreads, but the magazine format, including advertising, never entered into the making of these images, at least for the artists mentioned here. Although some of this work appeared in General Idea's *FILE* magazine, let's not confuse this photography with what was to happen in Toronto.

Sometimes this romantic—or morbid—reaction to rationalist and didactic conceptual art was imported into Toronto.[16] But Toronto had its own version of conceptual art. Take Ian Carr-Harris' early work, which, with its letrasetted photographs, where text seemingly redundantly explains the image, superficially looks like conceptual art. But simple comparison (*Wendy Sage Being Compared*, 1973) or illustration (*A Man Illustrating*, 1973) here is banal. Rather, the one-to-one comparison of plain Wendy Sage to superstar Elizabeth Taylor is a power differential that is cultural and psychological, not just a demonstration confirmed linguistically. Language naturalises or masks a social dynamic; one might say the relation is ideological; but such didacticism does not seem the import of this work, which seems instead rather theatrical. These works enact a social pragmatics not a linguistic one, although it is reinforced linguistically. In *A Man Illustrating*, the man conforms as an illustrative principle; he is generic to the task: "A man illustrating the muscles of his back"; Lynn conforms as a societal expectation, a real woman in a typical sexist situation: "Lynn, demonstrating that her work is never done." Here language returns on the image to frame it differently.

This work shares none of the dominant characteristics of the three main variants of historical conceptual art—tautological, declarative, or contextual. Toronto's instead was performative. Was this a wry conceptualism or conceptualism gone awry? Or was this actually Toronto's variant of conceptualism, and unique to the city? Toronto's conceptual art was embodied, gendered, and dealt with codes—social and otherwise—and the transgressing of them. Conceptual art in Toronto was a performance in which the viewer was complicit, especially when the art took on an installation aspect that instantiates a performative space, as for instance in Carr-Harris' *If You Know What I Mean*, 1977, with its wink of social assurance manifest in the suspension of its statement; or *But She Taught Me More*, 1977, with the slightly knowing perversion of its pedagogic statement: "But she taught me more than all of them/with a slight but ironic lift of the hem." Here the turn of the sentence commands the spectator's turn to the other side of the work in an ironic complicity that enjoins the spectator to the sentiments of the work.

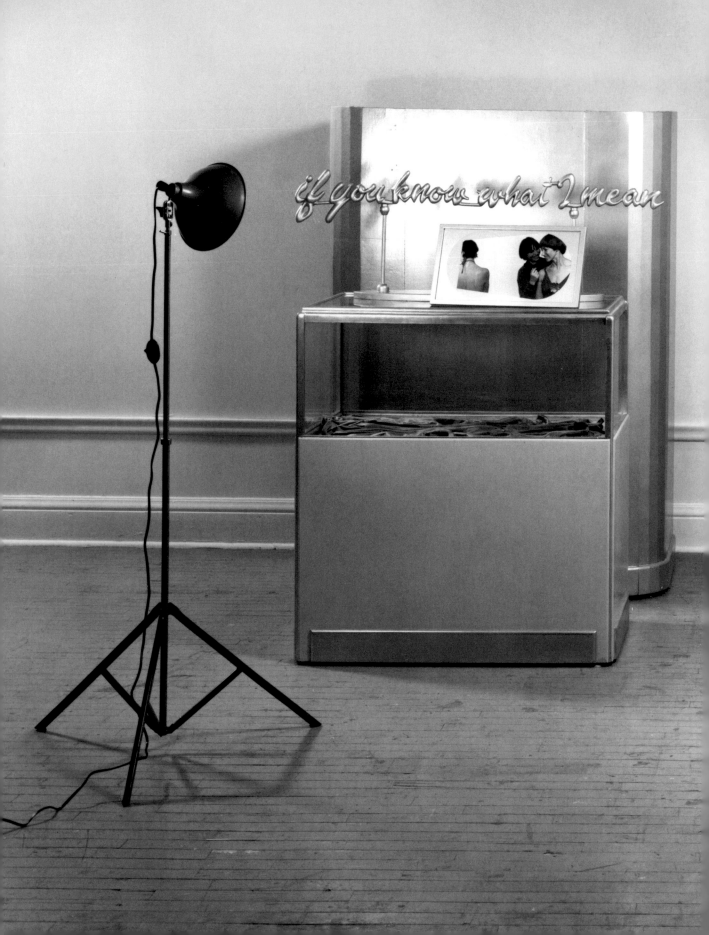

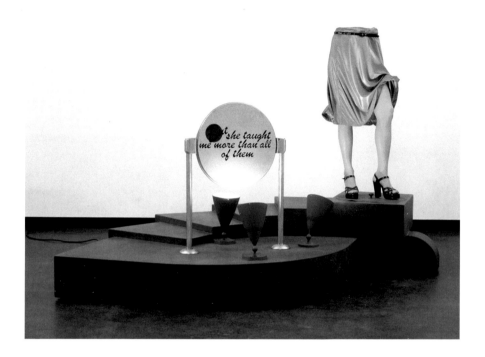

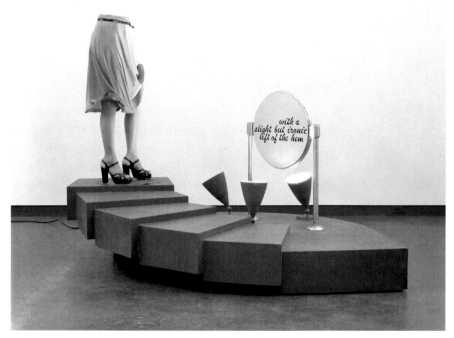

Ian Carr-Harris, *But She Taught Me More*,
1977, assemblage

OPPOSITE
Ian Carr-Harris, *If You Know
What I Mean*, 1977, assemblage

Equally perverse, or maybe just plain *outré*, in this clumsy, ironic-cum-erotic performance of *But She Taught Me More* was the retro patina of its materials and the unappealing aesthetic of its deco staging. The 'perversion' of the work was not just its theatricality (as if in coy answer to Michael Fried's charge of theatricality against the situational aesthetics of Minimalism Carr-Harris consciously aligned his work to).[17] It was also its *démodé* quality: its costuming of retro camp period vintage wear; its clunky, clinical, repressive, and dated department store feel of the 1940s or 1950s. If so inclined, one might indulge a fetish for either—or both. Yet, the staging of this quasi-didactic display is decidedly non-erotic. Nonetheless, gesture and scene evoke a little memory theatre, which is primarily one of display. This simple scenario is merely a display *of* display, where a surreptitious act—the raising of a hem—is made very public by being elevated on a spotlit platform. But the scenario is, as well, fundamentally the *display* of display: an apparatus for pointing it out. It is this instructive purpose, perversely instructional, we could say, that gives the work its conceptual flair and, in the end, perhaps its particular 'erotic' quality.

Simultaneously the spotlight was both outside and inside the work, literally and figuratively. A light was put on a situation; it was, thus, theatricalised. In itself, a spotlight already entails a platform, whether one is there or not. A spotlight was put on spotlighting, thereby reflexively drawing attention to itself. This spotlighting of spotlighting was a means of quoting itself, of seemingly seamlessly, through nothing visible except light itself, embedding one display within another. This embedding and embedded framework is then repeated, dividing while eliding the mannequin scene and the spotlit quotation, the actual quotation that equally is spotlit within the work, that is: "but she taught me more...." This embedded framing, frames within frames, was how language and image went together, as in Carr-Harris' earlier photo-text work, though here splayed out spatially. Witnessing this, we could never again think the relationship between image and text as innocent and other than as being embedded within a theatricalising framework that was inherently performative—in Ian Carr-Harris' work or Toronto art, for that matter.

What was Carr-Harris telling us here about Toronto art with *his* ironic lift of the hem? What did he let us in on about the mechanisms of its art? Moving into installation, technically we are beyond conceptual art, but these works only demonstrate and physically dramatise the theatricality already operative in the image-text relationship of what passed for conceptual art in Toronto (or performance for that matter), but was never stated as such. In a sense, this work spells out didactically what Toronto art would be, how it would present itself, and what demands it would put on its audience.

Could we then make a non-queer artist such as Carr-Harris a test case for the 'camp' conceptualism of Toronto art? For if his work shared

pertinent principles with General Idea's, for example (who did not yet publicly self-identify as queer artists, however), then these principles were of a generality that could pass for characteristics of Toronto art.

What would these be? Let's abstract their mechanisms before we approach their contents. We have already singled out spotlighting and quotation as operant devices, although seemingly neutral themselves. Both are *mechanical* devices that are quite *empty* forms. They seem purely functional—and external to the essential dictates of art. A spotlight separates light from dark to expose a scene. Quotation embeds one expression (one set of words, for instance) within another, while yet distinguishing them. Both bring something to view: one by separating, the other by embedding. Each has a secondary effect: spotlighting (separation) is to elevation as quotation (embedding) is to framing. Spotlighting is an external framing while quotation is an internal framing, more properly an *en*framing. The two operations work together, but not necessarily in an overtly visible way, to bring something about. They themselves, though, are empty forms that need to be filled, yet nonetheless cannot be separated from what they present.

When we turn from Ian Carr-Harris to General Idea, not so coincidentally then, we again find these same functional devices in play as principle operations of their *1984 Miss General Idea Pageant* and *The 1984 Miss General Idea Pavillion*. Their whole apparatus was founded on the elevation of Glamour in the apotheosis of Miss General Idea, whose first operation is one of separation.[18] Here is another case of a fetishising cutting out performed by a spotlight. However, this act only reveals the emptiness of what is elevated: the vacancy of its images, which leads, inevitably to a reversibility of whatever is raised up: Miss General Idea's de-crowning. Glamour's elevation leaves a vacuum that has to be filled with words—such as proliferates at the base of the image, otherwise known as a caption, but which in itself is its own little verbal performance, as we see in "Objet d'art".

Wherever the spotlight operates, inevitably too, we find a complementary enframing:

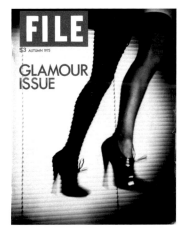

FILE (Glamour Issue), autumn 1975

> THE FRAME OF REFERENCE is basically this: a framing device within which we inhabit the role of the general public, the audience, the media. Mirrors mirroring mirrors expanding and contracting to the focal point of view and including the lines of perspective bisecting the successive frames to the vanishing point.[19]

"Frames of reference" constrain us to the artists' 'vision' but also attune us to the equally constrained formats, one acting—while merely being enframed—within another. The artists' infiltrating 'vision' appears in the 'look' of the image, while their invasive, parasitic content displaces

OBJET D'ART

Glamourous objects open themselves like whores to meaning, answering need with vacancy, waiting to be penetrated by the act of recognition.

The object signals a world beyond Nature. An object has edges, perimeter, surface. An object seperates itself from its surroundings with innocent pride. An object exhibits unashamedly a closure and a brilliance, in a word a SILENCE which belongs to the world of myth.

The futuristic profile of the MISS GENERAL IDEA SHOES neglects joints to exhibit a continuity of surface which is enchanting, otherworldly. They raise the Participant into an unnatural (hence cultured) position in which walking is rendered difficult, transformed from movement to a frozen gesture-like a pencilscratch across a photo portrait it is jagged with sophistication.

This gesture of immobility becomes rarified, exquisite. The Participants' calf muscles swell against the expected brush of black silk hose. The moment becomes poised on the brink of a delicious terror, the terror of sexuality itself.

that of the original host format. Mirrors-mirroring-mirrors thus was not so much an empty formalist abstraction as it was an operation of embedding: a means of inhabiting 'formats', to use General Idea's terminology, but which we can also call genres. "We are obsessed with available form", they write. "We maneuver hungrily, conquering the uncontested territory of culture's forgotten shells—beauty pageants, pavillions, picture magazines, and other contemporary corpses. Like parasites we animate these dead bodies and speak in alien tongues."[20] Here was Toronto's fascination with genre, which was common to more artists than just General Idea. Together these obsessive operations produce invested forms. Quotation leads to the pleasure of identification with particular genres. Cutting out meanwhile expresses a fetishising desire. The former is content to act within the enframed context of a particular genre or inhabited format, while the latter has the power to transgress limits.

Speaking in alien tongues was a way of performing otherwise through the formats or genres one appropriated. So spotlighting and embedding were not simply means of emptying a scene and displaying its vacancy (the falsifying rituals of glamour, the duplicitous motivations of advertising) or of employing scare-quotes on the ready-made material of popular culture; something else was produced, presented, and performed in the process. Moreover, all this effort at staging was not merely means to put a *representation* on view, but to evoke *meaning* through performance. Meaning was displaced or disguised in another (alien) content. An empty form did not mean empty meaning, *pace* Susan Sontag. These empty vessels were meant to be filled anew by images and texts, looks and formats.

As David Buchan wrote of women's performances, "Platforms, pedestals and runways are used to separate the audience from the meaning and ensure that they get it at the same time." Platforms were a means to spatially distance the audience; formats or genres were means to temporally distance it—one as form, the other as content. Through these means, the audience maintained their complicity: getting it, on the one hand, ritually through separation and, on the other hand, ironically through consumption.[21] Through devices that both distanced and absorbed the viewer at the same time, "the elevation of the concept is achieved and the work is made accessible".

Performance in Toronto was not a secondary entertainment solely dependent on the banal culture it was so easily parodying. Nor was it merely a cliquish art world amusement. The performative mode was a shared discourse between artists and audiences. Moreover, it was a mode with recognisable properties that crossed disparate practices. The propensity for performative strategies suggests a common front uniting various media in Toronto—as well as work by men and women, gay and straight artists.

General Idea, "Glamour" [Objet d'Art], *FILE*, autumn 1975

Yet the dominance of these strategies in the downtown art scene remains unrecognised. Misrecognition usually means disavowal. Where did this dismissal stem from?

The Trouble with Conceptual Art

Effort of late has been expended to constitute the category of conceptual art for certain Canadian works produced in the 1970s in order to demonstrate—in light of exhibitions and publications elsewhere—that Canada, too, was part of this international movement.[22] Perhaps the issue is not why there is still no recognition for Canadian conceptual art internationally but, rather, why *in its time* there was resistance to this category locally. For instance, we know that a conceptualising art practice, as its own category, was not recognised in the *Vie des arts* Toronto issue. So when we look at the reception of conceptual art in Toronto in 1977, we must ask why the lack of discussion? Is it that a discourse was missing or that the objects of that discourse were absent? Why did works that fit the look not present themselves to such an analysis, present themselves as such as conceptual art? Why were they not received or perceived as such? Either, (1) there was no conceptual art; (2) there was no understanding or perception of what might be conceptual art; (3) it existed but there was no critical interest in such art. Perhaps the confusion was because the objects were spread over separate disciplines: photography, video, and installation.[23] The misleading situation was compounded by a confusion of categories, indeed, to a confusing of categories, firstly that of the visual and the linguistic. Here was the problem. Categories were not kept straight because they could not be kept straight. Yet destabilising identity was denied in continuing resistance to the language properties that constituted conceptual art. A dangerous supplement, language contaminated the pure presence of the work of art. It came to contaminate a whole scene.

The trouble with conceptual art was the problem of language. The problem of language was that it took away from the unencumbered, direct experience of the work of art, the unadulterated presence of which was reflected in the embodied presence of the observing self. Self-sufficient art was tautological with a self-sufficient subject. Art was without need of the disciplinary reading conceptual art contrarily gave of its language structuring—let alone what critics had to say. You could say that there was not so much a modernist but rather a phenomenological bias amongst the supporters of Toronto's advanced art, for instance, Roald Nasgaard at the Art Gallery of Ontario and critic Walter Klepac, not to mention the postminimalist sculptors and painters themselves. The AGO's 1978 exhibition Structures for Behaviour, which included the sculpture of Americans Richard Serra and Robert Morris and Canadians David Rabinowitch and George Trakas, was the signature expression of this phenomenological

Richard Serra, *3 = elevations*, 1978, Structures for Behaviour exhibition, site-specific installation

bias, with its heavy-metal steel sculptures and macho commandeering of space. This work strictly oriented itself to a perceiving subject that was first and foremost a body, and it conducted this body in space without the need of language. Robert Morris himself had written, "Deeply skeptical of experiences beyond the reach of the body, the more formal aspect of the work in question provides a place in which the perceiving self might take measure of certain aspects of its own physical existence."[24] Language was not of the order of this experience, indeed, could not be of the order of this experience. The skeptical position was a moral one, too: the body was not to be used frivolously. Its performance sternly was task oriented.

The purely perceptual was performed in a silent soliloquy in which language did not intrude. Indeed, the work of art solely articulated itself; it was a single level of articulation with no division for language's parasitic entry.[25] As one of the theorists of this work, Annette Michelson, writes, or warns, about the inaptness of any linguistic analysis of art, for which she took structuralism as the invasive, offending model: "Faced with abstraction's single level of articulation, structuralist thinking retreats", structuralism according to Michelson being unable to comprehend the modernist trajectory of the arts. She adds, "The source of conflict would seem to lie principally in the application of the linguistic model and of a semantic function to our contemporary painting and sculpture, which resist the notion of any authority or model, any notion of code and message in their stubborn claim for autonomy, immediacy, and absoluteness."[26] Yet, even when Michelson delivered this lecture in 1969, an art was gaining visibility, an art that would be instantiated sometimes by language alone: conceptual art. This young art derived its logic from the very Minimalism Michelson defended against structuralism, and the upstart's acknowledgement of art's language structuring eventually would redound upon the absolutist claims of its predecessors.

While Michelson claims that phenomenology was renewing criticism after the obsolescence of structuralism, chronologically it was the other way around, at least in France. Here is a representative structuralist denunciation of phenomenology by Michel Foucault (though he would reject the structuralist label for himself): "If there is one approach that I do reject, however, it is that (one might call it, broadly speaking, the phenomenological approach) which gives absolute priority to the observing subject, which attributes a constituent role to an act, which places its own point of view at the origin of all historicity—which, in short, leads to a transcendental consciousness."[27] Foucault in return rejects Michelson's and Morris' mutual positions, Michelson also being Morris' powerful advocate. However, when this was written as the 1970 English foreword to Foucault's 1966 book *The Order of Things* (therefore contemporary to Michelson's observations), both phenomenology *and* structuralism were under attack by an ascendant poststructuralism, of

which we can take Jacques Derrida's 1966 lecture "Structure, Sign and Play in the Discourse of the Human Sciences" at Johns Hopkins University as having symbolically initiated.

For the moment, let the following statement from Derrida's lecture stand as a sign for a problematic that would not recede: "This was the moment when language invaded the universal problematic, the moment when, in the absence of a centre or origin, everything became discourse—provided we can agree on this word—that is to say, a system in which the central signified, the original or transcendental signified, is never absolutely present outside a system of differences."[28] The discourse of art could never be the same after such an invasion.

Toronto, too, could not be immune to this discourse, especially in this period 1977–1979, a whole decade after Michelson's intervention, when phenomenology, informed by Michelson and Maurice Merleau-Ponty, still ruled the language of Structures for Behaviour. Not only would this anti-phenomenological discourse begin to institute itself in Toronto's art criticism, language would insinuate itself into artistic production as its unnatural supplement.[29] Language would not stand on its own as text but would gravitate towards the photograph to ally itself and find an affinity there. Henceforth, language could not be separated from the photograph as photography itself could not be separated from the performative. Here were the essential and defining conditions of the work being produced in the downtown Toronto scene.

While the phenomenological and performative discourses were not in dialogue with each other in Toronto (a Rabinowitch sculpture did not speak to a General Idea photograph), the advocates of one did not necessarily critique the other. Yet, it was not quite a *dialogues de sourds*, where each would go its own way. A hierarchy was implied where phenomenology was considered serious and the performative thought trivial. So even though each would go its own way, the performative route would have to both invent and justify itself at the same time as this frivolous exclusion. What it would invent and justify, in time, would be the Toronto art scene.

The distinction between these positions as two absolutely different 'performances' can be illustrated by a case where neither language nor photography is evident: in a mirror. Here is a seemingly neutral device that exposes the viewer to two different forms of behaviour. Consider these near contemporary accounts. Here is Michelson's 1969 analysis of Robert Morris' famous 1965 Green Gallery exhibition where he showed four mirrored cubes whose volumes paradoxically were defined by their reflective mirror surfaces: "*Real* cubes were described by the *virtual*, inaccessible, intangible spaces of their mirrored surfaces."[30] According to Michelson, these works initiated "a radical reevaluation of the presuppositions and aspirations which had informed much

of the best sculpture—and criticism—of the recent past". For this work "takes account of, uses, renders visible the manner in which the reflective process is grounded in, inseparable from, the radically engaging physicality of the work, a structure which in this instance visibly (virtually) absorbs the spectator". Furthermore, "it constitutes a particularly brilliant instance of the manner in which Morris undertook to question the aesthetic convention, the distinction obtaining, in traditional aesthetics and criticism of sculpture, between a 'real' or operational space—that of the beholder—and a 'virtual' space, self-enclosed, optical, assumed to be that of sculpture". Now contrast this essay with a 1973 article—"Are You Truly Invisible?"—by General Idea: "Consider your mirror's feelings. Must it always reflect you? A) Coerce all your mirrors to look at each other. B) Now that you've turned them onto the ultimate narcissism, steal away your reflection while they aren't watching. Carefully. It's all done without mirrors. How they'll talk about you! The vacuum created by your invisibility has got to be filled with words. They'll talk and talk...."[31]

The two positions 'inhabit' virtuality differently, one engaging physicality in a silent absorption of the spectator, the other expelling the viewer and leaving a residue of talk. The distinction obtained between the two was that one evinced a serious critical discourse, the other issued in glib talk. Yet both would be dismissed for their common theatricality. The case against minimalist theatricality famously was made by Clement Greenberg's disciple Michael Fried. Fried's 1967 critique was a long grievance that we can summarise in the statement that literalist work (what Fried called Minimalism) is theatrical because it "includes the beholder" in its situational objecthood. "Objecthood amounts to nothing other than a plea for a new genre of theatre; and theatre is now the negation of art", he writes.[32] There was a moral dimension, a puritanical religious eschatology even, to Fried's denunciation. There was a "war", he says, between modernist painting and literalist art; painting must "defeat or suspend theatre" since "art degenerates as it approaches the conditions of theatre". Against a sensibility "corrupted or perverted by theatre" only Modernism could supervene by its "secreting or constituting, a continuous and perpetual *present*".[33] Objecthood is presence; Modernism is presentness. Bad object, good painting. One is theatrical, the other pictorial. One is physically, the other optically achieved; one durational in experience, the other instantaneous; one non-art, the other art.

It may seem like quibbling over words—'presence' versus 'presentness', whether durational or instantaneous—but Michelson recognises their problematic complementarity when in her lecture she reminds us that, "It is the dream of absolute immediacy pervading our culture and our art, which replaces, in a secular age, a theology of absolute presence. That dream is figured on the reverse side of the idealist coin."[34] And Derrida

VideoCabaret, *The Patty Rehearst Story*,
1976 (poster)

VideoCabaret, *The Bible as Told to
Karen Ann Quinlan*, 1977 (poster)

would concur. For her argument against Lévi-Strauss was an argument
for Modernism as a whole. Minimalism was only a deviation within
modernist discourse, not its diametrical opposition (likewise the same
could be said of American conceptual art). So the argument against
theatricality has a longer trajectory, which, in fact, can be traced to
Clement Greenberg's 1939 article "Avant-Garde and Kitsch". Kitsch was
many things but it was mainly spurious culture, "vicarious experience
and faked sensations", produced by industrial manufacture to satisfy
the needs of the urban masses. In Greenberg's day and according to his
classification, it was "popular, commercial art and literature with their
chromeotypes, magazine covers, illustrations, ads, slick and pulp fiction,
comics, Tin Pan Alley music, tap dancing, Hollywood movies, etc, etc."[35]

30 years later, what occupies the pariah position opposed to modernist
painting that kitsch held for avant-garde in 1939? Was it the 'novelty art'
of Pop and Minimalism Greenberg regularly excoriated? Fried credits
Greenberg for being the first to analyse the theatrical quality of presence
and how it nudges Minimalism into the condition of non-art.[36] But
even before the arrival of Minimalism, 'theatre' was the enemy. Theatre
was the name of an uncontained contamination. "Having been denied
by the Enlightenment all tasks they could take seriously", Greenberg
states in his 1960 lecture "Modernist Painting" (influentially republished
in 1965), "[the arts] looked as though they were going to be assimilated
to entertainment pure and simple". To avoid assimilation, the solution
was "to eliminate from the effects of each art any and every effect that
might conceivably be borrowed from or by the medium of any other
art".[37] What was not eliminated, corroding the borders between two arts,
contaminating their 'purity', as well as the distinction between art and
life, came to be known in the late 1960s as that dangerous entertainment
Fried called theatre. Taking Fried at his word, and following a hint from
one of his footnotes to "Art and Objecthood", where he writes that the
essays of Susan Sontag's book *Against Interpretation* "amount to perhaps
the purest—certainly the most egregious—expression of what I have
been calling theatrical sensibility in recent criticism", could we not
speculate that for the late 1960s 'camp' would be the word that would
answer to the earlier function of 'kitsch'?[38] Camp was the kitsch of the
late 1960s. For in some respects Sontag's 1964 "Notes on 'Camp'" was as
influential as Greenberg's "Modernist Painting" on subsequent cultural
development. In the concluding essay to her book, "One culture and the
new sensibility", that Fried quotes in his footnote, she writes:

> All kinds of conventionally accepted boundaries have thereby been
> challenged: not just the one between the 'scientific' and the 'literary-
> artistic' cultures, or the one between 'art' and 'non-art'; but also
> many established distinctions within the world of culture itself—that

between form and content, the frivolous and the serious, and (a favorite of literary intellectuals) 'high' and 'low' culture.[39]

Fried responds: "The truth is that the distinction between the frivolous and the serious becomes more urgent, even absolute, every day, and the enterprises of the modernist arts more purely motivated by the felt need to perpetuate the standards and values of the high art of the past."[40]

Could anything be more frivolous and beneath standards than the following, written in 1968 by Stefan Brecht, on New York's Theatre of the Ridiculous?

> This theatre has attracted little but unfavorable notice: it is slovenly, amateurish, silly, just boring; a put-on, really an actor's lark; not art, certainly not serious art; a coterie occasion for a pariah in-group; by and for queers (not the nice kind, but drag queens and dykes and leather/motorbike/S and M hard trade); a display case for transvestites, pure camp, devoted to movie fetishism; anyhow just adolescent pornography; ritual enactment of an impotent humiliation of women (vicious, loveless); pointless, emotionally impactless, untheatrical; certainly devoid of social relevance; in sum, *stupid* and *immoral*.[41]

It might seem that we are on a long and frivolous excursion here, but doesn't Brecht describe, though in extreme form, some of the interests, themes, and attitudes of the seriously disdained frivolous art of Toronto during the 1970s, even the entertainments too dismissed to be discussed? And it was taking place at your local state-funded art gallery. Take the post-feminist experimental theatre of the Hummer Sisters, who were in residence at A Space during these years.[42] No impotent humiliation of women here. "Born in the crossfire of rock and TV" and nurtured by American culture, performing with banks of video monitors and backed by a rock band that later became the Government, the Hummer Sisters took candid aim at topical real-life soap operas: the kidnapped media heiress Patty Hearst (aka Tania) persuaded to terrorism and bank robbery by the Symbionese Liberation Army (*The Patty Rehearst Story*, 1976); the comatose teenager in a drug-and-alcohol-induced vegetative state battled over for pulling the plug (*The Bible as Told to Karen Ann Quinlan*, 1977). Writer John Bentley Mays called the real as if made-for-TV Patty Hearst story a "vulgar pop odyssey"; the Hummer Sisters called theirs "a post-feminist, neo-terrorist, radical back-rub rock'n'roll clone porn concert".[43]

Then again, take the prominent example of General Idea. Headlines from daily newspapers are a good way to publicly shame frivolous behaviour. Two such reviews of General Idea's 1975 Going thru the Notions exhibition correspondingly read: "General Idea still detailed

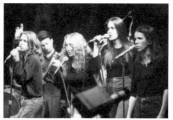

VideoCabaret, *The Bible as Told to Karen Ann Quinlan*, 1977 (documentation)

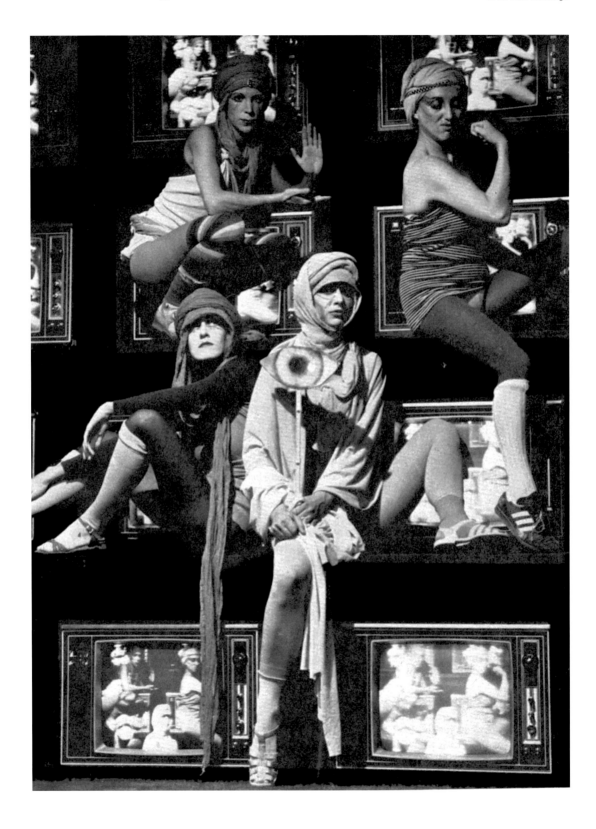

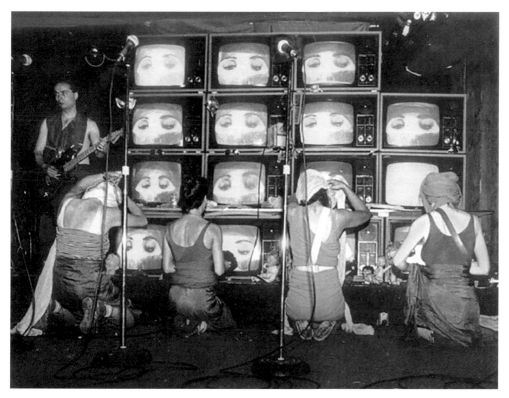

VideoCabaret, *The Bible as Told to Karen Ann Quinlan*, 1977 (documentation)

triviality" (*The Globe and Mail*) and "3 trendy young men market themselves" (*The Toronto Star*). To the first reviewer, General Idea "remain mere conceptualists, tinkerers in search of an art", whose work "of pseudo-philosophy and one-liners that comes with the package" parades itself as "half-formed thoughts, variations on mass production themes and failed attempts to make art out of the tawdry artifacts of consumer society".[44] The second reviewer similarly dismissively writes: "General Idea is a trio of highly intelligent but trendy young men, Michael Tims, Ron Gabe, and Jorge Saia who, armed with impressive organizational abilities and the help of a gaggle of art-groupies, have been marketing glitter, glamour and, ultimately, themselves for the past four years.... It is their love affair with suffocating self-definition and their dallying with atmospheres of vague fetid evil that is getting more arteriosclerotic and uninhabitable all the time. It's a vein nobody can profitably mine any more. Someone has to tell them how long their train's been gone."[45] Right.

With its tawdry glitter and suffocating glamour, the devalued image was only a result of self-degradation, which its own theatricalising self-elevation through language could not disguise. Language was an outside that came to divide the integrity of the interior. Yet it was thought that serious artwork ultimately confirmed the subject's self-proximate possession. Language's invasive partitioning divided the subject from him/herself thus separating the viewer, as well, from the essence of the work of art. An essential proximity was distanced from itself. However, as Derrida attests in *Of Grammatology*, "The speculary dispossession which at the same time institutes and deconstitutes me is also a law of language."[46] Language threatens the proper, in all senses of the word and in particular those given by Derrida of the "*metaphysics of the proper: le propre*—self-possession, propriety, property, cleanliness".[47]

The specular dispossession of photographic essentiality opened the image to the ambivalence and irony of performance. The performative mode insinuated itself into the gaps language opened in the image. As a consequence, the photograph no longer could be neutral—or natural. It lent itself to performance and received debased coin in return. Language contaminated photography and opened it to the banalities of the social. It was through photography's cultural constructions, not by means of its natural indexical capacity, that the visual banalities of advertising, for instance, infiltrated the artwork in order to become a vehicle for another type of artistic performance.

Toronto's version of so-called conceptual art could not be received because of what rested within it. What was between works was also what contaminated them within. What was within and between, but also what united the variety of works produced in Toronto, was talk. Talk and talk. *Talk* was the theatricality of Toronto art. It was as if language

was attracted to image as talk, and image was thus seen to be a frivolous performance. It was "entertainment pure and simple".

So of the many oppositions and resistances, spoken or otherwise, to the camp sensibility in Toronto art, one was from mainstream journalism; another from phenomenological or modernist authorities; the final was from a contemporary political art whose earnestness would castigate performance's frivolities, even though political art sometimes would avail itself of its opponent's strategies for its own ends. And yet such was the continuing resistance to language that even some performance practitioners reliant on it rejected its consequences. Take performance artist Elizabeth Chitty, whose personal transition in this period from dance to performance was dependent on the adoption of language as a constituent element of her work. Her performances were nothing if not voluble. Nonetheless, she could later write:

> Moving from dance to performance art in the 1970s meant moving from dance conventions to possibilities formed by multiple disciplines. These possibilities soon became sharply focused (or limited, depending on one's point of view) by the emerging importance of cultural theory, especially issues of representation. The role of theory in determining art practice grew during the late 70s and with it, the power of curators and critics increased. Even when those same curators and critics emerged from the artist-run centres, it meant that the balance of power shifted again from the primary production of the artist to the word.[48]

1977: 'Deconstructing' Fashion, Advertising, and Gender through Photography

Semiology contributes towards understanding the two aspects of photographic use in Toronto in the late 1970s: the constructive and the deconstructive, though the two sometimes were one and the same. But this is so only if we delimit its explanatory prowess by seeing what was original in its application by Toronto artists. That is, we need to understand, as well, what in these works exceeds semiology's structure of intelligibility. The function of structuralism is to render an 'object' intelligible; the function of semiology, or at least the mythology practiced by Barthes, is to render an image suspect. So constructed, object and image are seen to be artificial, which counters the usual case where an image authorises itself as something natural: "Semiology has taught us that myth has the task of giving an historical intention a natural justification, and making contingency appear eternal. Now this process is exactly that of bourgeois ideology."[49] Though written in the 1950s, Barthes' methodology was no crude Marxian class analysis or "pious show of unmasking". (It differed as well from and was superseded, too, by the then [1977]

countervailing influence of Louis Althusser.) "This book has a double theoretical framework", Barthes writes of *Mythologies*, "on the one hand, an ideological critique bearing on the language of so-called mass-culture; on the other, a first attempt to analyze semiologically the mechanics of this language."[50] It was the sophistication of the latter, not the critique of the former, that made semiology attractive to artists such as David Buchan and General Idea, two of its practitioners in Toronto, as well as the fact that Barthes handily offered the tools with which to counterpose their own subversive simulations of advertising.

Presumably, these artists already were adept readers and myth consumers, as artists tend to be. What was correspondence art, after all, but the connoisseurship of mass cultural imagery re-composed and circulated as a personalised mythic system? But artists were as well responders to the media bias of the Toronto School of Communication and to hometown guru Marshall McLuhan and his *Mechanical Bride: Folklore of Industrial Man*, 1951, with its precursory lessons in demystifying advertising. When the book was republished 16 years later in 1967 it was seen to be camp and a perfect model, in part, for *FILE*, which began publication a few years later.

By the mid-1970s, General Idea had already absorbed Barthes' lessons, incorporating them by 'plagiarising' his texts within their own. They put these lessons to use as their own performative methodology in their 1975 Glamour manifesto:

> We knew that in order to be glamourous we had to become plagiarists, intellectual parasites. We moved in on history and occupied images, emptying them of meaning, reducing them to shells. We filled these shells then with Glamour, the creampuff innocence of idiots, the naughty silence of sharkfins slicing oily waters.[51]

What was Glamour but an artificial myth constituted out of the *démodé* detritus of culture, its "forgotten shells"? There was no need to naturalise what obviously was historical here. Rather artists overdid the ersatz; they put quotation marks around it, a procedure that marked the artificiality of the cultural product. As Sontag says, "Camp sees everything in quotation marks."[52]

When Barthes suggested turning the devices of myth against itself and creating a third semiological chain departing from the second that myth constitutes, he was scarce on examples of what he meant by any resulting artificial myths, or who its practitioners could be, although he allowed that "literature offers some great examples". But contemporary artists were well aware how to use advertising, for instance, as a departure point. This procedure had the advantage of keeping familiar models before us, though at an ironic distance.

Marshall McLuhan, *The Mechanical Bride*, 1951 (reprinted 1967)

OPPOSITE
General Idea, "Glamour" [Stolen Lingo],
FILE, autumn 1975

STOLEN LINGO

We knew Glamour was not an object, not an action, not an idea. We knew Glamour never emerged from the 'nature' of things. There are no glamourous people, no glamourous events. We knew Glamour was artificial. We knew that in order to be glamourous we had to become plagarists, intellectual parasites. We moved in on history and occupied images, emptying them of meaning, reducing them to shells. We filled these shells then with Glamour, the creampuff innocence of idiots, the naughty silence of sharkfins slicing oily waters.

Advertisement from *Esquire*

David Buchan, *Modern Fashions Suite:
Cam-o-flage Brand Underwear*, 1977

Advertisement from *Esquire*

For instance, in *Modern Fashions*, 1977, we actually know the sources for David Buchan's 'advertisements'. They are adapted mainly from *Esquire* men's magazine from 1959 to 1963, in a period when such magazines were defining men as a consumer group. One plays off a sport shirt advertisement ("Men like you like Truval shirts!") by banally reproducing its format, itself borrowed from conventions of individualising Renaissance portraiture. In his derivative *Men like you like Semantic T-shirts!*, Buchan's own posing mimics its models' postures but varies the allegorical devices accompanying them. In tacit acknowledgement that a mass-produced look-a-like shirt cannot by itself individualise, only the associations built around it by media hype, Buchan hijacks the buttoned-down descriptions to substitute his unbuttoned own. Typically advertising delivers only one message at a time, but Buchan complicates his message by making his T-shirts signify within a larger system; they are 'semantic'—but with more than one meaning, or rather with one meaning operating through an other. In *his* scenario, allegorical devices now only signify within a clever turn of phrase absent in the original, and mean something altogether different.

While not employing *Esquire*'s language, Buchan honours its original aims. In the magazine's inaugural issue, its editorial read, "*Esquire* aims to become the common denominator of masculine interests—to be all things to all men." Buchan's 'advertisement' is nothing but all things in its sexual innuendo. Buchan addresses the reader man to man, at least for those who can read the codes, which are not between the lines but out in the open, though not plain to see, and are thus an acknowledgment of queer signifying at a time when it might have operated more underground (think hanky code) than openly acknowledged.[53] So in creating a third semiological chain, mock advertising such as this does not stop at establishing an artificial myth, one in dialogue with its source; it appropriates, diverts, and perverts the original message to another end altogether.

These ends would vary. Not every panel of *Modern Fashions* had the same aim, just as in page-after-page magazine advertising. Deconstructing advertising was an outcome, not the purpose. Rather, deconstructive procedures were used towards constructive pursuits. Buchan was a 'wardrobe artist', as he called himself, and his advertisements show off both his wardrobe and his word skill; the latter was entertainment, too, not just copy. Freed from the page, though still signifying their original contexts, these commercially out-sourced, large-scale photographic blowups boldly drew attention to themselves and their own self-reflexive self-promotion: their manipulation of an *idea*. Please see *Atten(ua)tion Please*. Fashioning these messages as performances massaged the genres they inhabited. Attenuating costumes and attenuating prose 'shaped' the message in order to sell the artist's idea to the observer.

Men like you like *Semantic* T-shirts!

Going down? Perfect for all kinds of watersports. Get below the surface – get to the bottom of things in this outfit designed with total immersion in mind.

Tennis anyone? A bit of the old back-and-forth? In this dialogue with balls, it's not important who serves, but the quality of the exchange.

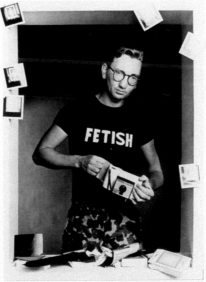

Our jocks are tops. Play ball, go for a long one, he shoots – he scores. Catch my drift? At any rate, in this game, it's three stripes and you're out.

This self-reflexive statement of the nature of compulsive self-identification in the latest style in self-addressing. His fetish, why the Semantic T-shirt!

Tell them who you are. When you've got something to say, don't just say it – wear it! No one likes to go unnoticed, and what better way of saying look at me than a sign. Logo Boys dancing to today's beat.

DISSIDENTS WITH A DIFFERENCE

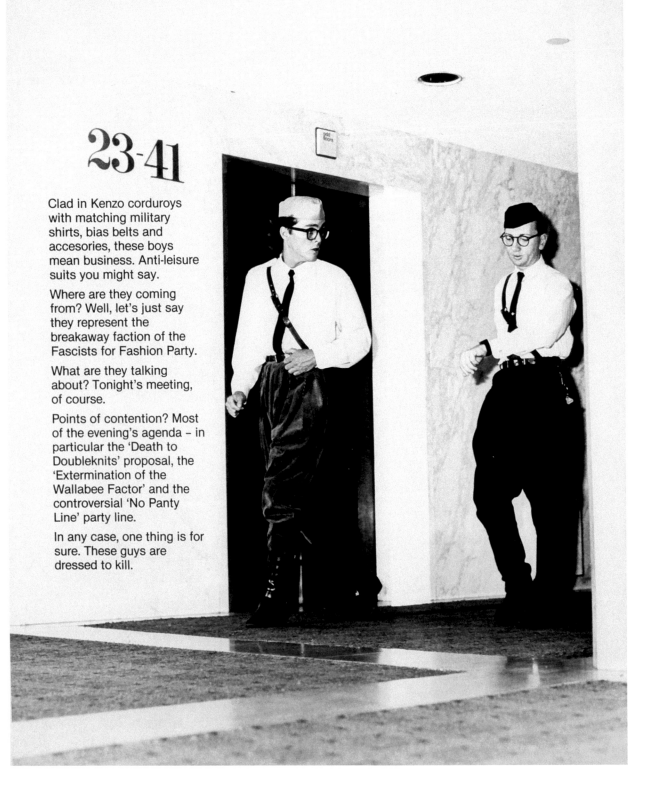

23-41

Clad in Kenzo corduroys with matching military shirts, bias belts and accesories, these boys mean business. Anti-leisure suits you might say.

Where are they coming from? Well, let's just say they represent the breakaway faction of the Fascists for Fashion Party.

What are they talking about? Tonight's meeting, of course.

Points of contention? Most of the evening's agenda – in particular the 'Death to Doubleknits' proposal, the 'Extermination of the Wallabee Factor' and the controversial 'No Panty Line' party line.

In any case, one thing is for sure. These guys are dressed to kill.

There was more to artificiality than artificial myth; there was affinity to the artificial *over* the natural, and not only in pose or in costuming and presentation. Artificiality foremost was an affinity to the *un*natural and the deviant. Here was the worry of theatricality's degeneration, perversion, and corruption. Deviancy, however, was not a subject, the content of the work, or its offensive issue; artists sought instead to deviate an image by deviating code. What you see is not necessarily what you get.

Here was the interest in artificial myths invented by artists of this moment in Toronto. Their invention was original. A few years later, this practice, already long commonplace among Toronto artists, became known in New York in the 1980s, as if originating there, of course, as appropriation art. But let's distinguish between the strategies of the two, appropriation and inhabitation. "Appropriation quotes or parodies other cultural or popular discourses, codes, styles, or production techniques within a high art discourse and institutionality.... Inhabitation parasitically assumes cultural forms or codes, empties them of their 'content' and by inserting its own effects a critical disruption."[54] Although the former uses the language of the latter to radicalise itself, in appropriation art irony appears in the borrowing, not actually in what was done with it. An image was tampered with, but not its code. What you see is what you get, as Frank Stella said—and you get it right away. This type of work operates on the level of recognition alone, so the work of American artists Sherrie Levine, Richard Prince, Barbara Kruger, or Jeff Koons has an immediate visual appeal that is at odds with the discursive deviancy of their Canadian contemporaries such as General Idea and David Buchan. In the latter work the visible is only a disguise for other operations taking place—a subtle, though significant difference between Canadian and American art.

Having been there, done that, General Idea moved on. They moved on by destroying their work to this point. It wasn't a real destruction, only fictional, but the distinction is not that important. On the levelled ground of this destruction, during this period they developed a new body of work, which, however, is little discussed. By destroying *The 1984 Miss General Idea Pavillion* they dismantled the overall framework or thematic container for their ongoing practice, though the Pavillion was later 'reconstructed' in the early 1980s through an 'archaeological' excavation of its 'ruins'. In the interregnum, what they replaced it with was in dialogue with what was happening around them in Toronto: addressing the questions of what was an 'effective' art and what was a 'transgressive' one. And were they, indeed, one and the same?

General Idea's 1977 *S/HE* is a transitional work. While it doesn't specifically reference their Pavillion or its constraining narrative, it composes its images with some of its props, and the mock celebrity

P 59
David Buchan, *Modern Fashions Suite: Men Like You Like Semantic T-Shirts*, 1977, silver gelatin print, 152.4 x 116.8 cm
OPPOSITE
David Buchan, *Modern Fashions Suite: Dissidents with a Difference*, 1977, silver gelatin print, 152.4 x 116.8 cm

assumed by its models' attitudes suggest they would be *chez soi* there. Like Buchan's *Modern Fashions*, *S/HE* has the appearance of a slick set of advertisements, although we are less certain what they are selling than Buchan's where the pitch is directed by its mode of address. Buchan's series furthermore are one-off knock-offs of actual advertisements whereas in *S/HE* the serial is part of its mode of presentation. Its message is composed along a chain of separate images, whose overall look varies little from one to another. The unity of appearance lies in the fact that 'sheen' is repeatable, that the auratic is an act that hides within appearance while making (a product) visible, which means that the auratic itself is iterable: it is a repeatable product. In other words, artifice is not a supplement to appearance, appearance actually *is* artifice. *S/HE* is as much about how this look is achieved as the 'message' it conveys.

So while *S/HE* immediately addresses us, it directs us, too, by its commanding text, which demands our attention as much as it dictates the models' poses. But text is not as telling as photographic technique, which remains silent. More is going on in the image than it is telling us. *S/HE* is as much sociological as semiological. It reveals as much what General Idea learned from their own studio practice as from Roland Barthes' theories. The work revels in what it reveals as media manufacture. As well as an end product, *S/HE* is also its manufacture. It lets us in on the industry's behind-the-scene manipulations—an apparatus whose fabrication is exactly a construction: a star is *made* not born. *S/HE*'s own manufacture replicates that of the media and conspicuously displays it as such.

It's all about presentation, and the presentation of presentation. It's all about exposure: how much is given out at any one moment, and what; what is framed and how it is lit. It is not about what is given to view as content, as how it is given to view. Disguised behind the models' ostentatious performances, we find an anonymous and silent act—the photographer's. The studio and darkroom make it all happen; together they deliver the magic of the (staged) moment. The controlled manipulation of, first, the lighting of the shoot and, then, the dark grain of the print is the material means of appearance—but also a metaphor for it. Light and dark. Even before any other divisions, chiaroscuro structures the very fabric of appearance.

From the start, in reading the title, *S/HE*, we sense a potential for equivocation. This ambiguity is fundamental. Not just a fundamental ambiguity, it is an ambiguity in the fundament, in the ground of the image. With their blurred and obscured images, the middle panels of each series are instructive ("What's-her-name?"/"What's-his-name?"). Their very lack of clarity—between black and white or figure and ground—is a visual disordering that repeats the title's nominative unsettling. The problem of naming this amalgamated subject extends to the work's doubled meaning.

PP 63-68
General Idea, *S/HE*, 1977 (remade 2014),
C prints, series of 10, each 78.7 x 60.9 cm

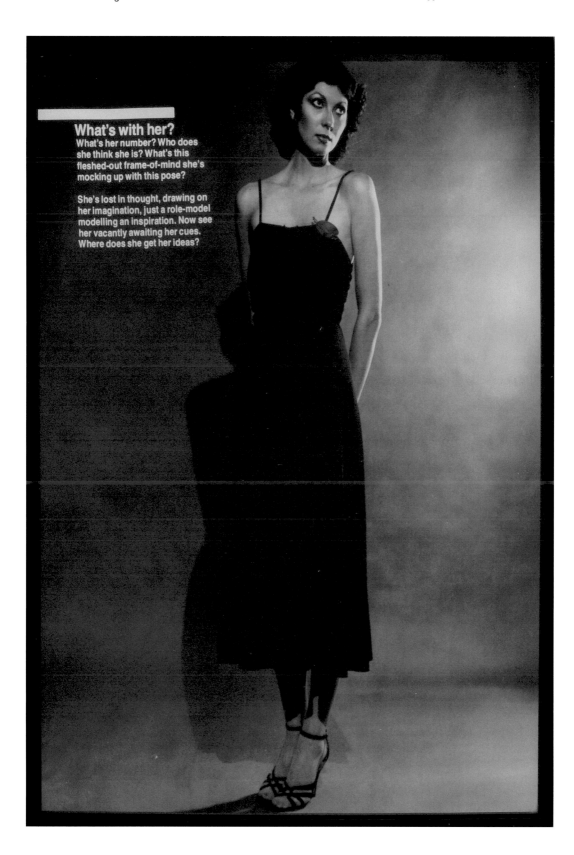

What's with her?
What's her number? Who does she think she is? What's this fleshed-out frame-of-mind she's mocking up with this pose?

She's lost in thought, drawing on her imagination, just a role-model modelling an inspiration. Now see her vacantly awaiting her cues. Where does she get her ideas?

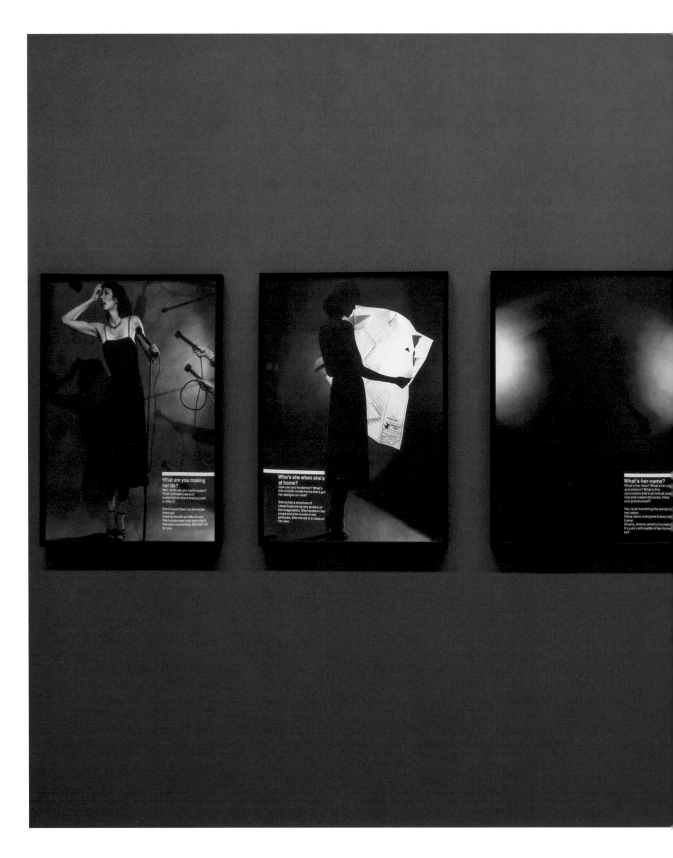

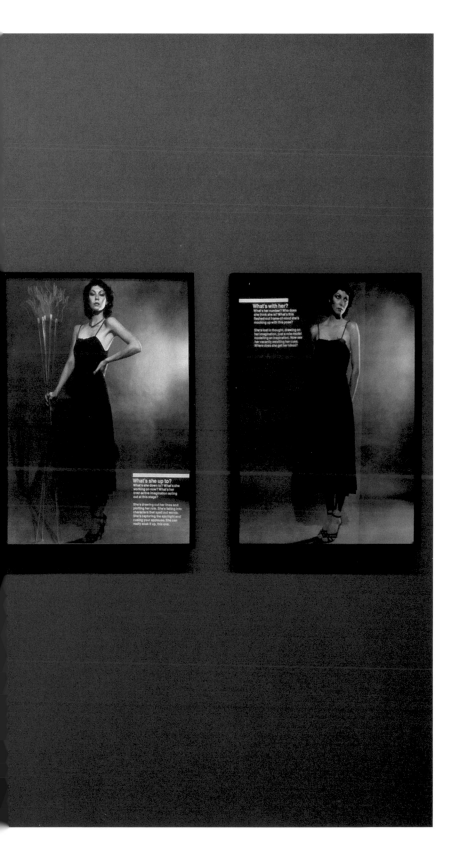



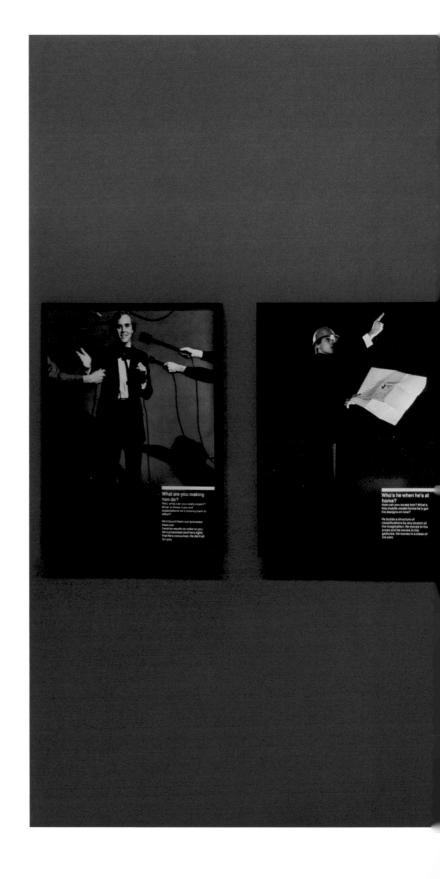

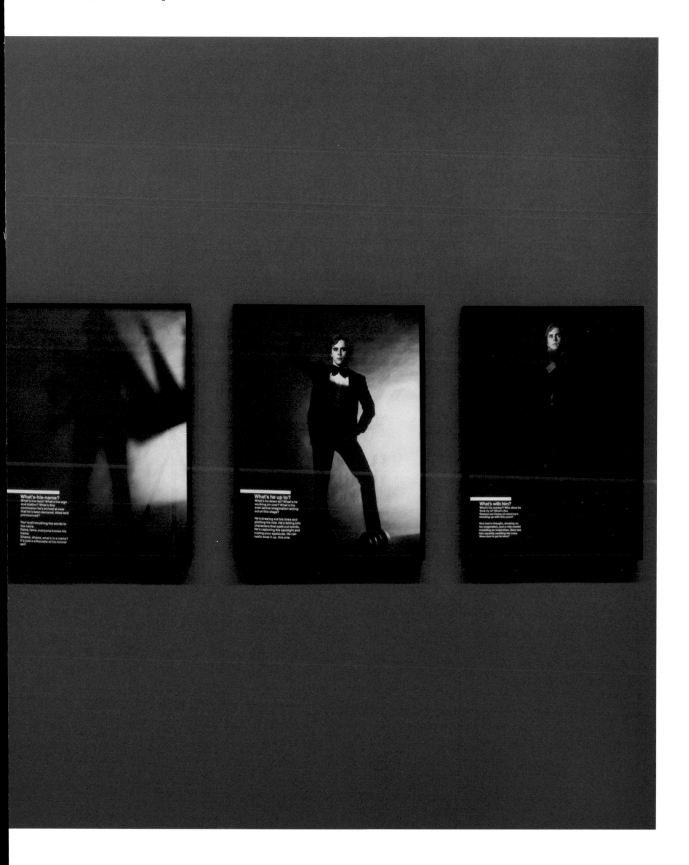

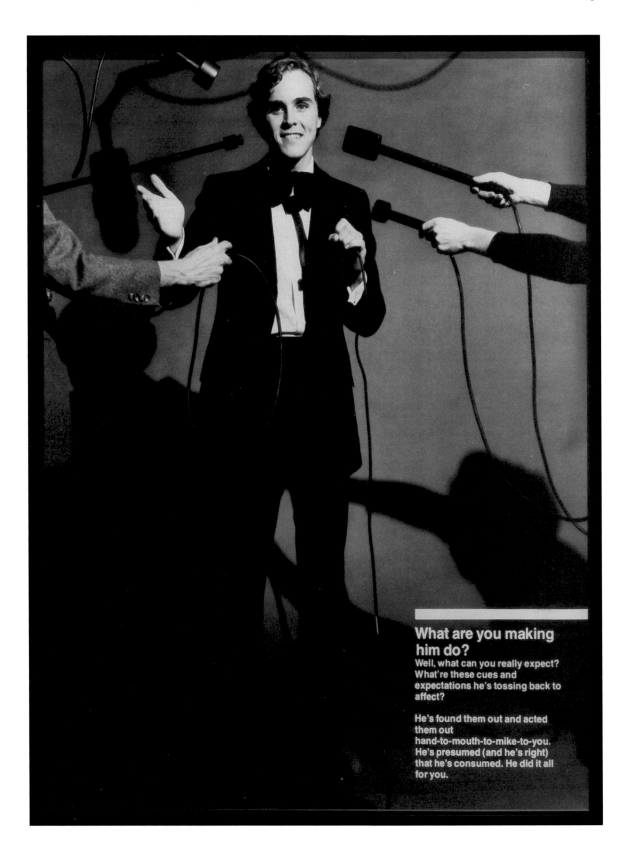

What are you making him do?
Well, what can you really expect?
What're these cues and
expectations he's tossing back to
affect?

He's found them out and acted
them out
hand-to-mouth-to-mike-to-you.
He's presumed (and he's right)
that he's consumed. He did it all
for you.

Moreover, exactly who is speaking and being spoken to here? A double intonation directs a division of address. The two-tiered texts address the subjects of each image (or, rather, the roles the models play) at the same time that they address us (its viewers) asking: "What's with her?"/"What's with him?" If the first text aggressively frames the question, the second descriptively answers, explaining the visible pose. The question: "What's with him? Who does he think he is? What's this fleshed-out frame-of-mind he's mocking up with this pose?" The answer: "He's lost in thought, drawing on his imagination, just a role-model modelling an inspiration. Now see him vacantly awaiting his cues. Where does he get his ideas?" Where does he get his ideas? Well... from the artists who posed the model, and the text that prompts the mannequin's responses—from nothing interior really, nothing constituted and prized as individual subjecthood. The texts then are just as much prescriptive as descriptive; they are prompts to be fulfilled. The models do as directed: "She did it all for you." Inhabiting parallel worlds, this is no 'he said, she said' dilemma for the subjects. Rather s/he are *said*. Language alone commands the subjects while, at the same time, undermining their commanding poses. S/he assume their roles through an impersonal language construction that distributes identity within a regime that both institutes *and* permutes them. The process of attributing or assigning identity is never secure. In *S/HE*, gender equivocation aligns to meaning equivocation, a situation Barthes calls "non-decidability".[55]

So we would be mistaken if we parsed such works as Buchan's or General Idea's and treated them solely as if they deconstructed advertising with the aid of semiology. The ambiguity of these works and their messages is always such that it is difficult simply to say that artists were for or against any particular image they appropriated, even if they performed through it. (Equally, we would be revealing only part of the story if we said that these works were prescient in investigating the construction of gender before that terminology was commonplace, or queer sensibility before all these artists were fully out.[56]) The ambiguous and the artificial mingled in much of Toronto's art: the ambiguous, the artificial, *and* the transgressive. Semiology went together with sexuality and subversion in works that were not so much interested in contesting images as in appropriating, diverting, and perverting codes.

There was something about *S/HE* that made it different from conventional conceptual art. Language *demanded* while the image *performed*. It was a performative situation that somehow commanded our attention and participation, too. Was this something specific to Toronto? It was accomplished in part by that ubiquitous Toronto talk. This talk had tone. It was dominating... and had a little of the dominatrix about it. It was manipulative, bitchy ("what's with her?"), and gave the impression of being, you know, a cliquish in-crowd lingo, as if transgression was an

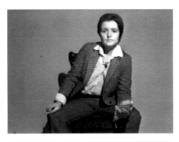

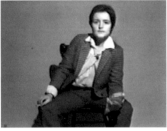

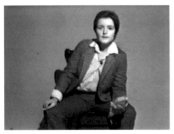

Rodney Werden, *'Say'*, 1978, video (stills)

Rodney Werden and Susan Britton at the
1978 Canadian Video Open

in-crowd code. Such talk set the tone in Toronto. If you had a complaint about some Toronto art as frivolous entertainment, this would be its other face, except now you would be the one dismissed, darling.

We would expect then to find this dominating tone in other Toronto works, say, in Rodney Werden's 1978 video *'Say'*. Here 'say'—the word, not the title—is neither an exclamation nor an invitation to chat. It is an imperative. Speaking off-screen, the artist asks the sole, seated subject—a butch dyke with an unconsumed glass of whisky in one hand and a cigarette in the other—to repeat words after him: "say mouth... say tongue... say slippery... say teeth... say shoulder", it starts with the replies obediently coming in-between—and goes on with no inflection for almost four minutes. By themselves single words are innocent enough but collectively build in sexual innuendo, yet every moment and every word are as neutral as any other. What the words might signal in a dominated sexual situation is enacted here as a power dynamic between off-screen voice and on-screen subject treated to *this* scene of domination.[57] We witness the woman's slight discomfort in pose and occasional hesitation in response as an unstated resistance to this power differential the camera apparatus imposes. Once again, as in *S/HE*, the dependent subject is *said* from outside the frame. And as in *S/HE*, the title moreover sets up ambiguity as a precedence of linguistic ambivalence signaling sexual ambivalence.

'Say' shows that the Toronto paradigm (a performative art that was embodied, gendered, and dealt with transgressing codes) applies equally to moving images at a time when Toronto video artists were at the forefront of the new medium. Take Susan Britton's 1978 video *...And a Woman* as another example. It is as succinct as *'Say'*. Two women mouth clichés. They are the clichés of 1960s foreign film. The actors themselves are clichés. In fact everything here is a parodied cliché, starting from the title itself, the music, and the abbreviated scenarios mimicking glamourous gestures of jet set romantic love and loss. And so too is the slightly out of sync dubbing; its lip flap from Italian, let's say, to English is an empty sign, too. Since we know that the women here are actually speaking English (though the dubbing is Euro-inflected English), it is as if they are already translating themselves. Both actors inhabit their roles with a campy wide-eyed pouting willingness, yet inherently distance themselves from them at the same time, in part through this verbal disjunction. They maintain this distance in order to create a space, a gap in which to accommodate the contradictory societal positions they need to fulfil as women. The title of the work suggests the plenitude of a metaphor that is *ever* to be fulfilled: and a *woman*. But perhaps the title is, as well, sardonically dismissive: dot dot dot, *and* a woman, that is, an artist... *but* a woman, etc.

In Toronto, women's work and work by women artists were in affinity as performances that aligned in images. But women artists made these images ever so slightly discrepant through the overlay of the other ironically

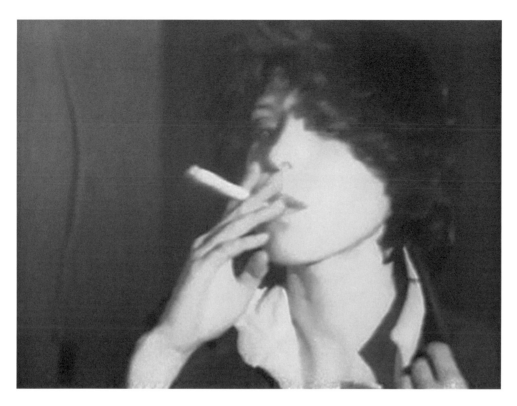

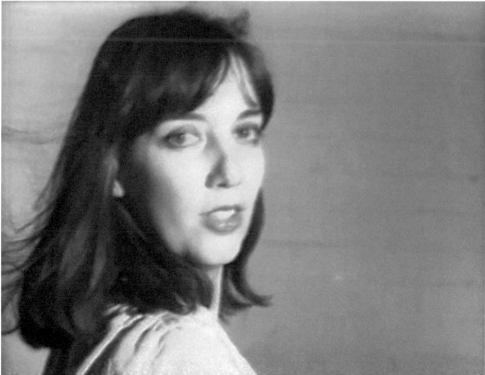

Susan Britton, ...*And a Woman*, 1978, video (stills)

distancing portrayals they performed and the images they substituted. Performance by artists, both male and female, was an inhabitation that deviated inherited images and so deviated codes of behaviour in the process. Competency with codes gave Toronto artists the means to divert them, whether these codes were technological, semiotic, sexual, or social.

Toronto art was medium sensitive and genre specific. Works tended to fetishise formats and what they brought into view, however ironic the gaze, while substituting their own contents and displaying dissenting attitudes in the process. Performance was all about pose—but in the end it also was all talk. It was the talk of the town, as a matter of fact, however circumscribed that town was as a localised art scene.

1 Barthes' *Elements of Semiology*, 1964, was available in an English edition in 1967 and an American edition in 1968. *Mythologies*, 1957, was translated in 1972 as *Critical Essays*, 1964. His books of textual theory followed: *S/Z*, 1970, 1974; *The Pleasure of the Text*, 1973, 1975; *Sade/Fourier/Loyola*, 1971, 1976; as well as *Roland Barthes*, 1975, 1977 and *A Lover's Discourse*, 1977, 1978.

2 "American mythology is deactivated and included in [artists'] larger mythological structures, their concern with themselves as artists concerned with culture." Bronson, AA, "Pablum for the Pablum Eaters", in *Video by Artists*, Peggy Gale ed, Toronto: Art Metropole, 1976, p 198.

3 *Glamazon* was performed 14–15 December 1975 at the St Paul Centre, which at the time also hosted the efflorescence of independent dance during this period. In his article "Artists in Residence: Women's Performance Art in Canada", David Buchan mentions the autumn 1973 performance *Dance Soap* by Marien Lewis ("one of the earliest pieces of Women's Performance Art done in Toronto, of the format occupation variety, and to a certain extent helps to acclimatize the audience to the medium"); the 26–27 June 1975 *Queen of the Silver Blades* (Susan Swann, Mary Canary, Margaret Dragu); the 25 July 1976 *Torch Showcase* (Brenda Donahue, Dianne Lawrence, Carole Pope, and Suzette Couture); and the 15 January 1976 *Love-Letter* by writer A.S.A. Harrison. Buchan, David, "Artists in Residence: Women's Performance Art in Canada", *Vie des Arts*, vol 21, no 86, 1977, p 86. On 24–25 June 1977, Buchan presented what you could call an homage to these women with his *Fashion Burn*, "a punk rock fashion parade" at Crash 'n' Burn, the punk club in CEAC's basement. See Buchan, David, "Fashion Burn", *FILE*, vol 3, no 4, autumn 1977, pp 60–61.

4 Oille, Jennifer, "Glamazon, Etc", *Only Paper Today*, vol 3, no 3, January/February 1976, p 11.

5 Alain-Martin, Richard, and Clive Robertson, *Performance au/in Canada*, 1970–1990, Québec: Éditions Intervention; Toronto: Coach House Press, 1991; Mars, Tanya, and Johanna Householder eds, *Caught in the Act*: *An Anthology of Performance Art by Canadian Women*, Toronto: YYZ Books, 2004.

6 Ninety, Radz, "Glamazon", *Only Paper Today*, vol 3, no 2, November/December 1975, p 1.

7 Buchan, "Artists in Residence: Women's Performance Art in Canada", p 86.

8 Steltner, Elke, "Elke Steltner Talks to David Buchan", *Only Paper Today*, vol 4, no 5, July 1977, p 8.

9 Another "entertainment" in the art scene was the complementary device of lip synch, which Buchan employed in part two, *Geek/Chic Comes Alive*, where six "Geek Models" lip-synched pop songs.

10 Buchan, David, "Geek/Chic", *FILE*, vol 3, no 3, spring 1977, pp 47–50.

11 Steltner, "Elke Steltner Talks to David Buchan", p 8.

12 Barthes, Roland, "Myth Today", *Mythologies,* New York: Hill and Wang, 1972, p 135.

13 "High Style Meets Low Life", in "Geek/Chic", p 50. Buchan would have been well versed in General Idea's concepts, so "The no-man's land between good taste and bad" makes reference to General Idea's Borderline Cases: "For the past few years we of General Idea have been exploring and mapping the Borderline Case, the no-man's region between self and other, inside and out, the arena of our affliction.... In this show, which concerns the prototype for Luxon V.B., we address ourselves to that exact and exacting space marked by glamour: the interface between content and context, nature and culture, inside and out." General Idea, *Luxon V.B.: The 1984 Miss General Idea Pavillion No 101*, self-published, 1973. Also see the anonymous (General Idea) article on "practicing non-artists", where Clara the bag lady (an actual Toronto street person) "defines the space between culture and nature, which is glamour." "Confronting the Perilous Future—The Careful Hiding of Identity", *FILE*, vol 1, no 2 & 3, May/June 1972, p 10.

14 Sontag, Susan, "Notes on 'Camp'", *Against Interpretation*, New York: Dell Publishing Co, Inc, 1966, §2, p 277.

15 "They have paraded their homosexuality as though that in itself gave the mag. some bizarre status within the enigma of the alternate society. Instead the problems of homosexuality as an actual way of life recede into the pageantry of camp parody." Anonymous, "FILE: The Great Canadian Art Tragedy", *The Grape* [Vancouver], 24–30 May, 1972. Here's what Buchan said about the reception of "Geek/Chic": "When I originally created the piece, I thought my ideal audience would be an art audience, but it seems that the art audience of Toronto is not all that willing to accept what I offer them as art." Steltner, "Elke Steltner Talks to David Buchan", p 9.

16 For instance see the review of James Collins' work at A Space: Bronson, AA, "James Collins, A Space, February 1–12", *artscanada*, vol 34, no 2, May/June 1977, p 54. Always the astute observer, Bronson comments, "Photography (and the 'non-photographic' use thereof) is, of course, enjoying a certain modish popularity these days. In particular, photo-works by artists who are decidedly not photographers, or even photographers in the photographic tradition, are getting new attention." He also adds, "Marketing is a concern which must not he overlooked in looking at Collins.... The pretty girls sell the art while the self-portrait sells the artist. This is not to suggest that Collins has 'sold out'; rather he has integrated the needs of the market into his product. The result is a body of work that is unremittingly contemporary."

17 For Carr-Harris' extensive critique of Fried, see his self-penned ficto-critical article on his own work in Elke Town, *Fiction: an exhibition of recent work by Ian Carr-Harris, General Idea, Mary Janitch, Shirley Wiitasalo*, Toronto: Art Gallery of Ontario, 1982. On this period of Carr-Harris' work, see Monk, Philip, *Ian Carr-Harris 1971–1977*, Toronto: Art Gallery of Ontario, 1988.

18 On General Idea's concept of "separation-as-elevation", especially as it pertains to Guy Debord's notion of the spectacle, see Monk, Philip, *Glamour is Theft: A User's Guide to General Idea: 1969–1978*, Toronto: Art Gallery of York University, 2012, pp 178–179.

19 Note here how this telescopic enframing creates a cone of vision that operates much like a spotlight, another case of the elision of these two devices. "General Idea's Framing Devices" was published in *FILE*, vol 4, no 1, summer 1978, pp 12–13, but was part of their 1975 performance and video *Going thru the Motions*. General Idea,

20 "Glamour", *FILE*, vol 3, no 1, autumn 1975, p 32. "One common characteristic of all these events and the General Idea's Beauty Pageants is that they make use of available formats, familiar formats,

acceptable formats for the re-creation and transmutation of current culture." Bronson, "Pablum for the Pablum Eaters", p 200.

21 What one consumed as well was one's own pre-critical history: the popular culture of one's adolescence. "At the same time there are the vicarious thrills available by reliving those moments when they were safely ignorant of sexual politics, rôle modelling and acculturation." Buchan, "Artists in Residence: Women's Performance Art in Canada", p 88.

22 See, for instance, *Traffic: Conceptual Art in Canada 1965–1980*, Edmonton: Art Gallery of Alberta, 2012.

23 The first exhibition at A Space's second location on St Nicholas Street in spring 1971, Concept '70, set some of this direction, presenting Canadian video and conceptual art. One of A Space's early participants, Robert Bowers, wrote in 1980, "There were no formulas for conceptual art. We were trying to codify that kind of art. Dennis Oppenheim and Vito Acconci's way of working became very influential." Oppenheim visited A Space for six days in May 1971 and Acconci for a week in June 1971.

24 Morris, Robert, "Aligned with Nazca", *Artforum*, vol 14, no 2, October 1975, p 39, quoted in Nasgaard, Roald, "Introduction", *Structures for Behaviour*, Toronto: Art Gallery of Ontario, 1978, p 19. For a critique of the exhibition, see Monk, Philip, "Structures for Behaviour", *Parachute*, no 12, autumn 1978, pp 20–27.

25 Robert Morris offers his explanation: "Some time ago George Herbert Mead divided the self into the 'I' and the 'me.' The former has to do with the present-time experiencing self, consciously reacting. The latter is the self reconstituted from various remembered indices." Only the "I" can authentically experience spatial sculpture. "The 'me' is that reconstituted 'image' of the self formed of whatever parts—language, images, judgments, etc.—which can never be coexistent with immediate experience, but accompanies it in bits and pieces." Morris, Robert, "The Present Tense of Space", *Art in America*, vol 68, no 1, January–February 1978, p 70; reprinted in Morris, Robert, *Continuous Project Altered Daily: The Writings of Robert Morris*, Cambridge, MA: The MIT Press, 1993, p 177. What would Morris say of the 'me, me, me' of camp? According to Morris, both language and photography participate in the "noise" of "cultural discourse", photography moreover having a "malevolent" effect (pp 79/201). In a footnote, he adds, "See Sontag, Susan, *On Photography* (New York: Farrar Straus and Giroux, 1977), for her thoroughgoing analysis of the insidious trivializing of experience perpetrated by photography", (pp 80/207).

26 Michelson, Annette, "Art and the Structuralist Perspective", *On the Future of Art*, New York: The Viking Press, 1970, pp 56–57, 51.

27 Foucault, Michel, *The Order of Things*, New York: Vintage Books, 1970, p xiv.

28 Derrida, Jacques, "Structure, Sign and Play in the Discourse of the Human Sciences", *Writing and Difference*, Alan Bass trans, Chicago: The University of Chicago Press, 1978, p 280. Derrida's lecture was delivered even before structuralism really had begun to be received in North America. Derrida's books available in English in the late 1970s included *Writing and Difference*, *Speech and Phenomena*, *Of Grammatology*, and *Spurs: Nietzsche's Styles*.

29 The anti-phenomenological discourse was also an anti-modernist discourse. It would theoretically ally itself to the performative modes of what was excluded by these discourses. For the critical introduction of this discourse into Toronto, see articles by Philip Monk such as "Structures for Behaviour", *Parachute*, no 12, autumn 1978, pp 20–27; "The Death of Structure", *Parachute*, no 16, autumn 1979, pp 32–35; "Yves Gaucher: Eyesight and Temporality", *Parachute*, no 16, autumn 1979, pp 47–48; "Stanley Brouwn and the Zero Machine", *Parachute*, no 18, spring 1980, pp 18–20; "Coming to Speech", *Performance*, Montreal: Parachute, 1981, pp 145–148 (delivered as a lecture October 1980). See as well his pamphlet *Peripheral/Drift*, Toronto: Rumour, 1979.

30 Michelson, Annette, "Robert Morris: An Aesthetic of Transgression", *Robert Morris*, Washington, DC: Corcoran Gallery of Art, 1969, p 35.

31 General Idea, "Are You Truly Invisible?", *FILE*, vol 2, no 3, September 1973, p 35.

32 Fried, Michael, "Art and Objecthood", *Minimal Art: A critical Anthology*, Gregory Battcock ed, New York: EP Dutton & Co, Inc, 1968, p 125. The essay was originally published in the June 1967 issue of *Artforum*.

33 Fried, "Art and Objecthood", pp 135, 141, 147, 146.

34 Michelson, "Art and the Structuralist Perspective", p 56. It is not enough then for Douglas Crimp to critique 'presentness' by means of the concept of 'presence' as when he writes, "What Fried demanded of art was what he called 'presentness'...; what he feared would replace that condition as a result of the sensibility he saw at work in minimalism—what *has* replaced it—is presence, the sine qua non of theater." Crimp, "Pictures", *October*, vol 8, spring, 1979, p 77.

35 Greenberg, Clement, "Avant-Garde and Kitsch", *Clement Greenberg: Collected Essays and Criticism*, vol 1, John O'Brien ed, Chicago: The University of Chicago Press, 1986, pp 11–12.

36 "Furthermore, the presence of literalist art, which Clement Greenberg was the first to analyze, is basically a theatrical effect or quality—a kind of *stage* presence." Fried, "Art and Objecthood", p 127.

37 "Modernist Painting", *Clement Greenberg: Collected Essays and Criticism*, vol 4, John O'Brien ed, Chicago: The University of Chicago Press, 1986, p 86.

38 Fried, "Art and Objecthood", p 141.

39 Sontag, Susan, "One culture and the new sensibility", *Against Interpretation*, p 297.

40 Fried, "Art and Objecthood", p 142.

41 Brecht of course is being complimentary, not critical, here. Brecht, Stefan, "Family of the f. p. Notes of 1968 on the theatre of the ridiculous", *Queer Theatre*, London and New York: Methuen, 1986, p 28.

42 The influence of Toronto underground theatre, then in its heyday in the late 1960s and early 1970s, on Toronto art and its artist-run institutions has yet to be examined. See Johnston, Denis William, *Up the Mainstream: The Rise of Toronto's Alternative Theatres, 1968–1975*, Toronto: University of Toronto Press, 1991. The A Space residency of the Hummer Sisters (Deanne Taylor, Marien Lewis, Bobbie Besold, and Janet Burke), amalgamated into the larger VideoCabaret, was one manifestation of an overlap.

43 Mays, John Bentley, "Should Karen Ann Quinlan be Allowed to Die", *Only Paper Today*, vol 5, no 1, February 1978, pp 18–19. "Live from Toronto, the Hummer Sisters Present VideoCabaret", *Only Paper Today*, vol 5, no 3, April 1978, pp 5–16.

44 Purdie, James, "General Idea still detailed triviality", *The Globe and Mail*, 1 November 1975.

45 Dault, Gary Michael, "3 trendy young men market themselves", *The Toronto Star*, 3 November 1975.

46 Derrida, Jacques, *Of Grammatology*, Gayatri Chakravorty Spivak trans, Baltimore: The Johns Hopkins University Press, 1976, p 141.

47 Derrida, *Of Grammatology*, p 26.

48 Chitty, Elizabeth, "Asserting Our Bodies", *Caught in the Act*, p 72. Chitty's statement points to another issue in Toronto: that of representation. Who has the authority to represent a community? Given the ethos of the artist-run, a history of that community can only be written by producers, by its artists, that is, by those who created and maintained the system. The contradictions of this position, allied later to issues of "appropriation of voice", as well as to the feminist demand that everyone be represented, have been detrimental to Toronto histories actually being written, because histories need be representations. Hence, even "those same curators and critics [who] emerged from the artist-run centres" are suspect if they attempt to write this history. This common attitude betrays still a belief in presence—in the subordination of the secondary derivativeness of writing ("the word") to the "primary production" of the artist.

49 Barthes, "Myth Today", p 142.

50 Barthes, Roland, "Preface to the 1970 edition", *Mythologies*, New York: Hill and Wang, p 9.

51 General Idea, "Glamour", *FILE*, vol 3, no 1, autumn 1975, p 22.

52 Sontag, "Notes on 'Camp'", §10, p 280.

53 "The most glaring omission [of the *Modern Fashions* catalogue] is a discussion of gay content within the work. All the ads are loaded with gay humour.... Buchan like other gay artists in Canada appears hesitant to be identified with any gay liberation movement as if it would somehow simplify or too easily categorise his work. On the other hand as current examples of gay culture (a gay critique of such artists is long overdue) such focus need not be downplayed. Needless to say the gay struggle continues even if the artists can survive and succeed in a straight society." Robertson, Clive, "Casual But Continuous", *Fuse*, vol 4, no 3, March 1980, p 169. Robertson is reviewing Buchan's *Modern Fashions* catalogue to his 1979 Glenbow Museum exhibition.

54 Monk, Philip, "Editorials: General Idea and the Myth of Inhabitation", *Parachute*, no 33, December 1983–February 1984, p 22. Reprinted in Monk, Philip, *Struggles with the Image*, Toronto: YYZ Books, 1988, p 170.

55 Barthes, Roland, *S/Z*, Richard Miller trans, New York: Hill and Wang, 1974, p 77. That General Idea were aware of *S/Z*, even as inspiration perhaps for the title *S/HE*, is evident by their inventive plagiarising of Balzac's story "Sarrasine", the subject of Barthes' *S/Z*, in their "New York Gossip", *FILE*, vol 3, no 2, spring 1976, pp 18–31. Non-decidability pertains in *S/Z* to the confusion of sexual identity of what turns out in "Sarrasine" to be a castrato.

56 Although pursuing somewhat different concerns, this Toronto work would ally itself to work by Mary Kelley, Victor Burgin, and others in London, but would not be recognised in any way in New York's New Museum's 1985 exhibition Difference: On Representation and Sexuality.

57 Could this work be looked at, as well, as unpacking the image-text relationship of advertising?

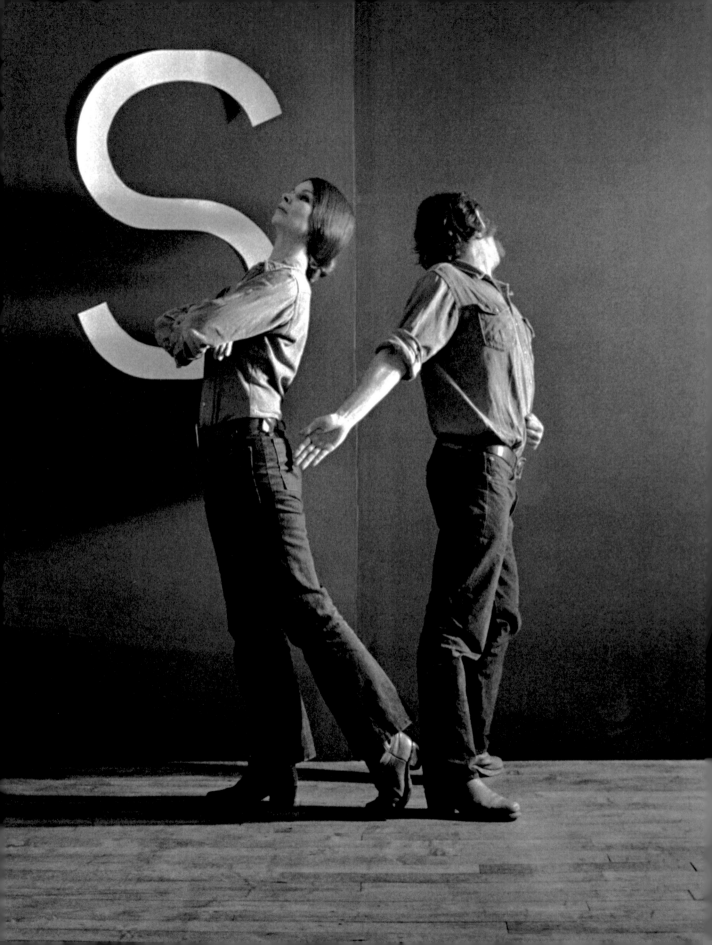

A Fashion for Politics

OPPOSITE
Carole Condé and Karl Beveridge,
Art is Political, 1975 (detail)

Carole Condé and Karl Beveridge, *It's Still Privileged Art*, 1976 (front cover)

Talking about her arrival in Toronto in 1977 in an early 1978 interview, Susan Britton said, "After my experience at NSCAD (Nova Scotia College of Art and Design), with Art & Language being there, *The Fox* being there, and talking for months about politics, and having the school divided into factions, it was a surprise to come to Toronto and find no one interested."[1] NSCAD had direct access to New York City's conceptual artists, and the mid-1970s was the moment conceptual art had become politicised. Would it take importing Art & Language and *The Fox* to Toronto, too, to make it political and to divide the city into factions as well? In a sense, yes.

One can trace this beginning to the exhibition It's Still Privileged Art, which opened at the Art Gallery of Ontario the beginning of 1976. The exhibition was a collaboration between Canadian artists Carole Condé and Karl Beveridge, who had lived as a couple in New York since 1969, having followed there in the footsteps of Canada's other famous art couple, Joyce Wieland and Michael Snow. Beveridge was making work that "focuses on possible shifts in perception brought about by exclusively logical matters" while Condé was making work that "consistently attempts to map 'materiality' onto specific acts of perception".[2] Beveridge showed his work at the Carmen Lamanna Gallery and Condé at the Pollock Gallery in Toronto. They exhibited to acclaim but had no gallery in New York. The phenomenologically-oriented, socially withdrawn, and internalised art discourse of their work was criticised though. "But *art about art*, pure art without real content, without social relations or a social ideology *is bullshit.*" This criticism, however, was self-critique: "That's one reason we stopped doing the work we were doing. We mistakenly believed that it was 'objective', that it transcended ideology, that it existed in the world as a thing in itself. On the contrary it reproduced the status quo, and thus it was politically reactionary." How did Condé and Beveridge so

quickly transcend the "art is art, politics is politics" divide to reject their own work so?

It's Still Privileged Art tells the story. Actually, the artists are the ones who tell it since the exhibition was in two parts, the installation and an accompanying catalogue. The catalogue, a pamphlet really, was written and produced by the artists as a collective effort. It was modelled, they say, on Chinese Maoist comic books. It, too, was in two parts: each spread had a text page faced by a captioned cartoon. The pamphlet was a division of labour even if the conclusions were hammered out together. The text was written from a woman's perspective, and as the writer identifies as "intellectual", calling the other "practical", we assume that Carole wrote the text and Karl drew the cartoons.[3] This is not inconsequential to what, in the end, is interesting about the pamphlet. But as the pamphlet is in part a cartoon, and a Maoist influenced one at that, we expect some simplification and rhetorical sloganeering. It was the season of popularity of the Red Guards, after all.

The pamphlet opens with a question of their collaborative work in the exhibition: "What can we claim for our present work? It's a start—the first work we've made as a concrete response to the desperate situation in which we as artists find ourselves. Whether what we're doing is an adequate response.... I don't know. We'll have to wait and see. *The answer will depend on how people participate and involve themselves*, not on how history will judge in retrospect." What "desperate situation" they faced as artists we will leave for the moment, but in retrospect history has judged: people did not participate, taking participation in the sense of an answer to the artists' call to political action. In the exhibition, people were met by plenty of sloganeering and an inelegant installation that the artists said was based on El Lissitsky's design for the Soviet pavilion at the 1929 Paris Expo, though he might beg to differ. The aggressive poster, based on the Soviet artist as well, hinted at what was to come: the two artists' angry faces merge to collectively shout "why do we police ourselves through our culture". Inside the AGO, stencilled banners—"that might have looked more at home outside than in", Eric Cameron wrote—wrapped the space and read (in hectoring all caps): "art is basically a function of the class in power"; "culture has replaced brutality as a means of maintaining the status quo"; "artists are one of the instruments of oppression"; "to attack institutions is to attack ourselves"; "art must become responsible for its politics". This Red Guard agitation was hardly ingratiating to gallery-goers or the gallery's trustees! Or to reviewers.

Critical response was neither petit-bourgeois incomprehension nor simple class resistance. Walter Klepac, for instance, knew what was at stake. "The single most important insight contained in the recent show is the couple's recognition of the fact that when an individual begins to

Carole Condé and Karl Beveridge, It's Still Privileged Art exhibition, 1976 (poster)

take personal responsibility for the meaning and implications of his or her cultural acts that person is inevitably led to an examination of the political character of society as a whole." Klepac, though, takes up the common complaint that "there seems, however, to be a dull earnestness about the present exhibition which severely undermines the vigorous and tough-minded critical re-evaluation it otherwise might have stimulated in viewers." But maybe critics only wanted to maintain their own comfortable positions by pointing out the comfortable contradictions of the artists. "The fact that the single most frequent sight in the exhibition is that of the two artists sitting in their comfortable loft talking to themselves might well arouse the suspicion that their exercise in self-criticism has not really extended beyond the confines of their relatively insulated existence within the inbred art circles of SoHo. Their avowed intention to develop 'an art practice that successively embeds itself in an expanding social consciousness' seems, by all indications, to have short-circuited into a form of entrenched narcissism."[4]

On the other hand, a partially sympathetic Eric Cameron (who taught at NSCAD in those years) recognised the perplexing problem of the intertwining of the personal and the political in artists' lives. "What concerns them most is not so much that [ie, their impotence] may be brought out of their radical intentions by the hypocritical acclaim of the establishment, rather that the manner and mode of the act of revolt itself may epitomize and endorse the object of their attack"—as when one of the banners reads "institutions enjoy criticism as long as it doesn't threaten their basic structure". (But for Condé and Beveridge self-critique had to be institutional critique at the same time: "It is our internalization of these institutions, as 'personal' ways of living and producing which must be attacked", the pamphlet says.) Cameron worries, "And again, could it be that, in introverting the revolution, they are doing the very thing that will, at each end, weaken the impact of what they are doing sufficiently to make it acceptable to those very institutions they are supposed to be attacking?" Introverting the revolution by projecting the personal was the issue. "Worst of all, is all their political posturing in fact just a way of solving personal problems and of extroverting the aggressions that develop in their private life?"[5]

Indeed, "the two artists sitting in their comfortable loft talking to themselves" was a common motif of the exhibition and cartoon pamphlet. And even though the rhetoric of the banners came out of those discussions, while seeming divorced from them; and even though the pamphlet relates the story of how the artists got to the position of this exhibition and ends with those same slogans, something else is revealed in Condé's narrative. The same language on the walls of the gallery and in the pages of the pamphlet had different effects. How 'reasonable' the pamphlet now sounds, yet how strident the same words were meant to

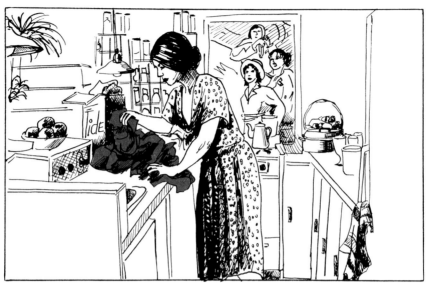

Cleaning house has to be completed before Carole goes to the studio. The studio should come first, after all a 'woman of vision' shouldn't be laden with practical concerns. But the real world stands in the way.

Karl sets up a new variation within a series of work which has preoccupied him for the past year. The work focuses on possible shifts in perception brought about by exclusively logical means.

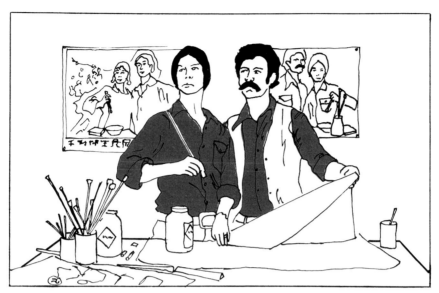

The poster on which it is based depicts two artists concerned with a social practice rather than 'self-expression'. We use ourselves as subjects to make the work specific, rather than abstract, or universal.

The poster seems a bit pretentious, too radical chic. In our society it becomes another consumer item. It was made for a post revolutionary society, and cannot account for the complex problems which we face.

Carole Condé and Karl Beveridge, *It's Still Privileged Art*, 1976 (selected pages)

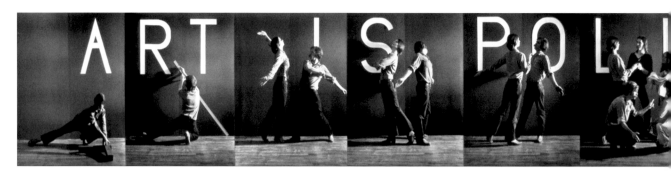

Carole Condé and Karl Beveridge, *Art is Political*, 1975,
silver gelatin prints, series of 9, each 50.8 x 40.6 cm

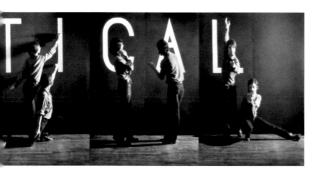

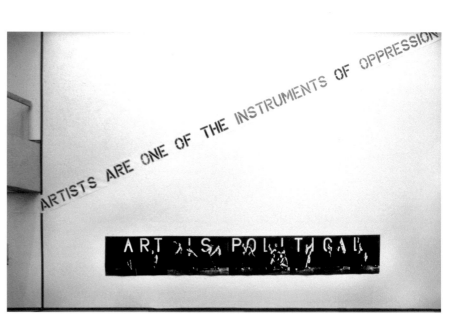

Carole Condé and Karl Beveridge, installation view
of It's Still Privileged Art, 1976

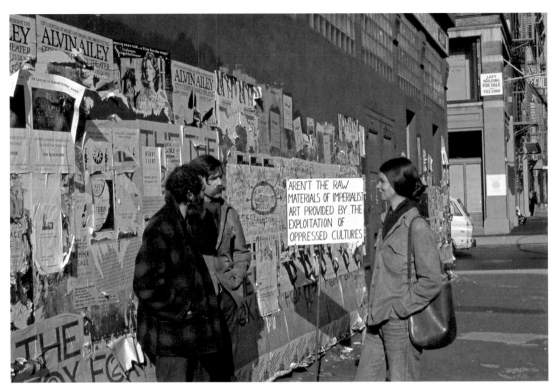

Carole Condé and Karl Beveridge, *Signs (Soho)*, 1975, C print

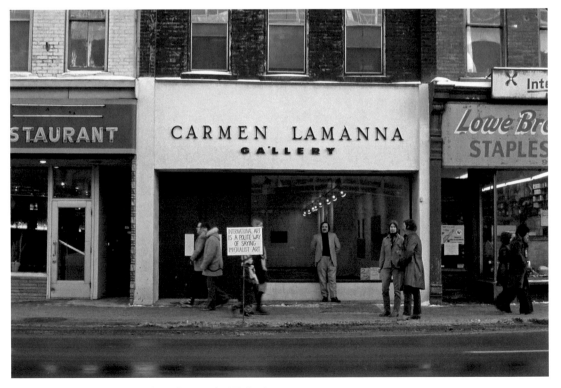

Carole Condé and Karl Beveridge, *Signs (Lamanna)*, 1975, C print

be when scrawled across a screenprint: "Why does the woman do the laundry and cooking?" "Why does the man rule the house?" This is in part because a lesson has been absorbed. In the end, a feminist analysis had result; the class analysis did not. Feminism changed the art world; politics only divided local scenes.

It's Still Privileged Art evolved out of conversations Condé and Beveridge had with each other since 1973, but specifically derived from their taped conversations from the summer and autumn of 1975. The latter coincided with their involvement with Art & Language (New York) and *The Fox* magazine.[6] Their political position was collectively elaborated within these associations and other radical groups including the Ad Hoc Women Artists' Committee, Artists Meeting for Cultural Change, and Anti-Imperialist Cultural Union.

You have to imagine the times and the difficulties for American artists, more particularly New York artists. The 1973 oil embargo whacked the American economy. Then in response to a bailout of bankrupt New York City, President Ford was reported to have said: "Ford to City: Drop Dead" (30 October 1975, *New York Daily News*). It was not what one expected of the triumphant progress of American art when collecting collapsed. Is it any wonder then, with their diminished expectations, that New York artists were in a punkish mood? It was a situation arch conceptualist Joseph Kosuth described as "really stagnant, really dead".[7] Is it any wonder then that New York artists abandoned the logical positivist model of the progress of art, which was meant to favour them as inheritors of a privileged system, for another determinist model—Marxism—and turned it against the capitalist system that had betrayed them? And what of Canadian artists who came to New York to fulfil their American dream, would they not, too, feel doubly betrayed?[8]

Condé and Beveridge joined *The Fox* as of issue number two and were an active part of its discussions and dissolution. When *The Fox* dissolved after its third issue as a result of expulsions, rancour, and political factionalism, some of the original Art & Language (NY) editors (by then Provisional Art & Language to mark an earlier schism) joined Condé and Beveridge to start up *Red-Herring*. But soon, as a result of the general disillusion political factionalism breeds, or as a wake-up call to the massive contradictions of their lives in relation to their political beliefs, nearly all the editorial board wandered away, left art, or returned to their home countries to take up social practices. When Condé and Beveridge joined the exodus and moved back to Toronto at the end of 1977 they brought the history— or baggage—of Art & Language, *The Fox*, and *Red-Herring* with them. Before they arrived they sent an advance party in the form of an exhibition at Toronto's Carmen Lamanna Gallery. The language of their work and the language of their dissent had evolved to match that of *Red-Herring*. They were now Marxist-Leninists committed to the proletarian cause.

The Fox, vols 1–3, 1975–1976

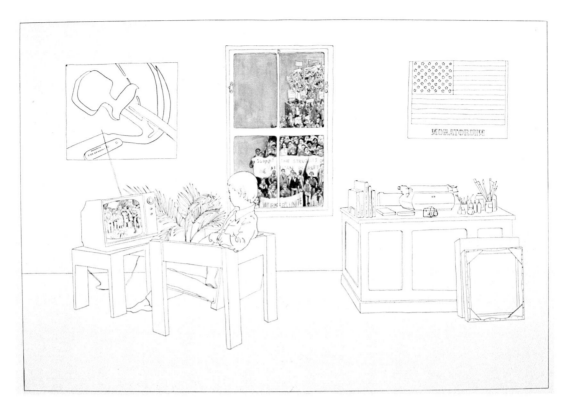

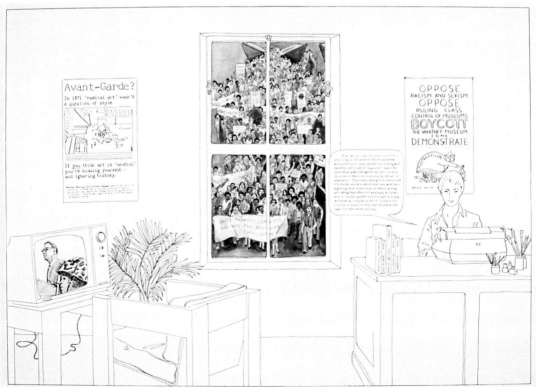

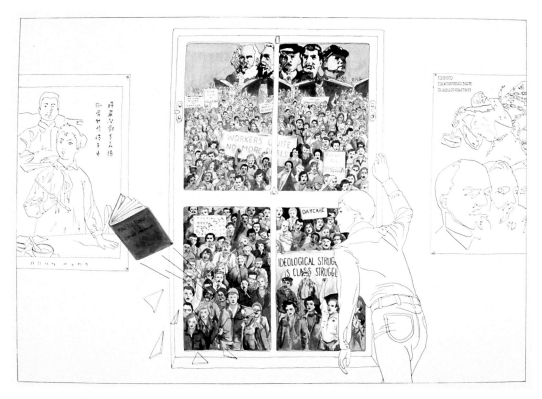

Carole Condé and Karl Beveridge,
The Window: one; *The Window: two*;
The Window: three, 1977

They had no natural community in Toronto, and some of their comments printed in *It's Still Privileged Art* may have rankled those 'provincial' artists who had remained in the city: "It's amazing how well places like Toronto reproduce the New York art community.... *Imperialist art is packaged in the wrapping of 'advanced' and 'free' expression, it is embodied in the very work itself.* How can we reject and refuse it without being called half-witted amateurs, or amusing but quaint provincials?... Would we have gained the same 'understanding' of the art market and its effects on art practice had we remained in Toronto?" The issue had always been the insularity of the debate, which was as well the insularity of the art community. It was even more so in Toronto, where this discussion seemed one more imperial import. If Toronto artists were ready to recognise the class character of their art, they were not ready yet to transform their practice into adherence to the proletarian cause.

At the time of It's Still Privileged Art, Condé and Beveridge said, "We can't escape the contradictions in any situation. *What we can do is exploit our own compromises.* Being in New York is one of them. We can use that for a time, until it becomes unproductive, or the situation in New York becomes impossible." Obviously the situation became impossible if Condé and Beveridge left New York, but that did not mean that the artists did not import the tail end of those debates—and compromises—to Toronto when they returned. Or maybe it was their logical conclusion: placing the ends of art at the service of the proletarian class struggle. "Suffice it to say that the proletariat represents our future interests", states a text work in their June 1977 exhibition at the Carmen Lamanna Gallery. But why make this statement by continuing to show in an art gallery? "Why do we consider addressing the petty bourgeiosie [sic] as such a limited aim? The petty bourgeiosie [sic] cannot be a class for itself, but must ally itself with, learn from, and work in the interests of the proletariat.... It has been in confronting our own contradictions, such as showing in this gallery, among others, that we recognize the need to unite with the proletariat. How do you unite with, and work in the interests of the proletariat? Bluntly, work in the organisations of the proletariat."

So the exhibition was a bit of bluntly imagining that working relationship at the same time as arguing artists out of their complacency and into the workers' struggle. "So what can we do about it?" asks one of the cartoon characters beneath a collaged image: "Individually, not much. Some people, especially 'creative' artist types, run around looking for 'alternatives'. But the only real alternative lies with the masses themselves, and the science which is based on their lives and struggles throughout history—scientific socialism." A three-part cartoon makes this argument without the need of words. An artist watches the revolution on television while it is being enacted outside her window. When a red book by Mao titled *Combat Liberalism* breaks through the window, the call is clear:

quit your insulated life with its mere signifiers of radicality (the interior decoration of Russian and Chinese communist posters and Warhol's contemporaneous hammer and sickle paintings) and get out into the street and join the revolution. One wonders, though, what role artists were to serve except to lend their manual talents to visually reproduce the socialist-realist clichés of communist art: the masses marching with their banners under the watchful authority of Marx, Engels, Lenin, Stalin, and Mao.

It was also out of the studio and into the factory with a lesson in class taught through cartoon-captioned collages of assembly lines and workers on the line fighting for their rights. But at times it seemed a cartoon idea of the working class, too. *Who* were Condé and Beveridge talking to in the Carmen Lamanna Gallery? Or talking *down* to. After the capitalists build their palaces to culture, one caption reads, "they invite the masses to share it with them. But, once again, the masses, who quite rightly can't make head nor tail of that stuff, are reminded of their class oppression, which beneficent capitalists dismiss as their lack of sophistication." It seems artists were in solidarity with bosses here.

In divesting themselves of their privileged status, artists were to abandon their 'personalism', too. So doing allowed them permission to shame by name the personalism of others in the manner of a Red Guard 'struggle session' as it was known during the Chinese Cultural Revolution. Already in their *It's Still Privileged Art* pamphlet, the artists had written, "In the Toronto museums and galleries one is less aware of the socio-economic and political underpinnings than in New York. Things that happen at Carmen Lamanna's or at the Art Gallery of Ontario seem to be more about personalities than political structures."[9] So as if a dazibao (big character) poster for the public humiliation of Carmen Lamanna, in whose gallery they were showing this work, one text denounced the artists' dealer. Lamanna was not being decried as a class enemy or capitalist roader but simply as deluded representative of an outmoded form of production, "entrenched in the petty bourgeois ideology of the small independent producer" that monopoly capitalism had already supplanted. "His opposition is regressive and futile for it flys [sic] in the face of reality. It has a certain romantic appeal, granted, but it obscures history. It ignores the socialization process—wherein artists, for example, are increasingly pushed to collectivize their interests, eg, C. A. R. [Canadian Artists' Representation], the parallel galleries etc— on the one hand, and the increasing repression on the other, inherent in the trend to state monopoly capitalism (fascism)." The text concludes, "Why this harsh analysis of Lamanna? 'Just to bite the hand that feeds us?' No, Lamanna pumps out propaganda, reactionary propaganda. This is also a piece of propaganda. But propaganda is not the issue. The question is, whose class interests does it serve?"

Over the ten or so years we have been associated with Lamanna, we hardly know him, nobody really does. We each have our own theories, but no one knows what really motiviates him, or what his ambitions are. That he is honest and sincere within his own limited framework, we don't deny, but there is more to Lamanna than the conspicuous development of his 'personality'. For all his emphasis on the 'individual' and his fight for the subjective 'perogatives' of their art, Lamanna typifies an objective process, which perhaps more than any other art dealer, speaks to present day reality.

The contemporary art dealer is a product of capitalism. They function as one of the mediators between the artist as a producer and the anarchistic market of bourgeios society. As monopoly capitalism developed out of competitive capitalism, the role of the art dealer changed little, remaining entrenched in the petty bourgeios ideology of the small independent producer. True the character of the market changed, especially in its international—imperialist aspects, but the relation between the artist and the dealer remained ideologically intact—if somewhat more business-like.

Art, as a form of consciousness, is an ideological weapon—it is a form of propaganda. High cultural production reinforces the ideology of competitive capitalism, a form of capitalism long superceded in all other sectors of society. Although it serves the interests of petty bourgeios ideology well, those interests are no longer sufficient to monopoly capitalism's political needs. High culture, bluntly, can no longer be left to its own devices. As the contradictions of monopoly capitalism intensify, there is an essential need for monopoly capitalists to bring high cultural production under control. Monopoly capitalists increase their control through the apparatus of the state, which serves the dual purpose of making it appear that this control is a process of 'democratization', while increasingly forcing the working class to foot the bill (taxes) for this process.

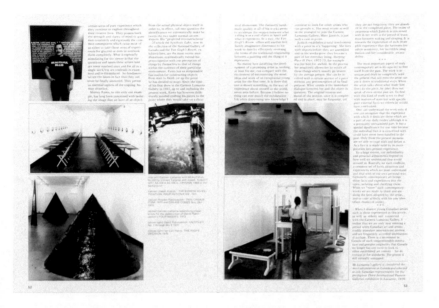

Carole Condé and Karl Beveridge, *Carmen Lamanna*, 1977,
photostat and collage, diptych, each 76.2 x 50.8 cm

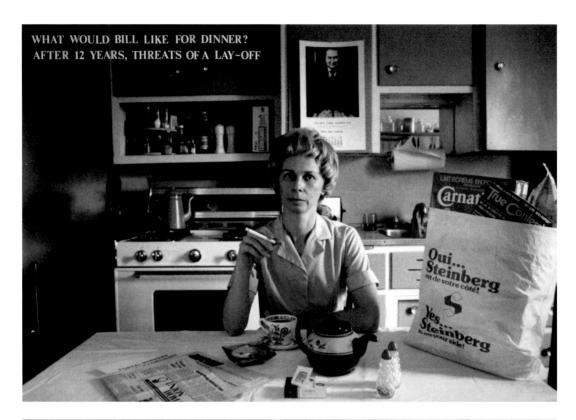

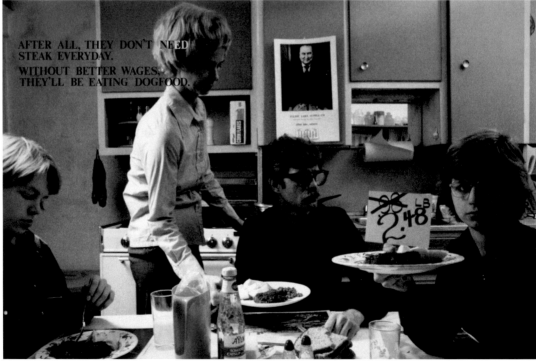

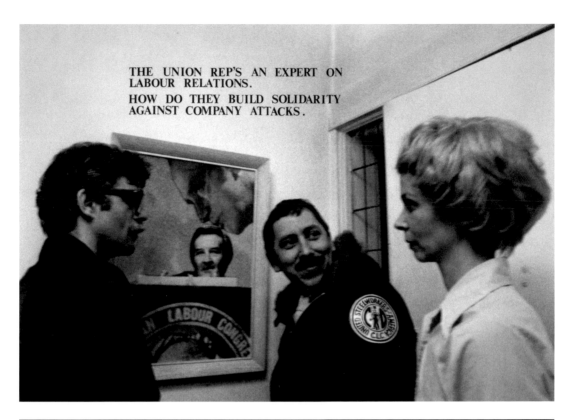

Carole Condé and Karl Beveridge, *Maybe Wendy's Right*, 1979,
C prints, series of 17, each 21.6 x 33 cm

But in a sense propaganda was the issue. Allegiance to the working class was not acted out in the streets or union halls but argued in a theatre of sorts. It was within this representational theatre rather than in agitation on the factory floor that "Real opposition must recognize the class character and social nature of cultural production." This theatre had its own rhetoric and recognised language, with warring protagonists and an audience looking on. Its representations were meant to have effects and lead to action: getting artists out of the gallery and into class struggle. In the end, these effects would be felt, not politically, but factionally in the various personalisms of the Toronto art scene.

Condé and Beveridge decided to have one more go at the petit-bourgeois Carmen Lamanna Gallery in spring 1979 before purging their history there and absolving themselves of this contradiction. They were on their way to evolving a new strategy of worker affiliation and it began to be articulated here, even though their representational theatre was even more apparent than before. The 17-part photo series *Maybe Wendy's Right* was a photonovel about a typical working class family's dilemma over a potential strike. With all the financial worry of a strike, maybe daughter Wendy is right that what's really at stake is socialism. The narrative's *mise-en-scène* is scripted, staged, and photographed within the set of a family home, with the Condé-Beveridge family playing the protagonists. Although the photographs lend the story an aura of reality, the shallow box of the image is no less a stage—or cartoon—than pictured in *It's Still Privileged Art*. This image, too, is constructed—yet the reality effect of its fiction must now be maintained; it only breaks frame once when at the kitchen dinner table daughter Wendy presents a plate of beef with its price tag to the camera. Fictionally self-contained, the work must implicitly acknowledge the imaginary fourth wall between it and the spectator and can no longer rhetorically refer to its gallery context or engage in a diatribe against the art world.

Two Toronto reviewers objected to this representational apparatus: one to its content, the other to its form. Tim Guest (ex-Trotskyite youth, contributor to *The Body Politic*, and Art Metropole employee) disliked the combination of "naive politics and bad art" and wondered with its "very obvious message" whether he "wasn't catching the irony behind the dumb allegory. But a careful reading proved there was nothing written between the lines." He complained that the exhibition was "self-conscious propaganda taken from an over-specialized and isolated rhetoric, and here, socialist realism and the fake spirit of 'proletarian culture' is too close for comfort." Basically, there were two problems: "First of all, this cut-and-dried narrative is an attempt to expose the basic daily contradictions of a working class family, but with the incredible omission that the structure of the nuclear family itself is never drawn into question. Secondly, although Condé and Beveridge try hard to personalize their figures, to the extent

of casting themselves in the leading roles (stretch wig, etc), they are never more than cartoon people with cartoon problems. And this reflects, not so much on the contradictions of capitalism, as on the failure of the Left to address those contradictions effectively, in human terms."[10]

At the time, I criticised the artists' conventional notion of representation conceived in its dual aesthetico-political signification. I claimed Condé and Beveridge's images did not have "the force of rhetoric of what Brecht called the social gest.... Failure to find the appropriate gestures for our situation, gestures that inscribe their meaning within them, is part of the defensiveness of this work. Its failure to relate gesture to public desire is what keeps the work within the limits of representation. While there is no social gest within the work, there is also no ambiguity within the images. The composition of signs point to one meaning only: representation as one meaning." One meaning visually was also uni-directional historically, reflecting the belief that the party apparatus ought to lead the masses' desires to a pre-determined historical end.[11]

Had Amerigo Marras not been in exile in New York City in 1979 he probably would have visited Condé and Beveridge's Carmen Lamanna exhibition as he had their It's Still Privileged Art at the AGO. After all, Marras and Condé and Beveridge were in agreement on the role of artists as instruments of capitalist oppression. But as Condé and Beveridge abandoned their rhetoric and moved forward eventually to embrace working with unions, Marras seemed to have regressed to where they polemically began. CEAC's demise is the story of this regression.

For those who remember it, the history of the Centre for Experimental Art and Communication sometimes is more myth than reality. Without the continuity of real estate, it is hard to maintain a history, and when CEAC lost both its funding and its building in 1978 its history seemed to vanish with it. For many then not on the scene, CEAC is a blank. A while back when amnesia had already set in, Dot Tuer tried to recover this history in her monumental archival research article, "The CEAC was Banned in Canada", published in C Magazine in 1986.[12] But there has been nothing else published since. For others, though, it's hard to forget the story of how an ambitious, tightly controlled and guarded artist-run centre amassed its own building, declared a radical political programme, and advocated knee-capping Red Brigade-style before its final debacle and closure.

Given what we know of the outcome, how did CEAC and Marras become so militant? A July 1975 letter to the editors of The Fox soliciting "an exchange of information on experimental art" established what the Kensington Arts Association, CEAC's predecessor, was at that date: "Our activity extends to exploration/shows in Language mechanics, Environmental Systems, Technology. The new K. A. A. building, to be opened next Fall, will be the physical centre for such explorative activity."[13] Such exploration hardly was revolutionary. Yet, later in 1977 Marras

Art Communication Edition 4, March 1977 (back cover)

claimed of those early days that, "What is currently known as Art &
Communication group was founded in Toronto in 1970 by Suber Corley,
Amerigo Marras and Jerald Moldenhauer. Its first initiatives, through
the publication *The Body Politic*, were clearly negativist and neo-Marxist
in ideology and were implemented within a larger militant collective
working towards a praxis of liberation: feminism, gay liberation, children's
liberation, anti-psychiatry, anti-ageism, and radical design."[14] By the time
CEAC published "Four Leading Questions as Principles of Revolutionary
Practice" in the January 1977 issue of *Art Communication Edition* it was
clear that its members really were dialectical materialists and Marxists
ideologues since the question "What is Art and Communication?" was
answered with:

> It is interface impact conducive within social forms as frames, structures,
> behaviour. Art as materialist practice and communication as dialectics
> in juxtaposition along contextual layerings produce revolutionary
> effects. Art & Communication is basically this: dialectical materialism
> practiced as ideology.[15]

What intervened between Marras' letter to *The Fox* and *Art Communication
Edition* 2? One was *The Fox* itself; another probably was Condé and
Beveridge's It's Still Privileged Art exhibition; the third was the discovery of
the pamphlet *Art as a Contextual Art* by Polish artist Jan Świdziński. The
discovery of this pamphlet was the stimulus for the Contextual Art seminars
held in the new CEAC building in November 1976. The second issue of *Art
Communication Edition* reported the event:

Jan Świdziński, *Art as a Contextual
Art*, 1976 (front cover)

> The November seminars of contextual art in Toronto were intended
> as confrontations among Art Sociolog. Collective, Jan Świdziński,
> (Provisional) Art and Language, Joseph Kosuth and Sarah Charlesworth,
> and some Toronto 'workers' involved in the theory and praxis of
> a contextual nature. The task was to find the commonalites and
> divergences among the parties, as a process of initiating a dialectical
> communication among these groups sharing similar elaborations of
> socio-political practice.
> Individual hostility (recent splits between (Provisional) Art &
> Language and Kosuth and Sarah Charlesworth, and further splits
> within (Provisional) Art & Language), New York cultural and economic
> domination, and the formalization of the (any) seminar situation
> did not help to bring about in depth exploration of the supposed
> commonality of the parties involved.[16]

In fact, the seminar was a fiasco. It was a little disingenuous for CEAC/
Marras to report the hostilities (the notice is anonymous) since Marras set

art communication edition

15 duncan st toronto

ACE (ART COMMUNICATION EDITION) PRODUCED MONTHLY.
SUBSCRIPTIONS AT $5.00 PER YEAR
CHEQUES PAYABLE TO KENSINGTON ARTS ASSOC.
 15 DUNCAN ST.
 TORONTO, ONT.
 368-4933.

Art Communication Edition 2, January 1977 (back cover)

up the confrontation in the first place: not the "intended confrontation" as dialogue, dialectical or otherwise, but the confrontational set up. The event met none of the speakers' expectations. Both Kosuth and Charlesworth were surprised that they had been given a couple days notice to present on Świdziński's formulations on Contextual art (which they knew nothing about and that were already dated, formalistic, and spoke from another context), not on their own positions. The New York artists refused to take any position, period. Although seemingly set up to advocate for Świdziński's views, the seminar saw his position demolished immediately. Speaking through a translator did not help Świdziński. Hervé Fischer of the Paris-based Collectif Art Sociologique, whose previous invitation to CEAC a year before had been cancelled, was equally frustrated. After an initial presentation of his group's sociological practice (which he delivered wearing a white pharmacist's coat), Fischer refused to participate for the rest of the first day offering an explanation that he declined to have translated: "*Je voudrais dire quelque mots en français pour signaler mon refus de parler dans un contexte impossible, américain. Peut-être dirai-je quelque chose sur ce contexte la prochaine fois.*"[17] Perhaps he was speaking more to the rudderless direction than the automatic fallback to focus on the American art star Kosuth, who nonetheless refused the attention. As host, a defensive and sometimes hostile Marras made no attempt to moderate the discussion. Meanwhile (Provisional) Art & Language, or at least a schism from it, preferred to sit on the floor with the audience rather than on the panel and made no contribution. And the Toronto 'workers' Marras referred to had an affinity for the discussion but no real language to deal it with. Marras (who had emigrated to Canada from Italy around the turn of the decade) agreed with Fischer saying, "I can only answer that I support his idea, that Canadians are not prepared yet for European ideas."[18]

At the beginning of the day Fischer had admitted "that I consider this seminar as something very interesting and maybe important, even if the differences between us seem very big, because it is the first time that people working in Europe, East and West Europe, and in North America, come together to discuss the possibility of using art as a way of changing society." Unfortunately, it was a wasted opportunity, and it is hard to believe, reading the transcript, that any of the participants would talk to each other again.[19] Nevertheless, Marras mythologised the event and it was parlayed into a series of seminars in Europe a half year later.[20] "It is not our intention to presume as conclusive any discussion on 'contextual art' (the premises for which were laid down in the seminars at the CEAC in Toronto during November 1976)", he then exaggeratedly stated—in front of Fischer and Świdziński no less—in the first of these at Fischer's École Sociologique Interrogative in Paris on 10–13 May 1977.[21] Judging from brief notes kept by one of the Toronto contingent,

discussion was productive and the sessions issued in the memorandum, "Third Front Common Statement", published in *Art Communication Edition* 6, July 1977.[22] "The Third Front is one strategy to offset the 'capitalist division of labour in the art market'." It proposed "to develop a socially based practice through which artists can provide a critical contribution in a social transformation towards an autogestive power base". And if the aim was to "begin an international network of communication for people of like aims", one of its key decisions was "to oppose the international art controlled from New York". Marras had managed to forge an alliance that by-passed the imperial art centre, even as he was trying to rent an office in New York as a CEAC branch. But how long would this united front last?

In its Toronto headquarters, CEAC itself united a number of activities. Aside from the fact that it was funded to be an artist-run centre and ran a programme of varied activities, notably of a non-exhibition sort (video and film screenings, performance series, talks), its real aims, as guided by Marras, were ideological.[23] Let's remind ourselves of what was stated in "Four Leading Questions as Principles of Revolutionary Practice" that "Art & Communication is basically this: dialectical materialism practiced as ideology". As this spectrum of activities was no dialectical unity, different interests led at any particular moment. Three strands predominated: contextualism, behaviour, and pedagogy. We have to reconstruct these activities through fragmentary archival documents, so our understanding is incomplete, but we can complement them with issues of *Art Communication Edition* where we can read CEAC's evolving ideological programme. It would be too neat a formula if contextualism, behaviour, and pedagogy were an unfolding dialectic of theory, practice, and teaching respectively, so we will look at each individually.

Contextualism: Contextualism was the invention of Polish artist Jan Świdziński and was marked by the situation of an isolated socialist Poland on the periphery of the New York dominated art market. Canada shared a similar peripheral position vis-à-vis New York but differed in being fully embedded in a continental corporate capitalism, though in colonial subservience to the United States. What attracted Marras to contextualism and what sustained his interest in the end are perhaps two different things, but he maintained his relationship with Świdziński and never turned against him as he did so many others whom he had originally embraced as ideological comrades. What was the affinity? According to Świdziński, contextual art placed itself outside art history and opposed conceptual art as the latest phase of stylistic modernism. It was neither an aesthetic system nor a formal system of logic but rather a system of meaning pragmatically applied and understood in actual contexts. Its statements were intentional: contextual art dealt with "assertions, statements expressed with conviction". Not just linguistic it

was, as well, "a social practice. Theoretical generalisations do not interest it."[24] Importantly, contextual artists "do not belong in the Art World and... are not under the pressures of the Art Business."[25]

Looking back sometime in 1978 Marras wrote, "The terms 'contextual', 'contextual', and 'contextual art' have been used independently in Canada and Poland in reference to different notions of art. In the Canadian situation, there were two positions that investigated the parameters of 'contextual art', the first involved the mechanisms of deep structure and language, the second involved the liberation movements (feminism, gay liberation, self-design and ultra-left). Now we view the problems in a different perspective."[26] Not only a difference of perspective, was contextualism and contexturalism a mere coincidence of terminology? How parallel yet independent were they given that Marras said they referred to different notions of art?

As for his "language mechanics" and Świdziński's system of meaning, we have to understand their association through Marras' later explanations of his "contextural-quantitative experiments" with language.[27] In the end, Marras equated his quantitative approach—whatever that means—with contextualism through the precedence of contexturalism. "The quantitative approach I proposed indicated the possibility of going from one system to another by using contextual outlines or structures that formed multiple reference systems or empty frames."[28] What perhaps attracted Marras to Świdziński's theory of meaning is its degree of generalisation by which he could flatter himself that by some coincidence of models—or of "empty frames"—he, too, was participating in a scientific discourse. Yet Świdziński's fixation as late as 1976–1977 on critiquing an outmoded form of conceptual art—and in particular Kosuth's 1969 notion of art as an analytical proposition which had long been rejected, by Kosuth himself moreover—only showed the isolated position of Polish art.

Yet, it may have been Świdziński's notion of pragmatics that gave Marras the lever to ascend from one empty frame to another. Certainly the notion of pragmatic contexts enabled Marras to link his own disengaged linguistic model to the social field. Already we begin to see this turn to pragmatic engagement in "Four Leading Questions as Principles of Revolutionary Practice" where, nonetheless, it is so obscurely and abstractly expressed that we wonder about its connection to anything real at all. Pragmatic reality is defined as an "interface impact conducive within social forms as frames, structures, behaviour... [whose] contextual layerings produce revolutionary effects".

In Marras' mind, contexturalism's 'r' set a precedent. That one letter absorbed the whole concept of contextualism and put CEAC on a par with Świdziński.[29] But in 1978 the issue was getting the 'r' of contexturalism and revolution back into contextualism. Świdziński's

contextualism had served its purpose. Through it CEAC could feel that the collective was participating in an international art discourse even from the sidelines of Canada. But it was time to disagree with Świdziński for whom contextualism was still an art practice. Or perhaps it was Marras' willful misreading of the logic of Świdziński's texts, as he admits that "Świdziński's text is still remarkable in so far as he investigates the logic or the principles of contradictions." Admittedly, Świdziński rejected conceptual art and all stylistic predecessors, but he was still an artist and believed in the discipline, though not in aesthetics or the art market. So while seeming to follow the historical trajectory of Świdziński's analysis, Marras ultimately contradicts him when he concludes, "The enunciation of the contextual paradigm is a rejection of 'art' in a long range analysis of the criticism of previous models of art and their ineffectual practice. Art is not capable of going beyond its own tautology and therefore becomes obsolete in the contemporary reality. I tend now to distrust all associations with the art world, indeed with 'art'."[30]

Behaviour: "Behaviour" was a banner word. This word, which was once spread across two pages of *Art Communication Edition* 4, was a dominating concept guiding CEAC's activities. "Where is art & communication's area of action?—It locates itself anywhere within intentional perimeters to affect the cultural neighbourhood outside itself. It is dependent on manifestation of itself. Itself being a context out of content back into context, that is ideological praxis back into social praxis or vice versa. Analysis and behaviour are the directing forces."[31] Analysis and behaviour were the directing forces. Behaviour was basic. Behaviour was interface. Interface was posited analytically and actuated behaviourally through intentional interventions in neighbouring contexts—that is to say as provocations. Contextualism and behaviour always went together, one as the articulation of CEAC's ideological programme ("dialectical materialism practiced as ideology"), the other as its realisation in performance situations.[32] Contextual Evenings, a series of events in New York in February 1977, and CEAC's May–June European tour the same year were a laboratory of its effects. This behavioural laboratory catalysed "the acceleration of a repressed behavioral response within a given group"—a condition of which was that it be a "confrontation with an unaware group".[33] As with laboratories these were closed experimental environments, where outcomes sometimes were volatile. Yet, in spite of CEAC's rhetoric, 'intentional perimeters' were still the art system, however, and 'neighbouring contexts' were still the international art world.

Its programming reveals CEAC's dominant interest in behaviour, whether it was the "Body Art" series of January 1976; the "Bound Bent & Determined: A Look at Sado-Masochism" events of April 1976; or the behavioural performances by resident artist Ron Gillespie and his Shitbandit collective; the dance performances and films by Missing

BEHAVIOR

CONTEXTUAL EVENINGS
IN NEW YORK
P.S.1
FEB. 25 8 PM
ARTISTS SPACE
FEB. 26 9 PM
FRANKLIN FURNACE
FEB. 27 8 PM
d boadway b bolak p dudar
d eagle l eng b eves r gillespie
i harry b kipping a marras
c radigan r shoichet d tipe w wise
ORGANIZED BY THE
C·E·A·C· TORONTO

Art Communication Edition 4,
March 1977

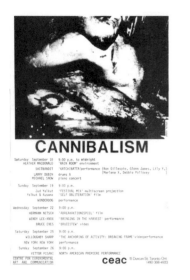

Poster advertising opening of new CEAC
building, 1976

CEAC exhibition, 1976 (poster)

Missing in Action 2, 1979 (page 2)

Associates (perhaps the most coherent practice happening there)[34]; and especially the March 1977 residency of British behavioural performance duo Reindeer Werk (Thom Puckey and Dirk Larsen). Perhaps Reindeer Werk influenced CEAC's performance style; certainly there was an affinity. As Thom Puckey writes, "Our work was pure, non-theatre-based performance art, concerned with extreme non-consequential forms of behaviour, self-referential and self-aggressive, and performed always in front of an audience. The sculptural qualities of the performance itself were amplified and extended through the build-up of physical tension amongst the members of the audience."[35] To a degree this describes CEAC's own confrontational performance style, with the exception that CEAC's was more verbal than physical, however.[36] "All of the performances arise from a collective situation and... exist in the form of the reading of statements which were tailor-made for each situation, often being critical of the surroundings we found ourselves in", tour member Bruce Eves wrote of the European performances, emphasising their linguistic and didactic character.[37]

During the Toronto Contextual Art seminars Marras had stated that Canadians were not yet prepared for European ideas; but were Europeans ready for CEAC? Reaction was often hostile to their performances. In Amsterdam CEAC performed *Which Will Follow,* whose text was a critique of De Appel's supposed orientation to theatre-based performance. "During discussions later in front [De Appel Director] Wies Smals told me she felt we were acting like gods of the art world, talking down to people there." Then in Ferrara, "Some students get up on stage and begin to mimic us. They stand in the corners and one at the microphone on the table takes a beetle and places it upon the microphone and then tried to hit it with a sledge hammer. Amerigo begins to stamp his feet loudly and clap yelling 'Bravo bambino'. More young students join in and they rip the paper with the statements and the questions off the wall, and take it out to the courtyard and burn it in a ritual. We were very excited by the response."[38] One wonders, though, whether the Europeans still were not more sophisticated than these somewhat naive Canadians, especially the Italians who had a developed political culture. After all, these were Italy's 'Years of Lead' brought on by Red Brigade terrorism and moreover the critical moment of Autonomia, whose political debates were much more articulated than the simple questions CEAC proffered. You have to wonder, who wouldn't object to the hectoring didacticism of these performances, some of which were elaborations of CEAC texts, such as "Four Leading Questions", spoken in English and translated into Italian, the basis of the Ferrara performance? Or verbal projectiles aimed at the audience as a series of mundane questions? For instance, "What is the definition of society? What society? What definition? Does society reproduce other bourgeois models? Does a repressive society reproduce repressive social models?" declaimed in Bologna as the performance *(interrog)azione.*[39]

Maybe the bambini were right after all and their spontaneous parody was spot on.

What was the origin of this confrontational interrogation style? Did it derive from the École Sociologique Interrogative, for which the "interrogative and critical function involves not giving the questions and answers"—despite the fact that sociological art's task was "to carry out a questioning and perturbing" of social reality?[40] At the November 1976 Contextual Art seminars, Fischer had said, "I try to discover again the questions under the ready-made answer-system, and to put them in evidence, and never give ourselves the answer. Even the best answers, even the best left-wing answers are ready-made answers."[41] But then again, so are even the best left-wing questions. Or was CEAC inspired by Reindeer Werk and its Behaviour School for the Development of The Third Man, whose members "will exist as behavioural catalysts—non-functioning as 'tutors' or 'students', but existing as questions.... It is not a school for problems or answers, but for questions"? CEAC had a habit of applying other peoples' ideas literally. Reindeer Werk had already written, "We treat individuals as questions rather than as people."[42] CEAC simply followed through this logic to the letter—whatever else it meant to Reindeer Werk. At any rate, CEAC did not wait for answers from its put-upon audience.

Pedagogy: Whatever its influence on CEAC's notions of performance, Reindeer Werk was key to another change of behaviour in CEAC—their attempt to establish a school. Marras concluded his 1977 report on Canadian art published in *TRA* magazine with the announcement that:

> The CEAC-Reindeer Werk collaboration is the first step towards the establishment of an expanded international network of workshops as a free-school system. The major headquarters are based in Toronto, Northern Ireland, London and New York. Most important is the international front being formed between Reindeer Werk, the Polish Contextualists, the École Sociologique Collective of Hervé Fischer in Paris, the WAVE network and the Centre for Experimental Art and Communication in Canada (presently opening their information office in New York) and the 'contextual' series of seminars in Europe and participation to the forthcoming Documenta in Kassel through the section on behavior contextual art.[43]

One never knows whether people realised they were collaborating as Marras had a bad habit of using other people's names and materials in promoting and furthering the interests of CEAC.[44] Just as one does not know whether there really was such a co-operative network of workshops or whether it was pure self-promotion (in an article where Marras never reveals his CEAC affiliation), since a school did not yet exist in Toronto, and since Marras was soon to cut relations with Fischer, for instance.

CEAC Ferrara performance programme, June 1977

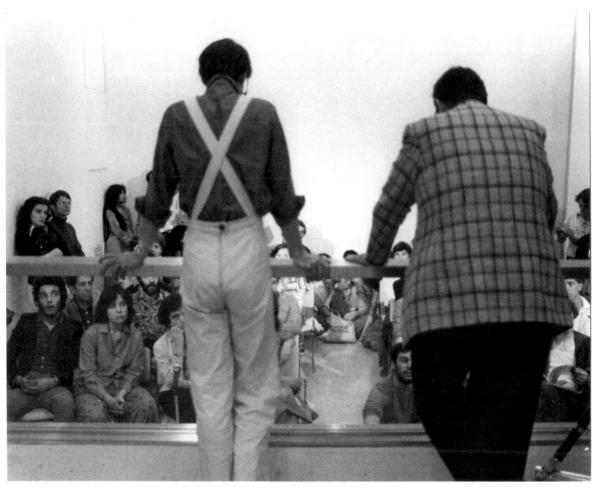

Suber Corley and Arturo Schwarz in CEAC Bologna
performance, *(interrog)azione*, June 6, 1977

Reindeer Werk was instrumental in securing CEAC an invitation to
participate in the school of all schools—in prestigious documenta 6
under the auspices of Joseph Beuys' Free International University for
Creative and Interdisciplinary Research conducted during the 100 days
of the event. Only Marras, Ron Gillespie, and Lily Eng were invited to
participate in Beuys' Violence and Behaviour Workshop, but Bruce Eves
attended too and gave a lecture on "homoeroticism and the simulacra of
violence in punk and BDSM".[45] Gillespie and Eng performed. Marras
lectured on CEAC and the Behaviour School in Toronto. Imagine Amerigo
Marras chalk in hand in front of Joseph Beuys' blackboard instructing
the master himself, explaining the finer points of behaviour and the
dialectic. He had arrived and really was a player now!

The editorial to *Art Communication Edition* 7, published to coincide
with documenta, reminded readers of CEAC's, indeed the KAA's, long-
standing commitment to pedagogy: "Since 1973, the CEAC has been
involved in didactic activities which encouraged communal decisions
for the shaping of a social form (of art). Early efforts included the
textbook for children designed by Yona Friedman with the intention
of educating all social beings in the making of choices for the self-
organisation of society."[46] The editorial may have been a ploy to
establish its authority, but CEAC recognised that a school was the
thing. With Beuys' Free International University and Fischer's École
Sociologique Interrogative already established, it was obvious that
to seriously compete internationally one had to institute a school
locally, so CEAC started advertising its Behaviour School in issue 5 of *Art
Communication Edition*: "The objective of the behaviour school is to
raise questions that are found in the social context of the CEAC within
the city of Toronto."[47] CEAC took advantage of "realizing its Behaviour
School at documenta 6",[48] but the reality of a school in Toronto was
cut short by the May 1978 crisis. The question, though, was whether it
would succeed anyway. Bruce Eves describes the School's actual failures:

Amerigo Marras, documenta 6
ID badge, 1977

> My participation in the workshops was only an involvement with
> the planning phase, and with the exception of a series named "Five
> Polemics to the Notion of Anthropology" the other courses gathered
> under the general, if overblown, heading of CEAC School were a bit of
> a flop. I remember the workshops as being either ill-attended and ill-
> conceived little vanity projects or a glorified day care centre. This idea
> was a direct outgrowth of the participation in Documenta and Beuys'
> Free International University and didn't last long. The plans for the
> 'Anthropology' series on the other hand were far more ambitious in
> scope and star power and approached the Contextual Art Conference
> in intensity and importance.[49]

The endeavour was serious enough for Marras to write a "Report on the Feasibility of Establishing a Branch of the 'Free University for Creativity and Interdisciplinary Research' in Toronto".[50] The ambitious "5 Polemics to a Notion of Anthropology", which was advertised to include luminaries such as Bernard-Henri Lévy, Marina Abramović, and Joseph Beuys himself, was to be its inaugural showcase. It logically followed on the theoretical work of the Contextual Art seminars, the École Sociologique Interrogative, and the Free International University, and it was prepared for by weekly discussions at CEAC on "the meaning of counter-information, counter-productivity, terrorism, the possible actions that create effective change".[51]

The mere local reach of a school probably would never satisfy Marras. So its failure was already anticipated by CEAC's participation in documenta 6. "Freshly back from Kassel, [Marras] found himself in the position of becoming what he once had detested, and no amount of rhetoric would change the fact that he had begun his entry into art stardom."[52] A star in his own mind perhaps. A player, and a rogue one at that, did Marras any longer really need to collaborate? Did CEAC any longer need the cooperative network of others? While acknowledging the contributions of others such as Świdziński, Fischer, and Beuys, Marras believed CEAC's "theoretical premises and practice [were] now already historical".[53] The Free University's Behaviour School was instructive in one respect: the École Sociologique Interrogative was not invited to participate. "While the CEAC supports the sociological art group", Marras subsequently notes, "it has adopted an identity of structure with the so-called Free University." Yet, at the same time, "to share commonalities does not necessarily mean to stagnate in a precise model. In fact, shifting focus makes us realise that there are alternatives to anyone's alternative. So that to the Free University, we have other alternatives", said Marras, now cutting the Oedipal apron strings.[54] Then sounding a bit like General Idea, he concludes, "How then does one defeat the dominant ideology if the alternatives are split by the same dominant ideology? Precisely by oneself becoming the occasional member of some of the thousands of networks in operation and thereby shifting the ground without freezing the role."[55] Hence, one of the many alternatives was occasionally flirting with the terrorism of the Red Brigade. "The long road to action is preceded by the 'spark' that will accustom people to talk to one another first."[56] *Strike* would be that spark.

The development of CEAC's Behaviour School went hand-in-hand with articulating CEAC's new ideology, which was the job of the retitled journal *Strike*. The international reach of a journal was always a preferred vehicle to establishing a school with only local effect. The masthead of *Strike* 2 explained: "*Strike* disseminates a critical practice based upon the new ideology. The directing group is allied to the revolutionary cause that intends to create cultural polemics, debates, confrontations and the

BEHAVIOUR

DOCUMENTA VI
KASSEL GERMANY SEPT. 8-16

"TO INVESTIGATE INTO 'BEHAVIOUR' IS TO FIND MORE OF OUR OWN NATURE, WE WANT TO FIND THE AMBIGUITY WITHIN EACH DISCIPLINE, AND IN THE END TO FIND THAT ALL HUMAN ACTIVITIES CAN BE UNDERSTOOD AS BEHAVIOURAL ONES. THE BEHAVIOUR SCHOOL IS THE PLACE FOR THE DIALECTICAL FORMATION OF SOCIETY, OF WHICH THE OBJECTIVE IS TO RAISE QUESTIONS FOR THE EMERGENCE OF A SPONTANEOUS BEHAVIOUR, CONTRARY TO THE LOGICAL ORGANIZATION OF THE REPRESSIVE SOCIETY IN WHICH WE LIVE" - CEAC'S BEHAVIOUR SCHOOL, AT THE FREE UNIVERSITY, WORKSHOPS AND PERFORMANCES, SEPTEMBER 8 - 16, COORDINATED WITH ARNULF RAINER; LILY ENG, BRUCE EVES, RON GILLESPIE, AMERIGO MARRAS (CEAC); DIRK LARSEN AND TOM PUCKEY (REINDEER WERK).

SCHOOL

Art Communication Edition 6, July 1977 (back cover)

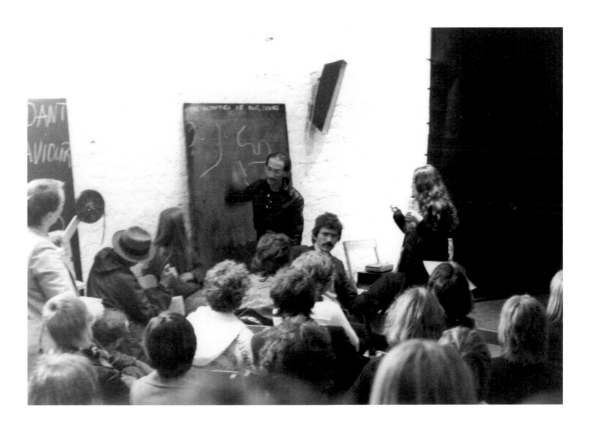

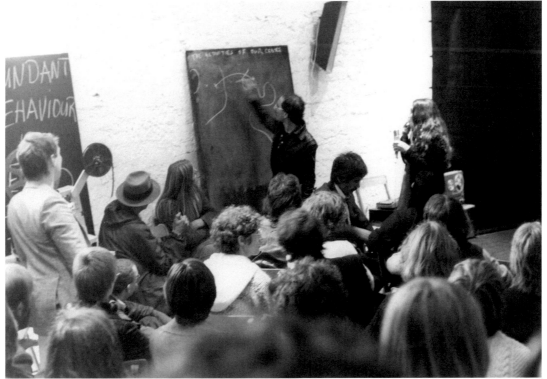

Amerigo Marras lecturing at Violence and Behaviour workshops at documenta 6, 1977

PROGRAM FOR VIOLENCE AND BEHAVIOUR WORKSHOP

	11am	12.30pm	2pm	3.30pm
THURS. 8th.	A talk and discussion with participants on the aims of the Behavior W/shop.	Lily Eng-action	Amerigo Marras talk on CEAC and the Behaviour School in Toronto	Stefan Eins-followed by Arnulf Rainer
Fri. 9th.	? George Levantes GENERAL GROUP DISCUSSION	? Caroline Tisdall →	Peter Byrne → ± 4.30	(6pm H+W Weber-Z) ? Lukasz Pyrq and Jan Piekarczyk and Behaviour traps NICOLAS URBAN .
Sat. 10th.	Stefan Eins ? and/or discussion	Gavin Jantjies Presentation/ Slides/ Discussion	3 pm. Amnesty Int. Polit. verfolg-ungen und ihre Ursache - film u. diskussion	6pm. Helga + Wolfgan Weber-Zucht Selbstorganisa-tion und Mobilisierung
Sun. 11th.	Bruce Eve's action - and Amerigo Marras.	Nina Sobel	xix Ron Gillespie action and reading.	Reindeer Werk-action and talk 6pm. H+W Weber-Zucht Nat. u. Int. Organisationen fur gewaltlose Revolution
Mon. 12th.	Bruce Eve and Amerigo Marras	Nina Sobel	Lily Eng-Action	Ron Gillespie-Action and Talk
Tues. 13th.	Caroline Tisdall John Latham		Robert MCdowell	Lukasz Pryq and Jan Piekarczyk with Behaviour Traps
Wed. 14th.	Free time for unprogramed who wish to participate by presenting their own views on behaviour.	Reindeer Werk-action	Discussion on future aims and development of Behaviour	-------------

Programme for Violence and Behaviour workshops at documenta 6, 1977

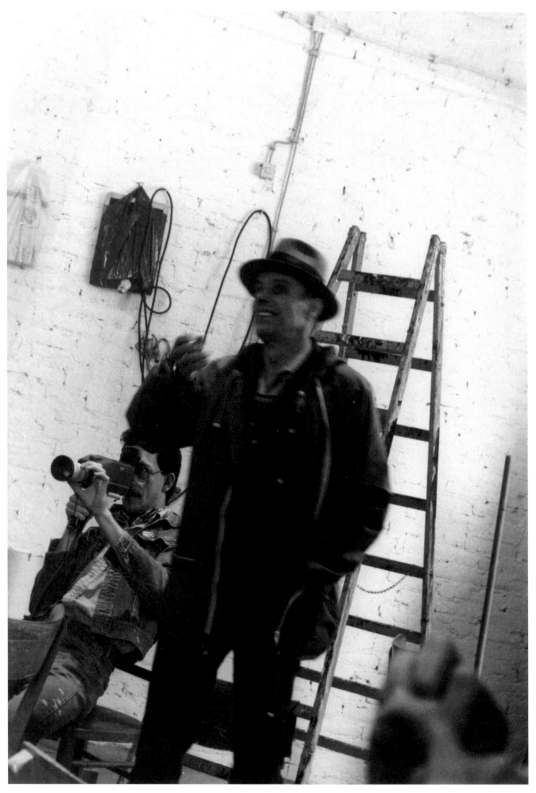

Bruce Eves and Joseph Beuys at Violence and Behaviour workshops at documenta 6, 1977

pursuit of collective education for a new community eliminating labour."[57] Meanwhile the editorial of the first issue justified the rebranding: "Are we supposed to explain the switch from Art Communication Edition to *Strike*? We want to come out closer to the de-training programme, opposed to service systems. We want to effectively move on and merge with the social stance that we foster."[58] Moving on and merging with a new social stance meant disengaging from past habits. Allying itself to the revolutionary cause meant abandoning any reactionary art stance. The successive issues of *Strike* succinctly outline this precipitous disavowal.

Already during the summer 1977 European tour, Marras began distancing himself from an art discourse that would prefigure his alienation from his former European art comrades. "I tend now to distrust all associations with the art world, indeed with 'art'", he admits. In material prepared for the Polish seminars and published in the first issue of *Strike* as "On Organization", he went further declaring, "I am approaching the toleration limit to any further internalization of the notion of 'art' and/or of 'art as something else'."[59] As the inaugural article in the first issue of *Strike*, "On Organization" surely was a signal statement. It had a solid Marxist title in the lineage, for instance, of Mao's "On Practice" or "On Contradiction", but it said nothing on the organisation of workers, let alone the art community, whose attempts at collectivity, through the artist-run system of parallel galleries or artists union (Canadian Artists Representation), Marras intolerantly dismissed. Instead artists in Canada and New York were accused of being careerist petty-bourgeois supporters of the class system.

Marras identified 'enemies', 'allies', and 'our people'. The enemy, of course, was "the entire art-world market that is presently directed by the New York cultural imperialism"; but the enemy was also the class system, as well as "those who hold the hegemony of the cultural ideology" (museums and art councils and their 'mandarins'), and ultimately most artists themselves, even the self-organised ones. "Although to be praised for their attempt to self-organize", in artists' collectives "petty-bourgeois ideas are calmly maintained". Not only artistic practice in general, art discourse itself was suspect: "When we discuss 'art', we are actually using the discourse as a pretext for established relationships in a class structure."

The glaring problem was that in supporting the revolutionary cause CEAC never could disengage itself from talking about art since this discussion, and the vehicle for it—*Strike*—was the site of its legitimacy. An instance of this contradiction was massively on display in the controversial second issue of *Strike* (May 1978) where an inserted four-page broadsheet "Dissidence in the 1978 Venice Biennale" complained of the National Gallery of Canada's selection of artists for the national pavilion and provided an analysis of the "socio-political function of art and art institutions" and on how "the legitimating [and ameliorating]

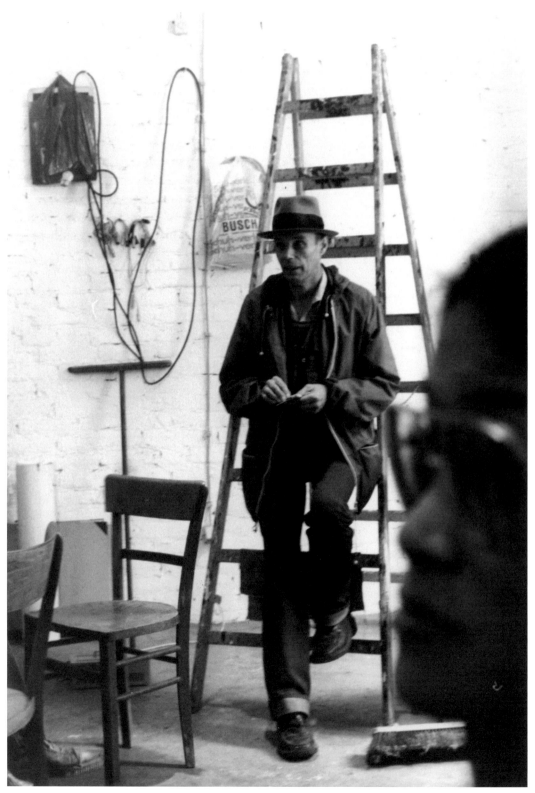

Joseph Beuys and Lily Eng at Violence and Behaviour workshops at documenta 6, 1977

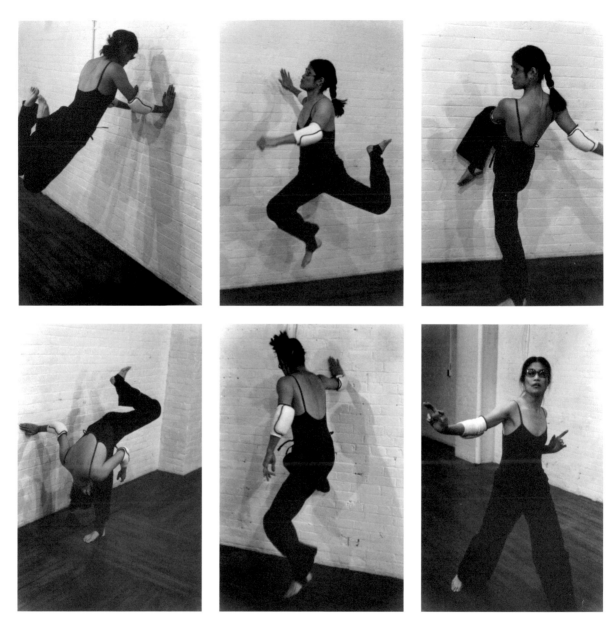

Lily Eng, *Solo Improvisation 1*, 1977

5 POLE

IDEOLOGY
'NEW PHILOSOPHY' Bernard-Henri Levy
'Open Road', J. Skovorecky

HUMAN RIGHTS
'Heresies'
Body Politic

WORK
Bruno Ramirez (ZEROWORK)
Peter Dunn & Loraine Leeson

BEHAVIOUR
Marina Abramovic
Socio-Biology

COMMUNITY
Joseph Beuys' FREE INTERNATIONAL UNIVERSITY
Maria Gloria Bicocchi ART TAPES

MICS to the notion of anthropology

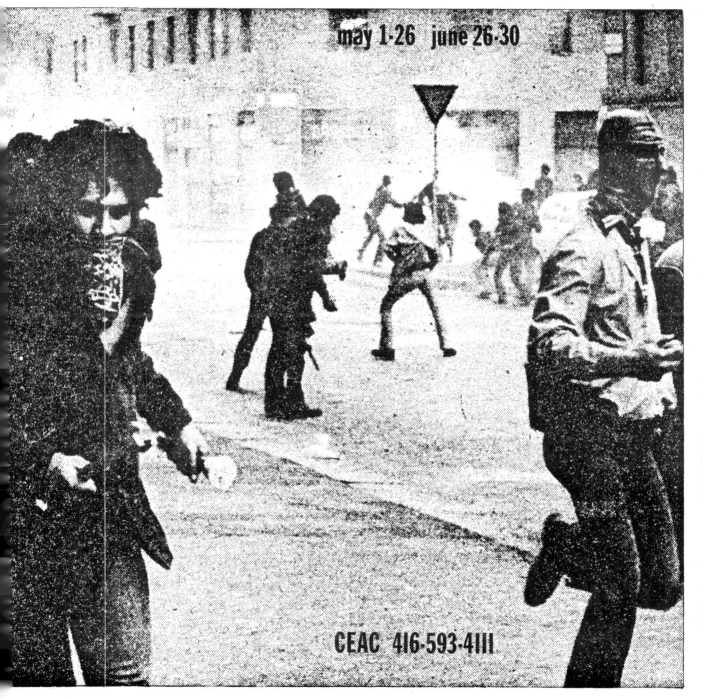

may 1-26 june 26-30

CEAC 416-593-4111

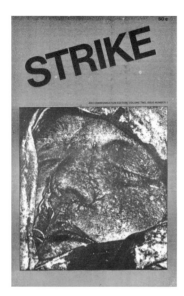

Strike 1, January 1978

Strike 2, May 1978

OPPOSITE
"Dissidence in the 1978 Venice
Biennale", insert in *Strike* 2, May 1978

function of art serves the interests of power" as an "ideological tool" of capitalism.[60] In this "Joint Statement by the Central Strike Committee", analysis began to diverge somewhat from that found, for instance, in Marras' "On Organization". Past practices, too, came in for self-criticism, "such as the idealist conceptions of Alternative Perceptions, Deviant Behaviour, Punks, etc". But in any intended crossover, merging with the social stance it wanted to foster, the Central Strike Committee wavered on the line. "Dissidence" was long on art analysis, short on class analysis. In their defense, the authors admitted, "so long as we remain even vaguely connected to an art context, a thorough critique of art practice is necessary". Yet, they were clear that art was part of the problem and not the solution: "We do not rule out the possibility of a truly radical function for art, but in the present socio-political contexts it seems that a radical function for art can only exist as a negative one. Only criticism is possible and not a positive practice, or at least criticism must be an integral part of any model of practice."

The committee states, "Our general purpose is to communicate not posture; avant-garde mystification must be countered by de-mystification. Therefore we wish to be as clear as possible so that response is to our ideas and not to their appearance; not as recent modernists who now use politics as yet another gambit." Here the committee implicated but did not name both mystifying artists such as General Idea as well as those in on the 'political' gambit, such the artists associated with *The Fox* in New York and, particularly in the Toronto context, Carole Condé and Karl Beveridge. In that "art must question its own sociology, its place in the relation of production", these relations were best seen not as strictly determined by an economic base as you might expect or as Marras previously argued, but rather recognised to be substantially ideological in nature: the pervasive forms or representations through which men live their imaginary relationship to reality. Here, Louis Althusser's writings on ideology were essential to this discussion since art—and CEAC follows Althusser here—was conceded to be "superstructural and not materially based".[61] Recourse to theory was necessary, but theory alone was not enough: "Our oppositions must be made clear against concrete examples and lead towards active transformation."

Yet in a statement of over 10,000 words, few concrete examples of active transformation are offered other than the brief mention of "proper preoccupations" for art such as an "oppressed native population or the structure of wage labour" or the belief "in the need to broaden the scope of the battle from the shop floor to everyday life". *Art* remained the favoured framework of discussion. The committee admitted that "the complete rejection of art is not the point and transition to activism is not automatic. Both strategies are effected by the need to account for pervasive ideology. When this is done we see that art may serve as one of

STRIKE, V12 n2, may 1978; 15 duncan st. toronto m5h 3h1 canada

DISSIDENCE IN THE 1978 VENICE BIENNALE

(Joint Statement by the Central Strike Committee: Amerigo Marras, Roy Pelletier, Bob Reid, Bruce Eves, Lily Chiro, and Paul McLellan)

Intentions

Dissent

As artists working in Canada we protest the National Art Gallery selection of Ron Martin and Henry Saxe for the Canadian participation in the '78 Venice Biennale. It must be understood that this selection does not represent unanimous approval in Canada but has been made in the face of dissent, and is both irrelevant and an embarrassment to artists working here. We reject the NAG's choice as yet more official art foisted upon people.

Specific Issue/ Heirs of the Guillotine

The NAG selection of worn our formalist trivia is completely inappropriate to the VB which has had an ongoing concern with art in relation to politics, however superficially the VB has interpreted this theme. The NAG's choice indicates either its deliberate avoidance of controversy or its ineptitude as the supposedly leading art institution in Canada unaware of the socio-political context as the contemporary issues of advanced art, and even of some art institutions in less apathetic parts of the world. (Despite the fact that this year's formal theme at the VB is the wholly ambiguous "Art to Nature; Nature to Art", the NAG should know better.)

On the other hand the VB on closer inspection proves itself to be little better, if more pertinent, than the NAG. As a tool of the Italian Socialist Party it seeks to discredit a radical critique of capitalism by the liberal strategy of assimilation, and manoeuvres like its unbalanced view of "dissident" art which, despite assurances of being constructive criticism within the ranks of Marxism, show the VB for what it really is - capitalist propaganda.

General Issue/ On the Road to Versailles

But our purpose goes beyond a simple criticism of Martin and Saxe, the NAG, the VB, and Eastern dissident art. When we take into account the social and political context of this specific issue, we find that our criticism must be extended to more generally include the soci socio-political function of art and art institutions of which our four principles are only examples. We discover that art has both a legitimating and an ameliorating function manifested as two accordingly distinct forms of art and sometimes as two elements within the same art.

Under the two presently dominant systems in the world, these legitimating and ameliorating functions take on the following respective forms: established and avant-garde art in advanced capitalism of the West, official and dissident art in authoritarian communism of the East. In both the East and the West the legitimating function of art serves the interests of power, and although the ameliorating function of art is often characterized as refractory, because it operates under the same dominant ideology it too usually ends up serving those same interests, which is why it is reformist rather than radical. Under authoritarian communism official art clearly serves the state and dissident art appears quite distinct from it. It is evidence of the greater hegemonic control of advanced capitalism that the legitimating function of art is not acknowledged - established art is not so easily recognized as a tool of the dominant ideology. Neither is the ameliorating function of art often recognized, or if it is it is restricted to formal innovation within the bounds of art and so easily co-exists with the legitimating function of art as two elements of the same art, e.g. formalist avant-garde - the avant-garde eventually becomes established art. More obviously recalcitrant art still under the weight of the dominant ideology directs its protests against universal orders instead of real powers, of if politically directed remains a token rebellion within the confines of the art context and serves as a guide to the survival of capitalism. Finally, capitalism uses the ameliorating function of art expressed in the East as dissident art to justify itself against not just authoritarian communism but socialism as a

general cause and all its possible forms.

In short, both the East and the West art serves the dominant ideology even when non-conforming; legitimating and ameliorating functions of art are just two sides of the same coin. We do not rule out the possibility of a truly radical function for art, but in the present socio-political contexts it seems that a radical function for art can only exist as a negative one. Only criticism is possible and not a positive practice, or at least criticism must be an integral part of any model of practice.

Approach/ Knee Capping and Other Games

We and others have made similar statements in the past but because we do not wish to work from the self-serving interests of the avant-garde, we take up these issues because of what we believe and not as yet another innovation or style. We are committed to what we say and will repeat as well as develop these ideas as long as circumstances deem it necessary to no matter how many times it has been done before. Our general purpose is to communicate not posture; avant-garde mystification must be countered by de-mystification. Therefore we wish to be as clear as possible so that response is to our ideas and not to their appearance; not as recent modernists who now use politics as yet another art gambit. Also, similar statements made in the past have not been comprehensive, but this is required if we are going to appeal to more people than just the few who are already part of the dialogue. This statement is just the beginning of a comprehensive work toward which the general principles that come out of this critique can go. There is not the time or the space for a thorough enumeration of all possible ways that art and art institutions function as ideological tools of capitalism or authoritarian communism, so we limit ourselves to those aspects that apply to our particular purposes here. Only with such a comprehensive work can we clear the ground for action beyond the confines of art. But so long as we remain even vaguely connected to an art context, a thorough critique of art practice is necessary, in fact, it may be argued

that a finally comprehensive work is never possible and that a transition from art to activism is not a simple and immediate thing because we carry the baggage of our ideological background - all the more reason for statements such as this one.

Our concern as artists working in the West is with art under advanced capitalism. Therefore we limit our discussion to legitimating and ameliorating functions of art as they exist under the social and political context here and only consider their forms in the East in so far as they are involved with our situation, i.e. dissident art used by capitalism for its self-justification.

Polemics

"Old Tactics"

The questions raised by the NAG selection of Martin and Saxe concern, in regards to Martin and Saxe, not only their appropriateness for the VB, but also the validity of their work at all and of most Canadian art as well as the international formalism they represent. Looking at the NAG, doubts are raised not only about its poor choice in this particular case, but also the NAG's performance in general and its function as a Canadian art institution and all art institutions in the international art support system. Most important, however, is the more general concern raised, by their example, of the socio-political function of art and art institutions to be dealt with at the level of theory.

Martin and Saxe/ Be-labouring Trivia

For the last several years the VB has been concerned with art and general issues of both a contraversial and political nature in their socio-economic setting. The way the VB has handled these concerns and its ultimate purpose is

its battle grounds and that it reveals the ideological function of all art and the class embeddedness of all artists which must be dealt with. Our only valid purpose can be the transformation to real democracy and conscious participation of all which entails the overthrow of capitalism." They conclude, "Towards this goal de-mystification is an important action for art—the dispersal of imaginary relations which have intervened and disarmed the material struggle."

In their desire "to communicate not posture", the committee was "as clear as possible" that, while art still had a role to play in the dispersal of imaginary ideological relations (and this was the critical function of *Strike*), the ultimate aim was to *re*-arm the material struggle in the overthrow of capitalism. Everything about *Strike* began to point to the journal as that vehicle. Take the May 1978 issue of *Strike*: from its cover image of Aldo Moro's bodyguards' bullet-ridden corpses; to the Brigate Rosse red star predominantly displayed on its back cover, indeed underscoring many of its pages as a red stamp of approval; to its translation of the theatre-of-the-absurd court transcripts "Red Brigades On Trial"; to the printing of the Red Brigade slogans "carry out the strike against the imperialist state of the trans-national" and "build the unity of the revolutionary movement"; to the publishing of Chairman Mao's "Combat Liberalism" underscoring the issue's editorial.[62] By the image projected both graphically and verbally, it would seem that the *Strike* editorial committee wanted to "move on and merge" with the Brigate Rosse. Unless all this was posturing, it was the armed framework within which to read the short and to the point, indeed striking, editorial that was to be so explosive:

> We are opposed to the dominant tendency of playing idiots, as in the case of 'punks' or the sustainers of the commodity system. The questioning through polemics of the cultural, economical and political hegemony should be fought on all fronts.
>
> To still maintain tolerance towards the servants of the State is to preserve the status quo of Liberalism. In the manner of the Brigades, we support leg shooting/knee capping to accelerate the demise of the old system. Despite what the 'new philosophers' tell us about the end of ideology, the war is before and beneath us. Waged and unwaged sector of the population is increasing its demands for 'less work'. On the way to surpass Liberalism we should prepare the barricades.[63]

The editorial was not so much an argument as strung together slogans, with the odd political demand thrown in—for "less work".[64] But what an effect it had! The reaction was swift. Even before the issue had been delivered from the printer, it was leaked to the tabloid *The Toronto Sun*, with the expected result: "Our taxes aid 'blood-thirsty' radical paper", the

headline read. Then followed the predictable outcome to this funding
scandal: questions on the floors of the provincial and federal legislatures
and quick revocation of every level of arts council funding. Without
ongoing funding, CEAC lost its building and suspended operations but
not without publishing one final issue of *Strike* a few months later.[65]

The editorial committee cobbled together some heavyweight
contributors from who knows where—Jean-Paul Sartre, Joseph Beuys,
and Madame Mao—but the final issue of *Strike* was dedicated to Human
Rights and its abuses—and it had one cause to serve. The notable case,
of course, was that of CEAC itself and its treatment under the repressive
regime of the Canadian government and its puppet arts councils.
"Foremost, what we wish to make clear is that what happened to *Strike*
and CEAC is a definite case of censorship, in fact, political repression."[66]

Strike's treatment amply demonstrated the journal's aim to show that
"liberal democracies are essentially repressive regimes". The anonymous
authors of "Snuff", the article that made this claim, thought that *Strike*'s
"radical analysis coupled with provocation proved to be very successful
as a means of creating debate on the issues of our analysis within a wider
audience, and as a social experiment to prod liberal democracies to
reveal their true nature as concluded in our analysis". This analysis "was
coupled with a provocative visual and verbal imagery". The problem,
the writers claimed, was that the government concentrated only on the
imagery and not their analysis which was the greater part of their work
and, besides, the imagery was no more violent than others found in art
and entertainment. Why the censorship and repression? "Why? Partly
because our imagery was drawn from reality, but primarily because it was
coupled with a radical analysis of liberal democracies, and it was that
analysis [contradicting themselves] that the media and the government,
the pillars of liberal democracies, feared."

Strike 3, October 1978

Was it a case of censorship? No. The second issue of *Strike* was freely
circulated, as was the final October issue. Was CEAC suppressed... or banned,
as it later claimed when it advertised, "As the futurists were in fascist Italy,
as the bauhaus was in Nazi Germany, as the constructivists were in the
Soviet Union, the CEAC was banned in Canada"?[67] No. It could continue its
activities—both artistic and political—only without government funding.
As Marras had admitted earlier, "When I refer to Canada, I refer to it as a
concrete reality: the economical base that allows my work to happen
but not my revolt (since I should be able to revolt without its economical
support)."[68] Was this still the case? Indeed, was it ever the case that CEAC's
revolt was not paid by their government funding?

CEAC allowed that it was surprised by the scandal: "We did not
anticipate the extremity of their reaction", it said of the governments' and
councils' responses. In reaction, did CEAC reveal its true nature, its true
face? ("If only words and images caused the reaction that they did, then

little is needed as a lever of provocation to force liberal democracies to show their true face.") CEAC's true face was revealed in its face-to-face with the true face of the government. Indeed, nothing seemed to exist outside this relationship. When push came to shove, it seems that CEAC's effectiveness only existed in relationship to the government. Initially, CEAC states, "Our intention, working from the insular art context, was to provoke debate and elicit reaction from outside the art world." In the end, it acknowledges, "We have actually achieved illiciting [sic] a response from outside of art and from the most powerful sectors of society." You have to admit that CEAC was successful. It was effective. Its success was its failure, however.

Through its defensive posture, "Snuff" showed that CEAC defined itself solely in relation to the State. "As far as the government was concerned, it was very easy for them to put an end to our activities, for they had only to cut off our funding." As a result, "now pushed as we are to this brink at which all our alternatives have been deliberately cut off", they came to the conclusion: "Now not only is it clear that there are no legitimate means to effective change, but *Strike* has been denied any means of legitimate change if such a possibility has ever existed." Strange logic: that a cessation of funds leads to ineffectivity! To a degree they were right when they said that they were being punished for their political views.[69] Yes, their funding was stopped, but it was naive of CEAC to expect that it wouldn't and disingenuous to argue that suspension of funding was censorship and, moreover, that there were no alternatives available to it once this funding was cut off. Isn't it a bit strange to realise that, for all its radicalism, CEAC eventually defined itself *solely* in terms of its government funding? Moreover, that it reconciled itself to this dependent condition to the degree that it gave up when it lost its funding. Only in Canada could this happen, you might say!

It did not take the government's provocation, though, to change CEAC's relation to the State. It already preexisted. Just as "Snuff" disavowed the ideological leeway most contemporary Marxist philosophers then gave to the work of art (and whose superstructural independence the authors of "Dissidence" had endorsed), so too CEAC misconstrued its analysis of the State.[70] Seeing its influence akin to a crude economic determinism, it made the State determinant in the last instance, at least in terms of Canada's art funding. It overemphasised the power of the state and its determinant role:

In Canada, the state supports art almost exclusively, e.g. by grants, and arbitrates its quality, e.g. by selection for festivals such as V[enice] B[iennale]. By this method the state reflects its own position and reinforces art's position as a universal abstraction above the material, special interests, the ideological. Art then functions as the ideological

CEAC Advertisement, *Magazine*
[Ontario Association of Art Galleries],
winter 1978–1979

As the futurists were in fascist Italy, as the bauhaus was in Nazi Germany, as the constructivists were in the Soviet Union,

the CEAC was banned in Canada

Video:
the finest colour production studios in the alternative network; European / North American transfer system facility; viewing and distribution of videotapes.

Film:
the first permanent film screening cinema for independent filmmakers in Toronto.

Crash N' Burn
the first punk rock palace in Canada and recordings label for new wave.

Services:
performance and seminar tours, information on current art activities through workshops, classes, and consultations.

Library:
the finest growing collection of artists' and dissidents' books, magazines, records, audio and videotapes.

Publications:
art communications edition and strike magazines, and the production of limited edition artist books.

15 DUNCAN STREET
TORONTO ~ 593 4111

tool of the dominant class through the state in the same way that the state itself is an ideological tool of the dominant class.[71]

The authors flattered themselves that it was their radical analysis that brought down the establishment's wrath and not simply their advocacy of knee-capping. Ten little words, an artist lamented in a letter to the Ontario Arts Council, "Can we now say that these ten words which caused so much controversy are enough grounds to stop the funding of such a crucial centre?"[72] The effect seemed disproportionate to the cause. Ten little words. But what an effect they had. What was CEAC's justification of its advocacy of knee-capping? The authors were insistent that what CEAC published were *only* words and images. "The suppression of what were only pictures and words was quick and severe." But it wasn't words and imagery, it was the specific phrase: "In the manner of the Brigades, we support leg shooting/knee capping to accelerate the demise of the old system."[73] The authors disavowed responsibility for this statement. In fact, "Snuff" obfuscated the phrase, never repeating it or addressing it specifically—"though we made some strong statements", the authors admitted. Instead, they subsumed it under the general category of "imagery", as if its words had no semantic meaning.[74] Its meaning instead was drawn from reality, an objective condition over which the authors had no responsibility, having merely reported it: "a powerful imagery whose impact depended on the urgency of the reality it was derived from".

When asked by a reporter whether he supported knee-capping, Marras thus replied obscurely: "Well, we are saying that it should be taken as a metaphorical point to realize that the problem is in recognizing real issues."[75] Well, if knee-capping was metaphor and the rest of *Strike* was only words and images, what do we make of the radical analysis they were coupled to? Was this only words and images, too? Metaphors and not incitement to action? An imaginary world with no effect? In the end it seems that *Strike*'s rhetoric was the means by which CEAC lived its *imaginary* relationship to revolutionary politics.

Missing Associates, 15 Dance Lab,
1979 (poster)

MISSING ASSOCIATES

Co-directed by Lily Eng and Peter Dudar

NEW DANCE
Fri April 20 and
Sat April 21 at 8:30

15 DANCE LAB
155A GEORGE ST, TORONTO
(1 block south of Queen, 1 east of Jarvis)
869-1589
Admission $3.00

In the last three years Missing Associates have performed in
AUSTRIA, BELGIUM, ENGLAND, GERMANY, ITALY, SCOTLAND, SWEDEN, YUGOSLAVIA, THE UNITED STATES, *and*
throughout **CANADA.**

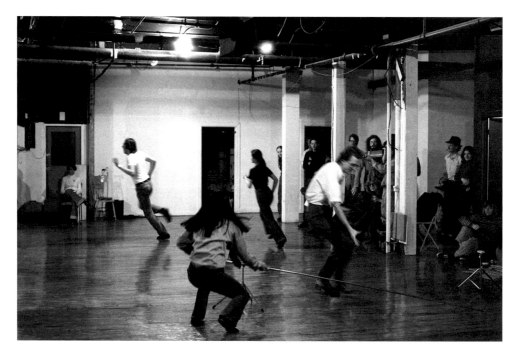

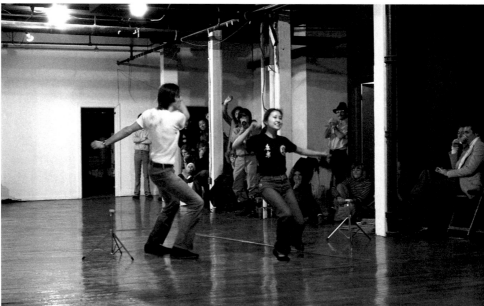

Missing Associates, *Crash Points*, 1976 (documentation)

Missing in Action 1, 1978

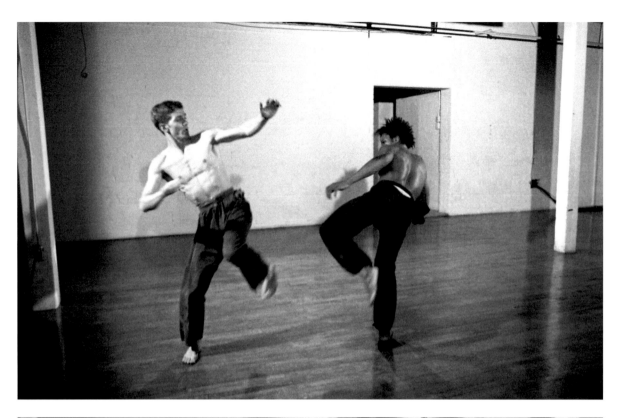

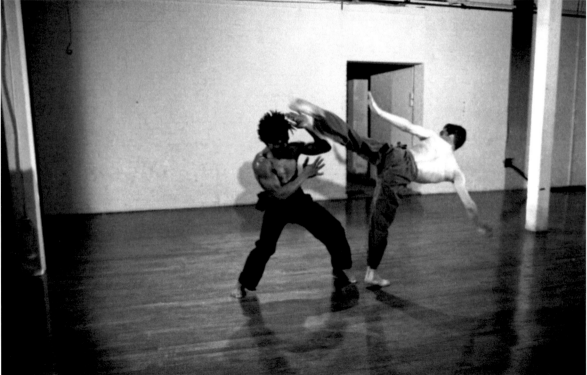

Missing Associates, *Penetrated (Male)*, 1977 (stills)

Missing in Action 2, 1979

6 *MISSING IN ACTION*

Where do you think you're going? You're an aggressor and you've committed unforgivable crimes! Yu-lan fires a shot at him.

With deep national and class hatred, Sister Tien raises her red-tasselled spear and plunges it into this enemy who dares to resist.

Missing in Action 2, 1979 (pages 6–7)

1 Gale, Peggy, "Videoview I: Susan Britton. Susan Britton talks with Peggy Gale", *Centerfold*, vol 2, no 4, April 1978, p 14.

2 Condé, Carole, and Karl Beveridge, *It's Still Privileged Art*, Toronto: Art Gallery of Ontario, 1976. All unacknowledged quotations are from this source.

3 It was Beveridge alone, however, who secured the AGO exhibition as he originally had been invited by AGO curator Roald Nasgaard to do a solo exhibition there.

4 Klepac, Walter, "Carol Condé and Karl Beveridge:... It's Still Privileged Art", *artscanada*, vol 33, no 1, April/May 1976, p 67. The exhibition took place at the Art Gallery of Ontario, 24 January–29 February 1976.

5 Cameron, Eric, "It's Still Privileged Art", *Vies des Arts*, vol 21, no 84, autumn 1976, p 94.

6 Condé, Carole, and Karl Beveridge, "Chronology", *Condé and Beveridge: Class Works*, Bruce Barber ed, Halifax: The Press of the Nova Scotia College of Art and Design, 2008, p 58.

7 Marmer, Nancy, "Art and Politics '77", *Art in America*, vol 65, no 4, July/August 1977, p 66.

8 Condé and Beveridge absolve themselves of any bad faith: "We came to New York believing in a certain system—international art—and believed that coming to New York was the only way to succeed in relation to it—which was true. We really believed that American art was the most 'advanced' in the world, and that it made a 'positive' contribution to society. We didn't come out of naked ambition—no use tearing ourselves down—it was an honest motivation to make what we thought was the 'best' art—even though that seems naive now. *What has changed is that we don't believe in the 'high art' myth any longer*. This change is due, largely, to our being in New York. If we had stayed in Toronto... it's hard to say, but I don't think we would have changed—at most we would've become bitter and resigned." Condé and Beveridge, *It's Still Privileged Art*.

9 They had already named the National Gallery of Canada's Brydon Smith and the AGO's Roald Nasgaard in *It's Still Privileged Art*: "We don't care if Brydon Smith or Roald Nasgaard are upset about whether or not it's art. The important question is whether our work upsets their political consciousness, or makes them question the role of art...."

10 Guest, Tim, "Maybe Wendy's Right", *Centerfold*, vol 3, no 5, July 1979, pp 277–278. Condé and Beveridge retorted in "Letters; what is the basis of his personalism", *Centerfold*, vol 3, no 6, July 1979, pp 282–283 and Guest replied with "Tim Guest replies", p 283.

11 Monk, Philip, "Reading and Representation in Political Art", *Parachute*, no 16, autumn 1979, p 50.

12 Tuer, Dot, "The CEAC Was Banned in Canada", *C Magazine*, no 11, 1986, pp 22–37. The article has been republished in Dot Tuer, *Mining the Media Archive: Essays on Art, Technology, and Cultural Resistance*, Toronto: YYZ Books, 2005.

13 Marras letter, 20 July 1975, CEAC Fonds, Clara Thomas Archives and Special Collections, York University, Toronto.

14 Marras, Amerigo, "Notes and Statements of Activity, Toronto 1977", *La Mamalle*, no 5, 1977, p 30.

15 "Four Leading Questions as Principles of Revolutionary Practice", *Art Communication Edition*, vol 1, no 2, January 1977, p 5.

16 "Contextual Art", *Art Communication Edition*, vol 1, no 2, January 1977, p 4.

17 Transcripts exist in a number of versions in the CEAC Fonds but also as edited paste-up boards ready for publication: CEAC Fonds, 1981-010/008(16) & (17). Fischer returned in a more participatory mood the next day, though pointedly handing out his "pills against US cultural-economical imperialism". Fischer had been frustrated the day before, according to him, because of the regional nature of the seminar when he thought that it should be a three-way discussion of "anthropologized art, contextual art, and sociological art", that is Kosuth, Świdziński, and Fischer. He could not get an answer to his question, "I would like to ask you [Kosuth] and to ask Jan how far you are aware and how you interpreted the differences between the kinds of research and practice you are doing now, he is doing, and we are doing in France?" Receiving no response, he attacked the one-way dialogue between the imperial New York art market and Europe. Fischer wrote a report on the seminar for *Parachute* (Fischer, Hervé, "Notes et Commentaire: Contextual Art", *Parachute*, no 5, winter 1976, pp 26–27) and a vitriolic analysis of Kosuth's lack of participation in Fischer, Hervé, *Théorie de l'art sociologique,* Tornai, Belgium: Casterman, 1977, pp 180–182.

18 From transcripts of the second day. The transcripts were intended for publication as *The First International Conference on Contextual Art* and to be ready for the Paris and Warsaw seminars. They were delayed for editorial reasons. Marras solicited an article from Fischer for publication in the book then appointed him "co-editor for the 'West' European contribution/front" (29 December 1976 letter from Marras to Fischer, CEAC Fonds 1981-010/028(2)). In the end, neither Fischer's text nor those of the contributors he solicited appeared, nor the one Kosuth subsequently sent, only Świdziński's previously published "Contextual Art" texts, the edited seminar transcripts, and Marras' introduction, which explained in 1978 that the "other texts contributed to the book have lost their meaning in light of recent tendencies of reality". Marras, Amerigo, "Notes & Acknowledgements", *The First International Conference on Contextual Art*, p 7. CEAC Fonds, 1981-010/008(01).

19 It appears that CEAC had a bad reputation amongst visiting artists. The Canada Council officer in charge of CEAC, Brenda Wallace, reported that "Almost every artist that came to CEAC, either from New York, Italy, Paris, Netherlands, were poorly received and complained about CEAC's poor hospitality. [...] [T]he confusion that reigned during these performances and panels was incredible [...] I understand the significance of behavioural art, but this wasn't behavioural art at all, and the people that they invited understand behavioural art very well also. They considered CEAC's 'manque de politesse' unacceptable. These guest are serious artists, international artists with very good reputations... many of these incidents were very unfortunate." Morin, France and Brenda Wallace, "On Parallel Galleries", *Parachute*, no 13, winter 1978, pp 48–49.

20 In fact, the two who had the most to gain—Toronto and Poland—mythologised it. "The symposium went on to become the most mythologised events in the history of Polish art of the 1970s." Serafinowicz, Sylwia, "Broken English: Jan Świdziński and Toronto's Contextual Art Symposium, 1976", *Villa Toronto*, Warsaw: Fundacja Raster, 2015, p 11.

"The Toronto seminars were simply the beginning for a platform of a new consciousness emerging in various countries with the same intensity and similar directions." Marras, "Notes and Statements of Activity, Toronto 1977", p 33.

21 Marras, Amerigo, "Intentional Statements, Contextual Art 1", a manuscript intended for publication by CEAC "for the seminars at the Ecole Sociologique Interrogative, Paris conducted by Hervé Fischer and at the Warsaw seminar conducted by Jan Świdziński". CEAC Fonds 1981-010/017(3). It seems that Marras returned in July to Galerie Remont in Warsaw for a second seminar to present "On Organization", subsequently published as part of "Notes and Statements of Activity, Toronto 1977" and in *Strike* 1.

22 "Third Front Common Statement", *Art Communication Edition*, vol 1, no 6, p 14. It seems that Fischer had already written "The Third Front" before the May 1977 Paris seminar, as indicated in a 5 April 1977 letter from Fischer to Marras in the CEAC Fonds (1981-010/028(2)) and in Fischer's book, *Théorie de l'art sociologique*, p 182.

23 Not everyone who is considered to be part of the CEAC 'collective' was on the same page politically—or was political at all. Initially, Marras provided the ideological direction until the Strike collective was formed where it is more difficult to attribute contributions.

24 Jan Świdziński, "Contextual Art", *Art as a Contextual Art*, Lund, Sweden: Edition Sellem, 1976. "(3) Contextual art is interested in the continuous process of the decomposition of meanings which do not correspond to reality and in the creation of new and actual meanings. (4) Contextual art operates with signs whose meaning is described by the actual pragmatic context."

25 This is the second text titled "Contextual Art" in *Art as a Contextual Art*.

26 Marras, "Notes and Acknowledgements", p 7.

27 "Beginning with contextual-quantitative experiments" with language is a phrase in a K. A. A. information pamphlet but we are given no indication what they were or mean.

28 "The deep structure of language interplaying with its possible variants of surface formations engages in a dialectical definition of pragmatic reality. The fragmentation of whole situations (in particular language situations) was perceived as contextural or quantitative systems. The term contexturalism, coined by Beth Learn in her first language investigation in 1974, was applied to the fragmentation of written language and systematized as a composite of elements in the form of mappings. These mappings, analogous to [Yona] Friedman's mappings, give an immediate pattern that has lost the meaning held within the original structure. The quantitative approach I proposed indicated the possibility of going from one system to another by using contextual outlines or structures that formed multiple reference systems or empty frames. The ontological location in each context or structure was also dictated by a quantitative relationship of elements within each pattern. That is, the meaning was an allocation of use which would reiterate a codification dependent upon the structure. Contexts became observable and from a ground function they became dominant figures to be studied. Any re-iteration of a specific context would allow for definite readings biased by the position of our role in each structure, molding the value judgement for our validation of moral, political or perceptual viewpoint." Marras, "Notes and Statements of Activities, Toronto 1977", p 31.

29 Though Marras admitted that, "Within the process of Canadian contextual invention, the error of confusing 'textural' with textual intention was not determined until the analogical symbiosis with the Polish position." Marras, "Intentional Statements, Contextual Art 1".

30 Marras, "Notes and Acknowledgements", p 7. Marras admitted, "Despite the fact that I first proposed and then organised the seminars, I cannot maintain the same approach toward the issues raised by the seminars. I only now see the naive attempt to generate a joint work with the participants to the seminars." It was only one step from finding the approach naive to finding the other participants naive.

31 "Four Leading Questions as Principles of Revolutionary Practice."

32 For instance, the masthead of *Art Communication Edition* 4 reads that the issue "appears in conjunction with the 'Contextual Evenings' series of performances, and discussions (as situations) in New York".

33 Marras, Amerigo, "Notes on Behaviour Art", *Communication Edition*, vol 1, no 4, n.p.

34 Working together as Missing Associates, Lily Eng and Peter Dudar were part of Toronto's independent dance movement that centered on the important and influential 15 Dance Lab. Founded by Miriam and Lawrence Adams, 15 Dance Lab opened in November 1974 and Missing Associates performed 12 times there between 1975 and 1979. But their brand of experimental choreography was also part of a crossover into art galleries—where it was better received than in traditional dance venues—and Missing Associates performed regularly (13 times) at A Space in 1973 and 1974. Besides screenings of Dudar's films and inclusion in its first European tour, they performed only three times at CEAC from 1976, yet they were associated particularly with this space in people's minds. Peter Dudar was also the author and publisher of two editions of *Missing in Action* in 1978 and 1979.

35 From a current description on Thom Puckey's website: http://www.thompuckey.com/index.php?/reindeer-werk/reindeer-werk-information/. In 1977, Reindeer Werk made the claim that "A tramp in the road, with his almost complete incapability in the 'directional thinking' used in conceptual art, has a more potent and direct effect on the people around him than a conceptual artist ever could. A tramp is someone to emulate. His swaying stance alone is a sufficient action." From Reindeer Werk 1977 press release, Archief ICC, Mukha-bibliotheek, Antwerpen. http://ensembles.mhka.be/actors/reindeer-werk?lang=en. Bruce Eves begged to differ: "To exhibit forms of behavior not common to ourselves is to exhibit fraudulent behavior. To act like a derelict within the frames of reference of 'art' without being a derelict in real life is a form of gross marketeering that keeps the derelicts in an oppressed situation." Eves, "'Art' and 'Behaviour'", *Art Communication Edition*, vol 1, no 7, p 36.

36 This performance style was tried out in New York during the Contextual Evenings at the Franklin Furnace ("Behavioural Evening", 27 February 1977), in London, Ontario ("The Diodes with Readings by A. C. E.", 28 April 1977), and at CEAC ("The Last Performance", 30 April 1977). See *Art Communication Edition*, vol 1, no 5, for a report on the New York performances. Although the condensed time frame of a 7-inch record, *RAW/WAR* gives an approximation of the feel of

134

these performances. Performance dates extended into documenta 6 that September, with a gig in Detroit in November.

37 Eves, Bruce, Canada Council Arts Grant application, CEAC Fonds 1981-010/014(20). The formal set-up varied according to each specific space but derived in general from Diane Boadway's proposal *Sociological Phenomena and Which Will Follow,* which "was designed to question the usual theatrical arrangement with the audience's role as voyeur/participant, as they would be interrogated/questioned with statements". ("Diane Boadway interview, 2012", http://mikehoolboom.com/?p=16049) Four amplified individuals (always CEAC members Diane Boadway, Suber Corley, Bruce Eves, and Amerigo Marras) took various positions in a room (in the four corners, for instance); one would start with a line from a text and after a determined pause another would carry on. (Delivery would vary performance to performance, sometimes shouting; and in Italy Marras, or Arturo Schwarz, intervened after each statement to translate into Italian.) Sometimes, Boadway relates, "a provocative situation was created by sometimes directly touching people or asking them to respond". Performances were written en route: "Amerigo and Bruce had input into the text and it became more political as we travelled deeper into the itinerary of the 1977 European art tour."

38 Boadway, Diane, "Journal", 1977. Unpublished; available at http://mikehoolboom.com/?p=15154

39 The Bologna performance text was published in *Art Communication Edition,* vol 1, no 6, July 1977, p 4. Similarly, a reading of the *Tractatus*-like "Intentional Statements on Contextual Art", which had been written by Marras for the Paris and Warsaw seminars, was offered as a performance on 28 May 1977 at Galerie Labirynt, Lublin, Poland.

40 Fischer, Hervé, Fred Forest, and Jean-Paul Thénot, "manifesto" (1975), *Art Communication Edition,* vol 1, no 6, July 1977, p 9.

41 Fischer, transcript *The First International Conference on Contextual Art.*

42 "The Behaviour School for the Development of The Third Man" and "The Third Man", *Art Communication Edition,* vol 1, no 5, May 1977.

43 Marras, Amerigo, "Canadian Vanguard 1970–1976", *TRA* (Milan), no 4/5, 1977.

44 In the letter of invitation to Marras to participate in documenta, Dirk Larsen writes: "Caroline [Tisdall, Beuys' Irish collaborator on the Free International University] rang me yesterday saying that you had sent her a folder of info. on what we did in Canada and America. She liked it, but was a bit put off by your stating that she was due to come to CEAC—or so she said. I'd like to have a copy of that folder if possible, as she said that it was dual copyrighted CEAC/Reindeer Werk, and I'd like to see what work of ours you've printed." CEAC Fonds 1981-010/14(21). The document likely was "Behaviour School/Scuolo di Comportamento", an unpublished document in the CEAC Fonds 1981-010/011(13), although it was not at all translated in Italian. Larsen's letter also indicated that Marras "was interested in doing a book on the work of the participating artists" of the Workshop but nothing appeared. Marras claimed that the Behaviour School was founded by Reindeer Werk, Marras, and Ron Gillespie. Marras, Amerigo, "Report on the Feasibility of Establishing a Branch of the 'Free University for Creativity and Interdisciplinary Research' in Toronto" (1977), CEAC Fonds 1981-010/012(10), p 2.

45 Bruce Eves in an interview conducted by Mike Hoolboom, "Bruce Eves Interview, 2013", http://mikehoolboom.com/?p=16077.

46 [Editorial], *Art Communication Edition,* vol 1, no 7, August 1977, p 2.

47 "Behaviour School", *Art Communication Edition,* vol 1, no 5, May 1977. After the initiatives with Yona Friedman, "later work, which was greatly influenced by the work of thinkers like RD Laing, David Cooper, Herbert Marcuse, Joseph Beuys, and Ivan Illich, was carried out to encourage the further materialisation of this intention [the self-organisation of society]. Through correspondence with European artists, the CEAC made some steps to initiate what was later defined as a 'behaviour school', that is a place where individual students would experiment with self-exploration for the dialectical formation of a new society."

48 So indicated the masthead to *Art Communication Edition* 7. "The present issue… in its entirety covers the propositions for this Behaviour Workshop at the Free International University."

49 Hoolboom, "Bruce Eves Interview, 2013". For a listing of courses, see "CEAC School", *Strike,* vol 2, no 1, January 1978, p 29.

50 Two documents were written, "Behaviour School/Scuola di Comportamento" (dated 1977, CEAC Fonds 1981-010/011(13)) and "Report on the Feasibility of Establishing a Branch of the 'Free University for Creativity and Interdisciplinary Research' in Toronto". The first was cobbled together from material already published in *Art Communication Edition* and meant for documenta 6 workshops; the second, which we take to be subsequent, was a comprehensive articulation of the school, and presumably was written by Marras to secure funding for research and European travel.

51 "Polemics", *Strike,* vol 2, no 1, January 1978, p 29.

52 Hoolboom, "Bruce Eves Interview, 2013". Marras biography in "Behaviour School/Scuola di Comportamento" reads: "The CEAC constitutes his working place, integrating his availability to anyone, letting others have complete touch with this experiences and the centre's information and with continuous research into other areas of thought."

53 Marras, "Report on the Feasibility of Establishing a Branch of the 'Free University for Creativity and Interdisciplinary Research' in Toronto", p 1.

54 Both to Beuys and Fischer. Fischer's coup de grace was delivered in a broadsheet insert in *Strike* 2: "We reject notions of art like sociological art, which only become extension of the dominant art, or the possibility of creating a pure socialist art within capitalism, because everything that exists in capitalism is subsumed by it." "Dissidence in the 1978 Venice Biennale", *Strike,* vol 2, no 2, May 1978.

55 Marras, Amerigo, "The Re-appropriation of Power", *Art Communication Edition,* vol 1, no 9, November 1977, p 8.

56 "Polemics", p 29.

57 *Strike,* vol 2, no 2, May 1978, p 5.

58 "Brave New Word: Strike!", *Strike,* vol 2, no 1, January 1978, p 2.

59 Marras, Amerigo, "On Organization", *Strike,* vol 2, no 1, January 1978, p 5. Quotations in the next paragraph are from this source, pp 5–6.

60 "Dissidence in the 1978 Venice Biennale" was issued as a "Joint Statement" by the Central Strike Committee, which consisted of Amerigo Marras, Roy Pelletier, Bob Reid, Bruce Eves, Lily Chiro,

and Paul McLellan. You might ask yourself what this small clique was central to, having mimicked the language of a centralised party apparatus, but without any supporters, be they workers or artists?

61 "A developed theory of ideology is important for our discussion of art because art is superstructural and not materially based, therefore art exists within the domain of ideology and an understanding of ideology becomes central to our critique of art." This statement in "Dissidence" was key to the authors' analysis. Was Althusser's notion of ideology brought in by new members of the committee since it was not previously in Marras' lexicon? See Althusser, Louis, "Ideology and Ideological State Apparatus", *Lenin and Philosophy*, Ben Brewster trans, London: New Left Books, 1971, pp 121–173. A New Left Books edition of Althusser's *For Marx*, with its essay "Contradiction and Overdetermination", had just been released in 1977, his *Reading Capital* already being available.

62 One cannot but be struck by the discordant recto-verso juxtaposition of the large image of the Red Brigade red star emblem on the back cover of the second issue of *Strike* and the full-page logo for the Bologna Art Fair (Arte Fiera: International Fair of Contemporary Art) on its reverse. Such advertisements commonly are given in exchange for display tables at these commercial fairs; its placement demonstrates CEAC's desire to participate in a limited way within the art system at its most capitalistic.

63 "Playing Idiots, Plain Hideous", *Strike*, vol 2, no 2, May 1978, p 3.

64 "Waged and unwaged sector of the population is increasing its demands for 'less work'." This is one of the rare mentions of what would align CEAC to Italian Autonomia and other leftist movements advocating the abolition or refusal of work. In a note to the article "Snuff" in *Strike* 3, the authors explained what they meant by "eliminating labour" through a short series of quotations from Marx. The series is quoted wholesale from the publication *Zerowork*, a short-lived American journal that published two issues in 1975 and 1977.

65 Actually CEAC managed a European tour during the controversy with a visit to Yugoslavia (Croatia) and the Bologna Art Fair. Other activities subsequent to the loss of funding were the publication of the third issue of *Strike* and the creation of a one-hour broadcast for Close Radio, KPFK, Los Angeles, broadcast June 1978.

66 "Snuff", *Strike*, vol 2, no 3, October 1978, p 13. Subsequent unacknowledged quotations are from this article. Who was the writer of this text? Was it the same Strike Central Committee that had penned "Dissidence in the 1978 Venice Biennale"? I don't believe all the members of that committee wrote the first text because it maintains somewhat of a stylistic whole. Presumably Amerigo Marras, having been listed first, was one of the authors. But the quality of the writing there, and in "Snuff", changed considerably towards a more fluid reading that suggests one or two others contributed significantly besides Marras, writers for whom English was their first language. This person no doubt also penned the sardonic subject headings in both articles. The addition of new members to the CEAC collective perhaps accounts for the 'correction' of Marras' position in "On Organization" by statements in "Dissidence in the 1978 Venice Biennale".

67 Advertisement placed in Ontario Association of Art Galleries, *Magazine*, winter 1978/1979, p 10.

68 Marras, "On Organization", p 6.

69 "Through *Strike*'s social experiment of radical analysis and provocation, the powers of liberal democracies were forced to contradict their own principles, revealing them to be the illusions of a false ideology. Through direct censorship our liberal democracy contradicted itself when it acted against individuals for their political beliefs through an economic sanction that intended their effective immobilization. It contradicted itself when a cultural body suppressed individuals for their political beliefs, while the political establishment suppressed their cultural expression. It contradicted itself when a cultural body which is supposed to be autonomous from political interests, is dictated to by the political establishment. It contradicted itself when it based such repressive actions on distortion, or used such distortion as a form of indirect censorship." "Snuff", p 15.

70 "This is where we part company even with Marxist artists or philosophers of art, who give a special status to art, seeing it generally as neutral and only certain practices within it as ideologically bound." "Snuff", p 15. Naturally, Althusser would be included within these remarks.

71 "Dissidence in the 1978 Venice Biennale".

72 Gerard Pas letter to Arthur Gelber, Vice-Chairman of the Ontario Arts Council. CEAC Fonds as referred to in Tuer, "The CEAC Was Banned in Canada", p 37. "Snuff" equally argued the separation of CEAC from *Strike*, p 13. In an interview Brenda Wallace, who was the Canada Council officer in charge of parallel galleries but who had left before CEAC's funding crisis, contends that Canada Council funding was not cut. CEAC's renewal was not due until December and that it was another request for a "supplementary projects grant" that was coincidentally denied. Morin and Wallace, "On Parallel Galleries", *Parachute*, p 49.

73 In its Statement to the Press, the Strike Collective (Amerigo Marras, Suber Corley, Bruce Eves, Paul McLellan, Roy Pelletier, Bob Reid) stated: "What position do we take in relation to the BR [Red Brigades]? We present their accusations of the ruling order in an extract of their court proceedings published in our paper. We share their anger and we agree that it is the power sector that must be on trial. We do not believe that terrorism makes any sense in the context here and we question the theoretical basis of any vanguard group that intends to lead or speak for the people, as little better than the farce of representation that exists in the present power structures of the state. We have published this material on the BR to rectify the repressed and distorted coverage they have received by all media." Quoted in Tuer, "The CEAC Was Banned in Canada", pp 35–36.

74 "Our tools were not guns but: radical analysis at the level of general theory; criticism at the level of specific polemics; and the use of a strong visual and verbal imagery drawn from reality, as a means of bringing about a confrontation with a factuality many ignore, and as an aide in provoking debate." "Snuff", p 13.

75 June 1978 broadcast on Close Radio, Los Angeles. It can be accessed at www.getty.edu/art/exhibitions/evidence_movement/audio/podcasts/closeradio.html

VENOM

a. SECRET vs SECRETION.

Everything is already there, available for the using. Any selection exercised by each person is dependent upon the knowledge over reality: **ideological behavior.** Witholding information makes for secrecy and slows down the possibility of letting others know. To know is to have access, to know is to potentially know even more. This access in turn extends further the limits of our reality and the potential of further secretions.

b. INTRODUCTION OF POISON INTO THE SYSTEM OF THE VICTIM.

Social organization is perceived as a set composed by individual units within classes or within differentiated roles of the same class. The relationship (distance) between individuals/groups determines the conflict/agreement between them. Each set of individuals tends to include/exclude the other as a process of elimination-dissent. Others call it generation gap, cold war, class struggle, or simply asphyxiation.

c. MALIGNANT VIRULENCE.

Normalcy is the norm established to lower the possibility of unbalancing the established control. To eliminate the balance is to remove the factors that build order. If we switch position/role of a guard with the inmate, the position/role of a judge with the accused, the position/role of the adult with the child, we come up with a different order of the world. To propose a switch is to question the established order: **norm deviation.** The concretisation of the question equals the epidemic disruption of society, which system is mor likely to react violently.

Antipathies and Sympathies

In the downtown Toronto art scene treading the line was often the case of drawing lines. Postures were antithetic positions. Romantic individualists or sentimental humanists, nihilist anarchists or diehard Marxists, never the twain would meet... except in magazines, it seems. This was a pattern in Toronto where discursive antagonisms were acted out in publications. Toronto talk was more than bar chatter. In part, this was possible because during the 1970s there were no fewer than 11 artist-run magazines active in Toronto. But not all of them carefully trod the line between ideological analysis and character assassination. Really, it is a wonder that there were not libel suits. The A Space 'coup' had a near slanderous afterlife in *Only Paper Today* and *Centerfold*. *Art Communication Edition*, later to become *Strike*, waged a war not only against individual artists but against art itself. It was always handy to have a magazine at your disposal, as editors were often the ones who wielded the antagonisms.

It took both antipathies and sympathies to make the Toronto art scene—which makes it no different than any other art community. But what distinguished Toronto, at least in its conviviality, was the intersection of the practical and the social. Artists both performed in and made each other's works. Video artists and photographers had key roles. Often allied to artists' publications, the photographer's studio supplanted the painter's as a social site that moreover articulated the various artefacts of the scene's dissemination. Meanwhile video created a rotating cast of characters that became the 'superstars' of a local soap opera. Practices were fictional as much as, well, practical. The social scene was reflected in those practical habits so much so that the scene then became a subject to itself—as a fiction of itself. It was an art scene if you said so... or showed your fictions of it to each other. As such, in retrospect, many of the period's artworks can be read as allegories of the creation of an art scene.

Amerigo Marras, "VENOM", *Art Communication Edition* 7, August 1977

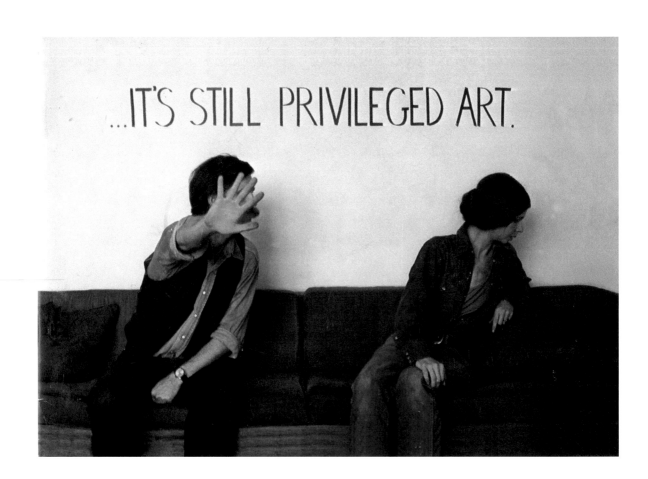

Antagonistic Couples

"Bourgeois Bitch"

As an MFA student Susan Britton had been inured to and endured the endless political discussions and factional divisions that Art & Language and other visiting artists like Carole Condé and Karl Beveridge introduced to NSCAD. She, too, was a Marxist. So when she produced the 1976 videotape *Why I Hate Communism No. 1*, we wonder, by evidence of the title alone, who is speaking... and from what position? Its counter-revolutionary stance is ambiguous, to say the least. For this supposedly Marxist artist is espousing liberal bourgeois notions of art as pillow talk—and, rightly, she is 'corrected' by her more politically astute male partner. But the tape is more complex—and ambiguous—than this. In the role the artist is playing, Britton is being 'fucked' by her unseen partner—not actually, but the camera sways rhythmically above her naked torso as if so. Between thrusts her partner asks her why she hates communism. She is glad to reply, she says, and does so in a manner Amerigo Marras and Condé and Beveridge would object as the romantic individualist delusions of a petit-bourgeois artist. Her partner agrees but goes further, calling her 'bourgeois bitch' or 'fucking bitch' and slapping her aggressively for her comments on beauty, art, and individuality. A sophisticated non-Marxist equally might object to the idealist banality of her remarks on art but not condone the brutality of her lover's response. Clearly, there is identification with neither role. As a political artist, Britton herself cannot possibly identify with the role she is playing; as a woman, she cannot identify with the abusive sexism of her male partner who occupies the power position. It is as if she embodies Stokely Carmichael's famous 1964 statement that "the only position for women in SNCC is prone", though she is supine here.

So what position do we in 1976 take between Marxism and feminism knowing the patriarchal attitudes of male-dominated political movements,

Carole Condé and Karl Beveridge, *It's Still Privileged Art*, 1976 (front cover)

Kim Tomczak, *Susan Britton*

whether Civil Rights, student, or New Left? Or is this opposition badly phrased? Is the issue too complicated to pin down this wayward artist? Or does the video actually signify Britton's disaffection and disillusion with political positions in art, period?

How different the complications of this coupling are from the unambiguous balletic romanticism of Condé and Beveridge's *Art is Political* and the harmony of couple to cause and each other that this work expresses. Yet, we know that Condé and Beveridge's It's Still Privileged Art was founded on feminist principles, too. Why then the lack of a common front between political artists that these two works convey: one earnest, the other ambiguous? Was it that Britton was interested in "trying to get beyond a static and simply didactic take on the world and develop a more intuitive class consciousness"?[1] We know where these artists agreed. We know, for instance, that Britton and Beveridge were in solidarity against semiology, Britton to its "current vogue", Beveridge to its "fadish" dilettantism in the art community, Toronto being no exception.[2] But this commonality was not enough to dispel the sheer antipathy between individuals—indeed of Britton and Beveridge themselves. What did this antipathy represent?

By 1979 intuitive class-consciousness was feeling bitchy. It lashed out at the political didacticism of the Toronto art world and found its target in *Centerfold* magazine. It was usually the other way round: *Centerfold* finding its target in the art world. (As *FILE* mimicked *LIFE*, *Centerfold* functioned as *TIME* and saw itself as a newsmagazine produced by and for artists.) In her article "Poison Pen Attack Gang of Four/You Want Know about Hegemony", a review of the May 1979 issue of *Centerfold* written for Toronto's *Artists Review* (and as if still in character from one of her insouciant videotapes), Britton criticises *Centerfold*'s "pedantic" and "patronizing" relation to artists; the editors' "self-congratulations for the moralizing liberal stance"; and their "harangue in the name of ideology that is didactic and self-righteous". Moreover, she complains of their disparaging "licence to slander bohemia", a designation for the artists who do not make proper and effective, that is to say "virtuous and moral", political art; furthermore, the editors themselves cannot muster an adequate class analysis, theirs being "neither dialectical materialism or an evolution of same, it is sentimental humanism".[3] Britton had crossed the line. Had she not been feted in *Centerfold* as recently as February that year in a long article on her recent video work, a fact that editor Clive Robertson reminded readers in his letter of response to *Artists Review* not to bite the hand that fetes you.[4] Contributor and future associate editor Karl Beveridge was delegated to correct Britton's 'personalist' aberrations in the following *Centerfold*. Here was the negative review Robertson warned of. Conveniently Britton's new videotape *Me$$age to China* was at hand to dismiss. Since Britton made so-called political art

she had to be answered politically: "Susan Britton's confusions would be of little concern were they not formally wrapped in political phraseology. As such they need to be answered politically. What could constitute an informed analysis of political language and practice becomes an adolescent rejection of rational thought." It is thus that she could be ridiculed from the title on ("Colonialist Chic or Radical Cheek?") as a "bright, lively, middle class woman" unable to recognise "the determining role of economic organization on social relations, that is the alignment of social classes". She started off the right way but "One thing for sure is that Britton is disillusioned. Her idealism got racked up somewhere along the line. But the idealism that once informed political involvement is the same that now informs her anti-political hysteria." No doubt Beveridge would say that her appearing and acting in *...And a Woman* spoke the literal truth of Britton's romantic individualism and *Why I Hate Communism No. 1* her nihilism. All this would be very easy to dismiss, but Beveridge warns, "Ironically, this romantic individualism, a product of middle class idealism, when pushed against the wall forms the ideological basis for what is ostensibly opposite, fascism. *The punk sensibility treads a very thin line.*"[5]

Kim Tomczak, *Karl Beveridge*

Mad Magazines

Toronto in the 1970s was the golden age of artist magazines.[6] These were no Xeroxed punk 'zines but sophisticated print products circulated nationally and internationally. As many magazines as there were, you had to watch your back. Karl Beveridge had to battle 'personalism' on two fronts: one against guerrilla attacks from the sidelines (the photocopied *Artists Review*) and the other from friendly fire from the magazine he worked with (*Centerfold*). In the very issue Beveridge corrected Susan Britton, Tim Guest attacked Condé and Beveridge's *Maybe Wendy's Right*. Guest cited the "unfortunate example" of their workerist exhibition for its "naive politics and bad art". In the next issue of *Centerfold* Condé and Beveridge answered, admitting that Guest's review "was okay, given the usual hysterics that pass for the criticism of 'political' art", but they questioned, "What is the ideological basis of Guest's personalism?"[7]

It seems that there could not be a month without editorial putdowns, ideological intrigues, letter-to-the-editor brawls, or unpredictable back-stabbings on full display in a variety of magazines. A turncoat case in point, besides Britton's, is Clive Robertson's critical switch of support for General Idea. The two could be friendly from afar when Artons still published *Centerfold* in Calgary, but once Artons moved into the warehouse building it shared with Art Metropole in autumn 1978 a couple blocks up from the recently defunct CEAC, the art scene's new centre of gravity, editor/publisher Robertson began to be infected by the internecine strife common to his new community. In his 1978 article on General

Idea's Reconstructing Futures exhibition at the Carmen Lamanna Gallery, Robertson complimented the trio, saying: "If I have learned anything about General Idea in the last five years it is that their initial frames of reference were so intuitively correctly selected as a panoply to deal with North American life that their tireless encapsulations of social research will long outlive the more redundant contexts of contextualism, performance or technological graffiti of the N. American art world."[8] Yet, a year later Robertson criticised General Idea in their next commercial outing for being exhibiting artists out to sell, as if in proof of their 1975 Glamour manifesto: "This is the story of General Idea and the story of what we wanted. We wanted to be famous, glamourous, and rich." Similarly, Robertson suggested applying General Idea's own criteria of success, "It isn't art unless it sells", as stated in *Press Conference*, to their own work. Robertson contends that "not all their work, as defined by them, is effective".[9] Made to sell, the work in the exhibition, he claims, was decorative kitsch that at times was politically retrograde. In Toronto, not only Pavillions, but bridges were burned, too!

Individuals did not speak only for themselves in these disagreements. Individuals were entities, too; that is to say they composed institutions and represented their interests. Polemics were phalanxes pitted against each other. Institutions and individuals were conflated. General Idea was Art Metropole and *FILE* magazine. Clive Robertson was Artons and *Centerfold*. And for a while Victor Coleman was A Space and *Only Paper Today*, and then only *Only Paper Today*—which then became a vehicle for Coleman to attack A Space's new regime after its 'palace coup'. An ousted director of A Space in AA Bronson's calculated coup, Victor Coleman took revenge through word count and column inches. *Only Paper Today* specialised in experimental literary and art writing, and Coleman himself was a leading poet, so riposte was ribald resentment as well as ridiculing revenge.

Institutions were points of view as well as the individuals that operated them. They were resources that gave access to funding that allowed publishing and, hence, the dissemination and dominance of one's stance. Institutions represented ideological positions. "Publishing is, in the sense we use it", Clive Robertson writes in a letter from the publisher announcing removal of *Centerfold* to Toronto, "a paradrop of ideologies".[10] But if publications were ideological fronts consciously directed to fulfil specific agendas, as Robertson believed, taking positions sometimes was more unconsciously revelatory. Take *Art Communication Edition*. It was a front for CEAC, initially disseminating its artistic programme, then its political one. There was none so outspokenly 'antithetical' as *Art Communication Edition*, but unspoken rivalries sometimes drove its ideology as much as what was consciously articulated.

Mimic Magazines

Perhaps CEAC's history is fated to be an oppositional one. Not only did CEAC see itself a rival, "it was cast in opposition to A Space", Dot Tuer suggests in her history "The CEAC Was Banned in Canada".[11] In telling her story, or rather in setting it up, Tuer casts another opposition, which better suits our purpose here. She opposes CEAC and General Idea by opening her article with two contrasting epigraphs drawn from their two rival publications: *FILE* and *Strike*. The first she presents is from General Idea's famous Glamour manifesto of 1975, in which the artists write:

> We wanted to be famous, glamourous and rich. That is to say we wanted to be artists and we knew that if we were famous and glamourous we could say we were artists and we would be. We never felt we had to produce great art to be great artists. We knew great art did not bring glamour and fame. We knew we had to keep a foot in the door of art and we were conscious of the importance of berets and paint brushes.

And the second is from Amerigo Marras' not-so-well-known 1978 article "On Organization":

> What perpetuates the reactionary mystification of the role of the artist is the 'world of scarcity' and the 'incapacity to survive' in a capitalist society. The artist defends the privilege and the entrenchment he/she holds in a capitalist society. Also symptomatic, even and not less so among the vanguard, alternative and co-op artist's groups, is the sense of hopelessness for social change, as these same groups mimic those repressive methods of economical capitalization adopted by the art world.[12]

One might argue this set up is too easy given that General Idea's "reactionary mystification" was nothing if not ironic.[13] Nevertheless, General Idea's empty shell of history becomes the empty rhetorical figure against which Tuer contrasts the fullness of CEAC's forgotten revolutionary materialist practice.

"Miss General Idea hangs around the left stage area for much of the action", Tuer writes of CEAC's cast of characters, as if General Idea's muse sought inspiration there for the artists' parasitic plagiarism.[14] But what if General Idea and CEAC were in secret communication, especially through their respective publications? And what if this communication naturally was one of rivalry? Let's extend Tuer's epigraphic opposition between the two to see whether we can productively trace their communication through this period when both *FILE* and *Art Communication Edition*, later to become *Strike*, were publishing. Doing so would enable us to read certain editorials and articles as critiques of the other's practice.

It would cast CEAC and General Idea's competitive relationship in a new light. Moreover, it would reveal a struggle for the assertion of a particular practice. Let's for the moment call this practice political. In effect, theirs was a struggle for the ideological domination of the Toronto art community.

It was more than just a battle of words. CEAC was as institutionally rivalrous with General Idea's empire as it was with A Space's. We can trace parallels through much of their activities. Both originating in commune-like situations, each instituted major multifaceted artist-run organisations. The Kensington Arts Association began in 1973 and became CEAC when it moved to Toronto's warehouse district, soon to become the centre of the art scene, in 1976; Art Metropole started on Yonge Street in 1974 and moved a couple blocks away from the defunct CEAC in 1978. Both conducted publicity campaigns and tours in Europe and New York. And, significantly, both published magazines.

In the end it was the words that mattered. This record is found in the magazines each individually published. Eventually self-serving, both publications originally fulfilled other functions. Modelled on *LIFE* magazine, *FILE*, 1972–1989, was the house organ of the short-lived correspondence movement before it became a vehicle mainly for General Idea's own mythological production and promotion of international fellow travellers (eg, the *mondo arte*). *Art Communication Edition* published for about a year (from late 1976) when it changed its name to *Strike* and produced three issues in 1978 before expiring. Publishing nearly monthly, it began really as a newsletter for CEAC activities but soon became a broadsheet in which the war of words, with General Idea sometimes as target, eventually escalated. While a target, General Idea was never named specifically, nonetheless, a close reader of both magazines would recognise the code words signalling a critique of their practice.

The opening communication between CEAC and General Idea took place just before *Art Communication Edition* started publishing through the auspices of a third artist-produced newspaper, *Only Paper Today*, which A Space published as a journal of experimental art and literary writing serving the Toronto art community.[15] *Only Paper Today* published an interview with Amerigo Marras by Robert Handforth, the ostensible purpose of which was to inform readers about the opening September 1976 of CEAC's new space and, indeed, remarkably, the ownership of a whole building, in addition to articulating the artistic programme and direction of this elusive organisation.[16] Handforth was then one of the directors of A Space, soon to resign in September 1977. As he was already an Art Metropole employee, perhaps he was seen to be fully in General Idea's camp, so in conveying information about CEAC to *Only Paper Today*'s readers, Marras also spoke obliquely through his interlocutor to General Idea. When asked whether CEAC was just another name for the

Kensington Arts Association, Marras obscurely replied: "Well you see, the K. A. A. is still alive and well. But the K. A. A. is now behind the props—the frame of reference." This is a noteworthy answer because, with its props and frames of reference, it exactly repeats the language of General Idea's fictitious *The 1984 Miss General Idea Pavillion*, which included props and plans that had been unveiled by General Idea in their Carmen Lamanna Gallery exhibition Going thru the Notions in autumn 1975, still fresh in memory. Handforth continued, "So now it's K. A. A. operating as CEAC", and Marras again enigmatically replied, "Yeah. CEAC is the public front. We wanted it to be descriptive." As in the case of General Idea's Pavillion, Marras projected CEAC as the rhetorical—you could say, performative—front for a collective activity, but one not so visibly focused on an artwork as in the case of General Idea. If this front was "descriptive", did Marras then mean—here having adopted General Idea's language—that he considered it to be mythological, too? For "description" was the classifying term used by General Idea for the mythological universe of correspondence art:

> I am not concerned with breaking myths, nor with making myths, but with the structural implications implicit in mythology's view of the universe. In myth it is clear that *everything* must be accounted for. Unlike science, myth starts with a vision and fills in the blanks. It structures a cosmology through description, not analysis.[17]

Myth was a disjunctive, even destructive, model allied to the cut-and-paste of collage that led to a synthesis—to new myths of alternate lifestyles:

> In this article seeing art as a system of signs in motion as an archive and indicator and stabilizer of culture as a means of creating fetish objects as residence for the field of imagery defining a culture, seeing all this and more in many ways we have become aware of the necessity of developing methods of generating realizing stabilizing alternate myths alternate lifestyles.[18]

Between 1973 and 1976 were already different worlds, so General Idea's earlier accounting for—based on Claude Lévi-Strauss' structural anthropology—was supplanted by Marras by another all-inclusive 'mythic' model: Marxism. Not for him any synthesis, Marras simply preferred disjunction. Refusing to answer Handforth's question about artistic policies, he said instead: "Usually what we try to do is build up contradictions—without ambiguity."[19] With this turn of phrase, Marras turned CEAC in opposition to General Idea, for General Idea was for ambiguity without contradiction, a concept evident in the title of one of their 1975 Pavillion blueprints, *Luxon Louvre (Ambiguity without*

Contradiction). Marras' clever, chiasmatic inversion contradicted General Idea's enterprise at its core by formally attacking their fundamental principle of ambiguity. He would always fundamentally oppose contradiction to ambiguity.

What would the antithesis of ambiguity and contradiction be? It would oppose a system of meaning to a system of conflict, of unending fluctuating interpretation to an explicit provocation that was non-stop.[20] It was not that General Idea saw themselves beyond conflict. General Idea considered Glamour a 'battleground', but the artists also thought of it as beyond Marxism. With the insouciance of a fashion-magazine caption, General Idea wrote: "Glamour replaces Marxism as the single revolutionary statement of the twentieth century."[21] Marras himself would rather forestall this replacement. He preferred his Marxism unadorned, or at least adorned with nothing but rhetoric. Yet he was not ready to quit his dialogue with General Idea and set their opposing journals on divergent paths. It appears that Marras saw *Art Communication Edition* as a means of a continuing critique of General Idea. For instance, the second issue of *Art Communication Edition* from early 1977 carried the article "Four Leading Questions as Principles of Revolutionary Practice". Simply stated, it was a radicalised answer to General Idea's Framing Devices, the artists' five-point agenda or master plan first promulgated in 1975, but it assumed much the same format. Compare the following:

> What is Art & Communication?—It is interface impact conducive within social forms as frames, structures, behaviour. Art as materialist practice and communication as dialectics in juxtaposition along contextual layerings produce revolutionary effects. Art & Communication is basically this: dialectical materialism practiced as ideology.[22]

> THE FRAME OF REFERENCE is basically this: a framing device within which we inhabit the role of the general public, the audience, the media. Mirrors mirroring mirrors expanding and contracting to the focal point of view and including the lines of perspective bisecting the successive frames to the vanishing point. The general public, the audience, the media playing the part of the sounding board, the comprehensive framework outlining whatever meets their eye.[23]

Despite their obscurity, the manifesto-like character of both pronouncements implied, theoretically at least, an incitement to action or at least participation. The measure of success for both was their effectiveness in the public realm. Yet, we have to consider whether the

closed frameworks of "mirrors mirroring mirrors" or "juxtaposition along contextual layerings" were not just self-serving rhetorical devices that had no practical effect outside their art context. However, these statements were themselves performative: they were means of their own enacting. They were their own effect, so to speak. They were an analysis of their own intentions as much as they were an analysis in extension, outside themselves. Players within the art scene, in the end it would be a matter of how CEAC and General Idea negotiated their specialised rhetoric in relation to a purported public realm. Effectiveness would be a matter of survival.

In its July 1977 *Art Communication Edition* editorial, CEAC strategically chose its enemy and thereby specified a role for the journal: "Art Communication Edition proposes for itself the role of being the 'antithesis to dominant ideologies', rather than the role of being alternative to the hegemony of commercially motivated journals."[24] An interesting distinction: Why discriminate between dominant ideologies and a specific form of transmission, even if it was the type one operated through? One wonders whether the 'antithetical' versus the 'alternative' was the new formula of the previous opposition of 'contradiction' and 'ambiguity'. For the article was a veiled attack on General Idea, who once again were not mentioned by name but obviously were representatives of 'alternative'. Only halfway through the article at the mention of *People* magazine, one of those commercially motivated journals, do we realise that it was not only the Time Life publication being questioned but also General Idea's newly formatted *FILE*. Or at least we were made to understand that *FILE* basically operated in the same manner as *People*: "How does 'people' magazine communicate to us? It teaches a 'popular' language" that reflects its audience as stereotypes of its own repression.[25] Marras' critique was topical. In the spring 1977 issue of *FILE*, General Idea disclosed the Time Life lawsuit against the artists for *FILE*'s simulation of *LIFE*. General Idea eventually complied by changing the look of the cover but surreptitiously got the last laugh by making that issue into a 'SPECIAL PEOPLE ISSUE': "FILE was entering the no-no-nostalgia age in preparation for 1984 and in keeping abreast of the TIMES was becoming increasingly concerned with PEOPLE."[26]

Marras thought the joke rather was on General Idea still playing its game of mimicry by inhabiting various hegemonic formats, that is, merely playing a role of being alternative. *FILE*, of course, was a vehicle for simulation of dominant *LIFE* magazine: "We maneuver hungrily, conquering the uncontested territory of culture's forgotten shells—beauty pageants, pavillions, picture magazines, and other contemporary corpses. Like parasites we animate these dead bodies and speak in alien tongues."[27] Two years later, Marras responded:

We know that mimicry is only the immature and most immediate response. We respond with safe patterns that are recognizable as the parody of the dominant 'culture'. The mimicry is only falling into the same view of history (of heroes). The correct pattern is, instead, being antithetical to the dominant culture; to completely break away from the main direction is to deny classifying oneself as alternative. We reject the process of absorption. We reject the process of parodying.[28]

By so openly rejecting General Idea's artistic practices of simulation (parody) and inhabitation of roles (absorption), Marras covertly rejected his mimicking rivals. To be antithetical was *not* to be alternative. One was either for contradiction or for alternative. There was no other choice. Marras concludes: "This argument brings in an important issue in the so-called alternative circles. We do not stand as alternative but as antithetical to dominant ideologies. To be antithetical is to reject any 'coming back' syndromes so pedantically proposed in reaction to revolutionary activisms." Presumably these coming back syndromes refer to General Idea's retro camp sensibility. Retro was the wrong camp. To be revolutionary meant first being factional. CEAC's factional enemy in the Toronto art scene was General Idea.

A new antithetical faction surfaced in the Toronto art scene that briefly united the two groups—for, however, rather than against. For the one thing General Idea and CEAC temporarily could agree on, when it broke in Toronto in summer 1977, was punk. Significantly, CEAC helped spawn it by playing host to the Crash 'n' Burn punk club in the basement of its Duncan Street building. General Idea, too, had a role to play promoting it by devoting a whole issue of *FILE* that autumn to "Punk 'til you Puke!" General Idea knew a good incendiary act when it saw one, so under the influence of punk it 'burnt down' its Pavillion soon after. CEAC would use the hard edge of punk to deliver its own hard-line message. *RAW/WAR*, a 7-inch record with CEAC slogans ("you people are the police") interspersed between the Diodes' raucous short-burst instrumentals, passed as the eighth issue of *Art Communication Edition* complementary to *FILE*'s "Punk 'til You Puke!" issue.

Already in July, CEAC had sent a letter from the frontline trenches ambivalently titled "Spanking Punk": "The latest rebellious form for Toronto's youth scene is the rave of *crash 'n' burn* punk rock groups."[29] Ambivalence would soon turn to antipathy a month after the release of *RAW/WAR* when the editorial to *Art Communication Edition* 9 (November 1977) unambiguously dismissed the latest rebellion:

In the western capitalist countries the Fall has cooled the steam produced by the 1977 summer of rock. Punks, mannerists, opportunists, nouveaux riche, promoters, fashion burnt, and all the other idiots fallen into the

image of anarchy as dictated by the vogue punk, rush towards the cliché of fashion like flies to a mound of shit. The fashion, the image, the shit has been widely explored and exploited by the mass media. Even the usual 'avant garde' magazines [read: *FILE* magazine] have covered the news while putting themselves into the picture.[30]

As if anticipating a critique of *FILE*'s later "$UCCE$$ Issue", the editorial goes on to say: "Capitalization has taken place as the time to cash in arrived. At last, the idea of anarchy makes money and the economical statement that punk rock might have made in the beginnings is forgotten." The editorial coyly concludes: "And we are ready to place the right device in the right place. Does any one understand what we mean?"

For those readers who did not understand, perhaps not exactly comprehending the turn from anarchic punk to revolutionary politics, CEAC placed this device and exploded a bomb in the second issue of the newly renamed *Strike* in May 1978: "We are opposed to the dominant tendency of playing idiots, as in the case of 'punks' or the sustainers of the commodity system.... In the manner of the [Red] Brigades, we support leg shooting/knee capping to accelerate the demise of the old system."[31] In a turn to world-historical revolutionary politics, *Strike*'s editorial board could not resist one last localising dig here at General Idea. Who were these players, either punks or (art) supporters of the commodity system, but those who self-identified with "the creampuff innocence of idiots"? General Idea, that's who.[32]

So obviously dismissed as a rival, would General Idea strike back? No, because when we look at the evidence of print, the rivalry between CEAC and General Idea was decidedly one-sided. Was this then a case of mimetic rivalry on CEAC's part alone—more mimesis than antithesis? Or was *Art Communication Edition* actually a serious critique of General Idea, unnamed though the artists ever were? This is part of a larger question: was antithesis merely a rhetorical device on CEAC's part or was it actually effective? How seriously do we take a statement of theirs such as: "We want to simply eliminate the dominant culture 'tout court'"?[33]

In the process, did CEAC want as well to eliminate General Idea *tout court*? At the height of punk Marras published an article with the anti-social title "VENOM". Under the heading "Introduction of poison into the system of the victim" we read: "The relationship (distance) between individuals/groups determines the conflict/agreement between them. Each set of individuals tends to include/exclude the other as a process of elimination-dissent. Others call it generation gap, cold war, class struggle, or simply asphyxiation."[34] CEAC and General Idea were mere spitting distance apart. Was Marras describing his own relationship to General Idea here? We recall that poisoning was a primary counter-strategy of Glamourous General Idea in their viral inhabitation of mainstream

media.[35] Indeed, mimesis was a subtle, invasive form of venom, which Marras had earlier rejected as absorption. Had General Idea all along infected CEAC, especially virulent Marras in his "conflict/agreement" with this rival group? Would this require its "elimination/dissent"? The theory of mimetic rivalry is that one kills what one copies.[36]

Yet, CEAC believed being antithetical was effective, especially in the move from the art system, where it considered consumerist General Idea to malinger, to the social realm of politics per se, where CEAC itself wanted to operate. So the editorial board explained in the inaugural issue of *Strike*:

> Are we supposed to explain the switch from Art Communication Edition to *Strike*? We want to come out closer to the de-training programme, opposed to service systems. We want to *effectively* move on and merge with the social stance that we foster. We know that within consumerist tactics, the antithetical position, as explained in issue 6 of Art Communication Edition, is an *effective* strategy [emphasis added].[37]

"Effective" was *the* word in the Toronto art scene. "During the last couple months the discussions [at CEAC] have been centered around the meaning of counter-information, counter-productivity, terrorism, the possible actions that create *effective* change, to a practice of scrutinizing texts and pinning down its obscurantist ideological incorrectness" [emphasis added].[38] In these discussions, CEAC may have passed beyond scrutinising General Idea's "obscurantist ideological incorrectness", but its rivals were talking about effectiveness, too—as in "What do you mean by 'effective' art?"

Such was the lead question to *FILE*'s "Punk 'til you Puke!" editorial—of all places. The answer was a little less effective... or was it? "Obviously art that has effect. Obviously art that affects an audience. Obviously being effective requires an audience. Obviously art that has an effect is art that has an audience."[39] This exercise in circular reasoning did not really answer the question of what was an effective art. However, more than asking the question, General Idea was making art about it as well. Not that it was necessarily making effective art, because who, for instance, was its intended audience? But it was posing the answer—performing it, that is. So it is to the artwork *Press Conference* from March 1977 rather than the "Punk" editorial that we must look to for an answer to this pertinent question.

Conducted at Western Front in Vancouver, this faux press conference was called to address the issue of effective art. It seemingly cynically concluded with the statement: "It isn't art unless it sells." But selling meant being "culturally operational", a situation where the artwork sold

General Idea, *Press Conference*, 1977, video

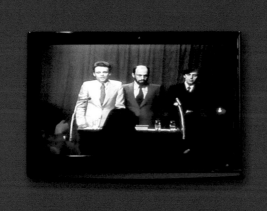

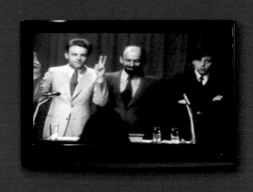

itself and its context, and where the objective was to "get the public to act on the basis of your work". Art was "not merely a medium for personal expression but potentially also a powerful cultural tool" and an "effective generator of cultural information that warrants consumer acceptance."[40] The press conference mimicked the language of a marketing sales pitch, as if culture was business and art its product, yet the performance maintained the artificiality of the set-up: playing to the camera with a complicit audience of equally faux journalists. Despite what they advocated in their "Punk" editorial, the artists chose to remain within the framework of the art system: "the best way is to test an idea first in a controlled situation like the art scene, look at your feedback, and then continue from then on". General Idea never intended to exceed the art frame and statements here were not meant to be taken literally as some, in light of their own notion of political effectiveness, proceeded to do.[41]

What of *Strike*'s editorial statement that, "We want to effectively move on and merge with the social stance that we foster"? How effectively did CEAC manage the crossover from art world to public domain? In his article in that issue, "On Organization", Marras admitted right away: "I am approaching the toleration limit to any further internalization of the notion of 'art' and/or 'art as something else'."[42] Presumably, effectiveness was to be found outside the art system, not, as in the case of General Idea, internal to it. Art essentially was a "cover-up" for maintaining the class system; even its discourse was suspect: "When we discuss 'art', we are actually using the discourse as a pretext for established relationships in a class structure."[43] But CEAC never could abstain from a discussion of art or from participating in the art system, although exempting itself presumably from the stigma of maintaining class relations for doing so. *Saying* the word 'class' seemed enough to absolve one from the contradictions of one's own position. In the end CEAC really was about rhetoric not politics. Rhetoric was detached from any real political end. Rhetoric automatically maintained the internalising art frame. Effectiveness was a matter of audience. Who, after all, was CEAC speaking to? Effectively moving on to "merge with the social stance that we foster" garnered attention CEAC didn't want—or expect. It reached an audience outside the art frame... and we know what happened then.

CEAC's demise left the field to General Idea. Was General Idea effective? They survived. Survival is effective. Survival of the species, of the genus, of the general idea. *FILE*'s "$UCCE$$ Issue" was 'proof' of their success. To survive, though, meant being adaptable, but also elusive as the artists had earlier stated:

> The triple strategy of Glamour is simple but evasive:
> 1. Concealment, ie, separativeness, postured innocence.
> 2. Hardening of the Target, ie, closure of the object, a seeming immobility, a brilliance.

3. Mobility of the Target, ie, the superficial image hides an APPARENT emptiness (changing one's mind, shifting stance, 'feminine' logic).[44]

There would be no "effective immobilization" of General Idea's activities by the government, even if "like customs agents on the borders of acceptance, we smuggle transgression back into the picture, mixing doubles out of the ingredients of prohibition".[45] General Idea had always made itself into a moving target. CEAC made itself into a static target of the media and politicians. Could it get mobile again, by learning anew? Could it take lessons from an old foe? Its final word on the role of art suggested so: "The only valid purposes for art in a pre-revolutionary situation are: as a front which, by its potential for ambiguity, is an easy means of obtaining government and corporate funds to put toward the revolutionary cause; or as a *direct* tool for *explicit* communication and provocation in the class struggle."[46] There would be no more contradiction without ambiguity, it seems, for CEAC. Rather the proposed aim was a combined "ambiguity" and "explicitness". The issue, perhaps a contradiction given CEAC's immediate circumstance, was keeping the knowledge of one from the other: the funding from the provocation. From whom did CEAC learn to dissemble? From General Idea, perhaps? Or was it dissembling all along?[47]

1 In a letter to CEAC requesting funding for a new work entitled *Toward a Correct Analysis*, Britton wrote: "To briefly discuss this piece I would say that it can be viewed as being in opposition to the current vogue of the French semiologists in their relation to much discussion of recent art, (ie, Barthes, Foucault, Althusser); that is, I am trying to get beyond a static and simply didactic take on the world and develop a more intuitive class consciousness. I will be trying to do a piece that has its roots in class instinct rather than objective fragmented discourse, leading toward an answer to the question, Art and Culture, for Whom?" CEAC Fonds, Clara Thomas Archives and Special Collections, York University, Toronto, 1981-010/27(11).

2 Beveridge, Karl, "Sado-Anarchism?", *Centerfold*, vol 3, no 3, February/March 1979, p 127.

3 Britton, Susan, "Poison Pen Attack Gang of Four/You Want Know about Hegemony", *Artists Review*, vol 2, no 16, 9 May 1979, pp 13–14. The Gang of Four, of course, was the faction associated with Mao, which included Madame Mao, in political control during the latter part of the Chinese Cultural Revolution. They were arrested after Mao's death in 1976 and put on trial in 1981.

4 Calling Britton a "smiling (so far uncriticized) artiste", Robertson replies, "Artons (publisher of *Centerfold*) organized the 1978 Canadian Video Open, awarding Susan Britton with one of two cash prizes. *Centerfold* then published an interview with Britton. More recently we printed a lengthy favourable review of Britton's new work." Robertson, Clive, "Take the Money and Run Susan", *Artists Review*, vol 2, no 17, 23 May 1979, p 6. Indeed, one of the editors she attacked, Lisa Steele, had written the recent article.

5 Beveridge, Karl, "Colonialist Chic or radical Cheek?", *Centerfold*, vol 3, no 5, June/July 1979, p 271. 'Poetic' nihilistic refusal of authority rather than rigorous class analysis was the issue. Punk was a very thin line between nihilism and fascism but also between anarchism and fashion; the second was as much a worry as the first. Lisa Steele had subtitled her earlier positive *Centerfold* article on Britton "Bakunin meets British Vogue" and concluded "But advocating the anarchist response... should not become just another fashionable stance." Steele, Lisa, *Centerfold*, vol 3, no 3, February/March 1979, p 120.

6 The photo magazines *Image Nation* and *Impressions* were founded in 1970, as was *Impulse*. *FILE* began in 1972 and *Proof Only* in 1973, the next year to become *Only Paper Today*. *Art Communication Edition* and *Parallelogramme* commenced in 1976, *Artists Review* in 1977, and *Centerfold* moved to Toronto in 1978. As well, the independent dance magazine *Spill* began publishing out of 15 Dance Lab in 1976 and the Music Gallery started *Musicworks* in 1978.

7 Guest, Tim, "Maybe Wendy's Right", *Centerfold*, no 3, vol 5, July 1979, pp 277–278. Condé, Carole and Karl Beveridge, "Letters; what is the basis of his personalism", *Centerfold*, vol 3, no 6, July 1979, pp 282–283; "Tim Guest replies", p 283.

8 Robertson, Clive, "General Idea and the Metahive: One beyond the metaphor", *Centerfold*, vol 2, no 2/3, 1978. Robertson places General Idea's work positively in relation to his implied critique of contextualism, Reindeer Werk's behaviouralism, and the schisms of Art & Language. Recently, Robertson had also written an introduction to the catalogue for this exhibition that travelled to Europe.

9 Robertson, Clive, "Consenting Adults: General Idea at Carmen Lamanna Gallery", *Centerfold*, vol 3, no 4, April/May 1979, p 195. We should note the separatist statement, "Know no galleries", published by Robertson in *Centerfold*: "As of the 1st October 1978 I have decided that no object, videotape, artist publication or performance, including lectures or readings, shall be, with my knowledge, exhibited, enacted or viewed in any public, private, educational or artist gallery." Robertson, Clive, "Know no galleries", *Centerfold*, vol 2, no 6, autumn 1978, p 93.

10 Robertson, Clive, "A Letter from the Publisher", *Centerfold*, vol 2, no 4, April 1978, p 5.

11 Tuer, Dot, "The CEAC Was Banned in Canada", *C Magazine*, no 11, 1986, p 28.

12 General Idea, "Glamour", *FILE*, vol 3, no 1, autumn 1975, p 21; Marras, Amerigo, "On Organization", *Strike*, vol 2, no 1, January 1978, p 5.

13 I am not here to advocate for General Idea, having a few years earlier delivered a lecture and published an article arguing for the capitalist basis of General Idea's mystifying system of Glamour. "Sentences on Art" was presented at the Rivoli, Toronto, 22 November 1982, and published as "Editorials: General Idea and the Myth of Appropriation", *Parachute*, no 33, winter 1983, pp 12–23. Reprinted in Monk, Philip, *Struggles with the Image: Essays in Art Criticism*, Toronto: YYZ Books, 1988, pp 131–182.

14 Tuer, "The CEAC Was Banned in Canada", p 25.

15 *Only Paper Today* was published by A Space under the editorship of poet Victor Coleman from 1973 until autumn 1978, when a schism caused by a 'takeover' of A Space led Coleman to publish it under the auspices of the Eternal Network. It continued publishing until 1980.

16 Handforth, Robert, "Amerigo Marras Talks about CEAC", *Only Paper Today*, vol 4, no 2, November/December 1976, p 2.

17 Bronson, AA, "Pablum for the Pablum Eaters", *Video by Artists*, Peggy Gale ed, Toronto: Art Metropole, 1976, p 197. This article is not so much a reprint as a substantial revision and updating of what appeared anonymously, though written by Bronson, in *FILE* under the same title in 1973.

18 General Idea, "Pablum for the Pablum Eaters", *FILE* vol 2, no 1 & 2, May 1973, p 20.

19 Handforth, "Amerigo Marras Talks about CEAC", p 2.

20 "A resonance which is ambiguity flips the image in and out of context. Layers of accumulated meaning snap in and out of focus." General Idea, "Glamour", p 29. For Glamour as a system of meaning in General Idea's work, see Monk, Philip, *Glamour Is Theft: A User's Guide to General Idea*, Toronto: Art Gallery of York University, 2013.

21 General Idea, "Glamour", p 31.

22 "Four Leading Questions as Principles of Revolutionary Practice". Dated 1976, it was published in *Art Communication Edition*, vol 1, no 2, January 1977, p 5.

23 "General Idea's Framing Devices" was published in *FILE*, vol 4, no 1, summer 1978, pp 12–13, but was part of the 1975 performance and video *Going thru the Motions*. Also consider the quotation by Marras: "The quantitative approach I proposed indicated the possibility of going from one system to another by using contextual outlines or structures that formed multiple reference systems or

empty frames." Marras, Amerigo, "Notes and Statements of Activity. Toronto, 1977", *La Mamelle*, no 5, 1977, p 31.

24 [Editorial], *Art Communication Edition*, vol 1, no 6, July 1977, p 2.

25 Marras, Amerigo, "on being antithetical", *Art Communication Edition*, vol 1, no 6 July 1977, pp 3–4.

26 General Idea, "Editorial", in the "Special People Issue", *FILE*, vol 3, no 3, spring 1977, p 17. Note the "no-no-nostalgia" comment which heralds the anti-sentimentality of their "Punk 'til You Puke!" editorial, the equivalent in reverse of punk's 'no future' slogan.

27 General Idea, "Glamour", p 32.

28 Marras, "on being antithetical", p 4.

29 "Spanking Punk", *Art Communication Edition*, vol 1, no 6, July 1977, p 24. Actually, bands started playing earlier that year in CEAC's basement. Also see Marras, Amerigo, "Report from Canada, Part 1: The Punk Scene" (unpublished manuscript), CEAC Fonds, which reveals that he was the anonymous author of "Spanking Punk."

30 "If Anarchy Succeeds Everyone Will Follow", *Art Communication Edition*, vol 1, no 9, November 1977, p 3.

31 "Playing Idiots, Plain Hideous", *Strike*, vol 2, no 2, May 1978, p 3.

32 General Idea evokes history differently when they write, "We moved in on history and occupied images, emptying them of meaning, reducing them to shells. We filled these shells with Glamour, the creampuff innocence of idiots, the naughty silence of sharkfins slicing oily waters." General Idea, "Glamour", *FILE* p 22. In the slippages that accompany the identifications of mimic rivalry, the *Art Communication Edition* editorial stated, "We continue to speak in an alien tongue", unconsciously adapting General Idea's terminology: "Like parasites we animate these dead bodies ['culture's forgotten shells'] and speak in alien tongues". General Idea, "Glamour", p 32.

33 Marras, "on being antithetical", p 4.

34 Marras, Amerigo, "VENOM", *Art Communication Edition*, vol 1, no 7, July 1978, p 4.

35 Miss General Idea "is more akin to poison, that other natural enemy to culture. Like poison Miss General Idea, objet d'art, posed on stiletto heels and bound in the latest fantasy, represents a violent intrusion into the heart of culture: the Canada Council, for example, or beauty pageants (essentially one and the same)." General Idea, "Glamour", p 25.

36 Marras' methodology could be called cannibalistic. He would 'absorb' a colleague's more fully articulated programme of thought then proceed to kill off this individual in print with a stab in the back in *Art Communication Edition* or *Strike*. Marras' treatment of Hervé Fischer of the Paris Collectif d'Art Sociologique is a case in point.

37 *Strike*, vol 2, no 1, January 1978, p 2.

38 "Polemics", *Strike*, vol 2, no 1, January 1978, p 29.

39 General Idea, "Editorial", *FILE*, vol 3, no 4, autumn 1979, p 11.

40 General Idea, *Press Conference*, performance video, Western Front, Vancouver, 9 March 1977.

41 In his review of General Idea's Consenting Adults exhibition, Clive Robertson decided to apply *Press Conference*'s criteria of effective art to their work there. See Robertson, "Consenting Adults: General Idea at Carmen Lamanna Gallery", p 195. In a letter to the editor, the artists responded that they considered "*Press Conference...* more concerned with the language of power than with 'effective art'."

"Letters", *Centerfold*, vol 3, no 5, June/July 1979, p 219. As General Idea reveal in this letter, the language of *Press Conference* was based on an advertisement in the American business magazine *Fortune* placed by an advertising company to tout the benefits of advertising to industry.

42 Marras, "On Organization", p 5.

43 Marras, "On Organization", p 5.

44 General Idea, "Glamour", p 31.

45 General Idea, "Editorial", *FILE*, vol 4, no 2, autumn 1979, p 17. The Strike collective referred to art councils' cessation of CEAC's funding as "direct censorship" and "an economic sanction that intended their [CEAC's] effective immobilization". "Snuff", *Strike*, vol 2, no 2, May 1978, p 15.

46 "Snuff", p 15.

47 In "Outline of a Proposal", a 1978 letter in support of an application to the "Artists with Their Work" programme administered by the Art Gallery of Ontario, Marras wrote: "In the context of the new Canadian generation of artists and cultural operators, I am participating to [sic] the process of cultural dissembling. Such a process of dissembling is carried out around pressing contemporary issues." Marras, Amerigo, "Outline of a Proposal", 1978, CEAC Fonds, 1981-010/08(18).

THE CABANA ROOM

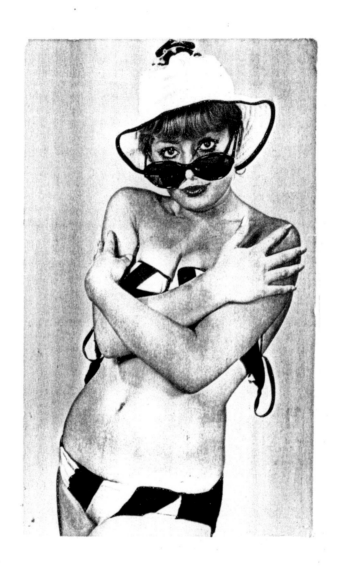

Upstairs at the Spadina Hotel

Opens July 20th

With Electra The Units Judith Doyle

Allegories of an Art Scene

As impressive as it was as a new form of technology democratising access, video was a rudimentary art form in the early 1970s. It had to take baby steps as it developed. While television was an unavoidable reference, it was not the immediate model. At the start, real-time recording dictated content, not broadcast transmission determining formats—though in time, this would come to reverse itself. Above all, the form was open. Video was process, not product, oriented. As Andy Warhol had restored experimental film to the tabula rasa of early silent cinema, so too video had to discover itself... and *self*-discovery was part of the trip. Remember, it was still the era of the hippie counterculture. So the personal, the confessional, and the voyeuristic were its operative modes. The camera was fixed and there was little editing. Form and content were as one.

Of early practitioner Colin Campbell's 1972–1973 videos, Peggy Gale writes that his "tapes spring from similar needs to explore and define interior realities [yet] the issues were never as simple as their presentation indicated."[1] Maybe, but looking back at the early years of video, and not just at Campbell's, you sense a certain passivity to the medium and a certain sentimentalism even to its content. What was needed to wake it up was some irony. The late 1970s would comply.[2] Video needed to distance itself from its concerns of those early years if it still wanted an audience. It needed to distance itself from *itself* by adopting new forms and new contents, by seeking new formats and new subjects. It needed the ironic distance of post-punk new wave. Distance, after all, is irony.

Take Campbell's 1978 *Modern Love*. No more the narcissistic self-love of early video, here the focus is on the other as object of attraction. The subject was modern love, or, perhaps, given the period, *post*-modern love. Modern love was post-romantic love. Post-punk, postmodern, what better sample group to survey than the cynical and ironic art scene? But the art community is charming here in its own louche way, especially

seen from 35 years later, even when it is performing naïveté in drag with five o'clock shadow. For members of the art community are not the subjects, after all, but the performers of this work. And what a stellar cast! Not so coincidentally, *Modern Love*'s cast of characters is also the cast of characters of our story here.

Modern Love's production values are just as rudimentary perhaps as Campbell's earlier video, but the model has changed to that of movie making or just plain television. Sets are bare with only necessary props; lighting is even; most shots are mid-shot or close-up, with minimal camera movement: the occasional pan, tilt, or zoom. It is the scenario now that is important: story, setting, and characters. Basically, *Modern Love* is a soap opera. But the transition to genre is not complete as there are lingering residues such as the disjointed compilation of episodes before we get to the main story. Or there are references to particular avant-garde practices, for instance, in the very beautiful cameos, screen tests *à la* Warhol of video artist Rodney Werden playing Heidi, a buxom blonde German *fräulein* in drag, and video artist Susan Britton likewise playing Pierre, an archetypal French cad.[3] Monolingual Heidi and Pierre's romance is linguistically doomed and acts as a foil to the main story of naive Robin and 'show-business' scum Lamonte Del Monte, played respectively by Colin Campbell in drag and artist David Buchan assuming his performance alter-ego. This is a picaresque tale of the ruin of a young woman told in a few short scenes. And the attraction to the art scene, in part, is to blame.

Robin is a young woman from Thornhill, a suburb north of Toronto, who has moved downtown where she works as a Xerox operator in a stockbrokerage in one of the financial district's bank towers (Campbell's job, actually) and spends nights at the Beverley Tavern (an actual seedy Queen Street bar, which hosted local bands and was frequented by artists and art students from nearby Ontario College of Art) to hear the new wave band Martha and the Muffins (the real band before its "Echo Beach" hit). Robin occupies her own syncopated distance from the scene she wants to be part of, exemplified in the very first shot where she claps off-beat to the off-screen band. Instantly we know that this is the clumsy rhythm of her own demise. Pickup artist Monte is, if you believe him, and we don't, a performer—"song, dance, TV, radio"—and doing a television special by Canada's sweetheart, Anne Murray... that he might work Robin into. He convinces Robin, when she visits his apartment, that his kitsch cocktail shaker used to get her drunk is a 1964 Las Vegas Entertainer of the Year Award. He is regular enough at the Bev to ask for "the usual" and have the off-screen bartender throw a bag of cheesies and chips at him, but not known to Robin, therefore perhaps an afternoon *habitué*, not at all the showbiz mover he cons Robin to believe he is. Within a few scenes Robin is introduced both to modern love and

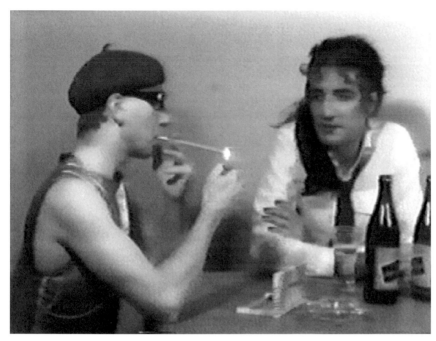

Colin Campbell, *Modern Love*, 1978, video (still)

Monte's sexual perversions, loses her apartment, her job, her money to Monte, and Monte himself. "Modern love", Robin laments at the end, "I guess I could get into it, once I find another room, another job...."

Campbell's follow-up tape was a follow-up on Robin. Hapless Robin had appeal, so in *Bad Girls*, 1979, Robin again is centre of attention, a star even. She has moved on from Monte and moved on from the Bev. She has moved on to another downtown new wave music venue, The Cabana Room, but, alas poor Robin, unlike the Beverley Tavern, The Cabana Room has a door policy. And Robin is still, well, Robin.

Part of Robin's gullibility that made her susceptible to Monte's con was her desire to be a star; witness her comment on singer Anne Murray: "She's from a small town like I am and she made it big." But before you get to be a star, you have to be *in* with the in crowd. Hence, the door policy. But before *we* get to the door of The Cabana Room, over the tape's title we hear "toot toot beep beep... hey mister, have you got a dime" and we immediately recognise the then-reviled yet catchy disco tune of Donna Summers' 1979 "Bad Girls" and remember that bad girls, sad girls, "like everyone else, they come from near and far... like everyone else, they wanna be stars". So maybe not a bad girl, Robin after all still is like everyone else, and what we will soon find in *Bad Girls* is not a study of types but of setting, not of individuals but of milieu. And the milieu is the Toronto music scene substituting for the art scene. Milieu assigns identity by enabling or denying entry. How do you get from a small town to the downtown art scene? That is the question. (Indeed, the distance from Thornhill to downtown Toronto is short compared to that for Campbell of the tiny farming community of Reston, Manitoba!)

So we find ourselves at the door to The Cabana Room, which again was a real club, founded and run by video artist Susan Britton and Robin Wall as a pox-on-both-your-houses flight from the political blowups of A Space and CEAC. Unlike the coincidental institutional start-ups of YYZ and Mercer Union as traditional artist-run galleries, which were another reaction to the perception of "being in on somebody else's show", The Cabana Room was a rock-and-roll bar, video lounge, and performance space in one—and the first of the new scene's local artist hangouts, a club with no pretentions... except being cool.[4] It *was* a 'club', but open to all—with no door policy, by the way. (The Cabana Room was a mothballed 1950s cocktail lounge, decorated as you expect by the name, in the run-down, turn-of-the-century Spadina Hotel, a derelict's drinking tavern on the fringe of the art community in a part of town deserted at night.)

The Cabana Room opened 20 July 1979. Soon after, Robin was at its door, having read about it in an article by Adele Freedman in Toronto's *Globe and Mail* (real article, real journalist, real newspaper—all three mocked in *Bad Girls*). But there, she suffers a litany of humiliations, not being trendy enough to gain entry from the doorman, played

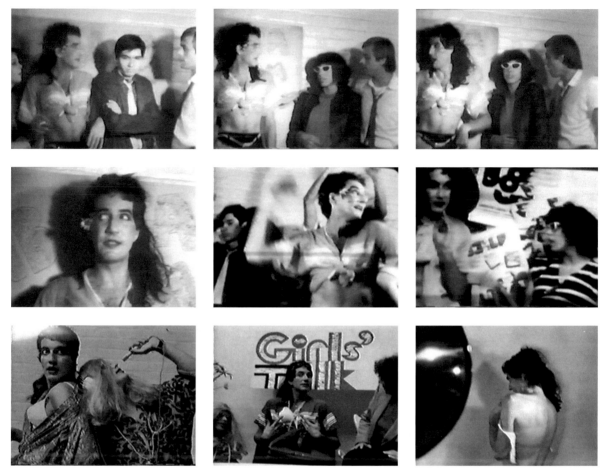

Colin Campbell, *Bad Girls*, 1979, video (stills)

THE CABANA ROOM

Sept. 7 & 8

The Fabulous Overtones

and Bad Girls serialized video

by Colin Campbell

THE CABANA ROOM

Sept. 14 and 15

The Basics and Guests

plus BAD GIRLS continues...

by General Idea's Felix Partz. "Who does she think she is? Where is *she* from?" complains Robin of yet another patron let in past her. "How am I ever going to get into the Cabana Room?" Indeed, that is the question. But, accidentally, she does, by a fluke of having a ponytail requisite for a retro twist contest.[5] Once inside, blithely unaware of the contest's codes, she fails to follow the rules of the game: our heroine dances on when everyone else freezes behind her. She doesn't know the rules, the codes, or the signifiers, the signaling or merely mimicking of which will make her acceptable: to be seen to be an artist, or *artiste*, and be recognised as part of a clique. Nonetheless, in front of the bar she then compiles a ridiculous list of dos-and-don'ts of how to succeed as a pop band from 'pop star' Steven Davey (playing himself). But in spite or, rather, because of her naïveté she soon becomes an overnight success with her two-woman band, Robin and the Robots, and their pathetic techno rendition of Donna Summer's *Bad Girls*. Toot toot... beep beep. Then in the roller-coaster of her success she suffers the star-is-born syndrome as band mate Heidi—played again by Rodney Werden, and now, post-Pierre, a landed immigrant—outstages Robin with her own further degenerated *German* version of *Bad Girls*, an ironic nod to period fascination with all things West German: Kraftwerk, Fassbinder, and the Red Army Faction.[6]

Following the episodic structure of the picaresque novel, *Bad Girls* was made according to the exemplary avant-garde film production model of Warhol's 60s Factory: episodes were written, shot, and edited during the week, and then screened weekends at The Cabana Room. This gave the video an immediacy derived from dealing with what was at hand. What was at hand was The Cabana Room. What distinguishes *Bad Girls* from *Modern Love* in part is what distinguishes The Cabana Room from the Beverley Tavern, and that was the extreme good luck of Campbell's friend Susan Britton having taken over a bar and opening it to the art community.[7] (Of course, given Campbell's typical casting, Britton plays the club's booker/owner, but is too alcoholic and coked-up there to be much of a svengali to Robin.) Moreover, the year it was made, 1979, marked a significant cultural moment: on the one hand, of music having fully transitioned from punk to new wave, and 'new wave' having become its own cultural trend; and, on the other hand, of the downtown Toronto art scene having sufficiently consolidated an identity of sorts that one could belong to it in a new way.

Robin, Campbell said somewhere, was a vehicle to talk about the alternative art and music scene in Toronto in a period when they uniquely intermixed. But was Robin perhaps a vehicle to talk specifically about the art scene through the masquerade of the music scene? With no history of its own to fall back on, avant-garde art in North America has often appropriated images of pop music to mask its discourse, deviating it in the process. And so did *Bad Girls*. With *Bad Girls*, Campbell

crafted an artwork through which the art scene could identify itself in the social scene of the 'Cabana Room'. And, viewing episodes serially in the real Cabana Room, artists did. The Cabana Room was the social setting where the art scene's newly consolidated identity could still be fluid enough to accommodate all that was experimental, transgressive, or merely mingling and posturing about it. The music club ambience supplied the veneer of sociability. The 'identity' *Bad Girls* reflected was more desire than reality, but that did not make it less real. It was a desire for something other than regulated daytime roles: Ms Britton, coked-out club manager (of the fictitious Cabana Room, that is) rather than Susan Britton, video artist. It was the nighttime mirror to the serious day-to-day construction of the art scene with its institutional responsibilities that called upon Canadian artists' "bureaucratic tendency and protestant work ethic"—but this mirror shone its dark reflection on other passions.

It was not just the delight in seeing Colin Campbell, Susan Britton, Rodney Werden, Ron Gabe, Tim Guest, Steven Davey, and others in ridiculous situations. And seeing the video, in situ, so to speak, as if enacted exactly where the audience was sitting—to be *in* on that. Of course, it was ridiculous. But was part of the pleasure of these images the representation they offered of a particular scene that artists were familiar with: their own? In putting it all together in a scenario, then acting it, was Campbell analysing this scene or parodying it? With its story of Robin's rise and fall, is *Bad Girls* then an allegory? I don't think Campbell originally intended it so. Was anything really at stake in terms of art world ambition for these insiders of an outsider situation (it was only Toronto, after all)? There were no admonitory life lessons to be learned from this as morality tale. *Bad Girls* was too camp for that. But, retrospectively, perhaps, yes, we could look on this work as an allegory of the art scene. Perhaps you might ask instead, with its assembly of Toronto art world insiders, whether *Bad Girls* actually was an allegory of *admittance* to the art scene? Recall what AA Bronson wrote, that "a premiere of a new Colin Campbell tape at the Cabana Room was a little like attending the Academy Awards". And remember Robin at the door struggling to get in, a geek bypassed by the chic. Campbell was no elitist, however, nor cynical parodist, and *Bad Girls* was not one more artefact of Toronto's fascination with the mechanisms of stardom *à la* General Idea, or, at least, not wholly so. Its emphasis was on failure, not so much on reversal of fame by degrading glamour.

The beginning of the video logically could only be about entry, as the beginning of Robin's story: her admittance to The Cabana Room and the art/music scene. If I remain there, outside that barred door, it is to insist on the openness of what you could call Campbell's hospitality. Because I think, although an art world insider, Colin lingered outside, too. You could argue that his aim was not only to picture a scene to itself but also

THE CABANA ROOM

Sept. 21 and 22

THE SECRETS

plus BAD GIRLS continues...

THE CABANA ROOM

Sept 29 and 30

THE VELOURS

BAD GIRLS continues..

Peter MacCallum, *Spadina Hotel at Night, 1979*

Peter MacCallum, *Twist Contest at The Cabana Room, 1979*

Peter MacCallum, *The Units performing at The Cabana Room, 1979*

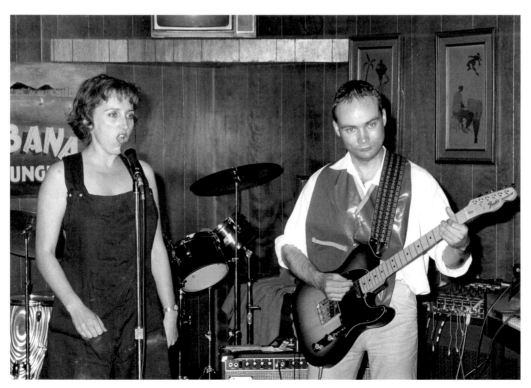

Peter MacCallum, *Marien Lewis and Andy Paterson, "Death of Television",
performance at The Cabana Room, 1979*

to use these images to attract others to it, and to facilitate their entry. While screened first to an insider audience, *Bad Girls* has outsiders as its welcome. Its head is with the in-crowd but its heart is with sad girls, bad girls.

Between insiders and outsiders, trendies and geeks, the line sometimes is obscure, especially when new cultural movements are in formation. How at the same time does the twist become camp and disco outré, the one hip, the other condemned?[8] Who is in on these decisions? Who besides the doorman enforces them? Obviously, there are signs that enable separation: who gets in and who doesn't. The quality of being 'off' is a sign of this division, a marker of the line between out and in. 'Off' is out, not in. The doorman instantly knows. 'Off' is only read from the inside and regulated there, while participated in unconsciously on the outside, where one miscomprehends one's status: "How am I ever going to get into the Cabana Room?" Perhaps it is a matter of how self-consciously one inhabits identity, how one handles distance and ironic detachment, how one performs a role, and how one perceives, for want of a better word, camp. Robin cannot.[9] Only the in-crowd's canniness can. When we view it, *Bad Girls* lends us this insider knowledge and places us at the centre of the in-crowd as participants in the scene.

Campbell's performance is between the two. Not just between out and in, but between degrees of 'off'—or performances of it. Robin is 'off'. She is camp without knowing it. Campbell is off, too; his is *knowing* camp, but performed as a loving portrayal of his hapless heroine. The two are distinct yet inseparable in performance. This portrayal has consequences. "Camp rests on innocence. That means Camp discloses innocence, but also, when it can, corrupts it"—as happens systematically in *Modern Love*.[10] What can one say? The art scene was necessarily corrupting.

Attuned to the dynamic of insiders and outsiders, Campbell operated like anthropology's typical participant observer. He was on the line between the two. The ethnographic report he brought back on this particular subculture, the Toronto art scene, is a mix of fact and fiction. It is based, though, on observation. Observation of gesture, character, and scene. Observation was adduced within point of view rendered as an artwork. Point of view was dependent on the ratio of fact to fiction. *Bad Girls* was a fiction based on 'fact' (the Toronto art scene), which made the result, perhaps, allegorical: the actual scene seen through a fiction.

Ironically, it was the supposed gatekeepers that both fantasised and realised the scene to be. We are talking here of the inner circle of the Toronto art scene: the sophisticated insider with an eye to the edges (Colin Campbell); the arch arbiters of taste, of high camp and low culture (General Idea); and the super cool 'it' girl (Susan Britton). The art scene that was to be was the art scene that was developing here—and being pictured to itself. The fictive image of it was not to disappear in its

later actual realisation as if means to an end that was then disposed of. It was a sustained discussion with fictional appeal, a discourse put forth through images that attracted others to it.

If Campbell's fictionalisation of the Toronto art scene rested on astute observation, General Idea's depended on dissemination. Campbell fictionalised the scene; General Idea fabricated one. The former was dependent on performance, the latter on photography. Campbell transmitted his fictionalisations through scripted videotapes, General Idea through the cut-and-paste of magazines. Part of *FILE*'s function was this photographic dissemination of the 'scene'. When General Idea's *FILE* began in 1972 it was a communication vehicle for the correspondence movement where one of its main roles was to publish the Image Bank Image Request Lists: "Functionally, the lists not only established and reinforced an evolving network of people, they also set up a moving field of significant contemporary imagery."[11] Once the correspondence movement was over General Idea localised this global strategy and centred it in Toronto by linking people in fictional constructs that were the artists' own devising. *FILE* had always been used as an occasion for fabricating events in order to include the pseudonymous correspondence scene in parodies of popular rituals. It now continued as a means to mirror the Toronto art scene back to itself differently: that is to say, as something glamourous. *FILE*'s BZZZ BZZZ BZZZ column reportage really was a fictionalised form of gossip that periodically ganged a clique together. That of the autumn 1979 'Transgression Issue' was a promiscuous platform where individuals, separated in space and time, could party together photographically. A fictional text linked the imagined scene in a lubricating narrative whose pretence was "the special preview opening of General Idea's Colour Bar Lounge"—their new cocktail lounge housed in the artists' Pavillion. David Buchan, Susan Britton, Colin Campbell, Steven Davey, the Diodes' Paul Robinson and other Torontonians mingled on the pages with those better known to the world such as Divine, Debbie Harry and Chris Stein of Blondie, among others. As in an actual gossip column some information was real, some not, some promotional, some fantastical. Accuracy was not the point—and no one necessarily would take its portrayal as real. Yet a magazine could be said to have real effects. In the end, it would be magazines, not necessarily artworks, that would serve to disseminate, not just an image but also the idea of an art scene in formation in Toronto, at the same time that artists were both imagining it (Campbell, for example) and constructing it (the artist-run system).

Fictional fabrication would be a common enough strategy in Toronto to unite seemingly oppositional work—the frivolous and the earnest—in like utopian representations of community. Faux photography was thus used constructively by artists of different aesthetic and political

PP 168–176
"BZZZ BZZZ BZZZ", *FILE*, autumn 1979

Getting into the spirit was easy at the special preview opening of General Idea's Colour Bar Lounge as MICHAEL LACROIX dished out cocktail music. The music flowed-like-honey-in-all-directions as guests noted Michael's pose which thoughtfully included that old G.I. favorite, the Negative Stiletto Motif. Hoping to fill that gap with something with body, G.I. debuted the Young Artist Cocktail featuring ROB FLACK as the young consumer. Hot on the heels of the Cinderella saga, Rob sized up the cocktail and submitted that it was a very demanding initiation into the art and spirit worlds. KEVAN (Bar-fly-weight) STAPLES was also into foot work as he dazzled guests with a display of disco-boxing which is knocking them out on the west coast. Getting a bit punch drunk after a few rounds Kevin boasted that Rough Trade's recent simulcast on T.V. and FM was an O.K. K.O. in T.O.

Fashion designer MARILYN KIEWIET of ROBIN struck another blow for glamour despite an unexpected loss of

altitude. She had been teetering deliciously all evening until some heel brought her down. Several guests were dying to get under foot as Colour Bartenders poured on the charmed. RENE BLOUIN participated in the christeni of an adult cocktail The Champagne Experience and between gulps leaked news his recent appointment at th Canada Council.

After a heady round of nightcaps many guests reti to the hide-a-bed section of the Colour Bar Lounge. As late night snack they sank their teeth into the new Blondie platter, 'Eat to the Beat', which CHRIS STEIN and DEBBIE HARRY had brought along as a lounge-warming gift. Lounge wizard, PAUL WONG had over imbibed as usual and had to be handcuffed to a bed. "this place is more like an orgy room than a ... said Paul before they gagged him. PAUL ROBINSON also went bottoms up but not before informing all of a possible Diode reunion in the recordi studios this fall. MISS MIM PAIGE, Miss General Idea

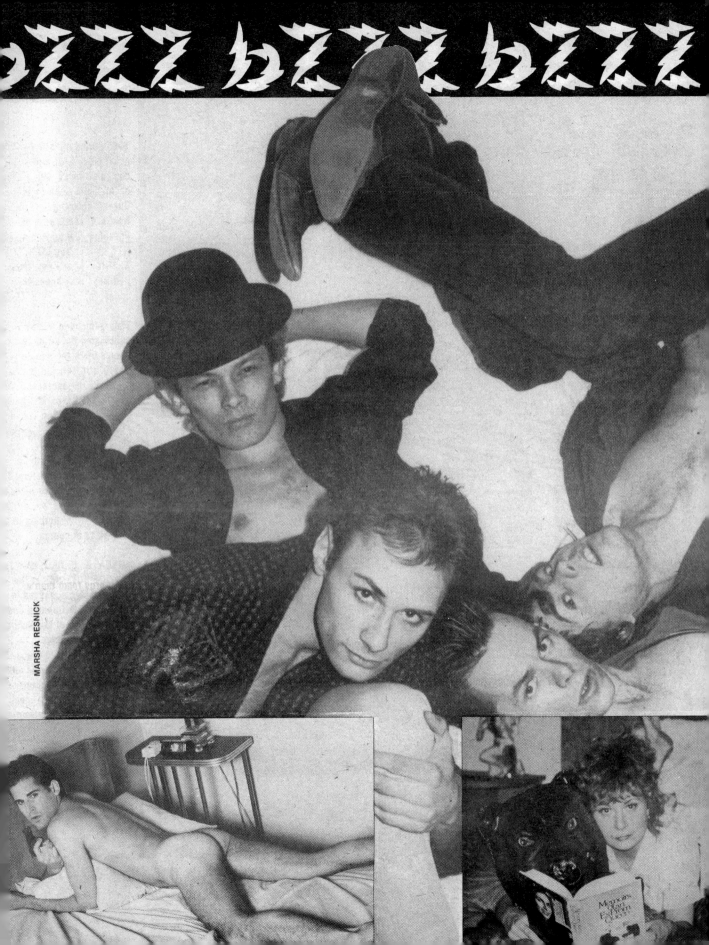

MARSHA RESNICK

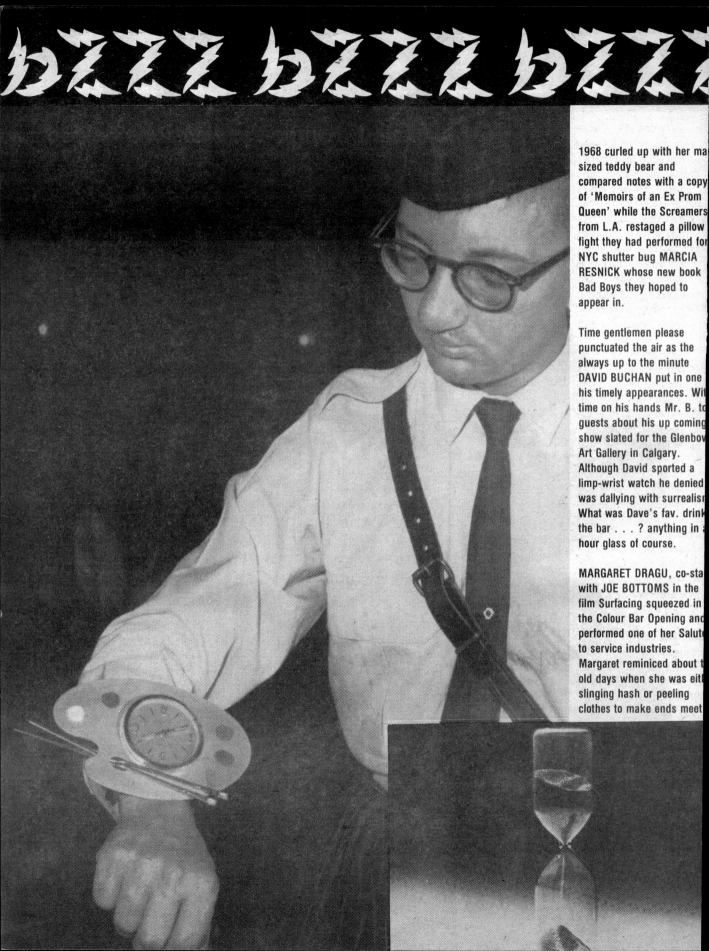

1968 curled up with her ma
sized teddy bear and
compared notes with a copy
of 'Memoirs of an Ex Prom
Queen' while the Screamers
from L.A. restaged a pillow
fight they had performed for
NYC shutter bug MARCIA
RESNICK whose new book
Bad Boys they hoped to
appear in.

Time gentlemen please
punctuated the air as the
always up to the minute
DAVID BUCHAN put in one
his timely appearances. Wit
time on his hands Mr. B. to
guests about his up coming
show slated for the Glenbov
Art Gallery in Calgary.
Although David sported a
limp-wrist watch he denied
was dallying with surrealist
What was Dave's fav. drink
the bar . . . ? anything in
hour glass of course.

MARGARET DRAGU, co-sta
with JOE BOTTOMS in the
film Surfacing squeezed in
the Colour Bar Opening and
performed one of her Salut
to service industries.
Margaret reminiced about t
old days when she was eit
slinging hash or peeling
clothes to make ends meet

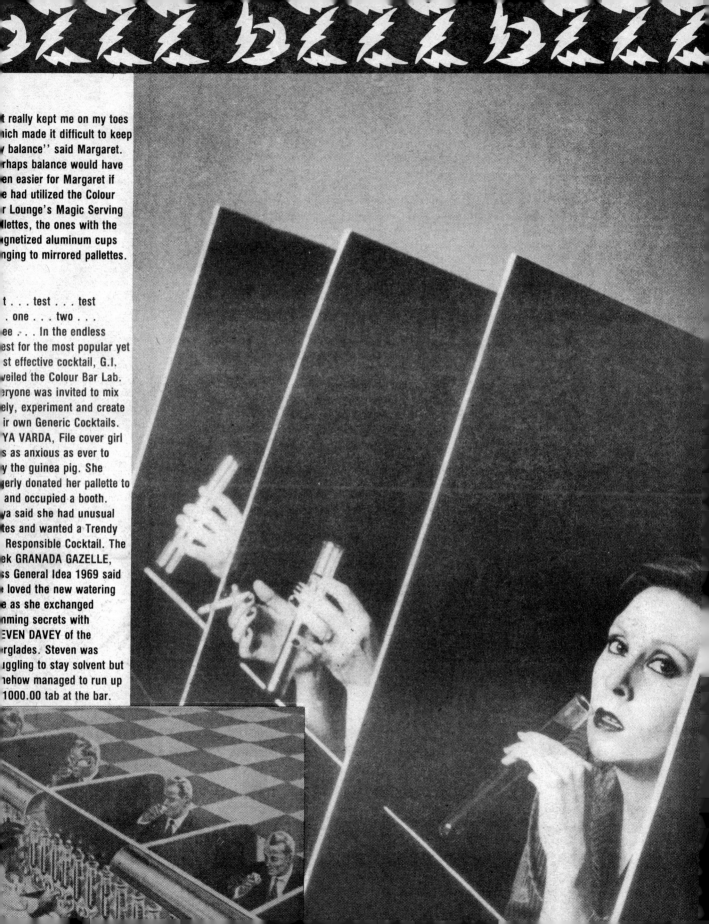

...t really kept me on my toes
...nich made it difficult to keep
...y balance'' said Margaret.
...rhaps balance would have
...en easier for Margaret if
...e had utilized the Colour
...r Lounge's Magic Serving
...llettes, the ones with the
...gnetized aluminum cups
...nging to mirrored pallettes.

...t . . . test . . . test
. . one . . . two . . .
...ee . . . In the endless
...est for the most popular yet
...st effective cocktail, G.I.
...veiled the Colour Bar Lab.
...eryone was invited to mix
...ely, experiment and create
...ir own Generic Cocktails.
...YA VARDA, File cover girl
...s as anxious as ever to
...y the guinea pig. She
...erly donated her pallette to
... and occupied a booth.
...ya said she had unusual
...tes and wanted a Trendy
... Responsible Cocktail. The
...ek GRANADA GAZELLE,
...ss General Idea 1969 said
... loved the new watering
...e as she exchanged
...nming secrets with
...EVEN DAVEY of the
...rglades. Steven was
...uggling to stay solvent but
...nehow managed to run up
...1000.00 tab at the bar.

SUSAN BRITTON, of Toronto's new nitery, the Cabana Room went mental when GREG of the PARROT restaurant ruffled her feathers with hints of his future foray into the nitery scene. Susan countered with news of an entirely new entertainment concept she's pioneering. It's an underground, armour plated video bunker with bullet proof glass. Model MAGGIE ?? caught in the cross fire said she thought there could never be too many nite spots. COLIN CAMPBELL, getting tipsy on the tubes, outlined the plot of his new video serial Bad Girls set for fall screenings at the Cabana Room. STEPHEN LACK, hot from the success of his Rubber Gun Show film denied rumours of an on again off again on and off screen romance with new co-star SALLY KELLERMAN. Anya Varda burst into tears at the mention of the other woman and continued sobbing as Steven confessed that his favorite cocktail was the Young Artist. SANDY STAGG toasted a clinched deal which will see four Colour Bar Lounge cocktails retailing at her uptown eatery, the FIESTA.

Fashion designer LEIGHTON BARRETT of EXCEL claimed a worlds record for constructing the worlds largest tube dress with the most darts per square inch. Bombshell DIVINE, looking like she was dropped by a B 52 squeezed into the sausage skin and said it fit like a glove. Leighton has also packaged Debbie Harry but this was definitely his biggest account yet.

persuasions. For instance, in *Roots: Lamonte Del Monte's Family Tree*, 1979, David Buchan doesn't employ photography as he had in *Modern Fashions* to deconstruct advertising, but rather to elaborate a story. Here he tells a family history in the form of a photo album. After losing everything, Robin ended *Modern Love* with the lament that "there will never be another Monte". Buchan ensured there would by diversifying his persona, whether lending him out to other artists as in the case of *Modern Love*, or letting out the dissolute performer's story as needed in a series of ongoing performances and slide shows of his own. Of course, *Roots* is an outrageous story based on an outrageous family. Riffing off Alex Hailey's television series in his title (Hailey's *Roots* had just been broadcast in 1977), Buchan fantasises an appropriately dubious family for Lamonte Del Monte, and each relative on the opposing sides of the Del Monte-Dumbrowski divide is given a low-comedic biography. For this purpose, Buchan pressed his own family of friends into this service (see them pictured in a group pose on the exhibition poster), so the family album is as well a who's who of the Toronto art scene.[12] Lamonte is a low class performer from a decidedly lower class, lumpen even; his is a family definitely without class-consciousness.

How this would contrast with the familial class-consciousness-raising of Condé and Beveridge's *Maybe Wendy's Right* made at the same time. Yet how similar *Maybe Wendy's Right* is to Buchan's *Roots*. Condé and Beveridge's work, too, began to be made by casting friends in scripted photo scenarios. Here it is primarily a small production and a family romance, with the artists playing working class parents and their real children their fictional offspring. Even though contested camps with different principles of art and senses of social responsibility, the performative and the political here share a common production practice. Fundamentally, Condé and Beveridge's work was no different from Campbell and Buchan casting friends and writing scenarios that somehow corresponded to their own situations. Only in Condé and Beveridge's case this context was understood as solidarity with the working class. In the grand scale of things, of politics and economics and class struggle, Buchan's and Campbell's scenarios seem trite and self-satisfied, small-scale and petit-bourgeois, yet their works address fundamental issues of exclusion—who is in and who is out—in order to recoup and revalue the marginalised of whatever party. With all these artists, photography's fictional constructs tended automatically towards the social, indeed towards utopian ideas of community, as different as they were: on the one hand, the ideals of an art community; on the other, the abolition of class in the dictatorship of the proletariat.

David Buchan, *Roots: Lamonte del Monte*, 1979, C print with cardboard overmat, 30.5 x 35.6 cm

David Buchan, *Roots: Marilyn Münster del Monte*, 1979, C print with cardboard overmat, 30.5 x 35.6 cm

David Buchan, *Roots: Rudi del Monte*, 1979, C print with cardboard overmat, 30.5 x 35.6 cm

David Buchan, *Roots: Mooch Dumbrowski*, 1979, C print with cardboard overmat, 30.5 x 35.6 cm

David Buchan, Roots exhibition, 1981 (poster)

1 Gale, Peggy, "Toronto Video: Looking Inward", *Vie des Arts*, vol 21, no 86, autumn 1977, p 85.

2 Consider Tom Sherman's implicit critique of early video in the then current desire for access to mainstream television: "[000011] We now turn our attention to the pioneers of the personal communications field. [000100] By a twist of fate they were among the first people to get their hands on the equipment. [000101] They were able to log their private lives as worthy material for public display because of their early entrance. [000110] Later on, those working in the new medium would have to approach the art of revealing themselves in an entirely different manner." Sherman, Tom, "The Artist Attains Ham Radio Status in an Era of Total Thought Conveyance", *Centerfold*, vol 2, no 6, September 1978, p 86.

3 What was Campbell saying in the voiceover epigraph before the title credit? "He couldn't be honest, or it would be taken too literally. Reflection, I see you."

4 Todd, Kim, "Letter to the Editor", *Only Paper Today*", vol 6, no 1, January–February, 1979, p 2. This letter announces the opening of the artist-run gallery Contact, which was soon to change its name to YYZ.

5 New wave had its camp element: hence the retro twist contest or Robin's references to the B-52s. This was hip camp. Camp worthy of its avant-garde heritage extemporises from the more degraded forms of pop music, as Jack Smith and Kenneth Anger earlier had used pop music in their underground films *Flaming Creatures* and *Scorpio Rising*. And so the subtext of *Bad Girls* is the unconscious of new wave: concurrent *démodé* disco. As we know, disco eventually opened a whole new repertoire for camp.

6 It should be noted how on the mark and *avant la lettre* Campbell was. For instance, *Semiotext(e)*'s "German Issue" was published in 1982.

7 A 7 September 1980 press release from Robin Wall states, "The Cabana Room, situated in Toronto's Spadina Hotel, opened July 20, 1979 as a nightclub/lounge providing entertainment specifically oriented to Toronto's art community. Regular events include bands (local and out-of-town), cabaret, performance, dance, and video.... The Cabana Room is not and never will be government-supported." A Space Fonds, 42-2, Edward P Taylor Library & Archives, Art Gallery of Ontario.

8 Let's remind ourselves how reviled disco was then amongst the rock scene and remember, for instance, Disco Demolition Night at Chomiskey Park in Chicago, where a crate of disco records was blown up between a baseball doubleheader on 12 July 1979, mere days before The Cabana Room opened. The two things punks hated equally were disco and hippies, and in Toronto one often could see ex-hippies turned new wavers on disco dance floors. Hello, Jorge. Hello, Ron.

9 "Detachment is the prerogative of an elite; and as the dandy is the nineteenth century's surrogate for the aristocrat in matters of culture, so Camp is the modern dandyism. Camp is the answer to the problem: how to be a dandy in the age of mass culture." Sontag, Susan, "Notes on 'Camp'", *Against Interpretation*, New York: Dell Publishing Co, Inc, 1966, §45, p 288.

10 Sontag, "Notes on 'Camp'", §21, p 283.

11 Bronson, AA, "Pablum for the Pablum Eaters", in *Video by Artists*, Peggy Gale ed, Toronto: Art Metropole, 1976, p 197.

12 For instance, Tanya Mars (performance artist and editor of *Parallelogramme* magazine [ANNPAC]), Andy Paterson (video artist, collaborator with Hummer Sisters, and member of the punk/new wave band The Government), Robert Stewart (also of The Government), Joanne Tod (painter and administrator of YYZ where *Roots* was shown), Andrew Zeally (musician), Randy Gledhill (performance artist), Rebecca Baird (artist), Kim Tomczak (media artist and one of the co-founders of Vtape), Jorge Zontal (member of General Idea), and George Whiteside (photographer), among others.

George Whiteside was the photographer of *Roots*, as Zontal was of Buchan's *Modern Fashion*, where his photo credit simply was "photography by Zontal", identified by a single name like the great portrait studios of Karsh in Canada or Harcourt in Paris. A story has to be written about the role of photography studios in Toronto of this period, combined as they were then with magazines such as General Idea's *FILE* and Eldon Garnet's *Impulse*. To take the example of Jorge Zontal, in the studio he shared as part of the collective of General Idea, images might be produced for: artworks by General Idea, or others, like Buchan; inclusion in various capacities of *FILE* (BZZZ BZZZ BZZZ and other editorial uses); record covers for Toronto bands such as Rough Trade, etc. In his case, the photography studio was also a portrait studio where images of individuals from various cultural scenes were put to the aforementioned uses or were turned towards the Zontal's own ongoing pursuits. Photography here appears at the intersection of a number of practices and the photographer's studio was a switching centre where photographs (sometimes of the same images) were sent off to serve various functions. But it could also be seen as a social site and one of the places from which the idea of an art scene was manufactured. See Monk, Philip, *Picturing the Toronto Art Community: The Queen Street Years*, insert in *C international contemporary art*, no 59, September–November 1998.

Desiring Machines

When those too old to pogo (being in their late 20s or early 30s) took punk seriously, they 'analysed' it instead and promulgated its rebellious destructiveness in other ways. In Toronto, the Centre for Experimental Art and Communication hosted the Crash 'n' Burn punk club in its basement in the summer of 1977, then closed it down, perhaps because its success was getting in the way of the revolution. Meanwhile General Idea paid punk ultimate homage by destroying their Pavillion under its influence that year and then commemorated the new movement in the best-selling special "Punk 'til you Puke!" issue of *FILE*.

But what was punk? Essentially, punk was a means to transition from hippie to new wave for the generation that had started in the sentimental naiveties of the former. Punk was too emotive, however, and not brainy enough to satisfy the suave sophistication of new wave's ironic intellectualism. At least for the art community. Punk's demolition was necessary, though. It cleared the way. But its three-chord DIY epiphany was not enough to provide the necessary tools of cultural sabotage. The joy of rebellion had to give way to the labour of insubordination. In a time of the Red Army Faction and the Red Brigade, of Mogadishu and Moro, what was needed was a deadly serious terrorism of the code. If General Idea could queer Marshall McLuhan, so too could Toronto artists deviate code. If three clumsy chords could wreak havoc on the music industry, what could the deviation of whole codes do?

By 1979, punk was long gone as an influence. The times were schizo; the participants, too: "Under your gaze we become everything from frivolous night-lifers to hard-core post-Marxist theoreticians," General Idea wrote in a *FILE* editorial. It was no longer an opposition of Marxists and semiologists as Toronto hitherto had divided. The scene was too fragmented now. The devious and the deviant were working other divisions that were not so clear-cut and oppositional. Political lines were blurred. In fact, what was a line but to transgress? Desire saturated the social field.

FILE

PUNK 'TIL YOU PUKE!

VOL. 3, NO. 4, FALL, 1977, $3.00

NAZI DOG & THE VILETONES

PLUS

SEX PISTOLS
RICHARD HELL
ROUGH TRADE
PATTI SMITH
TALKING HEADS
DEAD BOYS
THE CURSE
DAMNED

and featuring

I LOVE LUCASTA
with
THE DISHES

Debbie Harry, the blonde in Blondie, in the pink. (See centrespread.)

House Punk

The Centre for Experimental Art and Communication has been given
pride of place for breaking punk in the summer of 1977 in its basement
club Crash 'n' Burn. Yet, punk was happening all around: from 1976 on
at the New Yorker Theatre, El Mocambo, Hotel Isabella, the Horseshoe
Tavern, and elsewhere, even at A Space with the Talking Heads. The
catalyst for Toronto punk was the Ramones visit in September 1976 and
the influence at first was American not British. It was American bands,
for obvious geographic reasons, that were booked to perform in the city.
Toronto's Dishes and Diodes, the latter formed at the Ontario College
of Art, were really the first to kick it off.[1] But as elsewhere, punk was
a motley thing: The Dishes were a trace of glam and Roxy Music; The
Diodes were more Ramone-like in their rhythms, although their 'hits'
had the flair of British beat. They had nothing to do with the Sex Pistols.
The clichés of self-mutilation, bottle throwing, musical ineptitude, and
violence, that too, came later. It was almost pure invention, independent
of a band even, a Situationist strategy (if you believe Steven Leckie, aka
Nazi Dog) of creating hysteria around the *idea* of the Viletones, a group
that only came into existence after its first gig was announced and a band
had to form quickly and cobble together its first few songs in three days.
There were only ever a few songs.

 The new Toronto bands partly were a retort to music union control
of the Yonge Street bar scene with its shag hair cover bands. Crash 'n'
Burn was a fallback from these punk bands' riotous and popular forays
into that terrain—then exclusion. Initially a Diodes practice space, Crash
'n' Burn was opened to the community by the band and its manager
Ralph Alfonso. It burned bright for those few sultry summer months of
1977 only to suffer the fate of publicity: when its signifiers of violence
became obtusely real with the arrival of toughs from the suburbs.[2] But
it signified as well, however frenetically, a community; with Crash 'n'
Burn's dissolution something of those ideals dissolved with it, too. Tenant
complaints, police suspicion, and the general mayhem persuaded CEAC to
pull the plug and lock the door. A CBS record contract for the Diodes and
Leckie's attempt to drive a wedge between school and street did the rest.
Punk would continue but without the same sense of solidarity.

The Dishes, "Fashion Plates", 1977,
7" EP

The Dishes, "Hot Property", 1977,
7" EP

But what of punk's effect on the art scene? It stemmed in part from that manic moment of Crash 'n' Burn. With their skinny black jeans and leather jackets, the art scene slummed with street toughs but still primarily identified with art school smarts. What use value would punk then have? Coincidentally, both CEAC and General Idea had their own 'house bands'—the Diodes and Dishes respectively. This was in part a Warholian gesture, repeating that of the New York artist managing his own band, The Velvet Underground—but would this home invasion have a destructive effect? The Diodes were pressed into service for a couple of performances with CEAC personnel that were somewhat duplicated in the *RAW/WAR* 7-inch record CEAC put out as the eighth issue of *Art Communication Edition*. As General Idea had incorporated Carole Pope and Rough Trade into their 1975 *Going thru the Motions* performance, so they utilised the Dishes for their 1977 *Hot Property* and issued the band's record of the same name as a General Idea multiple, just to be clear who was working for whom. They could try the idea on for fun of DIY posing with the Dishes gear but application of principles was altogether more serious.[3]

Fellow travelling went beyond the fashion accessory of having one's own band. As punk was always good journalistic copy, why not put it to the service of art magazines, of both *FILE* and *Art Communication Edition*, say. At least their copy would be positive, wouldn't it? General Idea sympathetically responded in *FILE* with a complete packaging of the movement. It's hard to remember, so visually saturated as we are, that cut-and-paste photocopying and telephone pole postering began with punk, but *FILE* synthesized this look throughout its extensive compendium of British, American, and Toronto punk bands in the autumn 1977 "Punk 'til You Puke!" special issue. It was put together (albeit with some high-class New York help from photographer Jimmy de Sana) analogously to what the editors wrote about one of the featured fanzines: "Excellent slap dash safety pinned collage layout, occasional touches of blood-red ink."

It was not just tribute; there was analysis, too. The cleverly titled "Pogo Dancing in the British Aisles", by AA Bronson, brought French philosophy to bear on punk—but not any French philosophy, rather the anti-Oedipal machinations of Gilles Deleuze and Félix Guattari. Bronson was early in on the game of Oedipal demolition and his article was the first in Toronto to make use of the authors' schizo analysis. *Anti-Oedipus* was an effect that would persist: it had a longer fuse than the short temper of punk.

Bronson was inspired by one of Deleuze and Guattari's articles in the *Anti-Oedipus* issue of the newly influential journal *Semiotext(e)*, rather than their book of that title published in translation that same year, 1977. It's as if Bronson looked on from the sidelines of Crash 'n' Burn

and saw its closed space as the closed circuit of a desiring-machine: "the punk machine: 200 fans in a closed environment pump and strain in pogo rhythms, sex pistons, an essential component of the musician/ audio equipment/audience desiring machine. Spitting provides the electrical connection that bypasses the contained sexuality of the family to power this group desire." The sub-urban youth was a 'body without organs' attached to a desiring machine by the rips and safety pins of their ragged fashion: "Like S & M punk involves the body in a complete and brilliant desiring machine. Punks act out of necessity rather than fantasy. The mode of dress is characterized by the use of parts of the body in a complex of motifs or emblems.... The use of rips and zippers to isolate parts of the body, the manipulation of bruises, cuts, white flesh, ragged hair combined with leather, safety pins, loose ties, stiletto heels, pointed toes and exposed seams forms a language rather than a picture. In fact, words themselves join in that ragged grammar: not sentences or even ideas, but emblematic tattoos beat out on the drums of punk bands.... 'NO FUTURE'."[4]

Desiring machines implicated the individual in the social. "Punk rock is the visible, readable, codable and decodable desiring machine from which a new politics, a new economics must be erected", Bronson wrote. Allied to his statement that "Desire is anti-capitalist", what would this mean for the making of art? Perhaps it would be its unmaking. Or at least that would be the first step. And what would be destroyed would be that which was closest at hand: one's own work. General Idea took the radical act of destroying their own work, twice in fact. Their Pavillion caught fire in the performance *Hot Property*, October 1977, and simmered until it burnt to the ground in *The Ruins of the 1984 Miss General Idea Pavillion*, November 1977—but the fuse had been lit in the 'Punk' issue of *FILE*.[5] Now having never existed, the Pavillion was never literally destroyed. But General Idea destroyed its underlying system to the degree they could never go back. Under what reckless impulse were they so destructive? Blame punk. Perhaps it was inevitable; it was the logic of their system, after all; but when General Idea write in their 'Punk' editorial, "look how boring it is... look how bored we all are", should we be surprised that instead of "pass the envelop, please", they said "pass the match, dammit"? When Bronson writes in "Pogo Dancing", "Sentimentalism—the swamp in which capitalism breeds its docile subjects—is replaced by the magnetic/electric attraction/repulsion of active and passive, the slave and the conqueror", he was implicating General Idea. For they were docile sentimentalists, too! And when they write in the editorial accompanying this article that, "The sentimentalism of late 60s early 70s essentially surrealistic aesthetic has been replaced by a certain pragmatic anarchy which is now the theme of this issue", they meant us to take them at their word, because what are editorials for?[6] The whole

Image Nation, vol 18, 1978 (front cover)

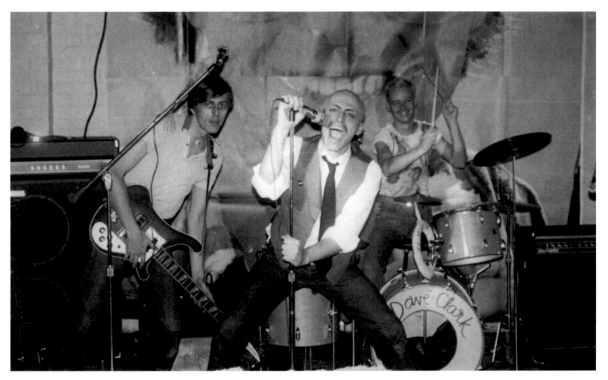

General Idea as mock band

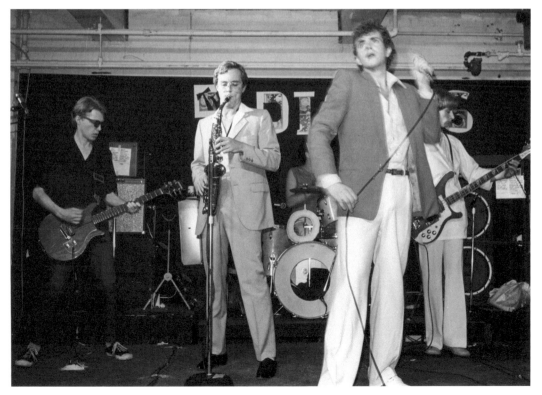

The Dishes at Crash 'n' Burn

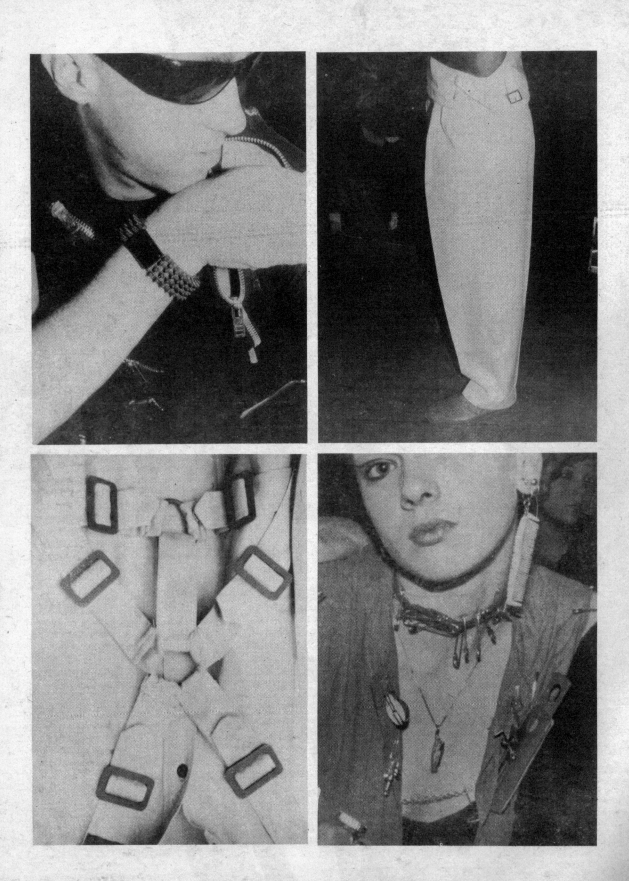

The pogo dancer is a simple extension of tweeters and woofers. He amplifies the sound psychologically and visually. These vertical pistons amplify time beating on his mind. Amplification drives a vertical wedge between mind and body — the wedge of repeated movement.

The pogo dancer doesn't create sound, he doesn't hear sound; he is part of the pumping machine composed of musicians, equipment, dancers, all enclosed in a shell of sound.

When the action is hot, the fans become the sounding board, the psychological emotional sexual amplifying system that drives the audio back through the performers and into the system. The result is a simple feedback buildup. Like Tinguely's machines, the punk machine self-destructs, smashing equipment, slashing skin, decorating the general milieu with broken beer bottles and safety pins. The dancers 'strangle' each other without breaking stride. Spitting at the band completes the electric circuit, becoming the highest compliment.

Desire is anti-capitalist. Present economies of production and distribution do not allow for an economy of desire. Nevertheless, 'the bureaucrat strokes his files.'

But as capitalism's complex resonance amplifies strange new need, its mushrooming electronic communications gadgetry creates hiding spots in tangled circuitry for perverted modern lovers:

Two men, two telephones and certain electronic circuitry (established for entirely different reasons) combine to form a simple desiring machine. The gay connection is particular here, because gay eroticism is group eroticism (as distinct from group sex).

So, too, the punk machine: 200 fans in a closed environment pump and strain in pogo rhythms, sex pistons, an essential component of the musician/audio equipment/audience desiring machine. Spitting provides the electrical connection that bypasses the contained sexuality of the family to power this group desire.

This is an anarchist motion by definition: decision-making is not a reflection of hierarchial control of groups or masses (Capitalism/Fascism) nor of theoretical Marxist equalities. In anarchy desire is restored to its central orchestrating role.

The patterns of desire are networks riddling the logics and the hierarchies of our capitalist/socialist superstructure. As the superstructure weakens, these patterns become apparent. With its lack of confidence in Britain, for example, the unemployed working-class youth become vacant territory. A working-class desiring machine, like a vampire, takes form through their bodies. Punk rock is the visible, readable, codable and decodable desiring machine from which a new

politics, a new economics must be erected. The strength of capitalism in Britain is dependent on its ability to recognize and utilize (manipulate) this existing desiring system. The strength of punk is dependent on its ability to generate new economies of production and distribution corresponding to the pattern of desire it has revealed. Hence the self-produced record, the fanzine.

Punk is anti-family. God Save the Queen (Mother). These prodigal sons and daughters do not want to go home. The tyranny of the family is not incorporated into this intensely pragmatic game-structure. Sentimentalism — the swamp in which capitalism breeds its docile subjects — is replaced by the magnetic/electric attraction/repulsion of active and passive, the slave and the conqueror.

Like S & M punk involves the body in a complete and brilliant desiring machine. Punks act out of necessity rather than fantasy. The mode of dress is characterized by the use of parts of the body in a complex of motifs or emblems (unlike high fashion, which deals with the decorated body, i.e. applied arts). The use of rips and zippers to isolate parts of the body, the manipulation of bruises, cuts, white flesh, ragged hair combined with leather, safety pins, loose ties, stiletto heels, pointed toes and exposed seams forms a language rather than a picture. In fact, words themselves join in that ragged grammar: not sentences, or even ideas, but emblematic tatoos beat out on the drums of punk bands 'NO FUTURE'.

The safety pin is a double image, and dualities are the key to punk. The safety pin pierces and mends, is at once domestic and savage, destructive and constructive. To a lesser or greater degree, all the punk emblems display this obsession with the domestic and the savage, the active and the passive. It is clear that chains may bind, but they are also weapons. Black leather may suggest bondage, but also declares the aggressive anarchy of motorcycle gangs. Bruises and cuts are at once wounds and battlewounds. Even the baggy suit jacket and loose tie suggests a capitalist authoritarianism on its day off . . . or is that skinny tie a hangman's noose?

Fanzines are the paperwork of this semiotic punk-machine. Like inter-office memos these quik-kopy gossip-sheets become tomorrow's toilet paper, like toilet paper completely contemporary, completely disposable. Hundreds of fanzines in small editions going everywhere interlace to recreate the web of desire . . . and alter it too, amplify it, provide the taste to hook you on the habit. Image is virus. Fanzines describe the motion of the aesthetic, making visible the virus making progress through the world.

* * *

Postscript:

In conclusion, a reservation: the working-class structure of British punk bands is not only a reflection of working-class reaction to inexcusable living standards, government policies and economic conditions in Britain, it is also, in true British spirit, a closed club. In reaction to class structure the punk scene has recreated the very system it set out to upset. If you don't speak a working class lingo you're an outsider, an intruder, you're putting on airs. Hence the ex-Biba's set haven't a chance, thank God, but neither have I.

AA Bronson

Gilles Deleuze & Félix Guattari,
Anti-Oedipus, 1977

Semiotext(e), vol 2, no 3, 1978

sentimental hippie enterprise of the eternal network, of correspondence art, and of the earnest artist-run system was suspect: burn it down!

We shouldn't be surprised. The "codable and decodable desiring machine" was just fancy new talk for what General Idea were doing all along as parasites animating dead bodies and speaking in alien tongues, only they were bringing the destructive, rather than insinuative, more to the fore. All along, Bronson said in retrospect, "We considered ourselves a cultural parasite and our method was viral.... We had abandoned our hippie backgrounds of heterosexual idealism, abandoned any shred of belief that we could change the world by activism, by demonstration, by any of the methods we had tried in the 1960s—they had all failed.... Now we turned to the queer outsider methods of William Burroughs, for example, whose invented universe of sex-mad, body-snatcher espionage archetypes provided the ironic myth-making model we required."[7] Wasn't William Burroughs, in his 60s, the new patron saint of punk? And while he had been the viral, cut-up inspiration for the mythic correspondence movement, there was never ever anything sentimental about him. Catching up on themselves, General Idea had to double down on destruction.

The *FILE* editorial did not advocate violence. Quite the contrary. It responsibly advocated an 'effective' art. The editorial asks, "What do you mean by 'effective' art?" And answers, "Obviously art that has effect. Obviously art that affects an audience. Obviously being effective requires an audience. Obviously art that has effect is art that has an audience." Obviously. "Obviously" was repeated bluntly as if a punk refrain. It was repeated reductively. Art was reductive to effect, and being effective was having an audience. Punk rock provided a model for securing a niche audience: "Curiously, while art struggles to emerge into a relevant cultural position, the Rrock 'n' Rroll avantgarde is struggling to disentangle itself from the centrally prominent dominant music industry. Let the music industry play the part of the museums—you'll see it's really just the same game, only the consumer is different." While Toronto was already artist instituted and run, what would this DIY ethos mean for it? General Idea called out to the art world in a mimicking Burroughsian gesture, "artists of the world—sell out—sell out before it's too late", a contradiction to punk authenticity unless 'selling out' meant to divest oneself of antiquated artistic myths: "Once and for all let's kill the alienation myth, the existentialism myth, the angst myth." (Oh, how all these myths would so soon return in the DIY expressionist painting scene of the early 1980s!)

General Idea had already floated the idea of an effective art—or, if you wish, flaunted the idea of an art that sells—in their faux *Press Conference* conducted at the Western Front in Vancouver 9 March 1977, which concluded brashly with the statement: "It isn't art unless it sells."

In inhabiting the form and public forum of a press conference General Idea was frankly implying that artists had to divest themselves of their isolating studios and inhibiting artistic myths to enter the marketplace: where art was "not merely a medium for personal expression but potentially also a powerful cultural tool." An effective art was one that would "get the public to act on the basis of your work".

Art had to reach an audience. In the *FILE* editorial General Idea suggested, "Consider a full-scale campaign aimed at the consumers' needs. To have effect, art must reposition itself in competition with other mass audiences." They then dismissed the art world with the sneering statement, "The Vega-matic is a more effective object than the entire output of art-objects in the 70s." Slice-and-dice was like the two-minute thrash of a good punk song. It was like the old cut-and-paste of correspondence art, with a new setting coming up right away for chance rearrangement. Media-matic was the way: take to the airwaves; inhabit capitalist codes. General Idea would do both with their video *Test Tube,* 1979, commissioned by De Appel to be broadcast on television. Inhabiting capitalist codes was the domain of their corporate activities, where content was then recoded to transgressive tastes. "Desire is anti-capitalist. Present economies of production and distribution do not allow for an economy of desire", Bronson writes in "Pogo Dancing". Consumption is the missing link here. Attending to consumer choice was the way to fulfil consumers' needs, wants, *and* desires (to signal and restore this Lacanian triad). Punk was pure machinic desire that short-circuited capitalism in a DIY conflation of production and consumption.

Punk, then, seems to have had a decisive impact on General Idea, destructive even, if we count the burning down of their Pavillion. Punk provoked the collective to plug its corporate identity into anti-Oedipal group desire. As an entity, General Idea itself was a desiring machine: Its anti-familial, an-Oedipal triadic structure was a counter-triangle to the dominant Oedipal one. General Idea would re-tool and re-invest in a new language to discuss the body, sexuality, and homosexuality in ways that were more aggressive and open than the disguised and sentimentalist camp strategies of their earlier work. You could say that, coincident with General Idea's Anti-Oedipal conversion, punk brought queer to the fore in their work.

CEAC had a mainline to punk with Crash 'n' Burn in the house. How would it respond to teenagers in the basement? Would it 'beat on the brat' or would it be able to channel the anarchic energy of Crash 'n' Burn constructively? Well, CEAC took to punk as much as punks took to Crash 'n' Burn. Before CEAC's adherence to terrorism, punk's provocation signified rebellion for it, and for a period of a few months its torn and tattered image adorned the newsprint of CEAC's tabloid *Art Communication Edition.*

EDITORIAL

What do you mean by 'effective' art?

Obviously art that has effect.
Obviously art that affects an audience.
Obviously being effective requires an audience.
Obviously art that has effect is art that has an audience.
To win a mass audience does not require art appreciation classes or longer gallery hours or lower prices. Consider a full-scale campaign aimed at the consumers' needs. To have effect, art must reposition itself in competition with other mass audiences. The Vega-matic is a more effective object than the entire output of art-objects in the 70's. Look around you . . . look how boring it is . . . look how bored we all are . . . Once and for all let's kill the alienation myth, the existentialism myth, the angst myth.

*The voltz stop. Elegance & alienation stop. Compelling frailty stop. A distant voice stop. Sombre & earnest stop. International darkness & deprivation stop. And black cloud rumour stop. Um yess I find the idea of entropy fairly exciting stop. We're not interested in entertaining any cultural con games stop. No I don't think of myself as an entertainer out to undermine the underground. Thankyou.**

Curiously, while art struggles to emerge into a relevant cultural position, the Rrock 'n' Rroll avantgarde is struggling to disentangle itself from the centrally prominent dominant music industry, while still retaining effectiveness. Let the music industry play the part of the museums — you'll see it's really just the same game, only the consumer is different.

ARTISTS OF THE WORLD — SELL OUT — SELL OUT BEFORE IT'S TOO LATE!

In Toronto and New York they fiddled with performance and fled to punk. Art/Rrock 'n' Rroll crossover was the original theme of this issue: Throbbling Gristle at the ICA; the Poles at the McLaughlin Gallery; the Dishes and the Talking Heads at A Space; the New York Dolls at the Mercer Arts Center; Talking Heads at the Kitchen; CEAC and the Crash & Burn.

Now every concert is an event. Alan Suicide is a musician, or is he? Michaele Berman is an artist, or is she? Robin Lee Crutchfield is an ———, or is he? Patty Smith is a poet, or is she?

The sentimentalism of late sixties early seventies essentially surrealistic aesthetic has been replaced by a certain pragmatic anarchy which is now the theme of this issue:

"It's cheap . . . it's easy . . . go do it!"**

* Crash & Burn News.
** Desperate Bicycles on their single of the same name.

FILE Magazine, Fall, 1977 11

Exterior view of Crash 'n' Burn

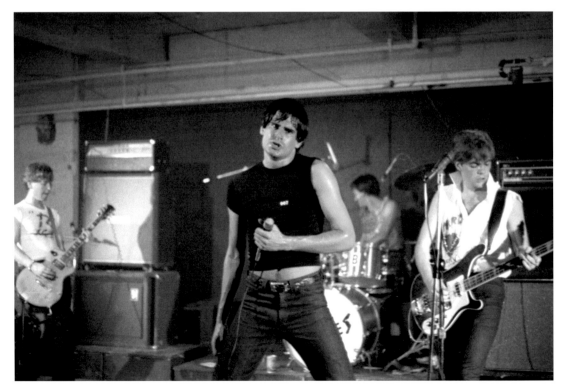

The Diodes at Crash 'n' Burn

The start of Crash 'n' Burn (officially you could say with Los Angeles' Nerves and Toronto's Diodes on 27–28 May 1977) coincided with CEAC's triumphant tour of Europe (May to mid-June), so the club was in full flow when Amerigo Marras and company returned to put out *Art Communication Edition* 6. That July edition had a four-page centerfold on what they had missed: Diodes, Dishes Jubilee, and Fashion Burn. Both Crash 'n' Burn and CEAC were on a roll and issue 6 was its reflection.

After the fiasco of the CEAC-hosted Contextual Art Conference in November 1976, CEAC reunited for a series of seminars with its original conference participants Hervé Fischer in Paris and Jan Świdziński in Poland. This diplomatic tour resulted in an *entente cordiale* issuing in a declaration of a "Third Front" published cheek-by-jowl with punk in *Art Communication Edition* 6. "A strategy to offset the 'capitalist division of labour in the art market'", the Third Front proposed "to develop a socially based practice through which artists can provide a critical contribution in a social transformation towards an autogestive power base". One of its preliminary steps was "to oppose the international art controlled from New York".[8] Upstart CEAC finally had bypassed New York, Joseph Kosuth, Art & Language, and Provisional Art & Language. It was a player now and a player needed a position. Could autogestive (that is, DIY) punk provide the right social attitude? Punks were anti-social, though: spitting was a sign of it. Punks were anti-social—and aggressive—in their attitudes and appearance, in their lyrics and loud musical crudeness. Their bottle throwing and fighting seemingly was the antithesis of sociability. But who said social practice had to be sociable? In this issue of *Art Communication Edition* where it was all beginning to come together for CEAC, the editors came up with a position that was more than a thesis. It proposed for itself the role of being antithetical.[9]

In his complementary article, "on being antithetical", Marras writes "The only acceptable history is the history of conflicts, one that includes oneself as relevant to one's life."[10] It would seem that the unruly DIY experiment in CEAC's basement was exactly this. The problem was, that in "the correction is a revelation of those contradictions existing in the systems we use... as consumers, or as exploited producers", that the:

> Dominant culture absorbs all the raw produces [sic] of the working mass and the undeveloped icons of it sub-culture: hence the rush towards 'povera' and conceptual sensibility, the search for the worn and torn, the hot interest in the revolutionary declamation of 'anarchy in the U.K.' Rough edges, residues of original life-styles, the residues of the exploitation inflicted by the dominant culture itself is recovered as raw material for recycling.

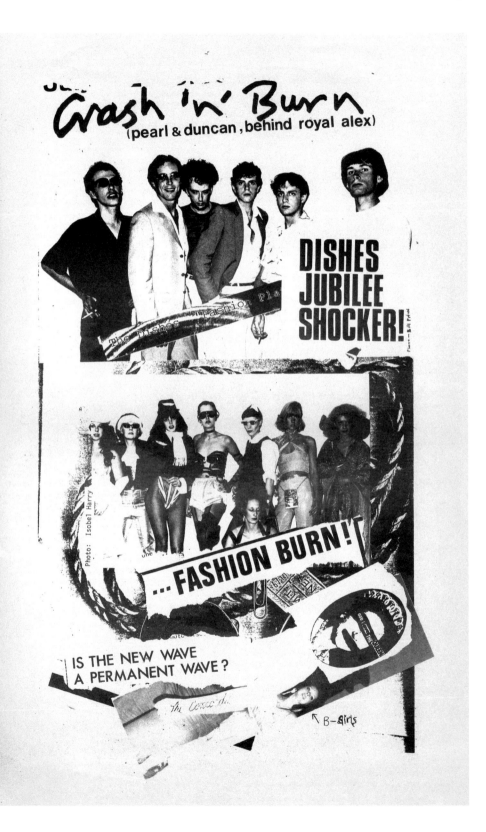

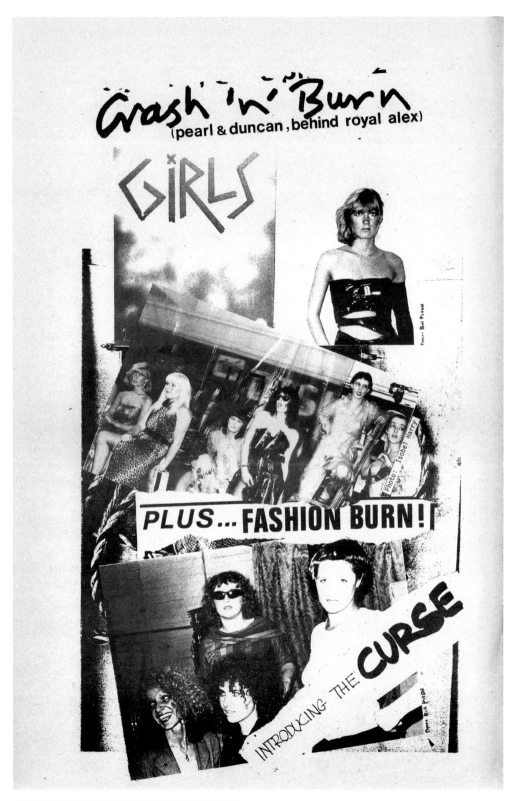

Art Communication Edition 6, July 1977 (selected pages)

FROM CALIFORNIA
THE NERVES

FROM TORONTO
THE DIODES

8:30 pm MAY 27-28 $3.00
GRAND OPENING! The CRASH AND BURN PUNK CONCERT SERIES
15 DUNCAN ST. (CEAC BUILDING) BEHIND ROYAL ALEX THEATRE

Art Communication Edition 6, July 1977
(page 24)

The problem was one of ownership and control of the recycled raw material; it was an issue of "the brutality of possession of the meaning in marginal culture by the dominant elite". The residual roughness of the distressed DIY punk style had the potential to be sold back to marginal youth as "a 'condition' of exploitation by the dominant class". So to prevent co-optation, "as radical marginals, it is incorrect to place oneself in an alternative ('parallel') situation.... We do not want 'recognition' by the dominant culture. We want to simply eliminate the dominant culture 'tout court'." This warning shot was aimed as much at artists in the parallel gallery system as at marginalised punks. It is not enough to be *alternative* to raise oneself, DIY, "to the level of self-consciousness necessary in order to become active in the process of self-determination.... The correct pattern is, instead, being antithetical to the dominant culture."

The main threat to punk was the media's ability "to control the raw power of language and package it as a consumable item". So Marras continued his argument, specifically on this threat to punk, later in the issue in an unsigned article, though written by him, "Spanking Punk". This is an equivocal title depending on the verbal or adverbial interpretation of "spanking" taken as either praise or punishment. If it was the former, then it was the egging-on of a revolutionary co-conspirator; if it was the latter, it was the admonishment of an upstairs Oedipal daddy. The article starts off well acknowledging that "the latest rebellious form for Toronto's youth scene is the rave of *crash 'n' burn* punk rock groups", although there is worry that "media coverage arrived promptly on the scenes with miles of columns about the rough scene and the fever of new wave rock".[11] Still there is praise for "challenging the well-worn CBGB's myth and creating their own... the really alive spirit at *crash 'n' burn*, so different from the New York scene". As in Bronson's "Pogo Dancing", the audience gets a nod, but not as part of a desiring machine, only parallel to it: "Parallel to the groups playing out their withheld rebellion, the crowded audiences are playing fashion conscious through their imaginations and recycling of low cost goods. The audience both shows off and mingles. Sometimes their signs of frustrated consumerism come out in broken beer glasses and make-up applied with razor blades."

Yet, there is something problematic about this playing out of a *withheld* rebellion. For it should be noted that "the punk rock scene in Toronto is considerably different from that in Britain, where the youth are victims of working class conditions. The Canadians, instead, exist on the edge of a capitalist surplus, having grown up in homogeneous suburban settings. The wall to wall carpet environment at mom's and dad's doesn't have the glamour and the punch of what one sees on TV." Touché. This capitalist surplus, and the inexpensiveness then of living on the edge, made the intersecting Toronto art and music scenes possible. (Although in an economic downturn with strikes and high

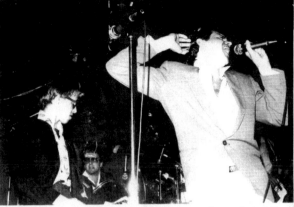

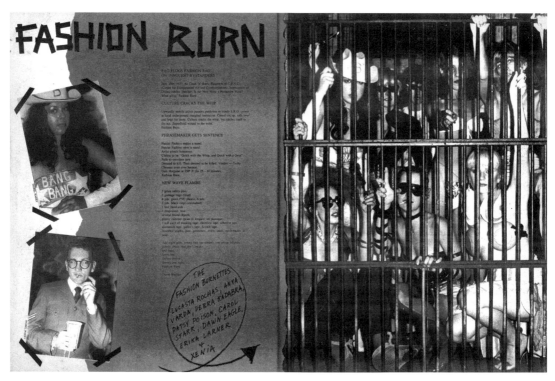

David Buchan, "Fashion Burn", *FILE*, autumn 1977

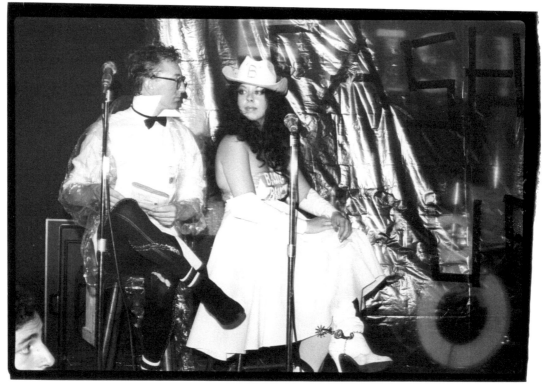

Isobel Harry, *David Buchan and Lucasta at Fashion Burn*, June 1977

unemployment, Canada, and Toronto—which was benefitting from
corporate headquarter relocation from Montreal as a result of the Quebec
provincial election of the separatist *Parti Québécois*—certainly was not
going through the severe social and economic crisis of Britain or even
that of the United States and a bankrupt New York City.) Here Marras'
praise turns to displeasure: "The emotionless generation dreams of
instant success... Forms have lost their contextual meanings and assume
the no-meaning of make-up.... Allowing oneself to be noticed helps
greatly to be different... Let's upset the old folks. The helmet and chain
look, lost its meaning except for the media history of what was a long ago
period of terror: Fascism.... Pushed to its extreme, the group offers what
the audience wants in its voyeuristic role: the treatment of a consuming
crowd with subconscious masochistic traits." Only the cynical—or smart
(one and the same perhaps)—could manipulate the situation: "Media
and advanced capitalization promise the dream of exclusive possession for
the smarter. Receiving coverage fuels the contradictions." In other words,
art school smarts would leave working class interests behind. Nonetheless,
there is always the potential for hope: "To channel the energy in a
revolutionary way still leaves different doors to choose from." This was
faint praise indeed since CEAC was soon to show punk the door by closing
Crash 'n' Burn.

Still there was enough continuing revolutionary enthusiasm for
punk for the editors of *Art Communication Edition* 7, August 1977, to
put an image of slobbering Stiv Bators of the Dead Boys, fresh from a
performance at CEAC and lifted from Ross McClaren's film shot there,
on its cover; to elevate Crash 'n' Burn as a legitimate CEAC venue on
the inside back cover; and to promote CEAC's punk foray into records,
RAW/WAR, on its back cover.

RAW/WAR was a compact enough statement to suffice on its own
as an edition of *Art Communication Edition* 8, October 1977, arriving
though when Crash 'n' Burn had already been shut down. A 7-inch
record was a quick and effective means to advocate an antithetical stance
in solidarity with a punk aesthetic. It was topical, not to any current
events, but to CEAC's political position. So on Side A, the Diode's
instrumental wall of sound collided with statements culled from the
journal read by Marras and Bruce Eves: "you people are the police...
any refusal to co-operate is a transgression on the code of ethics...", etc.
Side B offered a reading of a paragraph of Marras' "on being antithetical"
followed by that of the script to CEAC's Bologna performance overlaid by
a foul-mouthed rant by Mickey Skin of the all-women band, The Curse.
"What is the definition of society? What society? What definition?
Does society reproduce other bourgeois models? Does a repressive
society reproduce repressive social models?...", etc. / "scram... don't bug
me... get lost... I hate you... fuck off, you creep... get your fucking

Ross McLaren, *Crash 'n' Burn*, 1977 (still)

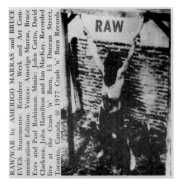

Amerigo Marras and Bruce Eves,
RAW/WAR, Toronto: Crash 'n' Burn
Records, 7", 1977

hands off me... don't touch me... you bastard... son of a bitch... go fuck yourself....", etc. Punk was on par with CEAC's notion of performance: aggressive, in your face, and repetitive, with quick bursts of sounds and 'strong lyrics' that were short on explanation and that sometimes led to metaphoric bottle throwing on behalf of disgruntled European audiences.

But who actually was disgruntled now? Marras must have been to close down so popular a venue as Crash 'n' Burn.[12] Punk had disappointed him. Already this could be seen in his ambiguous embrace of the movement, and the subsequent commercial packaging of rebellion proved his worries. Despite CEAC's own packaging of punk on the front and back covers of *Art Communication Edition* 7, the disillusion had already worked itself into venom there. The 'careerism' of punk was no different from that of artists, the editorial stated. The editorial's main purpose here was to signify a change in direction for CEAC: "to structure the shift in meaning, the artists' positions, and our editorial positions." Just to be clear, these positions were now emphatically antithetical: CEAC versus art. "We assume that art is not less than an idiotic activity with idiotic ideas that fill our consumerist addiction."[13] "Idiotic consumers" would be CEAC's critique of General Idea's notion of effective art.

Was this a statement of war? It seems that even the cordiality of the Third Front was to be shattered with the sacrifice of Hervé Fischer in order for CEAC to join Joseph Beuys' Free University at documenta 6 that September. What took place in this self-serving episode was the old inclusion-exclusion, elimination-dissent trick of the "introduction of poison into the system of the victim": absorb a colleague's more fully articulated position, then venomously eliminate friend as foe.[14] Was this to be the fate of punk? In what was to be the final November 1977 issue of *Art Communication Edition*, number 9, before its name change, its editorial left no doubt as to the fate of punk and CEAC's position on it:

> In the western capitalist countries the Fall has cooled the steam produced by the 1977 summer of rock. Punks, mannerists, opportunists, nouveaux riche, promoters, fashion burnt, and all the other idiots fallen into the image of anarchy as dictated by the vogue punk, rush towards the cliché of fashion like flies to a mound of shit. The fashion, the image, the shit has been widely explored and exploited by the mass media. Even the usual 'avant garde' magazines have covered the news while putting themselves into the picture. Capitalization has taken place as the time to cash in arrived. At last, the idea of anarchy makes money and the economical statement that punk rock might have made in the beginning is forgotten.[15]

In the end it seemed that CEAC had spanked punk after all, while
learning something in the process from the youngsters in upsetting
the old folks. The signpost was the change of name of the magazine in
January 1978 to *Strike* and its striking new image. Here Dead Boys Stiv
Bators gave way to just plain dead cover boys. Punk was now politics,
tout court, and vice versa.

All along Marras thought that artists associated with CEAC had
anticipated something of punk.

> The trend to sado-masochistic interest in the arts also created a strong
> interest [for punk]. The few body artists and performance artists
> working in Toronto had presented some tendencies and interests
> in S&M fashions (Darryl Tonkin and Bruce Eves). Blood-curdling
> and offensive performances by Ron Gillespie and the spontaneous
> Shitbandit group were also in this direction. More than anyone
> else, Gillespie initiated a work of collaborative activity with special
> emphasis on the body and the rejected lifestyle of the derelict and
> social outcast. Lily Eng's behaviour-body work anticipated some of
> the more theatrical and less sincere actions of the Viletones, who
> are now known more for their sensational stage work than for their
> musical qualities.[16]

Nevertheless, for a period CEAC had strategically allied itself to
punk, finding common ground in the record *RAW/WAR*. Perhaps you
could look at *RAW/WAR* as a riposte to General Idea's *Press Conference*
and the question of effective art posed there. *Strike*'s first editorial
likewise answered, "We know that within consumerist tactics, the
antithetical position, as explained in issue 6 of Art Communication
Edition, is an effective strategy."[17] The alliance of the 'antithetic' and
the 'effective' would prove highly ineffective though, because, in the end,
CEAC really chose the former over the latter, to its demise.

Crash 'n' Burn had drawn an unwanted police presence but not of
the type of scrutiny CEAC would endure a year later, which would lead to
its own closure. But it presaged the unwanted attention, censorship, and
legal action that were visibility's side effects and that would have broad
consequences for the art scene in the coming years. It had already started
just a block up the street from CEAC with a police raid on 30 December
1977 on the office of gay magazine *The Body Politic* with charges laid of
"possession of obscene material for distribution" and "use of the mails
for purpose of transmitting indecent, immoral or scurrilous materials".
The offending article was Gerald Hannon's "Men loving boys loving
men". The problem was that that August a twelve-year-old shoe-shine
boy, Emanuel Jaques, had been lured, sexually assaulted, and murdered
by three men on the Yonge Street strip of sex shops and body rub

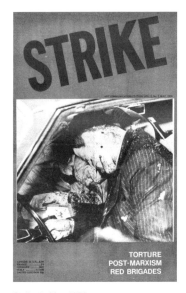

Art Communication Edition 7,
August 1977

Strike 2, May 1978

OVERLEAF
Art Communication Edition 8,
October 1977

SIDE A

1.2.3.4.5 (music) 5,4,3,2,1

- you people are the police, you people are
your own point of view

1,2,3,4,5 (Music) 5,4,3,2,1

- any refusal to co-operate is a transgression
on the code of ethics

1,2,3,4,5 (music) 5,4,3,2,1

- the contrary to not biting the hand that
feeds is to shut up and hide our critical
senses

1,2,3,4,5 (music) 5,4,3,2,1

- as a dialectical process, we see social
struggle as cultural struggle

1,2,3,4,5 (music) 5,4,3,2,1

- behaviour is not concerned with interperson-
al games as a means to communicate

1,2,3,4,5 (music) 5,4,3,2,1

- thus, whatever we do, even the annihilation
of any system, becomes a further contribu-
tion to the establishments' history, or does it?

1,2,3,4,5 (music) 5,4,3,2,1

SIDE B,

The art world, the chain of immense institutions and associated business proceeds to impose a fiction as the cultural reality. If we intend culture as the expression and consciousness of a human grouping then we must also believe that there is no absolute culture nor absolute language. As a dialectical process, we see social struggle as cultural struggle. We see that dominant culture is located antithetically to the marginal position of minority cultures and beliefs (as expressed by age, sexual and language differences). As radical marginals, it is incorrect to place oneself in an alternative situation. That is to say, it is ludicrous to think that it is only a matter of time before we receive recognition for our labour. We do not want 'recognition' by the dominant culture. We want to simply eliminate the dominant culture 'tout court'. To assume such a stance is to think that other relationships are possible and they are. The active participation (and self-awareness) by the majority is the social pattern that will doom cultural hegemony.

What is the definition of society?
What society?
What definition?
Does society reproduce other bourgeois models?
Does a repressive society reproduce repressive social models?
What is the language of each society?
What is the language of each society?
What is the behaviour of each society?
What is the behaviour of each society?
Does the questioning of the bourgeois social model create perhaps a new social model?
Who is questioning?
Who is determining the social parameters?
Does self management produce a model of continuous change?
How can ideology change social practice?
What are the tools to change such a practice?
Is it rather a change in consciousness?
Is such consciousness an individual viewpoint?

scram...don't bug me...get lost...I hate you... fuck off, you creep...get your fucking hands off me...don't touch me...you bastard...son of a bitch...go fuck yourself...get away you brick sweaty balls...I can't stand you...stick it up your fucking ass...you whore...I'll rip your lungs out...slimy pimp...you make me sick... you're a turd...don't make me puke...yuck... stick your dog shit head in the sewer...you're the scum of the earth...lousy lay...stinking ass ...you make me want to vomit...shove your money, your fucking money down your bloody throat...shut up...shut up...don't you dare say a word...don't talk to me...shake your shit out of here...you...dipshit you snoid ...you dumb suck...you suck the bag...ah, I think I'll throw up...blah...you're disgusting... oh, yeah...you dipshit...go twist your balls elsewhere

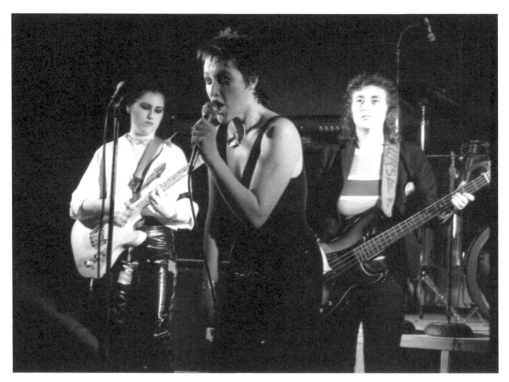

The Curse, 1978

parlours (where incidentally General Idea and Art Metropole were then headquartered). The call for clean-up eventually extended into scrutiny of the art scene. The Curse responded topically with their insouciant and provocative record *Shoeshine Boy* (which with its "Killer Bees" B side was called by Don Pyle "easily one of the greatest records produced from the Toronto scene"), refuting some of the purported innocence: "Shoeshine boy if that's your play/how'd you earn a hundred dollars a day?"[18]

The police, in fact, began to view the art scene in the same light as the degenerate drifters of the sleazy Yonge Street strip. Artists were as degenerate, perverse, and corrupt as Michael Fried warned theatrical incliners to be—and perhaps, worryingly, more dangerous. Drifters were detritus that left no traces behind; they could be moved along. A coalescing art scene tenaciously rooting itself in the unsurveilled districts of downtown was another matter; its images were contagious. Its cultural products had to be contained, controlled, and censored. So the disciplinary apparatus Foucault examined around the same time in *Discipline and Punish*, translated 1977, began to assert itself as the judiciary deployed police to raid *The Body Politic*, leading to charges, a long court case, and eventual acquittal. The raid and subsequent court battle united Toronto's gay and artist communities in political solidarity for the first time. This was the politics that mattered. Various censorship and court battles would plague the art community well into the mid-1980s.

It didn't take punk to turn contemporary art deviant. Punks were innocent compared to the art scene. But punks were the latest subject group to undergo academic examination as a subculture; and as subculture theory came out of the sociology of deviance—and was being formulated at the moment in England through Stuart Hall's Centre for Contemporary Cultural Studies in collective studies such as *Resistance through Ritual: Youth subcultures in post-war Britain*, 1975, and Dick Hebdige's *Subculture: The Meaning of Style*, 1979—we might wonder what reflected insight we can gain on understanding the Toronto art scene as a distinct subculture. Immediately, there would be the reservation that the art scene was not at all working class but, being middle class, was merely counter-cultural. However, here is my point about the effect of punk on the Toronto art scene: Punk turned the art scene from sentimentality to pragmatic anarchy, from hippie to new wave, and, yes, from counter culture to subculture.

Punk was not an agent of this change, only a vehicle. Liberated by punk, it was artists who were in charge of the controlled destructions that mirrored the building demolition happening around them. What had to be destroyed was the traditional art scene, and then another conception of it built up again; but what had already deviated from the former, and existed parallel to it during the early to mid-1970s, had to go as well: the whole hippie ethos of the early artist-run system. Conveniently,

The Body Politic, no 39, December 1977–January 1978

The Body Politic, no 40, February 1978

Centerfold, February/March 1979

The Body Politic rally, 1979 (poster)

punks hated hippies, too. Deviance was the way. Deviance may have been a dalliance in this period but it was used strategically between 1977 and 1979 to cultivate a separation from both the dominant culture and the vague druggy diffusiveness of the counter culture. The art scene needed just the right amount of visibility to make it a subset, a subculture, a unique art scene, but also the covert and subtle manipulation of styles and codes of belonging to make it obscure. A nighttime basement punk club was a good cover, the 'Cabana Room', too.

If you have ever subscribed to a magazine the police could get your name. And use it.

They have the names of all the subscribers to *The Body Politic.*

They have the names of people who used to be subscribers — but let their subscription lapse. They have copies of manuscripts for future publication. They have letters to the editor. They have two office rubber stamps. They have the mail that was in the out-tray on December 30, 1977 — the day five officers of the Toronto Police and the Ontario Provincial Police raided the office of *The Body Politic* and left with 12 shipping crates of material.

Why?

They have said that the material will be used as evidence to support two charges which have been laid against the paper. Both charges relate to allegations concerning the distribution of "obscene" material.

Rubber stamps.

Letters to the editor.

The names and addresses of anyone who subscribed to *The Body Politic* over the last few years.

Worried?

So are we.

So are a lot of other people.

"What the police did at *The Body Politic* last December would cause a national scandal if it occurred at a 'recognized' publication." — *The Edmonton Journal,* lead editorial, February 27, 1978.

"A blatant attempt at old-fashioned state censorship has been depressing us lately. ... We agree with *TBP* lawyer Clayton Ruby that the raid was illegal in its scope and a deliberate attempt to shut down a Canadian newspaper." — *Books in Canada,* "Notes and Comments," February, 1978.

"This looks like an attempt to cripple or close down the paper before it has been convicted of anything... It's a precedent that threatens freedom of the press..." — Robert Nielsen, The *Toronto Star,* March 29, 1978.

"The Canadian Civil Liberties Association is very concerned about the rather substantial search and seizure ... at the offices of *The Body Politic* ..." — Alan Borovoy, in a letter to the Commissioner of the Ontario Provincial Police, January 5, 1978.

The Body Politic is Canada's national gay newsmagazine. It has been publishing regularly for more than six years. The raid prompted protest demonstrations in Toronto, Vancouver, San Francisco, Los Angeles, New York, Melbourne, London and Copenhagen. It drew letters of condemnation from gay people the world over, and from individuals in publishing, broadcasting and politics.

And it concerns you. The 'climate' in Canada is changing. Or being made to change. And what the authorities describe as efforts to protect the citizenry begin to resemble infringements on some pretty basic civil liberties. It started with *The Body Politic.* It's moved on to *Pretty Baby* — the award-winning movie that can't be shown in Ontario because the Board of Censors has banned it. And it continues through the almost daily revelations of police crimes — crimes, according to sociologist Richard Henshel, "for which ordinary citizens go to prison."

Names on a subscription list have nothing to do with obscenity charges — whatever their merits. It is a clear attempt to intimidate subscribers to a magazine whose politics don't quite meet the tastes of the present provincial government.

It began with *The Body Politic.* There's no reason why it couldn't happen to the magazine you're reading now.

Your help is needed. The publishers of *TBP* are bidding to test the legality of the search warrant in the Supreme Court of Canada. That's an expensive battle ground. The trial on the actual obscenity charges is also expected to be long and costly.

The Body Politic Free the Press Fund has been set up to bring the issue before the public, and to raise the money that will be needed. Lawyer Lynn King has agreed to administer the fund in trust. All donations can be used only for the legal defence — none can go to cover operating expenses of *The Body Politic.*

Your donation would be greatly appreciated. By us, by the people at *The Body Politic,* and by all people who still believe in the freedom to think for themselves.

Make cheques payable to: Lynn King in trust for The Body Politic. *Mail to: Cornish, King, Sachs and Waldman, 111 Richmond St. W., Suite 320, Toronto, ON, M5H 3N6.*

THE BODY POLITIC FREE THE PRESS FUND

For further information, write to Tim McCaskell, Secretary, c/o Box 7289, Stn A, Toronto, ON, M5W 1X9.

1 On the history of Toronto punk see the comprehensive interview book, Worth, Liz, *Treat Me Like Dirt: An Oral History of Punk in Toronto and Beyond, 1977–1981*, Toronto: ECW Press, 2011, and the photographic memoir, Pyle, Don, *Trouble in the Camera Club: A Photographic Narrative of Toronto's Punk History 1976–1980*, Toronto: ECW Press, 2011. About half the images in this chapter are from Pyle's collection.

2 Ross MacLaren's 16 mm film *Crash 'n' Burn* captures some of its highlights in performances of the Diodes, Dead Boys, and Teenage Head, as does Peter Vronsky's CBC documentary *Crash 'n' Burn: Dada's Boys* in also revealing rare footage of David Buchan's *Fashion Burn*.

3 One of General Idea's showcards (*Showcard 2-052, "The Tyranny of the Myth of the Individual Genius"* [1977]), reads: "Being a trio freed us from the tyranny of the myth of the individual genius. It left us free to assimilate, synthesize and contextualize influences from our own immediate cultural environment. We admired the public access, immediacy and public support of certain trends in rock 'n roll. We posed for photos that could grace album covers. We knew that to be effective we had to reposition ourselves in conjunction with other mass media audience-pleasers, and we did."

4 Bronson, AA, "Pogo Dancing in the British Aisles", *FILE*, vol 3, no 4, autumn 1977, p 17. All quotations are from this page. Deleuze and Guattari, "Balance Sheet—Program for Desiring-Machines", *Semiotext(e)*, vol 2, no 3, 1977, pp 117–35.

5 *Hot Property* was performed at the Winnipeg Art Gallery, 22 October 1977, and *The Ruins of the 1984 Miss General Idea Pavillion* in Kingston, November 1977.

6 "Editorial", *FILE*, vol 3, no 4, autumn 1977, p 11. All quotations are from this page. What is pragmatic anarchy? As the term was never defined by General Idea, perhaps we can speculate: If the Sex Pistols were anarchists, entrepreneur and provocateur Malcolm McLaren, their manager, was a pragmatic anarchist.

7 Bronson, AA, "Myth as Parasite/Image as Virus: General Idea's Bookshelf 1967–1975", in *The Search for the Spirit: General Idea 1968–1975*, Toronto: Art Gallery of Ontario, 1997, pp 17–18.

8 "Third Front", *Art Communication Edition*, vol 1, no 6, July 1977, p 14.

9 "Art Communication Edition proposes for itself the role of being the 'antithesis to dominant ideologies', rather than the role of being alternative to the hegemony of commercially motivated journals." [Editorial], *Art Communication Edition*, vol 1, no 6, July 1977, p 2.

10 Marras, Amerigo, "on being antithetical", *Art Communication Edition*, vol 1, no 6, July 1977, p 3. All following quotations from pp 3–4.

11 [Marras, Amerigo], "Spanking Punk", *Art Communication Edition*, vol 1, no 6, July 1977, p 24. All quotations are from this page.

12 "Now to the $64,000 question: why was it closed down? I think there were two of three factors that led Amerigo to a stupid decision. Freshly back from Kassel, he found himself in the position of becoming what he once had detested, and no amount of rhetoric would change the fact that he had begun his entry into art stardom.... All the nihilist posturing aside, the bands were in search of record deals, and for Amerigo this led to disillusionment. According to Diane Boadway, he thought the bands simply weren't radical enough." Bruce Eves in an interview conducted by Mike Hoolboom, "Bruce Eves Interview" 2013, http://mikehoolboom.com/?p=16077. Although responsible for closing Crash 'n' Burn, Marras was still seeking to book the Sex Pistols as late as September. See letter to Virgin Records, dated 1 September 1977 in CEAC Fonds, York University 1981-010/014(12).

13 [Editorial], *Art Communication Edition*, vol 1, no 7, August 1977, p 3.

14 Marras, Amerigo, "VENOM", *Art Communication Edition*, vol 1, no 7, August 1977, p 4.

15 "If Anarchy Succeeds Everyone will Follow", *Art Communication Edition*, vol 1, no 9, November 1977, p 3.

16 Marras, Amerigo, "Report from Canada, Part I: The Punk Scene". An unpublished article from 1977 in CEAC Fonds possibly destined for *TRA*.

17 "Brave New Word: Strike!", *Strike*, vol 2, no 1, January 1978, p 2.

18 John Bentley Mays used the Jaques episode to create his own allegory of the art scene. See Mays, John Bentley, "Miracles of Emanual Jaques", *C Magazine*, no 2, summer 1984, pp 38–47.

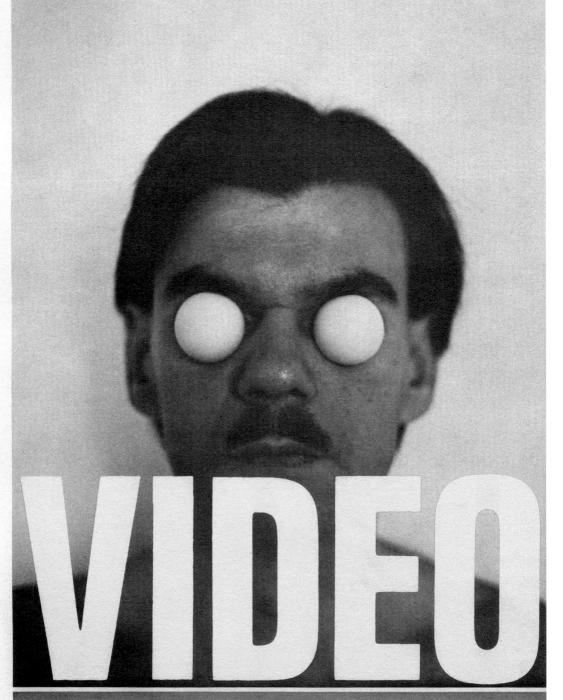

Tele-Transgression

History should at least be able to provide us an understanding of some of the forms and contents of period artworks in patterns that may not have been apparent at the time—that is, visible then as more than their forms or contents. History is more than the past's view of the past—and when it's not written, that's all we have—which is Toronto's persistent dilemma. In this respect, it's worth recalling Gertrude Stein's comment, "Let me recite what history teaches. History teaches." What does history teach? History teaches that over time some works increase in value, others diminish. But they do so in association with patterns of relevance that establish themselves retrospectively. Meanings are attributed to artworks that now go beyond their individual frames to join others in an historical narrative.

Thus we are now struck by the correspondence of performance and photography in Toronto in the late 1970s. Both were performative modes, a condition that we might have originally attributed to the former alone— and as a secondary artistic activity at that, one not so consequential to the development of art in the city as it was. As theatricalising forms, both equally were dominated by language. Talk was Toronto's theatrical mode.

Similarly, in a category that did not seem to exist in the past, we find that Toronto's 'conceptual art' (whether performance, photography, or installation) was embodied, ambiguously gendered, and dealt with transgressing codes, sexual, social, or otherwise. If talk is the more obvious signifier of Toronto's theatricality, code is the conveyor of its transgressions. Code is more covert, of course, than talk, but in a way Toronto artists were doing the same thing with both: from parodying cultural signifiers to inhabiting technological conveyances; from subversion of cultural codes to the diversion of technological ones. There is a more direct connection than we may think between parodying popular culture formats and transgressively diverting codes, that is, between the beginning of the decade and the end. Linking them establishes the story of the second half of the 1970s in Toronto art.

Video by Artists, Toronto: Art Metropole, 1976 (front cover)

The complementary subjects of "preformed cultural phenomena of fashion shows, ice follies, wedding ceremonies, cabaret entertainments or dime-store-novel plots" and the "uncontested territory of culture's forgotten shells—beauty pageants, pavillions, picture magazines, and other contemporary corpses" provide an image, but an image alone, of Toronto artists parodying popular culture formats.[1] What is important is not the ironic distance maintained in inhabiting these roles but the operations performed through them. Neither the particular formats or genres nor the actual images are essentially important; the former are interchangeable, while the latter are dispensable.

For the women performance artists Buchan wrote about, there was a need, however, to contest these images as roles. "Cloaked behind an ironic translation of the original intention of the genre", reflecting "the distance of the artist versus the proximity of the actual subject", and "often haunted by images of women in their past, the artists take advantage of their experience and use it to exorcize unwanted energies in these socially parenthetical situations". Buchan observes that "Their involvement with these models is plain to see, and it comes from the knowledge only experience and removed observance can bring together.... The sophisticated manipulation of these genres, the ability to see them as social constructs, thick with cultural reference, is combined with an internal physical need to play out the rôles." Operation and critique rested within performance. General Idea, however, had no need to play these roles in spite of saying "Like parasites we animate these dead bodies and speak in alien tongues." The ironic distance they maintained was translated into 'theory' and 'performed' in scenarios that linked image and text. For them, performance was this writerly relationship between the two. They called the practice "Stolen Lingo" and "Image Lobotomy" and described these operations in their 1975 Glamour manifesto.[2] The artists flaunted the method. Who cared if they plagiarised Roland Barthes and relied on his theories for their practice.[3] That was the point. But beyond this gesture of authorial appropriation, Barthes supplied the theory for mythic inhabitation that was applied, whether consciously or not, by a host of Toronto artists: General Idea, David Buchan, Dawn Eagle, Granada Gazelle, among others. Inhabiting formats or occupying images and inserting new content made a second myth from one prior. "All that is needed is to use it as the departure point for a third semiological chain, to take its signification as the first term of a second myth", Barthes explains.[4]

That Barthes lent the theory is not in doubt but the artists would move on, as would Barthes, of course. He had already long moved on. Toronto artists employed the same procedures as they had previously in taking over images and inhabiting formats but they now modified their strategies. Already there is a difference between what was summed

up in 1975 and what was happening in 1977. Contesting images was no longer the only end. The aim was more destructive, as disguised as it was: "Semioclasm" succeeded "mythoclasm".[5] No longer was it a case of infiltrating formats and inhabiting genres in order to transpose their contents; nor simply that of contesting images and their ideological representations; as much as it was a case of deviating images and subverting their codes in the process—diverting images by subverting codes. With their appeal to advertising, David Buchan's *Geek/Chic* and *Modern Fashions* appear to undermine the fashion image they replicate. But *Geek/Chic* only superficially is about the inversion of value—from chic to geek; it is rather the subversion of it by introducing a zero value into the fashion system. Analogously, the real effect of *Modern Fashions* is not supplanting images but supervening other codes on the ones they inhabit. Codes are infiltrated as much as images are inhabited. Images, in fact, were taken over in order to transform their codes.

"The Next Great Looking Television Artist"

By the end of the decade it was no longer the mid-70s' issue of stepping in to make myths of one's own from the debris of popular culture or of standing outside to ideologically deconstruct images of mass culture. Rather the charge was "to change the object itself, to produce a new object".[6] Some Toronto artists took this admonition from Roland Barthes to mean to change the medium itself. But really this was only their demand to enhance the dissemination of the medium, video in this case, by demanding access to broadcast or cablecast television. Toronto video artists had been at the forefront of the new art medium, which in the early 1970s was consciously counterpoised to television. By the end of the decade they sought a larger market share than the closed-circuit artist community. And television with its built-in audience was the place. This was inhabitation by invitation not infiltration and so the industry would set the technical standards and the terms of content.[7]

 The "Fifth Network Cinquième réseau" conference of independent video producers convened in Toronto in September 1978 to discuss non-mainstream access to television. As an article in the *Canadian Journal of Communication* subtitled it, thus identifying it from its point of view, this was a "conference on broadcasting, cable, satellites and computers for community action, social change via alternate and independent video". "Independent video producers", this was another name artists gave themselves, but it did not disguise the fact that this conference fractiously split between the social and artistic uses of the medium—but also between Canadian artists themselves on the issue of national representation, and even between independent producers of the artistic medium itself (Lisa Steele complained of the secondary treatment of single-channel video in favour of performance in the event).[8] The failure

Tele-Performance, 1978 (poster)

Centerfold, December 1978

to constitute a national organisation at this session, and the residual distrust of the industry itself, however, had the positive outcome of artists taking the matter into their own hands to set up their own distribution networks. Art Metropole had been distributing artists' videotapes since 1975 but in 1980 Lisa Steele, Susan Britton, Rodney Werden, Clive Robertson, and Colin Campbell broke away from its representation to start up Vtape for this purpose.

If by day the discussion was on market spectrum access, at night the issues were somewhat different, taken on by artists entirely, that is to say treated more obliquely and enacted in a concurrent event called Tele-Performance, organised by Clive Robertson. The day's proceedings had themselves been cablecast live, and the equipment allowed the evening performances to be televised as well. Evenings took a different bent than industry types might expect of television. For one thing, the entertainment was tele-performance, a hybrid category that was in fact a combination of two specialities of Toronto art: video and performance, and not just televised performance.[9] This would make it a signal event. Early Toronto performance art was oriented to popular culture entertainments, which were mimicked in live situations. At Tele-Performance the live situation also incorporated a mock television audience and the event was cablecast according to the conditions of television. Some artists incorporated this real yet metaphoric set-up (it was not an actual television studio) in order to produce their own television shows.

And so taking full advantage of the audience applause prompt, Lamonte Del Monte, aka David Buchan, hosted a music variety show, *Fruit Cocktails*, the live taping of which fictitiously was to be broadcast from "Lamonte's headquarters at Television City". All the mannerisms of lip synch delightfully were on display as well as Lamonte's own conceits in these well-choreographed routines, but this show-biz regular shared the stage, for instance, with Florida Sands, whose rendition of Petula Clark's "Downtown" was "more downtown than Petula ever intended".[10] *Fruit Cocktails* looked back not only to 60s singer-hosted TV variety shows, think a drunken Dean Martin, but also to Buchan's own trajectory as a 'wardrobe artist' before he passed the torch song back to feminist performance artists such as the Clichettes, who would be big in the 1980s. In fact, Lamonte gave the Clichettes their break here with a guest spot, and their lip-synch version of Lesley Gore's "You Don't Own Me" literally made their careers.[11]

If an earlier period of performance art classically culminated in the pop gloss of *Fruit Cocktails*, other performances those few evenings were more darkly engaged in current issues and their montage of media effects were a bit more rough-edged, punk even. Elizabeth Chitty's *Demo Model*, its title recalling Buchan's description of "game show hostesses

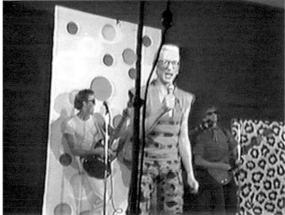

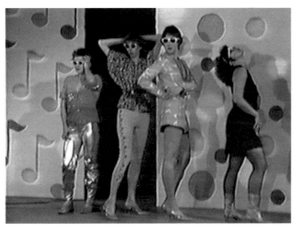

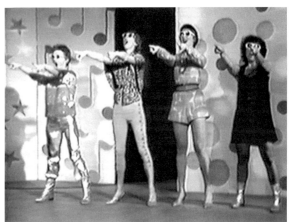

David Buchan, *La Monte Del Monte's Fruit Cocktails*,
Tele-Performance, 1978 (video stills)

opening Frigidaires with poise and charm, airline stewardesses doing mime performance of the location of emergency oxygen supplies", was a complex compendium of bodies, recording technologies, sign systems, and languages in various conjunctions and disjunctions. They did not so much communicate as signal, surveil, or record each other. For all the emphasis on languages, there was a significant failure of communication ("It was all Greek to me. I couldn't understand the language.... I couldn't break the code."), but something was definitely registered in the process. Tele-performance here was no transparent transmission, a matter simply of televising performance or of mixing pre-recorded video with live performance. Rather, more sinisterly, the two categories corresponded respectively to surveillance, on the one hand, and inscription, on the other. Modes of address were actually technical inscriptions; the site of reception was really the body.[12] This Foucauldian thematic of the political technology of the body would rule Toronto's art in the latter part of 1970s.

"The 'Tele-Performance' programme provided, without question, a broad spectrum of artistic responses to the whole shifting social and political relationship between the individual and the state as it is presently mediated by the ideological super-structure of television in particular and the communications media in general."[13] But performances are hardly academic papers, and it was in part the disjointed and artificial rather than seamlessly mediated nature of tele-performance that made it an apt vehicle for these investigations. In the real space of performance what was manufactured was in full evidence. Buchan's *Fruit Cocktails* faked the televised part; in staging, its seams were visible, presumably to be edited out in its 'future' fictional broadcast. As Chitty had, Clive Robertson maintained the divided dialogue between media in his genre-specific exposure of network television news. Given that Robertson published an artists' newsmagazine, it is perhaps no surprise that he decided on the television newscast to convey his distrust of artists on television, his real purpose here. His aim was to forestall the exposure of artists to the seduction of having their work on air. To this end, in his *Explaining Pictures to Dead Air*, he co-opts Joseph Beuys and channels his shamanic persona in the fiction that the charismatic art star had been hired to read the evening news: in Robertson's gold-face characterisation, "lip-syncing television's cultural propaganda".[14] Behind the anchor's back, playing on a video monitor, the backstory tells us some of the mechanisms and editorial processes of network news. Beuys himself actually appears ("to give it documentary credibility Beuys was also coopted to give his views"), prerecorded, while pretending to be a live hook-up talking, ja ja, of the "difficulty for artists to work with television": "The structure of society is not intended to give people like me enough time to explore what one thinks about possibilities to change the structure." Robertson

Elizabeth Chitty, *Demo Model*, Tele-Performance, 1978 (documentation)

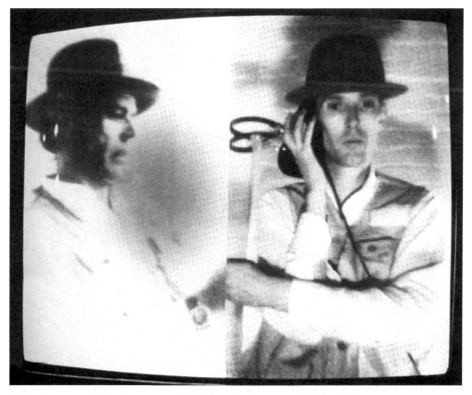

Clive Robertson, *Explaining Pictures to Dead Air*, Tele-Performance, 1978, video (still)

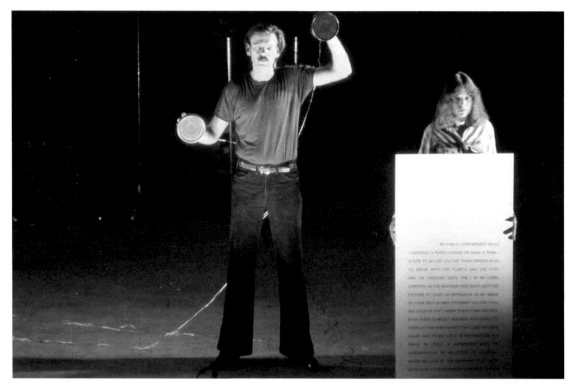

Tom Sherman, *See the Text Comes to Read You*, Tele-Performance, 1978 (documentation)

saw this performance as "a docudrama of how artists relate to the forms of television", but it was just as much a quasi-didactic lesson. Artists were told "there is no present role for artists in television. As the piece attempted to illustrate—we are exploited at the same time we are forced into exploitative relations with others."

As director of the videotape derived from Robertson's performance, it is no surprise that Tom Sherman shared some of his colleague's views on television. He, too, was part of the Tele-Performance roster and his *See the Text Comes to Read You* was another lesson, obscure as it was with its dense run-on text spooling like a *Krapp's Last Tape* for videophiles. It was an updated version of an artist's bond to his tape recorder. One might as well say television rather than tape recorder because the subtext is that we (ie, artists) do not add information to a uniform flow of machine-produced and disseminated data, but that we too are data processed: the text comes to read us.[15] The machine is not so much an extension of the self as a subversion of our subjectivity. Here the performance's title resonates with that of Richard Serra's 1973 character-generated video *Television Delivers People*.

Sherman had recently been appointed to the *Centerfold* editorial board and an article of his published there just after the Tele-Performance event, "The New Triumvirate", spells out another worry of absorption—but now of dissent transformed into a new consent. He contends that "the present ruling class of manipulators" are those put-upon in the countercultural 60s, and that the hippies and yippies are now running the media show, "idealist, though disillusioned" as they are.[16] It was their turn now, by choice not "forced into exploitative relations with others", to make a mass public conformable—and artists were complicit as active agents forming a triumvirate with broadcasters and police (the RCMP) at the service of the state: "Does not the artist correlate the internal response of the state as a whole and then publicly exhibit this response for the information of the government?"[17] As ex-hippies, artists, too, were complicit even before they put their work on television (if the government was looking to this degree), complicit even more so once on air.

In the end, Sherman was an artist, not a journalist, and his analysis of television was more fine-grained than Robertson's approach in *Explaining Pictures to Dead Air* in that it was not merely ideological but informational, that is, operating not on the consolidative level of ideas but on the disintegrative plane of data. Even if it would end in the same reproach to artists, the investigation entailed observation before explanation—or exhortation. In Sherman's case, the pre-given was phenomenological not ideological. So his practice operated between the perceptual and the verbal. Although part of Tele-Performance, Sherman did not work between performance and video but between video and writing—not between image and text as you might think, correlating them, but as a video artist and then again as a writer. Yet one practice

Tom Sherman Writing from the Photographs
of Lynne Cohen and Rodney Werden
August 1-30 Cinema Lumière 290 College Street

Tom Scherman, Writing from the
Photographs of Lynne Cohen and
Rodney Werden, 8 x 10 cm, photo
invitation, 1977

could be the subject of the other. Sherman was one of the first generation of Toronto video artists, which lent him a certain authority when he criticised this work retrospectively, but he was unique as an experimental writer. He turned his writing to the different formats many of the artist-run publications offered and publicly exposed it, for instance in blown-up panels in cinema lobbies and windows.[18] Writing was as much an art medium as it was a fictional or critical one in this hybrid period. Even art criticism was to become performative.

How far was it from writing from photographs to writing from television? Not writing for television but from it. This was unlike any writing on television, though derived from it, that is to say television itself not from the words on it. Sherman set himself to describe television watching. The deadpan-delivered outcome was half nouveau roman description, half phenomenology of television perception. "I'm here writing television for people who watch it", Sherman says in "Television as Regular Nightmare".[19] He is hardly judgemental, as you might expect an artist to be in condemning the banalities of this mass medium. Writing here was neither didactic nor dogmatic because in this performance television was considered no one-way street where viewers were delivered as products to it, transparently subject to its ideology. Rather words tipped in favour of the watcher as obsessed interlocutor. These obsessive monologues engage with the medium as personal environment: talking to television in the closed circuit of viewing, scrutinising its appearance and the appearance of those on it. Is it a female newscaster so scrupulously examined here or is she "the next great looking television artist"?

This was a moment of large changes in information technology as satellite, cable, and fibre optics were rewiring the delivery of television signals. And many video artists wished to seize their opportunity to contribute to an allotted spectrum in this expanded universe. There were dissenters, though. "I dread to see what the artist will do on television when he or she decides exactly what's needed", the narrator of "Television as Regular Nightmare" worries and then proceeds fictionally and sardonically to dismiss this prospect.[20] Then in a complementary text published in *Centerfold*, "The Artist Attains Ham Radio Status in an Era of Total Thought Conveyance", if the title was not suggestive enough, Sherman takes a few swipes at early video art in the process, those Canadian artists lucky enough to get their hands on equipment, thanks in part to government funding, and who "were able to log their private lives as worthy material for public display because of their early entrance".[21] It was not enough to parade your personality as a television artist; new technologies subvert personalities, pervert them too. Rather than be guests of television, some artists preferred to be parasites on their host—indeed not just to provide entertaining content but to ungraciously pervert its technological codes.

OPPOSITE
Tom Sherman, "Television
as Regular Nightmare", in
Performance by Artists, 1979

PP 226–227
Tom Sherman, "Writing", *FILE*,
spring 1977

MUZAC FOR YOUR MIND AS YOU CHECK YOUR MAKEUP.....

It's right on time. That's what I like about it. It's time. Performers line up in front of the cameras. They have a lot of different backgrounds, personal histories, with only their reason in common. They have the reasons to be up there. Performing.

Did she get the microphone extension cord? What's the use of doing this piece if we don't get it on tape? You work to tape, don't you? There is going to be plenty of top-notch hardware around. Access scheduled by telephone. There is raw tape to suit your needs. So work freely. We'll put you in there, in the studio. Don't worry about the technical end. We have the technicians to keep the artists away from the equipment. They don't know about the equipment. Most of them would rather not know about the equipment. They want to stand in front of the cameras. They are on air looking into red light camera number 1. They perform to the camera. They want to broadcast their art. No reason why they shouldn't. I can't think of any reasons why not? They want to get out there by taking electromagnetic form. The wave form or particle or instant sheet of white heat, if you wish. Radio Energy Television Pictures. You are beautiful programme. You really know the language. You really turn on up there on the set. You are better up there than you are in person. Some of you are. But I worry about this thing about the pretty girls and the handsome men. You know so much of your performance depends on the way you look. She may be the next great looking television artist. Because the people will support stereotypes. But why am I here with you in this book?, skirting around in the clarity of these cheap newspaper ideas, formed and reformed by the popular press; the effects of violence on television, the dangers of sexual stereotyping, role reversal and the frequency of gender oscillation; women dominating other women, Indians taking over the cities, the prevailing will of the people dramatically changing the behavior of the artist.

I'm here writing television for the people who watch it. I dread to see what the artist will do on television when he or she decides exactly what's needed. The artist starts by looking around the dial. Television artists hang around their sets in long depressing stupors of surveillance. They refer to this as learning the language. Many watch with the sound off. Taking a look at your world. What channel are you watching? Doesn't matter. Watch whatever you had on the night before. My current focus is on morning network television. But

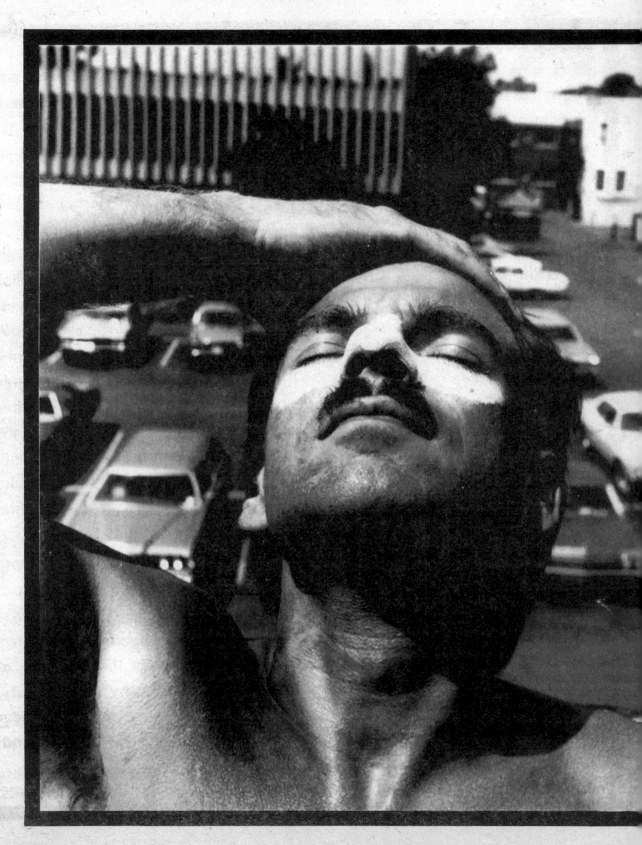

There's instability in my self image. Jerky transitions in my mechanical method of survival. Close shaves. By the skin of my throat I get away.

Opposite page: envisioner Tom Sherman. It's easy to see what people do in their homes. In their homes they are 'home' inside an enclosure of hand-built walls. They are home comfortably reading newspapers and magazines or watching TV. When they eat they listen to music on the radio. When they talk they play records on their stereo. The ones who go to a lot of movies read novels when they stay home. Those who watch quite a bit of television love to thumb through magazines at the newsstand. People in their homes, they all get a big kick out of a good coffee table picture book.

What pisses me off is the way people tend to generalize when they don't know what they're talking about. The only way to cut through their general babble is to ask specific questions of detail. That's a good way to catch a liar, too. But those I see rambling through their entire lives locked in the general mode of conversation, they are not necessarily dishonest people. In my case I speak in generalities when I lack the facts. Sometimes I write in the dark. With my eyes closed I miss the rich field of vision in front of my nose. Blind by my own wish I am not obsessed with the process of burrowing into pockets of detail. My fascinations I do not pigeonhole. I'm afraid I remain the cold, distant, insensitive generalist; the one with the questionable moves; sneak a glance at my slippery tongue as I state the following words from a point in my personal view: I would rather hash it up with a good liar than converse with a person who keeps still because he doesn't know. Or I run into collectors everywhere, so particular and precise their character — so warm and eccentric they are!

To appear authentic in conversation and print I enrich each sentence I pronounce with a bit of general detail; perhaps I quote a number or tell a temperature or exaggerate the adversity of conditions affecting my physical body. For instance it burns my ass to hear people advertising their '1 of a kind' identities.

TOM SHERMAN

"The Perverse Telephone Network"

Perhaps as the children of Marshall McLuhan in the immediate circle of his hometown, Toronto artists were more obsessed than others with the media, cannibalising formats of picture magazines (*FILE*) and news magazines (*Centerfold*) as well as pioneering in the new technology of video. They became experts in both hardware and software, adapting both to their own purposes. By the end of the 1970s, the shine was off technology. Artists were always adept at reading signs and ironically attuned to the persuasions of the media and its ideological formations, and their optimism now gave way to technological pessimism, perhaps answering to the dire tone of conservative Canadian philosopher George Grant's 1969 *Technology and Empire* rather than the positivist optimism of Marshall McLuhan's *Understanding Media*.

Underscored by its moog synthesizer theme song, *Here Come the Seventies* was the upbeat title of a Canadian Broadcasting Corporation television series that began the first year of the new decade. Get ready: the future is now! But the decade would not pan out as planned after the oil crisis of 1973, when the show conveniently ended. It was to be a decade, after all, of the dysfunctional and dystopian; a decade that invented the genre of the disaster movie. The economic predicaments, institutional crises, and social distresses of the 1970s (the OPEC oil embargo and concomitant recession, stagflation, and unemployment; the loss of confidence in public institutions Watergate represented; as well as Red Brigade and Red Army Faction terrorism, kidnappings, and murders) led to widespread pessimism by the end of the decade. "No future" was an apt slogan.

Crises were not as marked in Canada as elsewhere. This does not mean, however, that Toronto artists were not affected. "Here in Toronto, surrounded by signs of an affluent, middle class and self-satisfied culture, fed by the enlightened, if contested, patronage of the Canada Council, our artists wander, cultural zombies in the land of the living dead", AA Bronson writes in 1979.[22] But being zombies meant wandering, indeed operating covertly, in liminal zones: in the no man's land between public and private, which was also the locale of the art scene; in the entanglements between encoding and decoding, where communication systems inadvertently exposed themselves; and between old technologies and new, where hardware could be 'borrowed' and software 'stolen'. Curiously, these zones were relatively unregulated and unsupervised and whatever was hidden in the open was there for the taking.

If there was pessimism of the intellect, nevertheless, there was optimism in subversion. There was glee in pirating technological circuits. It was no longer a case of fabricating third-order semiological chains from second-order myths/ideologies—as if this were a public service, as well as an entertainment, that artists performed. There was a change

of emphasis from this visible, image-based activity, a change of focus from overt to covert operations, from accepted activities to perverse preoccupations and sly procedures. "The only possible rejoinder [to bourgeois ideology] is neither confrontation nor destruction, but only theft: fragment the old text of culture, science, literature, and change its features according to formulae of disguise, as one disguises stolen goods."[23] Given that it was new world Canada, there were no old texts but instead new technologies that could be so fragmented, being coded already and available for dismantling.

There was something about the moment that made all this possible. The late 1970s was a juncture of technologies, of hardware and conveyances, of the sophisticated and the crude, all situated at the conjunction and threshold of the analogue and digital, where the two coupled together awkwardly. It was this joining of differently configured technologies and their consequent misfit that allowed infiltration.[24] The aim here was not to syphon off contents but rather to use and abuse the carriers themselves.

When writer Judith Doyle confronted technology she put on two faces: one public, the other private. The optimistic, forward-looking public face corresponded to a think tank of sorts. Worldpool was an ad hoc group of artists interested in exploring new uses of technology, but from an artist's perspective, that met in Doyle's storefront office, Rumour Publications. Willoughby Sharp, one of its founding members, writes soon after its incorporation in late 1978, "Bell was right about wire uniting the world. But he would have been surprised by the *non*vocal applications of the network his vision inspired. Today, with telephony the universal communications medium, Ma Bell's voice grade telephone lines are being used increasingly for a wide variety of analog and digital transmission. Computers, facsimile, and slow-scan television (SSTV) are only three of the relatively new electronic systems currently enjoying intensified experimental development." Facsimile and SSTV were the rudimentary and cumbersome forms that artists embraced for a short period of time, but they were awkward aesthetically and slow, and the outmoded technology was soon to be replaced but not without offering lessons in perverting Ma Bell to other ends. "My work during the past year has convinced me that we *must* implement a logically integrated computerized communications network.... The Computerized Arts Network." He goes on to speculate, "I have a hazy vision of the day when we all will have access to a computer network containing the entire body of known facts."[25] Dream on, Willoughby!

An integrated network of independent nodes of artist activity paralleled mainstream, corporate ones, piggybacking on these commercially available communications systems for transmission, whose deviating purposes may have been frowned upon by owners and government regulators alike. But on the surface the problem was the straightforward mirroring

Judith Doyle, *Anorexial*, Toronto: Rumour Publications, 1979 (front cover)

Philip Monk, *Peripheral/Drift*, Rumour Publications, 1979 (front cover)

ANALOG

Word is a word for sounds and pictures. According to Ernest Fenollosa:

人　　　見　　　馬

Man　　　*Sees*　　　*Horse*

It is clear that these three joints, or words, are only three phonetic symbols, which stand for the three terms of a natural process. But we could quite as easily denote these three stages of our thought by symbols equally arbitrary, *which had no basis in sound.**

* E. Fenollosa: *The Chinese Written Character as a Medium for Poetry.* Edited by Ezra Pound. City Lights Books.

Inversely, a sound can tell a thousand pictures.

Analog is an imitation that travels well. A means for transforming, transmitting and storing information. It moves the way the original moves. In terms of light and dark, high and low, soft and loud or whatever. On the phone lines, this imitation is relayed along wires and cables, amplified at each station it hits. Every time it's amplified, it picks up garbage, or noise. (Diagram 1)

If there's 10 parts signal to 1 part noise . . .

Signal:　　　10　　　　10　　　　10　　　etc.
Noise:　　　　1　　　　　2　　　　　3

Figure 1:　The triangles are amplifiers along the line. When amplified, signal stays the same, but noise increases.

Analogs are as different as originals. This makes them bulky to store.

If analog's a problem, consider digital code. Bits are selected from the original, and assigned numbers. These numbers are given a binary weight. A binary weight indicates which particular numbers, of all to choose from, are ON and which are OFF. That sort of information *never* deteriorates.

The problem with digital thinking is that it assumes that bits make up the original. The whole is never digital, but digital imitation is remarkable. (Diagram 2)

BINARY WEIGHT							
	64	32	16	8	4	2	1
X = ON 1 =	0	0	0	0	0	0	X
5 =	0	0	0	0	X	0	X
9 =	0	0	0	X	0	0	X
0 = OFF 12 =	0	0	0	X	X	0	0

Signal　　Bits　　Numbers

Figure 2:　How a signal is approximated in digital code. The on/off's are plotted at the endpoint, reconstructing an outline of the signal.

On/off information is very compact, and fits into systems that provide cheap easy access. Like the home computer.

Telefacsimile transceivers make analogs of visual information on paper. These sound codes trigger copies on the other end. It is possible to go directly in and make your own sounds that trigger copies. By screaming, whistling, with electronic instruments . . . these are synthetic facsimiles.

How To Borrow a Facsimile Transceiver

1. Phone Xerox of Canada.
2. Meet the salesman in your own home.
3. Arrange to test the Xerox 400-1 telecopier-transceiver.
4. Ask to demonstrate it over a weekend.
5. Borrow the transceiver for the weekend.

How to Send a Telefacsimile

1. Call someone with a facsimile transceiver.
2. Put your image on the rotating drum.
3. Hook in the telephone.

Judith Doyle, "Worldpool", *Only Paper Today*, December 1978

of the language and logic of a corporate enterprise where optimism and technocratism go hand in hand. Following mentors in the art world instead, Doyle advocated a more surreptitious correspondence that bordered on the 'illegal'. We could call this her private face, and her advocacy not so much pessimistic as perverse. Since "Control is most effectively exercised in the carriers" and since "Broadcast communications authorities recognize perverse, idiosyncratic, amateur sub-systems as untenable trends", she recommends modelling activity on these amateur networks and by 'borrowing' equipment to access them. She observes, "C.B., ham radio, and amateur TV networks are proliferating, incorporating new surveillance tools as rapidly as they can be perverted."[26]

The "Perverse Telephone Network" was Doyle's model: "A sub-network sending and receiving interactive pornography using new audio, video, and facsimile transceivers and the existing telephone system. This network, with its open and shut nodes, is impossible to locate; the hardware shifts or falls apart, is easy to build or repair on principles of theft and bricolage, as it is composed of widely-proliferating surveillance tools. The network per se is the telephone system. The individual participants are interchangeable."[27] Describing the actual network ("The network of individuals who possess facsimile hardware for uncommercial applications is shifty and unpredictable") was the same thing as understanding it theoretically ("At this point the model of the network applies—impossible to locate, its coordinates are conditional and very shifty").[28] The statements are homologous without either being prior. So Doyle speculated on the network's shiftiness as a resource for 'theoretical fiction' in her "Model for a Prose Algorithm".[29]

Shiftiness also made for seeing the network as symptomatic. Saying theory, practice, and scene were homologous already meant understanding that the art scene was symptomatic. So when AA Bronson writes that "as capitalism's complex resonance amplifies strange new need, its mushrooming electronics communications gadgetry creates hiding spots in tangled circuitry for perverted modern lovers", he, too, was suggesting that resonances amplifying need were symptoms that capitalism itself created but could not initially control; and that the slippage between the two (creation and control) encouraged new entanglements as unforeseen inventions.[30] Punk was one of these entanglements but as a codified machine that could be read and (what was already) its borrowed elements rearranged. "Punk rock is the visible, readable, codable and decodable desiring machine from which a new politics, a new economics must be erected." So much for Annette Michelson's idea of the work of art as a single level of articulation resistant to coding and decoding. What was already borrowed and rearranged could be borrowed again and rearranged otherwise. A new politics and economics were not molar constructions; they could be micro-systems—micro-politics and micro-economics—

PP 232–233
Judith Doyle, "Theoretical Fiction" and "Model for a Prose Algorithm", *Only Paper Today*, October 1979

THEORETICAL FICTION

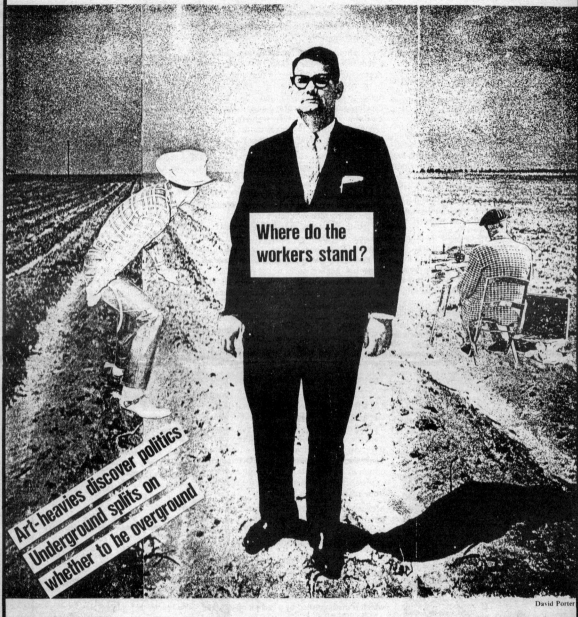

Where do the
workers stand?

Art-heavies discover politics
Underground splits on
whether to be overground

David Porter

Theory, displaced from the work of art, from it's object, appears fictive. And fiction, without it's natural ambivalence (the characteristic pre-eminence of events in sequence) seems first explanatory, then theoretical.

Somewhere between theory and fiction, a break has occurred. By placing the terms together, both become situated on their singular peripheries, in the mutual dislocation of this rupture. There is no definition for 'theoretical fiction', or rather, no torque of definitive

conditions implying a center. The conjunction (hence, conjecture) is to be found in the space between:an opening, or kinetic center of gravity, outside two bodies yet in roughly equivalent position, as in the shift of two gymnasts in mid-air.

The shift is temporary; the short, exhilarating force of falling bodies outside themselves, metabatic, out of control. 'Theoretical Fiction' is this unconditional issue from a break.

J.D.

JUDITH DOYLE MODEL FOR A PROSE ALGORITHM

FOREWORD

The Architecture Machine Group at M.I.T. was originally formed to investigate computer-aided architecture. Increasingly, their efforts turned to the spatial management of data - in effect, to developing a perceptual architecture for information.[1] Their systems, along with developments in telecommunications networking, and random-access information storage, point to the possibility of spatially-constructed fiction.

As the cost of memory plummets, concepts for manoeuvering through large bodies of information must be meticulously examined, for there are questionable inherent suppositions at work in most methods of information retrieval.[2] For example, 'classified' information presumes an incontestable array of classifications. 'Sequential' information posits time as it's own thesis, with a humourless, intolerant posture regarding lies and omissions. Even contextual information, where the text is context, requires that the reader assume the text, secondary to the vertical configuration determined by the author.

The unique feature of spatially-constructed fiction is its sequential indeterminacy. New technologies provide new models for a more responsive information system where the user determines point of entry and motion through the text. Each reading is ideosyncratic; subject to additions, modifications, disconnections and breakdown. These systems imply the possibility of a *demanding* fiction, equipped with perceptive, decisive, and active mechanisms; in effect, a robot.

MODELS
1. WALK-IN TERMINAL

The 'Walk-In Terminal' designed by the Architecture Machine Group, provides a useful model for an *information interface* system. The user is seated in front of an 8" X 11" screen with advent video display and rear projection. At either side of this chair are two touch-sensitive monitors. One displays a 'world view map' - insignias, key phrases and pathways comprising an overview of the database. Selecting a point of entry from this map, the user controls a flow of moving pictures, and sound between stereo speakers. He or she may stop, start, slow, or reverse the flow of information, steering closer into detail, or sidetracking, negotiating the direction of their interests.

(In this flow, the user recognizes signs and traces - "Is this what you want? Or this?" - assembling a kind of composite photograph of desire from obviously incomplete co-ordinates; a *recognitive* activity)

2. ASPEN VIDEODISC

Another model by the Architecture Machine Group. The whole of Aspen, Colorado - it's streets, stores, alleys, etc - is recorded on videodisc (a way of storing 57,000 images per side with random access retrieval). The user (still in the control chair) wanders through the streets at will.

(The co-ordinates here are more obviously spatial - the appeal is in moving invisibly. Unlike the correlative 'flags' of the Walk-In Terminal, each frame is discrete and complete, for that matter, could be 'live'. A surveillance system?)

3. PERVERSE TELEPHONE NETWORK

A sub-network sending and receiving interactive pornography using new audio, video, and facsimile transceivers and the existing telephone system. This network, with it's open and shut nodes, is impossible to locate; the hardware shifts or falls apart, is easy to build or repair on principles of theft and bricolage, as it is composed of widely-proliferating surveillance tools. The network *per-se* is the telephone system. The individual participants are interchangeable.[3]

(By participating in remote affiliations, the user is reduced to peculiar interests in disparate transmissions. Anything else ((anything unfit for the code)) can be eliminated. Can we call the voyeur 'non-interactive' and the pervert 'decompositional'? Signal and noise coalesce on this disjunctive surface ((with no body, no database)). The result is peripheral; a marginal remapping of the body's openings.)

★ ★ ★

A FEW TECHNICAL CONSIDERATIONS

1.

Before, I indicated that the 'Walk-In Terminal' is a perceptive, decisive, active mechanism. We can locate it's 'senses' at the points of juncture between the flow of information and the manual decision-making controls. Engaged in the flow, these navigational decisions have an immediate quality, so as to subvert 'selection between' into a cognitive moving-through. The activity is one of steering towards that which we recognize - first as a vague shape, but with increasing specificity.

Cues, clues, flags, and dynamic indications in the information flow are desire's correlatives; the mechanism interprets and perpetuates immediate motion through this heterorgeneous drift.

2.

The left-hand monitor in the terminal displays the same image throughout - a 'world view map' or overview of the database. Some imagery from the information flow is distilled into this static vista from which we choose an entrance. The reader, never trapped in the text, retains the option of returning to this decision; frustrated or dissatisfied, they may re-enter the algorithm from a fresh location.

Movement through the text enhances the map. Later, we will recognize some of it's figures as co-ordinates of our desire. "(Yes, I remember that, and it *is* what interests me.)"

3.

Pockets of cryptic, partial information are dispersed through the text; the consequence of our movement through these pockets *is* the text, which is distinguished by a certain opacity and density, ending in a new flow of partial information. The design is one of linked consequences, with links made by disjunctive motions.

4.

The system is polyvocal, the text - subsequent; the voices it assumes are subsequent, for the text is disentangled from the mutual determination of sequence and point of view. Connections are contingent, interchangeable - like the Perverse Telephone Network. No doors are shut at the point of consequence, for the system is not designed "to mark decisive choices between immutable terms (the alternative: either this or that)..."[4] Rather, voices are particular and interfunctional, peculiar to desire and displacement.

5.

Inserts, challenges, breakdown - a text without pre-determined sequence must prepare itself for all of these, for how can we determine this text's completion? At this point, the model of the network applies - impossible to locate, it's co-ordinates are conditional and very shifty. The text is immediately implemented in any given transmission; more than vulnerable to transgressions, it seems composed by them at every point. Effective and effectable, it is a fictive effect.

AFTERWORD
-SYMPTOMATIC MECHANICS

Correlative cues, clues and flags; indeterminate point of entry and breakdown; the contingent, subsequent motion resulting from this condition of recognition and emergency - these are some of the features of spatially-constructed text. The text may consist of stored language, imagery or sound, or a distributed network - its remarkable quality is the heightened ambivalence with which we enter; rather than locating information we have predetermined at the onset, we are moving through with an eye for the salience and protrusion of our immediate interests - in short, for difference.

What I am proposing is the inhabitation of new technologies with desire and indifference - two terms whose conjugality forms the basis of invention. Invention - an activity where features emerge, and are inhabited and misused with indifference to the intended function of the whole.

Symptomatic methods are not so much a model for fiction as for fictive instincts. Text resembles a disease, where the sum of the symptoms in their duration constitute the disease. Symptomatic mechanics displaces duration, allowing us to reconstitute the symptoms in our own peculiar time. This is not imaginative activity, where, in the narrative structure, we **follow assumptions**, *imagining them as our own. Rather, symptomatic mechanics employ concentration and observation with all the senses, in order to recognize the symptoms of our own desire.*

NOTES

1. Architecture Machine Group,
Massachusetts Institute of Technology, 9-511
77 Massachusetts Avenue
Cambridge, MA 02139
(617) 253-5960
William C. Donelson

2. Dr. Robert Arn addressed this problem during the Computer Culture Exposition panel discussion on Freedom and Control vis. Micro-Electronic Technology, when he noted the freedom of privacy and the freedom to lie. Thus elaborate encryption algorithms both inhibit and maintain information control.

3. The intelligence of the network is its simulation, for its own perverse purposes, of the technological network, the communications technology network. Our desire is: to be peripheral, and yet inhabit anonymously.
Terminal Gallery: Peripheral/Drift; Philip Monk, Parallelogramme/Retrospective 78/79

4. Machines attach themselves to the body without organs as so many points of disjunction, between which an entire network of new synthesis is woven, marking the surface off into co-ordinates, like a grid. The 'either...or...or' of the schizophrenic takes over from the "and then": no matter what two organs are involved, the way in which they are attached to the body without organs must be such that all the disjunctive syntheses between the two amount to the same on the slippery surface.
Anti-Oedipus/Capitalism and Schizophrenia; Giles Deleuze & Felix Guattari, Viking Press, 1972.

parasitic (more than parallel) on the larger social system with their own fluid dynamics. Such was the social art scene.

That the art scene itself could be read as a codable/decodable network made its calculations perverse. As a network, the art scene was "an eccentric and differentiated plurality of indeterminate entries and perverse connections".[31] There was more than one door into the 'Cabana Room' now. The more it modelled its practices on diverting capitalist codes, the more the art scene revealed what it already was. And an individual or an artist here was only a symptom within the system/society as a whole, a node in the network of this particular social scene.

The times were telling us something about circuits of desire and of the interchangeability of subjects. One had to change with the times. Identity needed to be fluid—or schizo. Glamour had already taught General Idea a thing or two about being evasive as well as mobile and this strategy still suited networked perverted modern lovers. "Even the most modern techniques of police surveillance cannot monitor the perverse mutations of today's specialized minority groups. Culture no longer reproduces... it multiplies."[32] So in multiplying themselves, at the end of the decade General Idea recognised "the wildly fluctuating interpretations you, our public, impose on us. Under your gaze we become everything from frivolous night-lifers to hard-core post-Marxist theoreticians."[33] So by 1979 we, too, have to forget that General Idea were, well, General Idea as we knew them.

They were burdened by their own history, indeed by a monument: The *1984 Miss General Idea Pavillion*. 1977 was a banner year for General Idea, starting with their Artists and Models exhibition, which featured *S/HE*, then the *Press Conference* performance and video in the spring, followed by the *FILE* "Punk 'til You Puke!" issue in the autumn, and winding down with the performances *Hot Property* and *The Ruins of the 1984 Miss General Idea Pavillion*, before finally concluding with Reconstructing Futures at the Carmen Lamanna Gallery. Indeed, the end of the year was conclusive: General Idea destroyed the Pavillion and the intellectual system that supported it. Theoretically, the Pavillion could be rebuilt but not without the system that generated it. Little else was exposed in Toronto in 1978 except the going through the motions of their tenth anniversary celebration, which included the *High Profile* performance at the CN Tower and a special issue of *FILE*—and an appearance at Tele-Performance with *Towards an Audience Vocabulary*. Meanwhile out of sight in Europe they tried on new identities under the guise of their commercial exhibitions in Italy, Ménage à Trois and Three Men.[34] So when General Idea exhibited Consenting Adults at the Carmen Lamanna Gallery in January 1979 it was as new artists dealing with new issues and responding to new times.

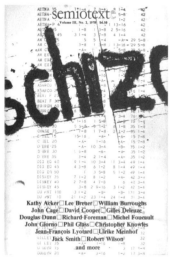

Semiotext(e), vol 3, no 2, 1978

OPPOSITE
Philip Monk, *Peripheral/Drift*, Rumour Publications, 1979 (selected pages)

PERIPHERAL/DRIFT
A Vocabulary of Theoretical Criticism

Philip Monk

Criticism is in a state of drift, out of control.
Its loss, however, is willed; its drifting
theoretical. Initially the question is: How is
criticism presently adequate to its object? Yet,
beyond this question, how is language itself
adequate, as language is the role and "model" of
criticism? Criticism as theory frees itself from
its traditional object - the work of art; it is
responsible - in its theoretical irresponsibility,
i.e., in not answering, responding to the work of
art - for its excess and loss. But in exceeding
the object and losing it, is not this excess and
loss, for itself, jouissance, its own bliss?
Desire has no object - it is outside use, want
and demand; and theory similarly no longer finds
its impulses in the work of art, in an object,
formerly its own object. It can still nominate
a work of art, and say, "That's it for me," as
part of the binary "That's it"/"So what"; but
usually it says "What's in it for me?", or "How
can I use this?".

Theory no longer assumes a subservience to its
object (the prerequisite of a science) in a
presumed secondariness of non-presence to the full
presence of the work of art and the artist, the
guarantor of that presence. Theory now, in a sense,
is fictive. Nevertheless, as its own object,
theory is not a metalanguage, which would return it
to the formal, as a formal language. It is a drift.
This drift is atopic, without a site: theory does
not take itself to be central but peripheral
(not centered in meaning, in society). Theory's
displacement is the movement of its desire, the
loss of its privileged site and meaning, its
prescriptive and normative authority.

The following attempts to sketch a revaluation of
the values (by disguise and theft) of art and theory
through a critical vocabulary of intensive, shifting
terms.

BODY/CONVULSION

Through criticism I bring my body (my language)
into crisis. What is my body to me but a
representation, an image-repertoire, an identity?
That is the representation I bring to my body as
a subject. But I am also inscribed in
representation from "outside": against the
insistence of this recording gaze (a technique) I
offer the resistence of the surface of my body.
Yet against this representation, my body convulses;
it breaks; it disarticulates this inscribed
surface of representation and identity. It
distends and extends itself; or rather, language/
writing imposes a limit to the body, impels the
body to the limit.

The "truth" of the body (its phenomenology) is an
ideology (not natural but created, with its own
history); its limit, this necessary fiction.
Phenomenology cannot ensure the "truth" of the
body. Its promotion of the experience of
temporality is only the most recent of abstractions
created from the meditative space of the art
gallery, while outside I am condemned to the
political technology of my body. Against this
body, against the resolution of tension in the
experience of the work of art, all that is left to
me in my body is my own physical disgust and
convulsion, my own control of my body in the willed
loss of control and usurption by cataclysmic desire

The convulsive body is exemplary in its lack of
control, as a usurper of intensive moments,
displacing energy over the body onto the other,
outside of any hierarchy, identity or coercion.
It is an anoedipal organ.

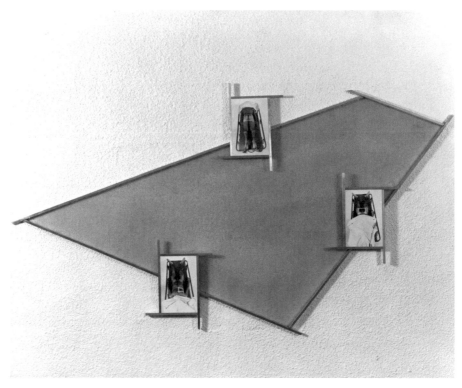

General Idea, *Autopsy*, 1979, mounted photographs and aluminium, 137 x 354 cm

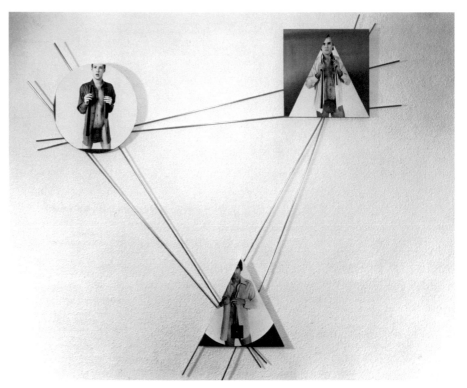

General Idea, *A Geometry of Censorship*, 1979, mounted photographs and aluminium, 256 x 270 cm

The title Consenting Adults rhetorically pointed to a problem, though not to permission as you might expect. It was not, after all, sexual liberty *entre nous*; yet the issue was only partly one of censorship. A regulatory apparatus came between us. More than between us, it was overseeing us: surveying and surveilling us. From beginning to end, from anatomy to autopsy, so to speak, a coercive apparatus articulated our bodies. Here was an embodiment of Michel Foucault's thesis of *Discipline and Punish*, 1977, translated 1979, of the disciplinary apparatus of the political technology of the body.

The titles to some of the exhibited works, such as *An Anatomy of Censorship* and *A Geometry of Censorship*, seem to announce a repressive hypothesis only. Yet, nothing is covered up (only partially in *Autopsy*, to fetishising effect). The body is front and centre for all to see. In *Autopsy*, a prone and supine male figure stretched on a gurney has its upper body covered while its exposed erogenous zones are clearly demarcated. No more ethereal Miss General Idea, visible but just out of grasp, but a material body, there—not ritually elevated but mundanely splayed out in front of us. No diffuse media representation but close inspection. No spotlit spectacle but the grey scrutiny of a police report. But when we read the texts to *An Anatomy of Censorship*, we find, opposed to the repressive hypothesis the title proposes, obsessive strings of words aligning with fetishising lines of sight. We witness a proliferation of talk, of an "incitement to discourse" on sexuality.[35] The texts of *An Anatomy of Censorship* ad lib from Foucault's recent books and Barthes' *A Lover's Discourse*, 1977, translated 1978, corresponding to images that appear in *Autopsy*. In amalgamating Foucault and Barthes (and Deleuze and Guattari's anti-fascism) here in *An Anatomy of Censorship*, General Idea were *au courant* theoretically, although not so far ahead of the pack as before. They were also *au courant* politically, acting in solidarity with other artists in support of *The Body Politic*. Coincident with their exhibition the trio participated in the January 1979 Body Politic Rally for the gay newspaper charged with obscenity, and performed an earlier slide-and-voiceover variation of *An Anatomy of Censorship* there. Amerigo Marras no longer could complain of General Idea's aloofness from gay liberation issues with their participation at the rally or with articles such as radical homosexual Guy Hocquenhem's "We Can't all Die in Bed" published in *FILE* (along with hardcore advocates Jean Genet and Robert Mapplethorpe), an issue which had problems, incidentally, at the printers over Mapplethorpe's photographs.

Referring to the *Body Politic* trial, AA Bronson distinguishes the issues of censorship for artists when he notes, "Although the issue for the readers of the newspaper was primarily one of sexual freedom, the issue for the artists was considerably larger: the right to exhibit (and not only exhibit but investigate and develop) 'perverse' behavior."[36] The art scene

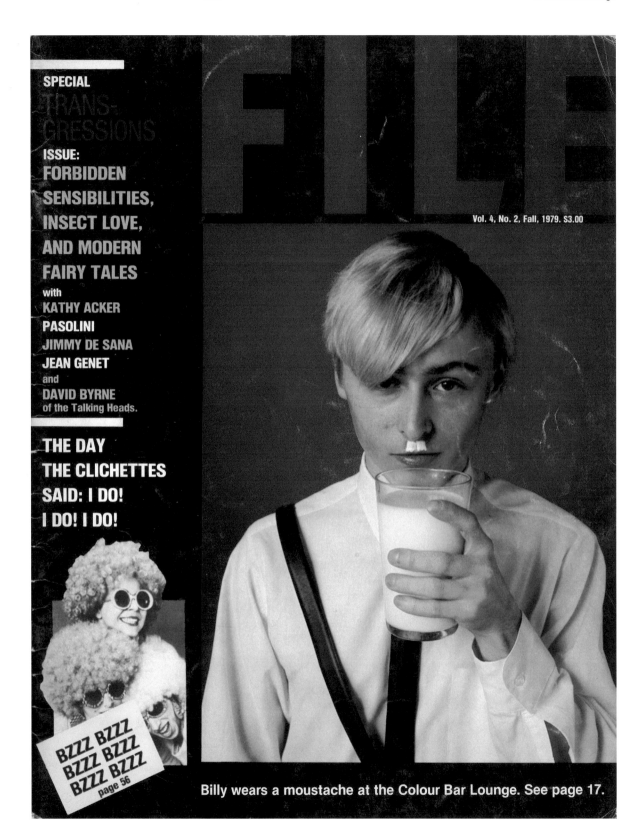

FILE

Vol. 4, No. 2, Fall, 1979. $3.00

SPECIAL
TRANS-
GRESSIONS
ISSUE:
FORBIDDEN
SENSIBILITIES,
INSECT LOVE,
AND MODERN
FAIRY TALES
with
KATHY ACKER
PASOLINI
JIMMY DE SANA
JEAN GENET
and
DAVID BYRNE
of the Talking Heads.

THE DAY
THE CLICHETTES
SAID: I DO!
I DO! I DO!

BZZZ BZZZ
BZZZ BZZZ
BZZZ BZZZ
page 56

Billy wears a moustache at the Colour Bar Lounge. See page 17.

EDITORIAL

ROCK THE BOAT PEOPLE!

To tell art's story consistently and well, to keep art in the top-of-the-mind segment of public attention – these are the artists's first responsibilities.

The artist's ability to fulfill this responsibility depends inevitably on his expertise in the use of the mass media. And yet, ironically, too much mass media expertise and the artist becomes . . . ycccccch! . . . trendy.

These days a friend visiting General Idea is likely to be served a new drink – 'trendy responsibility'; a ratio, a balance, a borderline case, one of the many effective cocktails available at General Idea's newly opened Colour Bar Lounge (see page 56).

A lot of people ask us for the recipe, so we have assembled this special issue of FILE about this new concoction. You, the art lover, can now mix your own effective cocktails at home.

Yes, 'trendy' is a word to be grappled with, as 'glamour' once was. Certainly there is one peak moment when trendiness rises to its most effective, when it becomes a powerful tool for dealing with existing structures. It blooms for a night or a season, and then is consumed by what many call Capitalist chaos. And what name shall we give that distance that separates the trendy from the avant-garde?

Note: a responsible trendy is never consumed. S/he is consummated. Letting oneself be consumed is sheer irresponsibility, like developing a drinking problem.

Our role? Like customs agents on the borders of acceptance, we smuggle transgressions back into the picture, mixing doubles out of the ingredients of prohibition.

Solve your drinking problems with trendy responsibility, the drink which builds residual effects and yet still lets you see double. All of this without the slightest taste of stale rhetoric.

Interested? Mix together a few of the ingredients found on the following pages – we call them transgressions. Cultural, social, political, sexual, take your pick. Here's mud in your eye!

Cheers. Salut. Chin chin. Zivelo.

Mr. Bill wears a mustache in General Idea's upcoming TV special currently in production on location in Amsterdam. Mr. Bill knows that fascism is a bottomless cup but he's liable to forget the unquenchable thirst for this intoxicating brew. To help him remember we've introduced this new cocktail. We call it Nazi Milk. The recipe? Nothing exotic. Something found in most homes. A basic ingredient with an oedipal undertaste, preferably white. Yes, milk was the vehicle for our message. This issue of FILE milks a whole new meaning out of this common nourishing substance. For more cocktails see page 56.

hotographer Jimmy de ana has a nice eye for ansgressions. Here he ixes insect love with a beral dose of sexual berration and suburban esthetics. The result? A ew book titled ubmission', with an troduction by William urroughs. For more insect ve, turn the page.

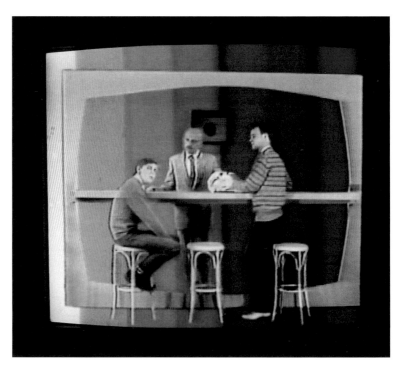

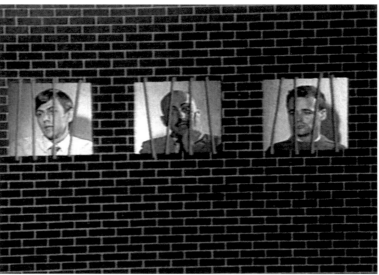

General Idea, *Test Tube*, 1979 video (stills)

was not only a place to exhibit artwork; it was an incubator of 'perverse' behaviour. Success was a measure of what you could get away with. This took just the right amount of exposure and balance of permission and prohibition.

The police were already stroking their files and preparing surveillance of the art scene. Censorship would be consequential in the 1980s, but could it be put off?[37] General Idea set grounds for its debate and strategies for its avoidance. Censorship for them, however, was only the middle term between surveillance and transgression. If censorship was repressive, surveillance and transgression actively courted each other in a game of hide and seek in the open. Transgression was the right mix of the permissive and the prohibitive. But it was also duplicitous. "Like custom agents on the borders of acceptance, we smuggle transgressions back into the picture, mixing doubles out of the ingredients of prohibition."

General Idea used their *FILE* editorial to the special "Transgression" issue to propose a middle ground: "trendy responsibility".

> Yes, 'trendy' is a word to be grappled with, as 'glamour' once was. Certainly there is one peak moment when trendiness rises to its most effective, when it becomes a powerful tool for dealing with existing structures. It blooms for a night or a season, and then is consumed by what many call Capitalist chaos.[38]

Some might debate whether this already was capitalism. Others would wonder how effective it could be. Writing at the same moment as the "Transgression" editorial and criticising the "fadish sado-anarchism" General Idea shared with *Semiotext(e)*'s editor Sylvère Lotringer, Karl Beveridge asks, "How can one, for instance, create an open and above board dialogue in the midst of an activity that is illegal and of necessity, secretive." The same could be asked of the art scene. Beveridge counter-proposed another model: "The Leninist model of a revolutionary party is based on this aspect of illegality, that is, an organization that is at war. What is at stake here is the institution of a revolutionary vanguard as an instrument of historical change and its relation to a mass movement."[39]

What was at stake seemingly was what party one belonged to and consequently what type of artist one was. Was one a fadish 'cocktail party artist' or an instrumental 'revolutionary party artist'? "Join the party." A party. The party in question was being held at General Idea's newly opened, though fictitious, Colour Bar Lounge—and the dilemma was that posed by Marianne, the colour stripe painter of General Idea's made-for-TV *Test Tube*, 1979.[40] The question of party allegiance perhaps was old fashioned—which was not a drink you could order at the bar here.

General Idea had participated in Tele-Performance with *Towards an Audience Vocabulary*, in which—in the closed circuit of its conceit,

frames framing frames, and mirrors mirroring mirrors—an audience was staged, literally put on stage, and put through its motions with a real one looking on idle. The performance never addressed the intended audience, a television audience, that is. But here a year later the artists were in Amsterdam talking to their audience on television. De Appel had commissioned from them a video for television, and the result, *Test Tube*, was state of the art, with production values that networks could not refuse, at least for technical reasons. It was state of the art, too, in asking pertinent questions of artists. It was not just a matter of which side were you on. Embracing the tube put one to the test.

So in the television set of the Colour Bar Lounge, so set in the tube—the set cleverly appearing as a television monitor with colour bar decor—hosts General Idea tell us, "We think of television as our test tube [...] to test out new formulae for making art consumable." It is a "cultural incubator" where "we isolate members of the art scene as our control group to test the effectiveness of our intoxicating cocktails.... And everyone is a host at the Colour Bar Lounge!" Within the double metaphors of television tube and science lab, as cultured hosts that were both contaminated and contaminating, General Idea entertain the question they constantly posed during this period: what is an effective art? Inhabiting television did they now have a solution?

In spite of the fact that *Test Tube* was destined to be televised and General Idea therefore were speaking potentially to its mass audience; in spite of the fact that this inhabitation of media incited the artists "to isolate this potent culture [art] and introduce the infectious mutations into the mainstream", or, in other words, "to inject into the mainstream of popular culture these germs of art discourse"; was this just talk? Or were General Idea really speaking to an art audience instead? Moreover, were they reflecting the art scene back to itself through the metaphor of mass media, indeed, through irreality television?

Fact: Increased congestion means increased reality consumption.
Fact: There *is* a reality shortage.
Fact: General Idea is doing something about it.
Our researchers have isolated members of the art scene as a control group in this experiment.
Everyone knows that the art scene has always been able to cope with reality shortage but, how?
We built the Colour Bar Lounge as our research centre for these investigations.
Here at the Colour Bar, curators, critics and artists are working with our staff.
They employ cocktails of meaning and fill them up again to create a renewable resource of multiple meaning.

Our bartenders are learning to create new cocktails to satisfy your complete reality needs.

Make it a reality at the Colour Bar Lounge.

Was the art scene simply art discourse or vice versa? Was General Idea injecting art discourse into the mainstream or were they rather using this discourse to describe what the art scene was about, and how it operated. We usually think the language the artists employ in *Test Tube* describes their own patented procedures—of viral inhabitation and fluctuating meaning—but in that General Idea use the art scene as a control group perhaps they are describing instead the collective behaviour that manifests itself as a scene. It wasn't a discourse that the art scene used, at least what is thought typically as an art discourse, but a screen for what the art scene did: an allegory of it enacted as an artwork—and solely through talk.

So having the last word on artists on television, as artists on television, that to think like, act like, and be like television would be to revolutionise the artist; and so saying, "Think of capitalism as another found format that we can occupy and fill with our own content", was no po-mo mishmash that confused what was at stake politically in a cynical sellout to the system. Nor were we to take at face value the statement, "the problem is, how to work *in*side the system, because there is no outside anymore", as an embrace of capitalism.[41] General Idea were not advocating for television, capitalism, or taking sides as to what was responsible art. Jorge reading AA's palm with a swizzle stick and saying, "And this is the line of effectiveness, and this is the line of social responsibility, and the distance between them is trendiness, and they all meet here in the mound of artistic endeavor", no longer opposed artists across divided lines of performative frivolity or political responsibility, as cocktail party artists or revolutionary party artists. The mix was more complex. Mix was their metaphor.

The 'embrace' of capitalism was at best a sleight-of-hand device since capitalism perhaps was the best metaphor for the constant devaluing and revaluing that artists pursued semi-covertly in the art scene. As Felix says in the video, "That's the way capitalism operates. It has to constantly open new markets. It cultures chaos with the understanding that there will probably be a new mutation to harvest, and refine, and re-inject back into the mainstream... at a healthy profit, of course." Profit would be redeemed another way in the art scene, of course.[42]

And trendiness? "And what name shall we give that distance that separates the trendy from the avant-garde?", *FILE* asked. Were General Idea mocking themselves and their own trendiness? But was trendy not the avant-garde? Not 'trendy responsibility', the editorial ironically proposed of an oxymoronic obligation "To tell art's story consistently and

well, to keep art in the top-of-the-mind segment of public attention—these are the artist's first responsibility." Trendiness was "a powerful tool for dealing with existing structures", but only by subversion. Trendiness was a refraction of the necessary transgressions by which artists needed to operate in the art scene—or a disguise for them. Trendiness was the art scene's symbolic capital. Trendiness was the tracking of its transgressions. But trendiness, as well, was the unavoidability of exposure as the blossoming art scene began to come to light. First exposure was to the in crowd that the art scene itself was; then to the wider semi-clandestine circle it disseminated its products to, those who participated; then to the police and city inspectors for whom illicit artists were no longer under the radar; finally to journalists who gave up the gig. Though ironically stated here, "top-of-the-mind segment of public attention" was not always what artists wanted!

The measure of an art scene in part is its ability to disseminate itself and attract others to it. Toronto did this job well and created a whole new art scene for itself in the first half of the 1980s on the basis of the fiction it made of itself in the late 1970s. But in attraction are the seeds of dissolution, too. If the new art scene was attracted by these images, eventually others from afar called them as well: the siren song of European expressionist painting and DIY Lower East Side figuration. The same old scenario reasserted itself of signs signifying from elsewhere and re-establishing their domination after an all-to-brief, yet fertile, hiatus of self-invention. In the seeming continuity of generations it was enough of a wedge to drive practices apart and in a very short period of time what was authentic disappeared along with what was ersatz. This, too, is Toronto's history, but telling no stories to itself it has never been related.

1 Buchan, David, "Artists in Residence: Women's Performance Art in Canada", *Vie des Arts*, vol 21, no 86, 1977, p 86. General Idea, "Glamour", *FILE*, vol 3, no 1, autumn 1975, p 32.

2 "Stolen Lingo": "We knew Glamour was artificial. We knew that in order to be glamourous we had to become plagiarists, intellectual parasites. We moved in on history and occupied images, emptying them of meaning, reducing them to shells. We filled these shells then with Glamour, the creampuff innocence of idiots, the naughty silence of sharkfins slicing oily waters." "Image Lobotomy": "Glamourous objects events have been brutally emptied of meaning that parasitic but cultured meaning might be housed there. Thus Glamour is the result of a brief but brilliant larceny: image is stolen and restored, but what is restored? Memories are blurred. Details have been erased. The image moves with the awkward grace of the benumbed, slave to a host of myths." General Idea, "Glamour", *FILE*, pp 22, 29.

3 "This is because myth is speech stolen and restored. Only, speech which is restored is no longer quite that which was stolen: when it was brought back, it was not put exactly in its place. It is this brief act of larceny, this moment taken for a surreptitious faking, which gives mythical speech its benumbed look." Barthes, Roland, "Myth Today" *Mythologies*, Annette Lavers trans, New York: Hill and Wang, 1972, p 125.

4 Barthes, "Myth Today", p 135.

5 "In an initial moment [of semiological analysis], the aim was the destruction of the (ideological) signified; in a second, it is that of the destruction of the sign: 'mythoclasm' is succeeded by a 'semioclasm' which is much more far-reaching and pitched at a different level." Barthes, Roland, "Change the Object Itself: Mythology Today", *Image Music Text*, Stephen Heath trans, London: Fontana Press, 1977, p 167.

6 "I believe, however, that even if the new semiology—concerned in particular recently with the literary text—has not applied itself further to the myths of our time since the last of the texts in *Mythologies* where I sketched out an initial semiotic approach to social language, it is at least conscious of its task: no longer simply to *upend* (or *right)* the mythical message, to stand it back on its feet, with denotation at the bottom and connotation at the top, nature on the surface and class interest deep down, but rather to change the object itself, to produce a new object...." Barthes, "Change the Object Itself", p 169.

7 It would be resisted. "Nor is video necessarily tv (broadcast that is) although it can be broadcast.... Most of video has moved out of the shadow of direct television references and has started to develop its own content and considerations. As independent producers, it is not up to us to make this content palatable or acceptable for broadcast tv as it exists today. We must face the fact that not only are we *not* tv, but that tv doesn't want us, and that has nothing to do with the technical quality. It has to do with content. We are dangerous. Because we work alone or in small groups, traditional societal censorship (meaning the consumers push for product) does not affect us. We aren't after ratings; nor are the ratings after us. We are effectively outside the power/money phalanx." Report by Lisa Steele in Duchaine, Andrée, "Fifth Network, Cinquième Réseau", *Parachute*, no 13, winter 1978, p 7.

8 "One remarkably dominant aspect of the conference in general was the evidence of a significant gap of mutual incomprehension between the two broad factions present who can be said to have represented the poles of 'social' video and 'art' video." Coutts-Smith, Kenneth, "Guest Editorial", *Centerfold*, vol 3, no 1, December 1978, p 5.

9 "Canadian artists leapt into the video/performance conjunction as early as the mid-sixties.... Perhaps it is our generation's experience of reality through the television set that has set in close union performance and video." Bronson, AA, "Automatons/Automorons", in Bronson, AA, and Peggy Gale, eds, *Performance by Artists*, Toronto: Art Metropole, p 291. Although a majority, the event included more than Toronto artists.

10 Campbell, Colin, "David Buchan: Lamonte Del Monte and The Fruit Cocktails", *Centerfold*, vol 3, no 1, December 1978, p 31. Of one of Lamonte's own numbers, Campbell writes, "Lamonte challenges all previous efforts at overcoming obstacles in communicating to the audience by singing *Going Out of My Head* in a strait-jacket. You try singing a song in a strait-jacket. To a corpse. He is positively touching as he bends over his recently, dearly departed."

11 In a sense this performance marks the transition for women from independent dance, which was having its moment in the second half of the decade in Toronto, to performance art. The four members had trained in dance. Louise Garfield, Janice Hladki, Johanna Householder would continue as The Clichettes, with Elizabeth Chitty going her own way as a performance artist.

12 For instance, when Foucault says in an interview, "What I want to show is how power relations can materially penetrate the body in depth, without depending even on the mediation of the subject's own representations." Foucault, Michel, *Power/Knowledge: Selected Interviews & Other Writings 1972–1977*, Colin Gordon ed, New York: Pantheon Books, 1980, p 186.

13 Coutts-Smith, "Guest Editorial", p 6.

14 Gale, Peggy, "Explaining Pictures to Dead Air: The Robertson/ Beuys Admixture", *Parachute*, no 14, spring 1979, p 8. The article also transcribes the script.

15 "... as I switch on the recorder and listen to me as I become myself for you are here a little late looking so good watching me under the assumptions you will continue to make about my public confinement while I undergo a rapid change or make a transition to allow you the third person so to speak with the fourth and the fifth and on through until the I in me loses control as the machine fires back another picture at least as impressive as my image of your self in very different colours talking loud or soft under their home control with their comfort assured according to their action their whims they turn you into filler and fix but lack of information is a thing in itself a difference and the dissemination of multiples of yourself makes me look at the machines coact with us in such a clean manner of reproduction." Sherman, Tom, "See the Text Comes to Read You", unpublished text, 1978.

16 Sherman, Tom, "The New Triumvirate", *Centerfold*, vol 3, no 1, December 1978, p 58.

17 "With the media so obviously in the back pocket of government, here is a question the RCMP, the artist, and the broadcasters all might ask themselves. Who says what, on which channel to whom, with what effect?" Sherman, "The New Triumvirate", p 59.

18 Some of these texts were written from photographs (for example,

"Writing from the Photographs of Lynne Cohen and Rodney Werden, at Cinema Lumiere in Toronto, August 1977") but as its own disciplined practice and distinctive outcome. Sherman published his fiction in *Only Paper Today*, *Art Communication Edition*, *FILE*, *Impulse*, and *Centerfold*.

19 Sherman, Tom, "Television as Regular Nightmare," *Performance by Artists*, pp 149–58. The text was written spring 1978 so presents a thematic whole with "See the Text Comes to Read You" and "The Artist Attains Ham Radio Status in an Era of Total Thought Conveyance".

20 Sherman, "Television as Regular Nightmare", p 150.

21 Sherman, Tom, "The Artist Attains Ham Radio Status in an Era of Total Thought Conveyance," *Centerfold*, vol 2, no 6, September 1978, pp 86–92. This text is set as if it was logically generated and rolled out like the character-generated scrolling television text.

22 Bronson continues, "Touched by the fever of perverted eroticism, inverted rationale (called 'sensibility') and the sibilant persistence of social relevance, they careen through the bohemian-machine of Toronto's artist-run institutions, meeting expectations like modern kids must with oedipal parents: schizophrenically." Bronson, "Automatons/Automorons", p 291.

23 "To act as though an innocent discourse could be held against ideology is tantamount to continuing to believe that language can be nothing but the neutral instrument of a triumphant content. In fact, today, there is no language site outside bourgeois ideology: our language comes from it, returns to it, remains closed up in it. The only possible rejoinder is neither confrontation nor destruction, but only theft: fragment the old text of culture, science, literature, and change its features according to formulae of disguise, as one disguises stolen goods." Barthes, Roland, *Sade/Fourier/Loyola*, Richard Miller trans, New York: Hill and Wang, 1976, p 10, (originally published in 1971).

24 "The problematics of hardware are located at the juncture of TV and telephone—the fibre optic cable system." Doyle, Judith, "Facsimile Hardware", *Spaces by Artists/Places des artistes*, Tanya Rosenberg ed, Toronto: ANNPAC, 1979, pp 54, 56.

25 Sharp, Willoughby, "Worldpool: A Call for Global Community Communications", *Only Paper Today*, vol 5, no 10, December 1978, pp 8–9.

26 Doyle, "Facsimile Hardware", pp 54, 56.

27 Doyle, Judith, "Model for Prose Algorithm", *Only Paper Today* (Theoretical Fiction Supplement), vol 6, no 8, October 1979. Her footnote here refers to a parallel investigation: "The intelligence of the network is its simulation, for its own perverse purposes, of the technological network, the communications technology network. Our desire is: to be peripheral, and yet inhabit anonymously." Monk, Philip, "Terminal Gallery/Peripheral Drift", *Spaces by Artists/Places des artistes*, p 34.

28 The first quotation is from Doyle's "Facsimile Hardware", p 56, the second from "Model for Prose Algorithm".

29 "The system is polyvocal, the text—subsequent; the voices it assumes are subsequent, for the text is disentangled from the mutual determination of sequence and point of view. Connections are contingent, interchangeable—like the Perverse Telephone Network." Doyle, "Model for Prose Algorithm".

30 "Two men, two telephones and certain electronic circuitry (established for entirely different reasons) combine to form a simple desiring machine." Bronson, AA, "Pogo Dancing in the British Aisles", *FILE*, vol 3, no 4, autumn 1977, p 17.

31 "A *network* seems to coalesce as the 'site' of the peripheral drift, composed as it is of shifting subjects, subjects created through the inscribed symptoms of recording techniques. The network is an eccentric and differentiated plurality of indeterminate entries and perverse connections." Monk, "Terminal Gallery/Peripheral Drift", pp 32–33. Including the application of Roman Jacobson's linguistics, notions of the network largely depended on the dissemination of 1970s French textual theory, such as Barthes' *S/Z*, published 1970, translated 1974, and Deleuze and Guattari's *Kafka: Toward a Minor Literature*, published 1975, translated 1986. For example: "In this ideal text, the networks are many and interact, without any one of them being able to surpass the rest; this text is a galaxy of signifiers, not a structure of signifieds; it has no beginning; it is reversible; we gain access to it by several entrances, none of which can be authoritatively declared to be the main one." Barthes, Roland, *S/Z*, Richard Miller trans, New York: Hill and Wang, 1974, p 5. And: "We will enter, then, by any point whatsoever; none matters more than another, and no entrance is more privileged even if it seems an impasse, a tight passage, a siphon. We will be trying only to discover what other points our entrance connects to, what crossroads and galleries one passes through to link two points, what the map of the rhizome is and how the map is modified if one enters by another point. Only the principle of multiple entrances prevents the introduction of the enemy, the Signifier and those attempts to interpret a work that is actually only open to experimentation." Deleuze, Gilles and Félix Guattari, *Kafka: Toward A Minor Literature*, Dana Polan trans, Minneapolis: University of Minnesota Press, 1986, p 3.

32 General Idea, *An Anatomy of Censorship*. This work exists in two forms: as a series of nine Showcards and an artist project in *Performance by Artists*, Bronson and Gale eds, pp 87–93.

33 "Editorial", *FILE*, vol 4, no 1, summer 1978, p 7.

34 They had already began this transition from the Pavillion—and its planned destruction—to the corporate identity of the threesome in 1977 as evidenced by Showcards of that year. On the transition from one (Miss General Idea) to three (the corporate troika of General Idea), see Monk, Philip, *Glamour is Theft: A User's Guide to General Idea*, Toronto, Art Gallery of York University, 2012, pp 218, 223. That they would fall back into making work referencing the Pavillion was a sometimes automatic reflex for the artists, a "relapse into all too familiar roles" (*Showcard #1-105*) that they criticised in others.

35 "The 'putting into discourse of sex', far from undergoing a process of restriction, on the contrary has been subject to a mechanism of increasing incitement; that the techniques of power exercised over sex have not obeyed a principle of rigourous selection, but rather one of dissemination and implantation of polymorphous sexualities". Foucault, Michel, *The History of Sexuality, Volume 1: An Introduction*, Robert Hurley trans, New York: Pantheon Books, 1978, p 12.

36 Bronson, "Automatons/Automorons", p 295.

37 On censorship in the Toronto art community during the early 1980s with reference to the late 1970s, see the chronology by Judith

Doyle, "A Chronology of Censorship in Ontario", *Impulse*, vol 9, no 2, autumn 1981, pp 26–31; the chronology by Cyndra MacDowall, "The Struggle Over Freedom of Expression", *Issues of Censorship*, Toronto: A Space, 1985, pp 63–76; and Jennifer Oille and Dot Tuer, "Censorship in Canada: Case History: Ontario", *Vanguard*, vol 15, no 3, summer 1986, pp 30–33.

38 "Editorial", *FILE*, vol 4, no 2, autumn 1979, p 17.

39 Beveridge was reviewing the "Schizo" issue of *Semiotext(e)*, vol 3, no 2, 1978. Beveridge, Karl, "Sado-Anarchism?", *Centerfold*, vol 3, no 6, September 1979, p 338.

40 The Colour Bar Lounge was the cocktail bar in *The 1984 Miss General Idea Pavillion*. *Test Tube*'s script is published in Elke Towne ed, *Video by Artists* 2, Toronto: Art Metropole, 1986, pp 59–66. Karl Beveridge might have imagined *Test Tube*'s party scene similarly when he concluded his review of *Semiotext(e)*, "I'm sure we will see more of this fascinating inquiry into the schizo-inanities of revolutionary neurosis. Meanwhile Lotringer can be seen any Friday night dancing to the disco sounds of the International(e)." Beveridge, "Sado-Anarchism?", p 338.

41 This was in answer to the question, "And the problem is... how to work outside the system?"

42 What darkly bloomed in the art scene inevitably would be recuperated and consumed by capitalism to its profit, which has become, in part, the unexpected economic role of the avant-garde and underground. As has happened elsewhere, the downtown scene, then known as the Queen Street art community, eventually led to the gentrification of the district and the disappearance of its artists.

Index

Image Credits

Acknowledgements

My first thanks are to my first reader, Michael Maranda, who edits my material at the Art Gallery of York University. Then to the support of Duncan McCorquodale at Black Dog Publishing, designer Albino Tavares, and editorial staff.

The archives for the Centre for Experimental Art and Communications being housed there, as well as the Clara Thomas Archives and Special Collections, York University was essential to my research. I owe a sincere debt of gratitude to its staff as well as to that of the Edward P Taylor Library & Archives, Art Gallery of Ontario, where the A Space Fonds are located.

Many people assisted in supplying photographs or scans without which this documentary history could not exist. I particularly want to thank Fern Bayer, AA Bronson, Canadian Lesbian and Gay Archives, Elizabeth Chitty, Carole Condé and Karl Beveridge, Ian Carr-Harris, Demetra Christakos, Carmen Colangelo of the Carmen Lamanna Estate, Judith Doyle, Peter Dudar, Barr Gilmore, Isobel Harry, Peter MacCallum, Sabrina Maher, Ross McLaren, Don Pyle, Clive Robertson, the Studio of Richard Serra, Tom Sherman, Adam Swica, Deanne Taylor, Kim Tomczak, Vtape, and George Whiteside.

Portions of the text have appeared in *Fillip* 20, autumn 2015.

This book had its origins in an exhibition of the same name held at the Art Gallery of York University from 10 September to 7 December 2014. I would like to express my ongoing appreciation to the rest of the staff there: Emelie Chhangur, Suzanne Carte, Allyson Adley, and Karen Pellegrino.

Black Dog Publishing Limited
10a Acton Street, London WC1X 9NG
United Kingdom

Tel: +44(0)20 7713 5097
Fax: +44 (0)20 7713 8682
info@blackdogonline.com
www.blackdogonline.com

Designed by Albino Tavares at Black Dog Publishing

British Library Cataloguing-in-Publication Data.
A CIP record for this book is available from the British Library.

ISBN: 978-1-910433-37-9

Black Dog Publishing Limited London, UK, is an environmentally responsible company.
Is Toronto Burning? Three Years in the Making (and Unmaking) of the Toronto Art Scene is printed
on sustainably sourced paper.

The Art Gallery of York University is supported by York University, the Canada Council for the
Arts, the Ontario Arts Council, and the City of Toronto through the Toronto Arts Council.

art design fashion
history photography
theory and things

www.blackdogonline.com